意大利超前卫艺术

La transavanguardia italiana

阿·博·奥利瓦　主编

Achille Bonito Oliva

中国　山东美术出版社

ShanDong Fine Arts publishing house China

图书在版编目（CIP）数据

意大利超前卫艺术／（意大利）奥利瓦主编 . —济南：
山东美术出版社，2001.2
ISBN 7-5330-1405-7

Ⅰ．意... Ⅱ．奥... Ⅲ．油画–作品集–意大利–现代
Ⅳ. J233

中国版本图书馆 CIP 数据核字（2000）第 55572 号

策　　划：全山石
　　　　　姜衍波
封面设计：韩济平
版式设计：李晓雯
意文翻译：王　军
英文翻译：孔新苗
责任编辑：李晓雯

出版发行：山东美术出版社
地　　址：济南市胜利大街 39 号
邮政编码：250001
制版印刷：深圳华新彩印制版有限公司
规　　格：889 × 1194mm
开　　本：10 开　26 印张
版　　次：2001 年 2 月第 1 版
印　　次：2001 年 2 月第 1 次印刷
印　　数：1–2500
定　　价：280.00 元

TRANSAVANGUARDIA ITALIANA
ITALIAN TRANS-AVANTGARDE
by Achille Bonito Oliva

Promoted by:
Ministero degli Affari Esteri
Incontri Internazionali d'Arte

In co-operation with:
Studio Arte Italo-Cinese

Editor:
Valentina Bonomo

Assistant editors:
Brunella Buscicchio
Fabrizia Casagrande

Secretary:
Federica Guida

Photographs credits:
Aurelio Amendola
Giorgio Colombo
Alessandra Como
G.Como
Giuseppe Gernone
Enzo Lattanzio
Sandro Mahler
Attilio Maranzano
Paolo Mussat Sartor
Foto Parlantini & c
Massimo Piersanti
Georges Poncet
Paolo Pellion di Persano
Prudence Cuming Associates
Giuseppe Schiavinotto
Paolo Terzi
Dorothy Zeidman

前　言

《意大利超前卫艺术》一书，再次证实了1979年阿奇莱·博尼托·奥利瓦提出的理论即当代意大利艺术运动具有世界性。

我们想以此书的出版纪念这一运动发起20年，并重申"国际艺术交流会"对该运动的形成所起到的非同凡响的作用。

在几十年的工作中，我们基金会始终以进行不同文化间的交流与对比为不变的宗旨。

《意大利超前卫艺术》一书的出版，表明了我们对中国文明的兴趣。为此，1993年在斯波莱托艺术节之际我们曾举办过一次名为"明天之艺术观点"的展览，邀请了一批中国艺术家，以便使欧洲的青年一代对中国的艺术有所了解。另外，为了扩大交流的规模，1995年，我们还举办了名为"意大利妇女与艺术"的展览，以及名为 "Kinomata，意大利电影中的妇女" 的电影展。

这些年来，许多年轻的艺术史学家、批评家、经纪人和收藏家，以及所有使艺术体系生存和发展下去的人士，与我们进行了合作，我要感谢他们，感谢所有使我们的倡议顺利实施的人。

首先，我要特别感谢 Valentina Bonomo，她为这本书的编辑作了许多协调工作，并和艺术家们一起，挑选整理了从超前卫运动之初直到今天的作品。

我也要感谢中国山东美术出版社，他们的热情和奉献是非常可贵的。

国际艺术交流会秘书长

格拉切拉·布翁滕皮·罗纳尔迪

Il libro "Transavanguardia Italiana" , ancora una volta, conferma il valore cosmopolita del movimento italiano teorizzato da Achille Bonito Oliva nel 1979, di cui celebriamo quest'anno il ventennale con una pubblicazione che ribadisce anche il ruolo degli Incontri Internazionali d'Arte.

La nostra Fondazione, nel corso della sua pluridecennale attività, ha sempre puntato sullo scambio e sul confronto di culture differenti. In particolare, quest' evento conferma il nostro interesse per la civiltà della Cina, alla quale abbiamo già dedicato un'iniziativa nel 1993, invitando alcuni artisti cinesi ad "Artedomani Punti di vista", nell'ambito del festival di Spoleto, che ha consentito di far conoscere in Italia l'arte cinese alle nuove generazioni; in seguito, nel 1995, abbiamo continuato ad alimentare questo scambio con la mostra "Women and the Arts in Italy" e con la rassegna cinematografica "Kinomata, Women in the movies in Italy".

Negli anni ci hanno seguito giovani storici dell'arte, critici, mercanti collezionisti, tutte voci essenziali per far vivere e crescere il sistema dell'arte: li ringrazio tutti, insieme a coloro che hanno lavorato per il buon esito di queste iniziative. In particolare il mio ringraziamento va a Valentina Bonomo, che ha coordinato la realizzazione di questo libro e con gli artisti ha raccolto una comprensiva selezione di opere, dai primi anni della transavanguardia fino ai giorni nostri.

Ringrazio inoltre le autorità e i musei cinesi, che con slancio ed entusiasmo ne sono stati i promotori,e naturalmente la Shandong Fine Arts Publishing House.

Graziella Buontempo Lonardi
Segretario generale
Incontri Internazionali d'Arte

This book, "Transavanguardia Italiana ",once again reiterates the cosmopolitan nature of the contemporary Italian art movement contemplated by Achille Bonito Oliva in 1979.

We thought of celebrating the movement's twenticth anniversary with a publication which also reconfirms the significant role of the Incontri Internazionali d'Arte in its formation.

The intentions of our Foundation, over the course of its many decades of activity, have always been directed toward exchanges and confrontations between a variety of cultures.

This particular event represents a confirmation of our interest in the civilization of China, following our 1993 initiative"Artedomani Punti di vista", an exhibition held in conjunction with the Spoleto Festival to which we invited a number of Chinese artists in order to provide the vounger generations in Europe with an opportunity to become acquainted with Chinese art. Consequently, in 1995, we amplified this exchange with the exhibition "Women and the Arts in Italy" and the film show "Kinomate, Women in the Movies in Italy".

We have had an attentive following of young art historians, crities, dcalers and collectors throughout these years, all voices cssential to keep the art system alive and growing.

I would like to thank everyone and, together with those who have worked to make these initiatives successful.

First of all, I am particularly grateful to Valentina Bonomo who coordinated the edition of this book and who, together with the artists, compiled a comprehensive selection of works dating from the beginning of the Transavanguardia movement to the present.

I would also like to thank the Chinese authorities and museums whose dedications and cnthusiasm have been invaluable as promoters of this project and, or course, the Shandong Fine Arts Publishing House.

Graziella Buontempo Lonardi
General Secretary
Incontri Internazionali d'Arte

目 录　CONTENTS

还艺术本原

——意大利超前卫艺术给我们的启示

（代 序）

邵大箴

20世纪是人类社会节奏变化最快速的时代，也是艺术最富有变化的时代。工业革命以及由科技革命引发的信息革命，给人类的思维、生活方式和文化艺术创造以极大的冲击，人类社会往何处去这个问题一直困扰着人们。许多社会精英分子提出了各式各样的新学说，试图找出圆满的答案，但是，迄今仍然在探索之中。与此相关的艺术往何处去的问题，也一直困扰着试图在创造上有所作为的艺术家们，也一直在困扰着试图真正理解和欣赏艺术的人民大众。社会在不断变革着，艺术也以相应的方式，但以更为迅捷的速度在发生着变化。革命、革命、革命，永无止境的革命，在艺术领域内展开。本来，人类的艺术史本身就是一部艺术变革史。这变革包括艺术的观念、风格、样式，当然也包括制作艺术品的媒材、手段以及展示的方式。但是，在20世纪以前的所有时代，艺术观念、风格语言的变化是缓慢的，走的是渐变的道路，而且其间有迂回、曲折，不是直线前进。前进和"后退"，似乎相继进行；向前看和向后看，似乎交织在一起。人们的思维不凝固在一点之上。人们既从对未来的憧憬中，又从对往昔历史的经验中吸取智慧，吸取前进的力量。20世纪物质文明的迅猛发展给人们以错觉，似乎人类社会的变化只有沿着直线的方式向前发展，革命、革命，不断地革命；似乎人类的艺术也只有按照这种方式变革、变革，不断地标新立异。一个世纪过去了，从

19世纪末到20世纪末，人类社会存在的现状和人类艺术存在的现状，给人们以什么启示呢？人类追求物质进步的欲望不断地增强，物质文明的取得以牺牲自然的和谐为代价，地球遭到污染，人与自然的矛盾日趋尖锐；个人主义的增长，使人与社会、人与人、人与自我之间的冲突日显激烈。艺术不断追求"革命"的结果，使艺术逐渐丧失自身的特征，艺术与非艺术、与生活行为难以区分。尤其是观念、表演、行为和装置艺术出现之后，西方艺术日趋荒诞化与观念化。传统的艺术观念被"消解"，随之而来的是艺术自身的被否定，包括技巧、制作方式，更不用说艺术品应该表现的艺术家个性了。只注重观念，不注重个性，甚至完全否定个性，否定个人感情表达，否定艺术技巧和手艺制作的艺术风尚，在20世纪60—80年代的西方，成为艺术主流。这种潮流以美国为中心，席卷整个西方艺术世界。当然也影响亚洲、非洲和拉丁美洲的许多国家。由此使艺术面临前所未有的危机。西方社会关于艺术前途的争论触及到文化、社会深层方面的问题，因此引起了许多社会学家、哲学家的兴趣，也正是由于他们的介入，使这场现在还在继续着的争论，具有广泛而深刻的社会意义。也就是说，艺术的表达方式、艺术思维实际上与人类的生存方式与关于人类前途、命运的思维有十分密切的关系。近三十年来，西方哲学界对现代主义的反思和关于后现代主义文化艺

术问题的讨论，说明曾经推动了现代主义文明发展的直线思维方式受到了人们的质疑：不断向前看、不断变革的理论所造成的后果引起了人们的忧虑。人们开始谈论迂回的思维方式，谈论东方哲学与东方人的思维特征。人们研究在向前看和憧憬未来的同时，要吸取历史上遗留下来的优秀遗产，作以古开今、借古兴今的努力。在艺术上，人们开始对作为现代主义灵魂、在近百年艺术理论中推崇备至的"原创性"（Originality）产生怀疑：原创性即独一无二性。是否可以摒弃一切前提，作为惟一的、至高无上的标准用来衡量所有艺术创造？而正是因为把原创性作为标尺来衡量评判一切，导致现代艺术走无所顾忌的"创新"之路，使艺术家们及人民大众困惑不解；与之相关的是艺术遗产的价值，对艺术传统的反叛与延续这些严肃的问题。反叛传统是一切艺术创新流派的口号，也是艺术走出传统桎梏的必由之路。确实，艺术家要走出新路来，必须摆脱旧传统的束缚，反叛传统中过时的法则，但是，这并不意味着要与传统一刀两断、彻底决裂。西方现代派中真正在创新上做出成绩的大家，虽然他们高举反传统的大旗，但是在艺术实践中无一不是在某些方面保持着与传统的一些联系的。自20世纪70年代观念艺术出现之后，西方"前卫"艺术大有与传统彻底决裂之势，因为传统的审美标准不论是古典的，还是在此之前贯穿于现代艺术的，都被视为落伍与过时。正是在这种情况之下，后现代主义的理论崛起，而这"后现代"恰恰是要在创新与传统之间找到接合点。再者，西方现代主义的"一元观"，也开始在后现代的多元观前面显得黯然失色。多元的艺术现象是由多元的价值观决定了的。多元的价值观的前提是承认各种艺术（包括各民族、各地区、各种风格流派）存在的合理性。西方中心论、现代主义一统天下论与多元论相悖，不能不处于受批评的位置。总之，后现代主义为传统与现代、西方与东

方架起了桥梁。虽然某些后现代主义理论家否定"个性"与"风格"，但个性与风格在70年代之后西方艺术中呈复苏之势也是很明显的。

20世纪70年代，意大利的现代艺术也发生了重要的变化。一群青年艺术家涌现于画坛。人们把不同的称谓加在这些艺术家头上，称他们为"意大利表现主义"、"新表现主义"和"超前卫"。这群艺术家中最著名的几位是桑德罗·基亚（Sandro Chia）、恩佐·库基（Enzo Cucchi），以及弗朗西斯科·克莱门特（Francesco Clemente）还有德·玛利亚（Nicola De Maria）和米莫·帕拉迪诺（Mimmo Paladino）。当时，意大利画坛占主导地位的是"贫乏艺术"（Arte Povera）。这一艺术运动是观念艺术运动的一个支系。它反对在艺术中运用任何的传统方法与主题。"偶发"的行动（happenings）和"装置"（Installation）是贫乏艺术运动竭力所推崇的。"偶发"的艺术作品所展示的动作限在一定的时间内，常常用录像的方式加以记录，而"动作"包罗万象，其中包括人的身体的动作。"装置"则需要材料、空间和某种设计意识。"贫乏艺术"反对艺术的商业性，对当下社会有批判和反叛的因素，这是应该给予肯定的。但他们把艺术仅仅作为一个过程来看待，并且认为艺术的全部价值仅仅在这过程之中。他们反对艺术作为过程的结果而存在。也就是说，他们重视的是"观念"，是艺术家对社会作出的陈述，而不是艺术品本身。这样，艺术的审美因素和感情色彩被抛弃掉了；同时，从事观念性创作的艺术家们不必也不应该去运用传统艺术作为自己创造的参照系。作为传统的画种——油画，也在观念艺术的禁忌之列，因为在他们看来，这种油彩技术、技巧远离观念远离现代，属于"明日黄花"之列。

艺术现象历来是三十年河东三十年河西。观念、偶发、行为、装置艺术，作为后期现代主义（Late-Modernism）现象，是现代主义过激思想与实践的延

续。作为一种艺术试验，和作为陈述观念思想、干预社会现实的一种手段，它们应该有存在的空间，但是如果以此来否定一切与传统联系的其它艺术创造，则是很荒谬的了。反叛必然会出现。在70年代的美国、德国和意大利出现的"新表现主义"思潮，就是这种反叛的具体表现。"表现"(Expression)本是早期现代主义常常使用的一个词汇，艺术表现力也是早期现代主义追求的。艺术表现与想象有关，没有想象，也就无所谓表现。艺术品中的表现力离不开主题、题材以及与之相关的造型语言，它既包含了内容、意义的一面，也包含与之相适应的形式、技巧的一面。做贫困艺术，做观念、偶发、行为艺术，当然与"想象"与"表现"风马牛不相及。谈表现、谈想象，就必然要联系被现代激进主义抛弃的造型语言——从主题到形式技巧，到媒材手段。所以"新表现主义"大思潮的崛起，标志着西方艺术风向的重要变化。可以把这种变化理解为从现代激进主义的一种倒退，也可以理解为是对传统艺术的某种复归。新表现主义是一股大的思潮，在西方不同国家有不同的表现。但其本质与形态有共同之处。所以，70年代意大利一群青年艺术家的艺术倾向也被称为是"新表现主义"或"意大利表现主义"。意大利这群艺术家作品中出现的共同倾向，被目光敏锐、关注艺坛风云变化的理论家阿奇莱·博尼托·奥利瓦(Bonito Oliva)及时发现，他称这种艺术倾向为"超前卫"(Trans-avantgarde)。所谓"超前卫"是超越前卫的意思。按照奥利瓦的原意，是指这些艺术家不受某种既成的模式的拘束，不用流行的界标来指导自己的创作，而尊重自己的想象与直觉。他们尊重艺术史，在艺术史上随意漫游，借鉴他们认为需要借鉴的风格、手法，并用自己选择的手法重新混合这些风格。奥利瓦对这群青年艺术家抱有热切的期望，认为他们运用的是与贫乏艺术完全相悖的艺术创作方法，预示着艺术又朝着生气勃勃的方向迈进。

因为对新时代的画家来说，跨越不同艺术风格，从它们当中吸取为自己的创作可用的因素，作新的"混合"或"融合"，使作品具有艺术表现力是非常重要的。这些年轻艺术家通过复归具象和运用类似表现主义生动的造型语言（素描与色彩），结合意大利传统的艺术风格所创造的新艺术，显示了作为原本意义上的"艺术"不像有些理论家所预言的那样，已经丧失生命力。相反，它还会适应时代，不断地向前推进。意大利的这群青年艺术家在创作的"自由性"与"随意性"方面与比他们较早的抽象表现主义或其他前卫艺术家并无很大区别，他们多为"即兴创作"，即不要求打好未来作品的腹稿。但与抽象表现主义画家不同的是，意大利的年轻艺术家们没有为自己的创作提出题材上或视觉语言方面的限制。他们自由地描绘客观世界，描绘自然，自由地采用融合往昔的风格，不以哗众取宠和以刺激观众为目的，作品不带政治色彩，作者的倾向和感情在作品的形象中自然地流露出来。作品给予观众以视觉上的愉悦感，而不是强加于他们以某种由作者预先设计的"观念"。

还有一点需要提出的是，"超前卫"艺术家的作品售价很高，这一点也曾受到观念艺术家的攻击。在"破除"传统艺术创造法则的同时，观念派艺术家们对艺术品作为收藏品（私人和博物馆收藏）也采取否定态度。在观念艺术流行时期，博物馆、美术馆和私人均无法收藏那些仅以显示过程，根本不顾忌创造成果的艺术品。其实，艺术品以一定的价格出售，被有关机构和私人收藏，丝毫不说明它们仅仅是商品和缺乏艺术品的价值，这是不言而喻的。以一定的价格出售艺术品，表明新表现主义或超前卫的艺术家们，在对待艺术创造与社会、与大众的关系上，遵循着传统艺术的法则，这是为"贫乏派"的观念艺术家们所不能容忍的。

意大利超前卫的艺术家们并没有、也无须形成

统一的艺术风格，不仅如此，即使他们当中的每一位艺术家也并非都具有前后统一的、鲜明的个性风格，只是因为在当今复杂多变的社会，艺术家们有更多的选择余地，有广泛的探索和创造的可能。在这几位艺术家的作品中，我们可以看到他们不同的个性、爱好、兴趣，看到他们借鉴了艺术史上从古到今各种不同的风格，看到他们不同的空间处理、造型方法、色彩和其它媒材的偏好，更看到他们各自不同的对现实、对人生、对自然的态度，看到他们作品充满了流动性与多变性，但是共同点把他们联系在一起：尊重艺术创造规律、尊重艺术遗产，把艺术创造作为审美的手段和对象提供给社会和大众，在艺术创造中享受创造的快感，恢复和进一步显示油画艺术语言和技巧的魅力。

艺术要随着时代的前进不断变化和发展，艺术语言和艺术表现手段，以及人们对艺术接受和欣赏的能力会不断拓展，艺术创新永远是最宝贵的品格。可是，艺术创造毕竟有自身的规律，它的根本点和基本属性——与人性、与社会大众、与历史传统的联系，它的审美特征，是永远不会改变的。我想，这也是意大利超前卫艺术给我们最重要的启示。

2000 年 2 月 14 日于北京

中央美术学院寓所

RITORNO ALLE ORIGINI DELL'ARTE
ispirato dalla transavanguardia italiana
(Premessa)

Shao Da Zhen

Il ventesimo secolo ha conosciuto cambiamenti sociali a ritmi velocissimi, che la nostra umanità non aveva mai visto, ed ha costituito un'epoca ricca di modificazioni anche nel settore artistico. La rivoluzione industriale e quella informatica, suscitata dalla rivoluzione scientifica, hanno avuto un forte impatto sull'ideologia, sul modo di vivere e sulle creazioni culturali ed artistiche, sollevando una questione importantissima, cioè quella relativa a dove andrà l'uomo, la quale continua ad ossessionare la gente. Un'elite di individui ha proposto diverse dottrine nuove e ha tentato di trovare la soluzione ideale per la questione sopraccennata, ma, non essendoci finora riuscita, resta ancora nella situazione della ricerca. Anche la questione su dove andrà l'arte ossessiona ugualmente gli artisti che desiderano dimostrare i loro talenti e le masse del pubblico che sperano di comprendere davvero ed ammirare gioiosamente l'arte. La società cambia continuamente, pure l'arte cambia nel medesimo modo, ma a un ritmo più veloce. Rivoluzione, rivoluzione, ancora rivoluzione, nell'arte si svolge una rivoluzione senza sosta. Infatti, la storia dell'arte dell'umanità è stata una storia della riforma, che succedeva sia nel concetto, nello stile e nella forma, sia nella materia, negli strumenti e nei modi di esposizione. Ma, in tutte le epoche prima del ventesimo secolo, il concetto artistico e il linguaggio stilistico cambiavano molto lentamente e seguivano una via non diretta di un'evoluzione graduale, persino tortuosa e piena di aggiramenti. Sembrava che si alternassero i movimenti di avanzare e di "indietreggiare" e che si intrecciassero sguardi in avanti e indietro. I pensieri umani non si fermavano mai sullo stesso punto. La gente attingeva l'intelligenza e la forza di progresso dall'aspirazione verso la futura bellezza ed anche dalle esperienze storiche. Il rapido sviluppo della civiltà materiale del secolo scorso ci ha dato la falsa impressione che la società procedesse in avanti lungo una linea tutta diritta; dunque si dovesse fare sempre rivoluzione e l'arte dovesse essere sempre riformata, nuova e diversa. Ormai è passato tutto il secolo. Ma che aspirazione ci hanno dato la società umana e l'arte da essa applicata, dalla fine del diciannovesimo secolo alla fine del ventesimo? L'ambizione umana riguardo al progresso materiale è sempre incrementata, il sacrificio dell'armonia della natura è stato il costo della sua realizzazione: il nostro pianeta è inquinato, il contrasto fra l'uomo e la natura diventa sempre più forte; l'incremento dell'individualismo esaspera di giorno in giorno il conflitto fra gli uomini stessi, fra l'individuo e la società, fra l'uomo e il suo ego. La continua rivoluzione dell'arte ha portato alla graduale perdita della sua propria natura e all'indistinguibilità fra arte e non-arte, fra l'arte e la vita. Soprattutto con la nascita dell'arte di concetto, di espressione, di azione e di installazione, l'arte occidentale ha espresso la tendenza a divenire sempre più assurda e concettuale. "Si è dissipato" il concetto artistico tradizionale, di conseguenza è stata negata l'arte stessa, compresi i suoi modi di lavoro e le sue tecniche, e in particolare la personalità dell'artista che va espressa nell'opera. La tendenza a prestare importanza soltanto al concetto, non alla personalità, e a negare completamente la personalità e l'espressione dei sentimenti personali, le tecniche artistiche e l'opera manuale, dagli anni '60 agli anni '80, era diventata la corrente principale dell'arte e anche una moda che imperversava nell'Occidente. Questa corrente, il cui centro era gli Stati Uniti d'America, ha coinvolto l'intero mondo artistico occidentale, influenzando naturalmente molti paesi dell'Asia, dell'Africa e dell'America latina, e ha condotto l'arte in una grave crisi mai vista precedentemente. La polemica

che si è sviluppata in Occidente sulle prospettive dell'arte, e che continua tuttora, toccando anche problemi più profondi della cultura e della società, interessa molti sociologi e filosofi, e proprio per il loro intervento acquista un significato sociale vasto e profondo. Ciò vuol dire che esiste un legame stretto fra il modo d'espressione dell'arte e il concetto artistico da una parte, e il modo di vivere dell'uomo e la sua concezione sull'avvenire e sul destino dell'umanità dall'altra. La riflessione sul modernismo e la discussione sui problemi culturali ed artistici del postmodernismo, affrontate nell'ambiente filosofico occidentale in questo ultimo trentennio, dimostrano che la gente ha già messo in dubbio il modo di pensare rettilineo che aveva promosso lo sviluppo della civiltà modernista e che lo sguardo sempre in avanti e la teoria della continua rivoluzione hanno suscitato la perplessità della gente. Ora si comincia a parlare del modo di pensare curvilineo ed a discutere sulla filosofia e sulle caratteristiche ideologiche degli orientali. Si cerca di assorbire nutrimenti dal patrimonio storico mentre si guarda in avanti e si aspira al futuro luminoso; si fanno sforzi per il principio di "aprire la strada nuova in base a quella antica e di realizzare la prosperità odierna appoggiandosi a quella del passato". Nel campo artistico si comincia a mettere in dubbio il criterio della cosiddetta originalità, cioè unicità, che è stato adorato per circa cento anni come anima del modernismo nell'ambiente dei teorici dell'arte. Si può considerarlo, ripudiando tutti gli altri fattori, come l'unico e supremo criterio con il quale si valutano tutte le creazioni artistiche? Ciò che ha indotto l'arte moderna sulla via del rinnovamento completamente privo di scrupoli ed ha offuscato la vista agli artisti e alle masse del pubblico è stato proprio il fatto che si è presa l'originalità come l'unico metro per misurare e arbitrare tutto; ne sono derivati anche i seri problemi del valore del patrimonio artistico e del tradire o continuare le tradizioni artistiche. Il tradimento delle tradizioni è lo slogan comune di tutte le correnti rinnovatrici ed anche l'unica via che conduce l'arte a liberarsi dal giogo delle tradizioni. Infatti, per aprire nuove vie, gli artisti devono slegarsi dai lacci delle tradizioni e tradire le regole inopportune del passato, ma ciò non significa che si debba avere una spaccatura radicale e una rottura completa con esse. Tutti i grandi artisti del modernismo occidentale che hanno ottenuto dei successi nel rinnovamento, pur tenendo alta la bandiera contro la tradizione, hanno mantenuto senza eccezione certi legami tradizionali nella loro pratica artistica. Dopo l'apparizione dell'arte concettuale negli anni '70, l' "Avanguardia" occidentale tendeva ad una completa rottura con la tradizione, perché i criteri estetici tradizionali, sia quelli classici che quelli seguiti precedentemente nell'arte moderna, erano tutti considerati superati. Proprio in questo contesto, è nata la teoria postmodernista che desiderava trovare il punto di congiunzione tra il rinnovamento e la tradizione. Per giunta, il monismo del modernismo cominciava a impallidire davanti al pluralismo del post-modernismo. I fenomeni artistici pluralistici derivano dalle nozioni pluralistiche del valore, la cui base è il riconoscimento razionale delle diverse arti (comprese le arti nazionali, locali e dei vari stili e correnti). La teoria eurocentrica e l'unicità del modernismo sono in contraddizione con il pluralismo, perciò devono certamente essere criticate. Insomma, il post-modernismo costituisce un ponte che collega la tradizione con la modernità e l'Occidente con l'Oriente. Nonostante che certi teorici post-modernisti neghino la personalità e lo stile, tuttavia è molto evidente che dopo gli anni '70, nell'arte occidentale si osserva una tendenza alla risurrezione della personalità e dello stile.

Anche l'arte moderna italiana ha conosciuto negli anni '70 notevoli cambiamenti. È apparso un gruppo di giovani artisti, denominati dal critico italiano Achille Bonito Oliva "transavanguardia". Tra loro emergono alcuni nomi famosi: Sandro Chia, Enzo Cucchi, Francesco Clemente, Nicola De Maria e Mimmo Paladino. In quel decennio, però, la corrente più importante della pittura italiana era l' "Arte Povera" che faceva parte del movimento dell'arte concettuale. Essa si opponeva a tutti i metodi e materie tradizionali, esaltava "happenings" ed "installazioni". Le opere degli "happenings" esibiscono movimenti di tutti i tipi, compresi quelli del corpo umano, ma limitati per un certo tempo e spesso presentati con il supporto della videocamera. Invece, per l' "installazione" ci vogliono materiali, spazi e certe idee di progettazione. L' "Arte Povera" si opponeva alla commercializzazione dell'arte, criticava la società che ne tradisce i valori. Però, considerava l'arte solo come un processo e credeva che tutto il valore dell'arte consistesse nel processo. Gli artisti dell' "Arte Povera" non ritenevano che l'arte esistesse come risultato del processo. Ciò significa che essi davano soltanto importanza al "concetto", al racconto dell'artista, non alle opere artistiche. Così, si sono ripudiati il fattore estetico dell'arte e i sentimenti espressi; inoltre, gli

artisti concettuali non sentivano la necessità di prendere l'arte tradizionale come riferimento, anzi non dovevano nemmeno farlo. La pittura ad olio, che è una pittura tradizionale, era rifiutata dall'arte concettuale, perché secondo i suoi artisti le tecniche di tale pittura erano ormai troppo distanti dal concetto e dalla modernità, dunque destinate ad appassire come i fiori caduchi.

I cambiamenti sono del tutto normali per l'arte. Il concetto, gli "happenings" e l' "installazione" erano fenomeni del tardo modernismo e costituivano la continuazione dell'ideologia e della pratica radicale del modernismo. Come esperienza artistica e strumento per il chiarimento di un concetto e per l'intervento nella realtà sociale, essi avevano ragione di esistere. Ma era assolutamente assurdo che in base a questi principi si negassero tutte le altre creazioni artistiche legate alla tradizione. La rivolta doveva sicuramente succedere! Negli anni '70 è nata, negli Stati Uniti d'America, in Germania e in Italia, la corrente del "neoespressionismo". "Espressione" è stata una parola frequentemente usata dai primi modernisti, che ricercavano l'espressività. L'espressione artistica riguarda la fantasia, senza fantasia non ci sarebbe la cosiddetta espressione. L'espressione artistica non deve essere separata dal soggetto, dalla materia e dal relativo linguaggio figurativo; deve comprendere, da una parte, il contenuto e il significato dell'opera, e dall'altra parte, la forma e le tecniche adeguate. L' "Arte Povera", l'arte concettuale e quella degli "happenings" non avevano certamente a che vedere con la "fantasia" e l' "espressione". Quando parliamo dell' "espressione" e della "fantasia", dobbiamo senz'altro affrontare il problema del linguaggio figurativo (soggetto, forma, tecniche e materiali), abbandonato dal radicalismo moderno. Insomma, la nascita della corrente del neoespressionismo segnava una importante svolta dell'arte occidentale. Si potrebbe intendere che questa svolta fosse un regresso rispetto al radicalismo suddetto, un ritorno verso l'arte tradizionale. Il neoespressionismo è una corrente generale, che si manifesta in modi diversi e in paesi diversi; ma esistono sempre dei punti comuni sia riguardo alla sostanza che riguardo alla forma. Proprio per il motivo sopraccennato, dei giovani artisti italiani degli anni '70 erano denominati "neoespressionisti" o "espressionisti italiani". Il critico italiano Bonito Oliva, osservatore attento e perspicace dei cambiamenti dell'arte, ha teorizzato con il termine "transavanguardia" tali modificazioni, riscontrando nelle opere degli artisti una linea comune. Secondo Bonito Oliva, gli artisti della "transavanguardia" non sono soggetti al giogo di schemi fissi, non seguono i criteri in voga nella creazione ma la fantasia e l'intuito. Essi rispettano la storia dell'arte nella quale viaggiano liberamente, traggono lezioni necessarie dagli stili e le tecniche che a loro piacciono, e mescolano stili e tecniche secondo la propria volontà. Bonito Oliva nutre piena fiducia in questo gruppo di giovani artisti, ritiene che i loro metodi di creazione siano contrari a quelli dell' "Arte Povera", preannunciando che l'arte si dirige di nuovo verso la vigorosità. Per i pittori moderni, è estremamente importante restituire l'espressività artistica alle opere, cavalcando diversi stili, attingendone fattori utili alla creazione, mescolandoli e fondendoli di nuovo. La nuova arte che si è creata attraverso la restaurazione dell'arte figurativa, l'uso del linguaggio vivace come quello espressionista (schizzo, colori) e l'assimilazione degli stili artistici tradizionali italiani, dimostrano che è erronea la profezia di certi teorici secondo la quale l'arte nel suo significato originale avrebbe perso vitalità. Al contrario, essa potrà progredire continuamente in conformità al fabbisogno del tempo. Questo gruppo di giovani artisti italiani ricerca la "libertà" e l' "irregolarità" nella creazione; in tale senso essi non sono molto differenti dagli espressionisti astratti e dagli altri artisti dell'avanguardia che svolgevano le attività artistiche prima di loro: anch'essi improvvisano le opere, per le quali non hanno bisogno di preparare un progetto neppure nella testa. La differenza fra loro e gli espressionisti astratti consiste nel fatto che essi non hanno prestabilito nessun limite sia nei materiali che nel linguaggio della loro opera. Essi descrivono liberamente il mondo oggettivo e la natura, miscelano senza riguardo stili del passato, non hanno lo scopo di pavoneggiarsi ed eccitare la vista del pubblico; le loro opere sono prive di connotazioni politiche, danno al pubblico sensazioni gioiose, non un "concetto" premeditato dall'artista, ed esprimono con naturalezza i desideri e i sentimenti nelle immagini.

Gli artisti concettuali hanno criticato il fatto che le opere degli artisti della "transavanguardia" sono messe in vendita sempre a prezzi elevati. Mentre cancellavano le regole tradizionali della creazione artistica, essi negavano pure le opere artistiche come oggetti da collezione (privata o di un museo). Anche nel periodo della grande diffusione dell'arte concettuale, né i musei, né le gallerie, né i privati riuscivano a collezionare quelle opere artistiche, che volevano dimostrare

solo il processo di lavoro e non dare nessuna importanza al risultato. A dire la verità, è molto chiaro che se le opere artistiche sono vendute ad un certo prezzo e collezionate da certe istituzioni o privati, non significa affatto che anch'esse diventano pure merci e mancano di valore artistico. La vendita delle opere dimostra che gli artisti neoespressionisti (o della transavanguardia) osservano le regole artistiche tradizionali nei confronti della relazione fra la creazione artistica da una parte e la società e le masse del pubblico dall'altra; ciò è sicuramente intollerabile per gli artisti concettuali del "Poverismo".

Gli artisti della transavanguardia mancano di uno stile comune e non ne hanno neppure bisogno; non solo, lo stesso artista può anche avere uno stile non definito ma mutevole, perché nella società d'oggi, complicata e piena di cambiamenti, gli artisti hanno una più vasta gamma di scelta e una più grande possibilità di esplorazione e creazione. Nelle opere di questi artisti che presentiamo, potremo notare le loro diverse personalità, predilezioni e gusti, i loro riferimenti ai vari stili esistenti nella storia dell'arte; i loro distinti metodi di trattamento delle figure e dello spazio, le loro preferenze per certi colori e materiali, le loro rispettive attitudini verso la realtà, la vita e la natura, nonché la mobilità e la variabilità che pervadono le loro opere, ma esistono sempre dei punti comuni che li collegano: rispettare le regole della creazione artistica e il patrimonio artistico, offrire l'opera come oggetto estetico alla società e al pubblico, trovare il piacere nella creazione artistica, riabilitare e continuare a dimostrare il fascino del linguaggio artistico della pittura ad olio.

L'arte continua a cambiare seguendo i passi dei progressi sociali, si sviluppano anche i linguaggi e i metodi di espressione artistica, nonché la capacità di comprensione e di ammirazione dell'arte, e il rinnovamento rimane sempre lo spirito più nobile nell'arte. Tuttavia, la creazione artistica ha le sue proprie regole da rispettare e non cambiano mai i suoi caratteri estetici e la sua natura fondamentale, cioè la sua relazione con l'umanità, con le masse popolari, con la tradizione e la storia. Credo che questa sia stata la più importante aspirazione lasciataci dalla transavanguardia italiana.

RETURNING THE ORIGIN OF ART

The inspiration from Italian Trans-avantgarde

(Preface)

Shao Da Zhen

The 20th century was the time when the rhythm of human society had the fastest changes and when most movements took place in art. The information revolution, which was caused by the Industrial Revolution and the revolution of science and technology, greatly impelled people's thought, lifestyle and the creation of culture and art. The question where human society will go always obsesses us. Many keen-witted people have put forward all kinds of new theories, trying to find out a satisfactory answer. But, so far, they are still searching. The relevant question--- where art will go --- also haunts the minds of artists who attempt to be successful in art creation and the people who want to truly understand and fully enjoy art. With the incessant movement of society, art changes correspondingly, but at a faster speed. Infinite revolutions took place in the filed of art. Per se, the history of art is a history of change. It includes the change of ideas, the style and the mode of art. It also includes the change of media and means of producing art works and the methods of showing them. However, before the 20th century, the notion of art and its the language of style changed slowly and gradually. It was not in a direct line,but in twists and turns. It seemed that progressing and receding occurred in turn and looking forward and looking backward mixed together. People's minds did not fix on one point. They got the wisdom and the strength to go on from both the longing for the future and the experience from the history. The material civilization of the 20th century developed so fast that it gave us an illusion. It seemed the change of human society could only go straightforward with endless reforms. It seemed that human art could only go in the same way with unlimited renovations.

From the end of the 19th century to the end of the 20th century, a hundred years had passed. But what aspirations have society and its applied art given us? In order to satisfy their enhancing desire for material, human beings destroy the harmony of nature and pollute the earth. The conflict between humans and nature becomes more and more fierce while the growth of individualism sharpens the conflict between humans and society, between man and his ego. The pursuit of "revolution" in art lead to the loss of art's own speciality and makes it hard to distinguish between art from non-art and life action. Especially after the appearance of idealistic, performing, behavioral and installation art, Western art became absurd and ideational. The traditional concept of art was dispelled, followed by the denial of art itself, which includes skill and means of production, together with the idea that works of art should express the artists' individualities. In the West, during the period of the 1960s to the 1980s, the mainstream of art was only to focus on notion. They did not pay attention to individualities and they even denied the expressing of one's feelings, technical skills and manual work. This trend developed from America and spread through the whole Western art world. It also affected many countries in Asia, Africa and Latin America, which made art confront the crisis that had never occurred before. In the West, the argument on the future of art that touched deeply upon the problems of culture and society aroused the interest of many sociologists and philosophers and their participating in made this continual argument have some broad and profound social sense. That is to say, the method of expression and artistic concept are,in fact,closely associated with the pattern of the human existence.

The discussion of western philosophy on the modernism review and the problems of post-modernism art in the past thirty years indicated that the unswerving line of thought which had once prompted the development of modernism culture was

questioned and people began to worry about the consequence of ceaseless reforms and looking forward. We started to talk about the tortuous way of thinking, the oriental philosophy and the thinking pattern of Orientals. People not only studied the progress and the prospect but also inherit the heritage from history and they tried to create the new on the basis of the old. When it came to art, the "Originality", which was also regarded as being unique and the soul of modernism, which was greatly recommended among art theory in nearly a hundred years, was doubted. Could it be the only and supreme standard to judge all art creations without any premise? Just because people did make originality the only standard to judge all, modern art was directed in a way of renovation. This puzzled both artists and the general public. Besides, there were many serious problems concerned, such as the value of art heritage,and rebellion against the mainteinance of art traditions. Rebellion was the slogan of all art renovators and it was necessary for art to break the chain of tradition. Truly, if an artist wants to create something new, he has to throw away the outdated in the tradition, but that does not mean that he should completely break away from tradition. On the contrary, those western modernists who were successful,all kept in touch with tradition in some way, although they held high the flag of anti-tradition.

Since the ideology art appeared in 1970s,the"Avant garde"art of West had gone toward the trend that thoroughly ruptured with the orthodox. Because the traditionally aesthetic norm, either the classical one or what ran through modern art before this time, was thought of as outdated. In such a situation, the theory of post-modern art rose abruptly, while it was precisely looking for the connection between renovation and tradition. Furthermore, the monism of western modernism started to eclipse in front of the pluralism that was based on the value of pluralism. Its premise was admitting the reasonability of the existence of diverse art forms (including art of all peoples, areas, styles and schools). Western central theory and modernism-monopoly theories were against the pluralistic theory and were sure to be criticized. In short, the post-modernism art set up a bridge between the orthodox and the modern, the West and the East. Although some post-modernism theoreticians denied the individuality and the style, it's obvious that they resuscitated in western art after the 1970s.

In 1970s, great changes took place in Italian modern art. A group of young artists sprang up and they had many titles, such as: "Italian Expressionism", "New Expressionism" and "Trans-avantgarde". Among them, the most celebrated were Sandro Chia, Enzo Cucchi, Francesco Clemente, Nicola De Maria and Mimmo Paladino. At that time, Art Povera, which was a branch of ideology art action and against any orthodox means and topic of art action, was the leading Italian form. Art Povera greatly recommended happenings and Installation. Art work of happenings reflected actions of a certain time that were recorded on video, while the actions included everything, such as body movements. Then Installation needed some material, space and some sense of designing. "Art Povera" should be approved because it opposed the commercialization of art and contained criticality and rebellion to the society. But they thought that art was only a process and all the value of art lay in the process. What is more they contradicted the existence of art as a result of process. Therefore, what they put weight on was "idea" and statements of the society made by artists, not art itself. So the aesthetic factor and colorful emotions were thrown away; meanwhile, the artists going in for the idea-creation did not need and even should not use the orthodox art as the reference for their own creation. Painting, as one kind of traditional art, was among the taboos of Ideology art because from their view, painting skill was far away from the Ideology and the Modern art and it was only "a glory of yesterday".

Change is quite normal in the historical process of art. The idea, happenings, action, installation art, as the appearance of Late Modernism, continued the extreme thought and practice of Modernism. As an attempt of art, and as a way of stating the idea and interfering with the social reality, these approaches should have room to exist. However, if all art creation related to tradition were denied by it, the result would be ridiculous. So, rebellion was sure to appear. The specific representation was the ideology trend of New Expressionism which appeared in America, Germany and Italy in the 1970s. "Expression" is a term often used by early-modernists and they also pursued the expressing power of art. Art expression was related to imagination. Without imagination, there would be no expression. The expressing power of art works relied on topics, themes and relevant figural language. It included not only contents and meanings but also the adaptable forms and skills. Making Art Povera, Ideology, Happenings and action art has nothing to do with imagination and expression. If you want to express, if you want to imagine, you have to think about the figural language discarded by Modern Extremis-from the topic to the form and skill, to the media and means. Thus, the rise of

the ideological trend of New Expressionism indicated the significant change of western art. This change can be regarded as a step backwards from Modern Radicalism. It can also be regarded as a return to orthodox art. New Expressionism was a powerful trend of thought and the different expressions in different western countries had the same origin and forms. Consequently, the art trend of a group of young artists in Italy was named as "New Expressionists" or "Italian Expressionists". The common trend of their works of art was noticed very early on by the art critic Bonito Oliva who had keen judgement and paid attention to the movement of art and he named it "Tans-avantgarde" which means beyond avantgarde. Bonito Oliva intended to mean that these artists were unconstrained by some fixing patterns or popular standards. They respected their imagination and instinct and they esteemed the history of art, wandered freely in it, learned from and mixed others' styles with their own selecting technique. Bonito Oliva placed his earnest hope on these artists and thought their way of art creation, which was completely contrary to Art Povera, indicated that art would forward with a new vigour. It's very important for artists of a new period to jump out of diverse art schools, to assimilate and to mingle useful factors from them in order to make their works expressive. These young artists combined the new art based on the style of Italian tradition with the return of the figure and the exertion of colorful figurative language (drawing and color) which was similar to Expressionism. It showed "Art" in its original meaning had not lost its vitality, as some theorists foretold. On the contrary, it would adapt to the society and constantly go forward. There was not much difference between the young Italian artists' creation and the earlier abstraction expressionists or other per-guard artists in liberty or randomness. Most of their works were the impromptu creation and they didn't require any drafts of intended works. But what made them different from the artists of abstraction expressionism was that they put no limit on the theme or vision language for their own creating. They painted the objective world and nature freely and their lack of restriction took the style of the past. To please or to stimulate the public was not their purpose. In their works, there was no sense of politics. The painters' trend and emotions among their works were naturally revealed. They offered pleasing visualization to the public rather than imposed on them some ideas the painters designed in advance.

Another point we need to notice is that ideology artists once complained that the price of Trans-avantgarde works was too high. While they cancelled the traditional rules of artistic creation, ideology artists denied the art works as collections (stored up by individual or museum). During the popularity of ideology art, museums and individuals couldn't collect those art works that only showed the process and discarded the result. In fact, it is self-evident that the fact the art works were sold at a certain price or were collected by some certain agencies or individuals didn't mean they were only commodities that had no value of art. Selling their works at a certain price revealed that New Expressionism or Trans-avantgarde artists followed the rules of the orthodox art, which the ideological artists of Art Povera could not accept.

The Italian artists of Trans-avantgarde hadn't and didn't need to form a consolidated art style. Moreover, not every one of them had a congruous and vibrant personality. That's because in a society full of changes, artists had more alternatives and possibilities of exploring and creating. From these works,we can see their different personalities, interests and likes and their difference in dealing with space, color and other media. We can see that they learned from various styles of art in history and they had different attitudes towards reality, life and nature. Their works are full of fluidity and changes. One common point joined them together-to respect of rules of art creation and the heritage of art, to offer the work as an aesthetic object to the public and society,to rehabilitate and continue to demonstrate the fascination of the artists'language expressed in oil painting.

Art alters and develops with the passing of time, whereas the language of art and its means of expression and people's ability to accept and appreciate art will be continuously broadened. Art renovation will be the most precious characteristic forever. But as art creation has its own law, its fundamental point and basic property-art's connection with human nature, with people and with tradition together with its aesthetic trait will never change. In my opinion, it's the most important inspiration that we can obtain from Italian Trans-avantgarde art.

意大利的超前卫艺术

阿·博·奥利瓦

艺术终于又恢复了它的内涵，回到了创作的正确轨道。它原本是极其精彩的，是一座通往人们内心世界的迷宫，在迷宫中人们为探知绘画的秘密而不断地求索。20世纪70年代末的艺术思想是创作者寻求自己内心的快乐和参与创作的刺激，作品的主题是虚构的，漂移不定的，似是而非的和模棱两可的，从来没有什么完全可以确定的东西。作品成为"游牧民族手中的一张地图"，艺术家们没有预定的行动方向，他们是"睁眼瞎"，他们在永不毁灭的艺术面前表现出对艺术的喜爱。

60年代，艺术具有说教主义的内涵，其中包括前卫派的说教主义的内涵：贫乏而程式化的艺术，受到了批评界的巨大影响，像受虐狂一样，遵循着一条约束性极强的创作路线，所幸的是，在这种情况下仍出现了几幅离经叛道的艺术之作。后来，人们摒弃了程式化的创作，不再理睬具有非难性质的苛评，开始使艺术丰富起来；起初，他们处于迷惘的状态，然而，这是寻求升华的必经之路；这种迷惘并不是一种禁欲苦行，更不是已经看破红尘，而是人们掌握艺术的能力在提高，在发展，由于艺术在不断地吐故纳新，艺术作品和艺术家也很自然地不断变化，因而人们对自己所掌握的一切也不断地提出疑问。丰富艺术意味着承担探索的风险，意味着在最初阶段的迷惘中，在难辨方向的黑夜里寻找艺术发展的光明。现在，绘画艺术终于受到人们的肯定，它不再是一种自我收缩保护的行为，而是一种积极的、渗透性极强的、充满光明的艺术活动。然而，最初人们认为，这种绘画造成了"不幸"，它使艺术失掉了连续性，从而破坏了艺术语言的结构平衡；它使人们盲目地发挥自己的想象力，忘记了对过去绘画艺术的学习；这不是一股有根之泉，而是一股无根无源的、卷带着许多各类沉积物的潮流。

前卫派一向是按照唯心主义传统的文化定式行事的。它认为艺术沿着一条直线循序渐进地不断发展。在这种思维方法基础上产生的是达尔文主义的艺术语言思想，是艺术进化论的思想，它肯定了历史中前卫派的祖先与艺术研究的最新成果之间存在着传统的联系。站在这一唯心主义的观点上审视艺术和艺术的发展，就看不到历史对它们的影响，就好像艺术创作脱离了历史的整体环境。

一直到70年代，前卫派始终奉达尔文主义的艺术语言为指导自己行动的哲学思想；这些文化进化主义者极其严格地、一丝不苟地、执拗地继承与自己"同一血统"的前辈的思想，对他们毕恭毕敬，从不敢逾越雷池一步。这种态度必然使艺术创作和艺术批评按照极其严格的、封闭式的继承轨道发展。新前卫派也确实曾试图挽救艺术家的良知，他们认为，艺术家的思想应完全建立在创作具有内在联系的作品之上，他们反对研究社会的消极的无条理性，主张艺术作品的内在联系应通过艺术语言的实验而实现。

这种论点强制人们接受了主导60年代艺术

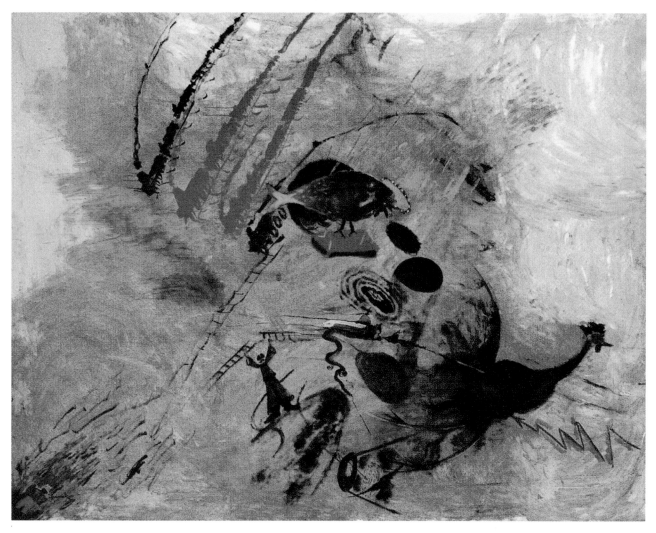

三四个干巴巴的艺术家　1979　200 × 256cm　**布面油画**
Most ghost post　1979　200 × 256cm　Oil on canvas
Tre quattro artisiti secchi　1979　200 × 256cm　Oilo su tela

基亚　库基　作
Sandro Chia-Enzo Cucchi

创作的标新立异的思想，使人们只重视艺术语言的发展，只推动对新技术和新方法的试验。然而，当时的社会现实却是非常活跃的，它本身就是提高创作能力和发展创作思想的最佳试验园地。

70年代的艺术家已经逐步进入一个新的环境之中，而标新立异的时代即将过去，当时，在经济的各个领域里，生产放慢了速度，世界正处于苦难之中，出现了一系列的危机，从而也使各种思想体系的精神危机暴露无遗。人们终于开始谈论艺术危机的问题。如果按照词源学的解释，我们把危机一词理解为"断点"和"核实"①的话，那么，我们便可以把它作为审视艺术真实性的永恒的视角。艺术危机的定义具有两个层次的含义：艺术的死亡和艺术演变的危机。

按照黑格尔的观点，从哲学的角度看，艺术的死亡应被理解为艺术家的行业已经过时，从而，理解和吸收艺术直觉的思想科学也随之过时。现代的观点则认为，艺术的死亡是指它再不能刻画现实。如果说，面对社会结构（经济、政治）、上层结构（艺术）已经明显地表现出无能为

①译者注：根据词源学，西方语言中"危机"（crisi）一词来自希腊语，其中含有"判断"之意。作者可能错误地将核实和判断混为一谈。

力，那么也可以明确地说，艺术创作已从追求质量（艺术价值）滑向了追求数量（商品）。

今天，从狭义上讲，艺术的危机被理解为艺术语言在进化过程中发生了危机，这也恰恰就是前卫派的达尔文主义和进化主义的思维危机。70年代末的一代艺术家，以他们的创新精神，扭转了这一危机。他们揭下了艺术进步的假面具，表明了在人力不可改变的世界面前，艺术不是积极进步的，而是根据它内部必然的演变规律循序渐进的。

现在出现了一个令人难堪的荒谬现象：缺少创新，艺术没有能力自行呼吸，从而进行生物似的快慢节奏的调节。创新总是产生于市场的需求，然而，市场又总是需求同样的商品，这些商品只是外形发生了变化。在此种意义上，60年代的许多文艺思想和艺术团体都只是竹篮打水，做了枉费心机的努力。这些团体，通过它们的艺术思想，建立了基本的艺术欣赏情趣的理念，使许许多多的艺术家向同一个方向寻求发展，以迎合艺术的社会消费和经济需求。

现在，所谓的艺术思想终于烟消云散了，每一个艺术家都可以通过个人的研究进行创作，他们各自追求自己的创作目标，也使社会的欣赏情趣变得丰富多样，个人化和独自创作与专制的社会和文化体制发生了冲突；政治思想、精神分析和科学，都以它们自己的观点，按照自己的计划，解决社会现实在自我产生过程中所造成的矛盾和问题。预防性的文化将生活紧紧限制在一座"集中营"之中，使其无法自由发展，并试图把人的愿望和物质生产引出曲折的、难以预测的道路；然而，人的愿望和物质生产则恰恰是在这种曲折而难以预料的道路上形成的。宗教式的思想体系、精神分析和科学的推测，试图把一切不同的东西都变得具有实用性，把一切产生于现实中的东西都用实用性和生产性等术语加以解释。

然而，无法用上述术语加以解释的恰恰就是艺术，它无法与生活混为一体，甚至还要把生存推向不可能的境地。在这种情况下，不可能便成为将艺术的创造力植根于自己创作计划之中的可能。在一个永不变化的愿望的推动下（意思是指除表面可能变化外其它永不变化），艺术家正开始使用一种面对现实无法转变的语言。在这个意义上，艺术成为生物产品，成为一种受愿望所支配的活动，它只要人们认可它的形象，而不必认可它的动机。艺术不接受跃迁，艺术家需要将通常的相对创作资料绝对化，需要在创作观念完全静止的地方创造出断断续续的动势。

艺术不是艺术家强行插入到艺术语言之中的评注，在现实面前，艺术语言从来不是模棱两可、含糊不清的。因而，70年代的艺术家的艺术创作是沿着崎岖的小路行进的，它要求人们经受一种不同的磨炼，具有一种不同的凝聚力。这种凝聚力实际变成了一种"分散力"，变成了一种对"不幸"的需要，一种社会需求的中断。这是一种完全必要的艺术经历，它重申了艺术的断点是无法避免的，事物的冲突和调和也是无法避免的。此时的艺术产生于人们对支离破碎的艺术现状已经有了明确的认识，已经清楚地知道无法恢复艺术的统一和平衡。政治思想、精神分析和科学宗教式的体系则非常乐观地试图将支离破碎的现状统一为超验的一个整体，然而，只有艺术才是可以超验的，因为它能够将自己的目的从外部转移到内部。

事实上，艺术本身具有一股储存的力量，它可以储存建立形象所需的能量，形象又被认为是个人想象的展示，个人想象则通过作品的浓缩升华成具有确确实实客观价值的物体，因为没有浓缩便没有艺术。浓缩是作品的质量，用简洁的语

言来解释，即"抓住视线"，也就是说，在作品的"浓缩场"的范围中，在艺术的循环的自足空间内，具有抓住观众的魅力。艺术按照它的内部法则运动，只有艺术家才具有上天的恩赐，才能够调整艺术的法则，只有排斥一切外力和外来促动因素的内在超验性才能左右艺术规律。

艺术规律和促动因素便是作品本身，它强迫人们接受它出现的事实，它是由材料、形象和思想构成的；画家在作画之时就已经将思想灌注于其中了，不借助视觉语言的规则，是无法将其思想阐明的。

70年代末，艺术出现纷乱的局面，它以不同的形式分散在许多作品之中，每幅作品都包含着自己的"艺术浓缩"，都具有自己的独特之处，都表现了艺术家与众不同的艺术冲动。这样，所谓的"艺术的不幸"便出现了，在60年代受到艺术语言的原则支配的文化氛围中，现在产生了不连续性。艺术国际化的乌托邦曾经标志着艺术的贫乏，为了打破国界，贫乏的艺术不惜放弃和丧失人类更加深层的文化根源。

贫乏艺术和60年代人们的经历是一种"艺术流浪主义"的表现，它建立在对人们追求绘画方式和技巧的认同之上；70年代，取而代之的是另一种不同形式的"艺术流浪主义"，它建立在艺术敏感性和作品的差异循序渐变的基础之上。

60年代，在政治上，人们宣扬权威，扼杀个性，与政治气候相一致的艺术，也丧失了个性，毫无生气。现在，具有个性的想象力突然从天而降，控制着艺术创作。艺术试图重新恢复艺术家的主观性，通过艺术语言的内在方式表现它自己。人类具有了人类学的价值，因为他要使人类的个体重新具有感情，在艺术领域里，就是要使艺术家具有自己的感情。

作品变成一个小宇宙，它能够收容艺术的丰富表现能力，并使其植根于其中，艺术能够使人重新具有很强的主观感染力，它甚至可以渗透到私人的生活习惯之中；无论在任何情况下，人们都要把自己行为的价值和动机建立在自己的感情冲动的基础上，而不是其它什么基础上。

贫乏艺术和重复艺术的思想体系已经过时，现在出现了一种新的艺术态度；它不宣扬权威，只承认艺术和作品的权威；作品自有它展示的魅力和价值，作品的题材不再是纯粹闭门造车式的唯心主义的、死气沉沉的内容。艺术又成为一种无限的创造活动，它来自创作者的艺术激情，为各种创作可能打开了大门，从具象到抽象，从思想的一闪念到柔和而浓重的色彩，应有尽有；这一切都在作品形成的同时被灌注在作品之中，因而，作品具有既吸引观众又令人惊讶的视觉效果。

70年代的艺术在漂泊不定的创作中寻找到了自己的最佳状态，寻找到了不受任何限制，在各个领域中向各个方向自由过渡的可能性。基亚(Chia)、克莱门特(Clemente)、库基(Cucchi)、德·玛利亚(De Maria)、帕拉迪诺(Paladino)等艺术家在"超前卫"的运动着的艺术创作领域中积极地活动着。"超前卫"应该被理解为穿越"前卫"实验的理念；可以假设每一幅作品的创作都是一个手工实验的过程，"超前卫"的作品不再按照事先已定好的设计和思想逐步形成；在创作现场，艺术家根据自己的观察和操作创作材料的手的感觉，按照自己的想象，即按照自己的思想和艺术敏感而创作。

艺术应具有戏剧性，应具有无计划的偶然性。因而，才能使每一个作品都区别于其它作品；这种艺术观念能够使年轻的艺术家们在"前卫派"的领域里畅通无阻，与传统建立起联系，然而，他们不再按照直线前进，他们的运动路线经

常是弯曲的，相互交叉跨越的，有时是倒退或向前飞跃的，他们的运动充满了突变，却从不重复。

"超前卫"的意思是采取一种漂移不定的艺术创作立场，它不遵守任何确定的规则，也不认为任何理念高人一等，它只遵循按照与作品创作同步存在的精神和物质状况而进行工作的原则。

"超前卫"还意味着有意地向西方文化中的理念中心主义提出挑战，意味着向实用主义敞开大门，它使艺术家具有了更广阔地发挥创作本能的空间；创作本能不是先科学的态度，而是一种后科学立场的成熟；后科学立场超越了把当代艺术同拜物主义的方法与现代科学等同起来的思想局限：创作成为一个能量活动量，在其自身中可以找到加速力和惯力。

供求关系就这样在形象创作的竞争中取得了平衡，艺术超越了前卫派创作的典型特征，它不再是一种疑问，也不再跨越观赏者的期望去寻找引起艺术创作的社会原因。前卫派艺术总是假设观众处于痛苦之中而不是处于幸福之中，观众需要被迫走出作品之外，去充分理解它的价值。

70年代末的艺术家，即我称之为超前卫的艺术家，他们发现，通过展示一种同时既为"谜语"又为"谜底"的形象，能够使艺术作品变得更加明亮、清新。艺术不再在黑夜中摸索，不再只是探索中的疑问，人们眼前出现了光明，这意味着从此人们可以创作出真正的艺术作品，艺术作品真正能够抓住人的注意力，即真正能够控制观赏者"焦急不安"的目光；而前卫派却使观众习惯了观看悬而未定的作品，习惯了刻意设计出来的不完整的艺术，习惯了通过自己的介入完善不完整的艺术创作。

70年代的艺术试图重新恢复作品令人欣悦的观赏价值。遥不可及的神秘主义又增添了性欲冲动的内容，增添了一种完全来自于作品的艺术浓

缩和内部超验的力量。

超前卫艺术是扇形运动的，它的变化在于允许艺术向任何一个方向发展，其中包括过去已经历的发展方向。"萨拉图斯特拉不想抛弃人类过去的任何东西，他希望把所有的一切都一锅烩制"（尼采）。这就意味着不怀念任何东西，因为一切都可以不断地得到，不再具有现在和过去的时间差别，时间差别是典型的前卫派的产物，它像考古学一样，总是生活在过去的时空中，总之，它需要重新获得活力。

通过绘画，桑德罗·基亚实践的是一个有思想支持的操作理论，是通过一个独特的形象或符号将形成的假设变成作品的操作理论。从一方面看，形象提示了最初的主题思想，从另一方面看，它也是绘画过程的鉴证，它展示了创作的内部行程、复杂的思考范围、可能的情感交流向各种截然不同的方向所进行的位移等等。

弗朗西斯科·克莱门特通过重复和位移实现自己的创作。他的作品以一个事先已经确定的东西作为基础，然而，在创作的过程中，作品又偏离了最初的原则。位移是按照斜线进行的，这是差异创造的明显标志。

恩佐·库基主张大规模运动的艺术，他以倾斜的符号记录他的艺术语言；在他那里没有停滞，只有动态的形象、符号和色彩，它们互相穿插，共同组成宇宙般的幻象。绘画作品在自己内部进行咬合，形成一个小宇宙，化解了其中各个不同成分之间的冲突。小宇宙和大宇宙就这样共同完成了一个穿越，在穿越过程中，混沌和宇宙得到了澄清，获得了自己所需的能量。

尼古拉·德·玛利亚的创作体现了艺术敏感循序渐进式的位移，它是通过一种绘画手段实现的，这种绘画应该是精神状态的外部表露，同时也应该是在创作过程中可能产生的感情震撼的内

心反映。其结果是建立起一个视觉区域，一个许多参照物交织在一起的幻象；在这个幻象中，感觉寻找到了外倾的空间，直至形成一种内在的结构。

米莫·帕拉迪诺所从事的是一种使一切浮现在表面的绘画艺术，他试图把所有敏感的资料都展示在视觉的层面上，其中包括隐藏在内心最深处的资料。绘画作品集聚和迅速扩展了文化主题和感觉资料。一切都用绘画、符号和材料的语言进行表达。绘画作品中贯穿着各种不同的成分，热与冷、抒情与思考、浓郁与稀薄，这些成分都通过色彩的调节而得以展现。

如今，从事艺术创作意味着同时在画板上展示一切，可以将普通人的形象、神话中的形象与个人历史相关的个人符号和与艺术史及文化史相关的公共符号熔于一炉。这种综合融会还意味着不再神话自我，而是把自我引入与其它表现可能的冲突之中，从而接受将主观置于许多事物的交错点之上的可能性。

打碎创作意味着打碎了对自我统一的迷宫，意味着采取了从不停止的、没有落脚点和参照点的漂浮不定的艺术想象。这一切都加强了"超前卫"的观念，因为它颠倒了前卫派重视参照点的观念。

每一个作品都成为把人们带回原创作地的充满波折的过程，它穿过许多参照的领域，借助于各种工具，依靠和谐的色彩和多种材料；作者的思想直接通过形象得到反映，然而，却隐蔽在作品的深处；它使作品零碎的组成部分形成一种动态的关系，永不聚合，也永不在统一的思想中寻觅避风港。

世上没有任何至高无上的准则，只有艺术创作的实践才能使每一个不稳定的东西稳定下来，同时又不使它处于稳定化的状态，变成具有象征意义的固定之物。作品保持着它的创作过程的流动性和自身的流动性，它在主题的周围活动，主题从不试图成为被效法的榜样，而要保持作品的偶然性和开放性，然而，开放不再是前卫派无限的浪漫狂热，而是无中心区的运动，是只以精神和感觉快乐为惟一目的的自由漂移。

La Transavanguardia Italiana

Achille Bonito Oliva

L'arte finalmente ritorna ai suoi motivi interni, alle ragioni costitutive del suo operare, al suo luogo per eccellenza che è il labirinto, inteso come "lavoro dentro", come escavo continuo dentro la sostanza della pittura. L'idea dell'arte alla fine degli anni settanta è quella di ritrovare dentro di sé il piacere ed il pericolo di tenere le mani in pasta, rigorosamente, nella materia dell'immaginario, fatta di derive e di sgomitate, di approssimazioni e mai di approdi definitivi. L'opera diventa una mappa del nomadismo, dello spostamento progressivo praticato fuori da ogni direzione precostituita da parte di artisti che sono dei ciechi-vedenti, che ruotano la coda intorno al piacere di un'arte che non si reprime davanti a niente, nemmeno davanti alla storia.

Negli anni sessanta l'arte aveva una connotazione moralistica, anche quella d'avanguardia: la formula dell'arte povera perseguiva nel suo disegno critico una linea di lavoro repressiva e masochistica fortunatamente contraddetta da alcune opere degli artisti. Successivamente la pratica creativa ha fatto saltare la censura formale attinente alla produzione artistica a favore di una pratica dell'opulenza, come riparazione ad una perdita iniziale, via ascensionale che non significa ascetismo o rinuncia ma crescita e sviluppo della capacità di diventare possidenti, al limite di un possesso messo continuamente in discussione dal naturale movimento dell'opera e dell'artista, che è di spossessamento e di superamento. L'opulenza consiste nella capacità di investire nella perdita iniziale, nella condizione notturna del quotidiano, il rischio della pratica solare dell'arte. Finalmente la pratica pittorica viene assunta come un movimento affermativo, come un gesto non più di difesa ma di penetrazione attiva, diurna e fluidificante. L'assunto iniziale è quello di un'arte come produzione di catastrofe, di una discontinuità che rompe gli equilibri tettonici del linguaggio a favore di una precipitazione nella materia dell'immaginario non come ritorno nostalgico, come riflusso ma come flusso che trascina dentro di sé la sedimentazione di molte cose, che scavalcano il semplice ritorno al privato ed al simbolico.

L'avanguardia, per definizione, ha sempre operato dentro gli schemi culturali di una tradizione idealistica tendente a configurare lo sviluppo dell'arte come una linea continua, progressiva e rettilinea. L'ideologia sottostante a tale mentalità è quella del darwinismo linguistico, di una idea evoluzionistica dell'arte, che afferma una tradizione dello sviluppo linguistico dagli antenati dell'avanguardia storica fino agli esiti ultimi della ricerca artistica. L'idealismo di tale posizione risiede nella considerazione dell'arte e del suo sviluppo al di fuori dei colpi e dei contraccolpi della storia, come se la produzione artistica vivesse avulsa dalla produzione più generale della storia.

Fino agli anni settanta, l'arte d'avanguardia ha conservato tale mentalità, operando sempre dentro l'assunto filosofico del darwinismo linguistico, di un evoluzionismo culturale rispettoso di ogni genealogia con una puntigliosità puristica puritana. Questo ha comportato una produzione artistica e critica attenta a porsi nel solco geometrico e chiuso della continuità. In definitiva la neoavanguardia ha inteso salvare la coscienza felice dell'artista tutta basata sulla coerenza interna del lavoro, realizzata dentro l'ambito sperimentale del linguaggio, contro l'incoerenza negativa del mondo.

Tale assunto comporta una coazione al nuovo che ha contraddistinto la produzione artistica degli anni sessanta, intesa come attività circoscritta al linguaggio che promuove il bisogno di sperimentare nuove tecniche e nuove metodologie nei confronti di una realtà dinamica e di per sé sperimentale quanto a capacità produttiva e sviluppo di tendenze del pensiero.

Gli artisti degli anni settanta cominciano ad operare nel momento in cui cessa la coazione al nuovo, nel momento del rallentamento produttivo dei sistemi economici, quando il mondo è attanagliato da una serie di crisi che mettono a nudo la vertigine produttivistica di tutti i sistemi ideologici. Finalmente si è parlato e si parla di crisi dell'arte. Ma se per

crisi intendiamo, secondo l'etimo, "punto di rottura" e "verifica", allora possiamo adoperare tale parola come angolazione permanente per verificare il vero tessuto dell'arte. Due sono i livelli a cui rimanda la definizione della crisi dell'arte: la morte dell'arte e la crisi dell'evoluzione dell'arte.

Hegelianamente, per morte dell'arte s'intende il superamento delle categorie del fare artistico da parte della filosofia, quale scienza del pensiero che comprende ed assorbe l'intuizione artistica. Più modernamente, la morte dell'arte rimanda alla constatazione che tale esperienza non riesce più ad intaccare i livelli della realtà. E, se da una parte viene sottolineata l'impotenza della sovrastruttura (l'arte) rispetto alla struttura (l'economia, la politica), dall'altra si afferma la caduta della produzione artistica da qualità (valore) a quantità (merce).

Oggi per crisi dell'arte in senso stretto s'intende invece la crisi nell'evoluzione dei linguaggi artistici. La crisi appunto della mentalità darwinistica ed evoluzionistica dell'avanguardia. Tale momento critico viene ribaltato dalla generazione artistica della fine degli anni settanta in termini di nuova operatività. Essa ha smascherato la valenza progressista dell'arte, dimostrando come di fronte all'immodificabilità del mondo l'arte non è progressista bensì progressiva, rispetto alla coscienza della propria e circoscritta evoluzione interna.

Ora lo scandalo, paradossalmente, consiste nella mancanza di novità, nella capacità dell'arte di assumere un respiro biologico, fatto di accelerazioni e rallentamenti. La novità nasce sempre da una richiesta del mercato che ha bisogno della stessa merce, ma trasformate nella forma. In questo senso negli anni sessanta sono state bruciate molte poetiche ed i sottostanti raggruppamenti. Perché i raggruppamenti, attraverso le poetiche, permettono di costituire quella nozione di gusto che, proprio per la quantità degli artisti operanti nella stessa direzione, consente il consumo sociale ed economico dell'arte.

Finalmente le poetiche si sono diradate, ogni artista opera attraverso una ricerca individuale che frantuma il gusto sociale e persegue le finalità del proprio lavoro. Il valore dell'individualità, dell'operare singolarmente, si contrappone ad un sistema sociale e culturale attraversato da sovrastanti sistemi totalitari, l'ideologia politica, la psicanalisi e le scienze, che risolvono all'interno della propria ottica, del proprio progetto, le antinomie e gli scarti prodotti dalla realtà

nel suo farsi. Una cultura delle previsioni stringe la vita dentro un campo di concentrazione che ne assottiglia l'espandersi e tende a ridurre il desiderio e la produzione materiale al di fuori delle vie tortuose ed imprevedibili entro cui si forma. Il sistema religioso delle ideologie, dell'ipotesi psicanalitica, scientifica, tende a rendere funzionale al sistema tutto ciò che è diverso, riciclando e convertendo nei termini del funzionale e del produttivo tutto ciò che invece nasce dalla pratica della realtà.

Ciò che non è riducibile in tali termini è proprio l'arte che non può confondersi con la vita, anzi l'arte serve a spingere l'esistenza verso condizioni di impossibilità. L'impossibilità, in questo caso è la possibilità di tenere la creatività artistica ancorata al progetto della propria produzione. L'artista ora opera sulla soglia di un linguaggio irriducibile rispetto alla realtà, sotto la spinta di un desiderio che non muta mai, nel senso che non si tramuta mai se non nella propria apparenza. In questo senso l'arte è produzione biologica, attività applicata di un desiderio che si lascia omologare soltanto nella propria immagine ma non nella propria motivazione. L'arte non accetta transizioni, coniuga dentro il bisogno dell'artista di rendere assoluto il dato relativo della produzione corrente e di creare discontinuità di movimento, laddove esiste l'austera immobilità del concetto produttivo.

Ora l'arte non è commento inserito dall'artista dentro il luogo del linguaggio, che non è mai doppio e speculare rispetto alla realtà. In questo senso la produzione dell'arte da parte della generazione degli anni settanta si muove lungo sentieri che richiedono altra disciplina e altra concentrazione. Qui la concentrazione diventa deconcentrazione, bisogno di catastrofe, rottura del bisogno sociale. L'esperienza artistica è un'esperienza laicamente necessaria che ribadisce l'ineliminabilità della rottura, l'insanabilità di ogni conflitto e di ogni conciliazione con le cose. Questo tipo di arte nasce dalla consapevolezza della irriducibilità del frammento, dell'impossibilità di riportare unità ed equilibrio. L'opera diventa indispensabile, in quanto ristabilisce concretamente rotture e squilibri nel sistema religioso delle ideologie politiche, psicanalitiche e scientifiche che ottimisticamente tendono invece a riconvertire il frammento in termini di totalità metafisica.

Solo l'arte può essere metafisica, in quanto riesce a spostare il proprio fine dal fuori al dentro, attraverso la possibilità di fondare il frammento dell'opera come una

totalità che non rimanda ad altro valore esterno al proprio apparire.

Sostanzialmente l'arte trova dentro di sé la forza di stabilire il deposito da cui attingere l'energia, necessaria per costruire le immagini, e le immagini stesse, intese come estensioni dell'immaginario individuale che assurge a valore oggettivo ed accertabile tramite l'intensità dell'opera. Perché senza intensità non si ha arte. L'intensità è la qualità dell'opera di darsi, nell'accezione lacaniana, come domasguardi, come capacità di fascinazione e cattura dello spettatore dentro il campo intenso dell'opera, dentro lo spazio circolare ed autosufficiente dell'arte, che funziona secondo leggi interne regolate dalla grazia demiurgica dell'artista, da una metafisica interna che esclude ogni rimando ed ogni motivazione esterna.

Regola e motivazione dell'arte è l'opera stessa che impone la sostanza del proprio apparire, fatta di materia e di forma, di pensiero direttamente incarnato nel luogo della pittura e del segno, non pronunciabile se non attraverso le grammatiche della visione.

In tal modo l'arte della fine degli anni settanta si presenta positivamente frantumata, disseminata in molte opere, ciascuna portante dentro di sé l'intensa presenza della propria esistenza regolata da un impulso circoscritto alla singolarità dell'opera creata. Così si delinea il concetto di catastrofe, intesa come produzione di discontinuità in un tessuto culturale retto negli anni sessanta dal principio dell'omologazione linguistica. L'utopia internazionalistica dell'arte ha contraddistinto la ricerca dell'arte povera, tutta tesa a sfondare i confini nazionali, perdendo ed alienando in tal modo le radici culturali ed antropologiche più profonde.

All'apparente nomadismo dell'arte povera e delle esperienze degli anni sessanta, basato sul riconoscimento di affinità metodologiche e tecniche, gli artisti degli anni settanta oppongono un nomadismo diverso e diversificante, giocato sullo spostamento progressivo della sensibilità e dello scarto tra un'opera ed un'altra.

Gli improvvisi smottamenti dell'immaginario individuale presiedono la creatività artistica precedentemente mortificata dal carattere dell'impersonalità, sincronica anche al clima politico degli anni sessanta che predicavano la spersonalizzazione in nome di un primato del politico. Ora invece l'arte tende a rimpossessarsi della soggettività dell'artista, di esprimerla attraverso le modalità interne del linguaggio. Il personale acquista una valenza antropologica,

in quanto partecipa a riportare l'individuo, in questo caso l'artista, nello stato di una ripresa di un sentimento che è quello del sé.

L'opera diventa il microcosmo che accoglie e fonda la capacità opulenta dell'arte di permettere il rimpossessamento, di tornare ad essere possidenti di una soggettività fluida fino al punto da entrare anche nelle pieghe del privato, che in ogni caso fonda sulla propria pulsione e non su altro il valore e la motivazione del proprio operare.

L'ideologismo del poverismo e la tautologia dell'arte concettuale trovano un superamento in un nuovo atteggiamento che non predica alcun primato se non quello dell'arte e della flagranza dell'opera che ritrova il piacere della propria esibizione, del proprio spessore, della materia della pittura finalmente non più mortificata da incombenze ideologiche e da arrovellamenti puramente intellettuali. L'arte riscopre la sorpresa di un'attività creativa all'infinito, aperta anche al piacere delle proprie pulsioni, di una esistenza caratterizzata da mille possibilità, dalla figura all'immagine astratta, dalla folgorazione dell'idea al morbido spessore della materia, che si attraversano e colano contemporaneamente nell'istantaneità dell'opera, assorta e sospesa nel suo donarsi generosamente come visione.

L'arte degli anni settanta trova nella creatività nomade il proprio movimento eccellente, la possibilità di transitare liberamente dentro tutti i territori senza alcuna preclusione con rimandi aperti a tutte le direzioni. Artisti come Chia, Clemente, Cucchi, De Maria e Paladino operano nel campo mobile della transavanguardia, intesa come attaversamento della nozione sperimentale dell'avanguardia, secondo l'idea che ogni opera presuppone una manualità sperimentale, la sorpresa dell'artista verso un'opera che si costruisce non più secondo la certezza anticipata di un progetto e di un'ideologia, bensì si forma sotto i suoi occhi e sotto la pulsione di una mano che affonda nella materia dell'arte, in un'immaginario fatto di un incarnamento tra idea e sensibilità.

La nozione dell'arte come catastrofe, come accidentalità non pianificata che rende ogni opera differente dall'altra, permette ai giovani artisti una transitabilità, anche nell'ambito dell'avanguardia e nella sua tradizione, non più lineare ma fatta di affondi e di scavalcamenti, di ritorni e di proiezioni in avanti, secondo un movimento ed una peripezia che non sono mai ripetitivi in quanto segnano la geometria sinuosa dell'ellissi e della spirale.

La transavanguardia significa assunzione di una posizione nomade che non rispetta nessun impegno definitivo, che non ha alcuna etica privilegiata se non quella di seguire i dettami di una temperatura mentale e materiale sincronica all'istantaneità dell'opera.

Transavanguardia significa apertura verso l'intenzionale scacco del logocentrismo della cultura occidentale, verso un pragmatismo che restituisce spazio all'istinto dell'opera che non significa atteggiamento prescientifico ma semmai maturazione di una posizione post-scientifica che supera il feticistico adeguamento dell'arte contemporanea alla scienza moderna: l'opera diventa il momento di un funzionamento energetico che trova dentro di sé la forza dell'acceleramento e dell'inerzia.

Così domanda e risposta si pareggiano nell'agone dell'immagine e l'arte supera la connotazione tipica della produzione dell'avanguardia, quella di costituirsi come interrogazione che scavalca l'aspettativa dello spettatore per rimandare alle cause sociologiche che l'hanno provocata. L'arte d'avanguardia presuppone sempre un disagio e mai la felicità del pubblico, costretto a spostarsi fuori dal campo dell'opera per comprenderne il pieno valore.

Gli artisti della fine degli anni settanta, quelli che io chiamo della transavanguardia, riscoprono la possibilità di rendere lampante l'opera mediante la presentazione di una immagine che contemporaneamente è enigma e soluzione. L'arte così perde il suo lato notturno e problematico, del puro interrogare, a favore di una solarità visiva che significa possibilità di realizzare opere fatte ad arte, in cui l'opera funziona veramente da domasguardi, nel senso che doma lo sguardo inquieto dello spettatore, abituato dall'avanguardia all'opera aperta, alla progettata incompletezza di un'arte che richiede il perfezionante intervento dello spettatore.

L'arte negli anni settanta tende a riportare l'opera nel luogo di una contemplazione appagante, dove la lontananza mitica, la distanza della contemplazione, contemplazione si carica di erotismo e di energia tutta promanante dalla intensità dell'opera e dalla sua interna metafisica.

La transavanguardia si muove a ventaglio con una torsione della sensibilità che permette all'arte un movimento in tutte le direzioni, comprese in quelle del passato. "Zarathustra non vuole perdere nulla del passato dell'umanità, vuole gettare ogni cosa nel crogiuolo" (Nietzsche). Questo significa non avere nostalgia di niente, in quanto tutto è continuamente raggiungibile, senza più categorie temporali e gerarchie di presente e passato, tipiche dell'avanguardia che ha sempre vissuto il tempo alle spalle come archeologia e comunque come reperto da rianimare.

Sandro Chia pratica, attraverso la pittura, la teoria di una manualità assistita da un'idea, dalla messa in opera di una ipotesi formulata attraverso la particolarità di una figura o di un segno. Se l'immagine costituisce da una parte lo svelamento dell'idea iniziale, dall'altra è anche testimonianza del procedimento pittorico che lo produce e ne svela l'interno circuito, la gamma complessa di riflessi, le possibili corrispondenze, gli spostamenti ed i rimandi fra le diverse polarità.

Francesco Clemente opera attraverso la ripetizione e lo spostamento. Parte da un'immagine preesistente che riproduce anche mediante la pittura. Ma ogni volta la riproduzione altera e sposta ciò che è riprodotto, secondo variazioni tanto sottili quanto imprevedibili. Una certezza anticipata è alla base dell'opera che nella sua effettuazione implica uno scarto rispetto alla norma iniziale. Lo spostamento avviene per linee oblique, segno tangibile della produzione di differenza.

Enzo Cucchi accetta il movimento eccellente dell'arte, inscrivendo le cifre del proprio linguaggio sotto il segno dell'inclinazione, dove non esiste stasi ma una dinamica di figure, segni e colore che si attraversano e colano reciprocamente il senso di una visione cosmica. La pittura mastica dentro di sé ed assorbe nel microcosmo del quadro la collisione tra i vari elementi. Così microcosmo e macrocosmo compiono insieme una traversata, in cui caos e cosmos trovano il deposito e l'energia della propria combustione.

Nicola De Maria opera sullo spostamento progressivo della sensibilità, praticato mediante gli strumenti di una pittura che tende a darsi come esteriorizzazione di uno stato mentale e come interiorizzazione di possibili vibrazioni che nascono durante l'esecuzione dell'opera. Il risultato è la fondazione di un campo visivo, di una visione all'incrocio di molti rimandi, in cui le sensazioni trovano una estroversione spaziale fino a risolversi in una sorta di architettura interiore.

Mimmo Paladino pratica una pittura di superficie, nel senso che tende a portare ad emergenza visiva tutti i dati sensibili, anche quelli più interiori. Il quadro diventa il luogo di incontro e di espansione a vista d'occhio di motivi culturali e di dati sensitivi. Tutto è tradotto in termini di pittura, di

segno e di materia. Il quadro è attraversato da temperature differenti, caldo e freddo, lirico e mentale, denso e rarefatto, che affiorano, alla fine della calibratura del colore.

Ora fare arte significa avere tutto sul tavolo in una contemporaneità girevole e sincronica che riesce a colare nel crogiuolo dell'opera immagini private ed immagini mitiche, segni personali, legati alla storia individuale, e segni pubblici, legati alla storia dell'arte e della cultura. Tale attraversamento significa anche non mitizzare il proprio io, ma invece inserirlo in una rotta di collisione con altre possibilità espressive, accettando così la possibilità di mettere la soggettività all'incrocio di tanti incastri. "L'essere e il delirio di molti" (Musil).

La frantumazione dell'opera significa la frantumazione del mito dell'unità dell'io, significa assumere il nomadismo di un immaginario senza soste o punti di ancoraggio e di riferimento. Tutto questo rafforza la nozione di transavanguardia, in quanto ribalta l'attitudine dell'avanguardia di avere il privilegio di punti di riferimento.

Ogni opera diventa una peripezia che porta e ritorna nel luogo dell'opera, che attraversa i campi di riferimenti molteplici, che si serve di tutti gli utensili, una manualità direzionata dalla grazia del colore e di molte materie, un pensiero che pensa direttamente attraverso le immagini e si acquatta nel fondo della visione, come una temperatura che fa da collante e permette ai frammenti dell'opera di tenersi in una relazione mobile che non si serra mai e mai cerca riparo nell'idea di unità.

Non esiste alcuna regola demiurgica ma soltanto la pratica creativa dell'arte che rende stabile ogni precarietà senza trasformarla in stabilizzazione e simbolica fissità. L'opera conserva il flusso del suo processo, del suo essere operosa nei dintorni di una soggettività che non tende mai a diventare esemplare ma semmai a conservare il carattere dell'accidentalità, di un'apertura di campo che non significa l'ebbrezza romantica dell'infinito dell'avanguardia, ma muoversi senza centro lungo derive segnate da un'unica prospettiva, quella del piacere mentale e sensoriale.

The Italian Trans-avantgarde

Achille Bonito Oliva

Art is finally returning to its internal motives, the reasons which constitute its working, its place par excellence the labyrinth-the "inside work," the continuous digging inside the substance of painting. The idea of art in the 70s has been to rediscover within itself the pleasure and the peril of getting your hands dirty, and rigorously so, in the substance of the imaginary, made up of driftings-off and elbowings-in, approximations and never definitive landings. The work becomes a nomad's map of the progressive movements practiced outside of any direction preconstituted by artists, the seeing-blind, wagging their tails around the pleasure of an art that doesn't stop at anything, not even history.

Art in the 60s, including that of the avant-garde, has had a moral character: in its critical design, the formula of the Italian "arte povera" (literally, poor art) pursued a repressive and masochistic line, fortunately contradicted by some artist's works. Later on creative practice did away with the formal censorship of artistic production to favor the practice of opulence to amend for an initial loss, an access that means neither asceticism nor renunciation, but growth and development of the capacity to become a land-owner, at the limits of a possession put into continuous debate by the works and the artist's natural movement of dispossession and overcoming.

Its opulence consists in its capacity to invest an initial loss, in the nocturnal condition of the day-to-day, with the risk of a solar practice of art. Finally pictorial practices are taken up as an affirmative movement, as a gesture which is no longer one of defense, but of active, daytime, fluid penetration.

The initial precept is that of art as the production of a catastrophe, a discontinuity that destroys the tectonic balance of language to favor a precipitation into the substance of the "immaginario", neither as a nostalgic return, nor a reflux, but a flowing that drags inside itself the sedimentation of many things which exceed a simple return to the private and the symbolic.

By definition the avant-garde has always operated within the cultural pattern of an idealistic tradition which tends to shape the development of art into a progressive, continuous and rectilinear line. The ideology which subscribes to this mentality is Linguistic Darwinism, an evolutionary idea of art ascertaining a tradition in the linguistic development from our avant-garde ancestors up to the latest outcomes of artistic research. This position's idealism lies in its consideration of art and its development apart from the blows and counterblows of history, as if artistic production were torn away from history's more general production.

Until the 70s avant-garde art maintained this mentality, operating within the philosophic theory of Linguistic Darwinism, of a cultural evolution respectful of every geneology with a puristic and puritanical punctiliousness. This caused an artistic and critical production careful of getting trapped into the geometric rut, subject to its continuity. As their final aim, the neo-avantgarde tried to save the artist's happy conscience, entirely based on the internal consistency of his work, realized within the experimental limits of language, against the negative inconsistency of the world.

Such a theory causes that coercion to be new which characterized artistic production in the 60s, an activity circumscribed to language which promoted the need to experiment with new techniques and new methodologies in the face of a dynamic reality, experimental in and of itself in its productive capacity and in its development of tendencies of thought.

Artists in the 70s begin to operate at the very point where the coercion to be new leaves off, at the moment of the productive slow-down of economic systems, when the world is entangled in a series of crises ,tripping the productivistic giddiness of all of its ideological systems. Finally, the discussion is continuing of a crisis in art. However, if by crisis we intend, according to the etymon, "breaking point" and

"verification," then we can use the word as a permanent angulation to verify the real stuff of art. The definition of the crisis in art refers to two levels:the death of art and the crisis of the evolution of art.

In Hegelian terminology, however, the death of art means the bypassing of the categories of artistic working by philosophy, the science of thought which includes and absorbs artistic intuition. More recently the death of art refers to the realization that such an experience can no longer corrode the various levels of reality. If on the one hand the impotence of the superstructure (art) compared to the structure (the economy, politics) is underlined, on the other we can ascertain the fall in artistic production from quality (value) to quantity (merchandise).

Today the crisis in"artin sensu stricto "means the crisis in the evolution of artistic language °™ the crisis in the avant-garde's Darwinistic and Evolutionary mentality. This critical moment is overturned in terms of new operability by the artistic generation of the 70s. They have unmasked the progressive valence of art, demonstrating how in the face of the unchangeability of the world, art is not for progress but rather progressive with respect to its consciousness of both its own and circumscribed internal evolution.

Now the scandal paradoxically consists in the lack of novelty, art's capacity to achieve a biological respiration of speedings-up and slowing-down. Novelty is always born of a market demand for the same merchandise, but in a transformed shape. In this sense, many poetics and their relative subgroups were burned in the 60s. Because through their poetics, the sub-groups permit the constitution of the notion of taste which, by reason of sheer quantity of artists working in the same direction, allows the social and economic consumption of art.

Finally the poetics have been thinned out, every artist working on an individual research that shatters social taste, and pursuing the finality of the work itself. The value of individuality, of working by oneself, is contrary to a social system crossed by superimposed totalitarian systems, political ideology, psychoanalysis and the sciences, all of which resolve the antinomies and swerves, produced in the forward movement of reality, inside their own viewpoints, their own projects. Inside a concentration camp which cuts down on its own expansion and tends to reduce all desire and material production off its own torturous and impregnable routes, a culture of forecasts has to tighten its belt. The religious system of ideologies, of psychoanalytic and scientific hypotheses, tends to transform all that is different into something functional to the system, recycling and converting into terms of functional and productive all that is instead rooted in reality.

That which cannot be reduced to these terms is art, which cannot be confused with life. Art instead serves to push existence towards conditions of impossibility. In this case impossibility refers to the possibility of keeping artistic creativity anchored to the project of one's own production. The artist of the 70s is working on the threshold of a language which cannot be reduced to reality, under the impetus of a desire which never changes in the sense that it is never transformed except in its own appearance. In this sense, art is biological activity, the applied activity of a desire which only lets itself be ratified according to its image and not its motivation. Art will not accept transactions, conjugated inside the artist's need to make the relative data of current production absolute and to create discontinuity of movement, while the austere immobility of the productive concept exists.

Today art is not the artist's insertion of remarks within the territory of language, never dual or specular with respect to reality. In this sense the production of art by the 70s generation moves along paths which require other disciplines and other concentrations. Here concentration becomes deconcentration, the need for catastrophe, breaking with social needs. Artistic experience is a necessary lay experience that confirms the uneliminability of breaking-off, the incurability of every conflict and reconciliation with things. This type of art is born in the consciouness of the irreducibility of every fragment, of the impossibility of recreating unity and balance. The work becomes indispensable because it concretely re-establishes breakings-off and imbalances in the religious system of political, psychoanalytic and scientific ideologies, which tend instead to reconvert the fragment in terms of metaphysical totality.

Only art can be metaphysical because it succeeds in transfering its ends from outside to inside itself in its possibility of establishing a fragment of the work as a totality which recalls no other value outside of the fact of its own appearing.

Basically art finds inside itself the strength to decide the store from which to draw the energy necessary to construct its images, and the images themselves an extension of the

individual "immaginario" that rises to an objective and ascertainable level through the intensity of the work. Because without intensity there is no art. Intensity is the work's ability to offer itself, or what Lacan calls the "look-tamer", its capacity to fascinate and capture the spectator inside the intense field of the work, inside the circular and self-sufficient space of art functioning according to internal laws regulated by the demiurgic grace of the artist, by an internal metaphysics which excludes any outside motivation.

The rule and motivation of art is the work itself, imposing the substance of its own appearing, made up of material and shape, of thought directly embodied in painting, and the sign, unpronouncable without the help of the grammar of vision.

In this way, art in the 70s appears deliberately shattered, disseminated in many works, each one carrying within itself the intense presence of its own existence, regulated by an impulse circumscribed to the singularity of the work created. Thus the concept of catastrophe is delineated , the production of discontinuity in a cultural fabric held up in the 60s by the principle of linguistic approval. The internationalistic utopia of art characterized the research of Italian "arte povera", bent on smashing national borders, thereby losing and alienating the deepest cultural and anthropological roots.

In opposition to the apparent nomadism of Italian "arte povera" and the experiences of the 60s, based on the recognition of methodological and technical affinities, the artists of the 70s respond with a nomadism both diverse and diversifying, playing on the sensitivity and the swerve between one work and another.

The unexpected landslides of the individual "immaginario" preside over the artistic creativity previously mortified by the impersonal, synchronic character and even by the political climate of the 60s, which preached depersonalization in the name of the supremacy of politics. Now instead art tries to ripossess the artist's subjectivity, to express itself through the internal form of language. The personal acquires an anthropological valence because it participates in bringing the individual, in this case the artist, back to a state of renewal of a sentiment towards himself.

The work becomes a microcosm which grants and establishes the opulent capacity of art to ripossess, to return to being a land-owner, of a subjectivity fluid up to the point of entering the folds of the private as well, basing the values and the motivations of its working in every case on its own pulsion.

The ideology of Italian "poverismo" and the tautology of conceptual art are bypassed by a new attitude which preaches no preeminence outside of that already inside art and in the work's flagrantly rediscovering the pleasure of showing itself off, of its own texture, of the substance of the painting unencumbered by ideologies and purely intellectual worries. Art rediscovers the surprise of an activity infinitely creative, open even to the pleasure of its own pulsions, and an existence characterized by thousands of possibilities, from the figure to the abstract image, from a flash of genius to the delicate texture of the medium, which all simultaneously cross each other and drip in the instantaneity of the work, assorted and suspended in its generously offering itself as a vision.

In its nomad creativity, art in the 70s has found its own movement par excellence, the possibility of unlimited free transit inside all territories with open references in all directions. Artists like Chia, Clemente, Cucchi, De Maria, and Paladino, work in the mobile field of the Trans-avantgarde, meaning the crossing of every experimental notion of the avant-garde according to the idea that every work presumes an experimental manuality, the artist's surprise at a work no longer constructed according to the certainty expected of a project and of and idea, but which forms itself before his eyes under the pulsion of a hand which dips inside the substance of art in an "immaginario" embodied somewhere between idea and sensitivity.

The notion of art as catastrophe, as unplanned accidentality making each work different from the rest, creates a transitability for young artists, even within the limits of the avant-garde and its traditions, no longer linear but made up of returns and projections ahead, according to a movement and a vicissitude which are never repetitive since they follow the sinuous geometry of the ellipse and the spiral.

The Ttrans-avangarde means taking a nomad position which respects no definitive engagement, which has no privileged ethic beyond that of obeying the dictates of a mental and material temperature synchronous to the instantaneity of the work.

Trans-avantgarde means opening up to the intentional check-mating of Western culture's logocentrism, to a pragmatism which returns space to the work's instinct, not pre-scientific attitude but if anything the maturing of a post-scientific position which exceeds the feticistic adjustment of

contemporary art to modern science:the work becomes th moment of an energetic functioning which finds the strength to accelerate and to achieve inertia within itself.

Thus question and answer come to a draw in the image match, and art bypasses avant-garde production's feature of setting itself up as an inquiry, ignoring the spectator's expectations in order to arrive at the sociological causes provoking them. Avant-garde art always presumes discomfort and never the happiness of the public, obliged to move out of the field of the work to understand its complete value.

The artists of the 70s, whom I call the Trans-avantgarde, have rediscovered the possibility of making the work clear through the presentation of an image which is simultaneaously enigma and solution. In this way art loses its nocturnal and problematic side, its pure inquiry, in favor of a visual solarity which means the possibility of realizing works well-made, in which the work really functions as a look-tamer, in the sense that it tames the restless glance of the spectator, used to the avant-garde's open work, the planned incompleteness of an art which needs the spectator's intervention to be brought to perfection.

Art in the 70s tends to bring art back to a place of satisfying contemplation where the mythic distance, the far-away contemplation, is brimming over with eroticism and energy originating in the work's intensity and in its internal metaphysics.

The Trans-avantgarde spins like a fan with a torsion of a sensitivity that allows art to move in all directions, including towards the past. "Zarathustra wants to lose nothing of mankind's past; he wants to throw everything into the crucible. " (Nietzsche). This means not missing anything because everything is continually reachable, with no more temporal categories and hierarchies of present and past, typical of the avantgarde, having always lived the time to its back as archeology, and in any case as evidence to reanimate.

The principle of centrality is shattered to favor oblique and mobile relations.

Sandro Chia practices, through painting, the theory of a manuality aided by an idea, by putting to work a hypothesis formulated in the particularity of a figure of a sign. If the image constitutes on the one hand the unveiling of the idea, on the other it's also evidence of the pictorial procedure that produces it and unveils its internal circuit, the complex range of reflexes, possible correspondences, the shiftings and cross-references between different polarities.

Francesco Clemente works through repetition and shifting. He sets out with a pre-existent image which he reproduces in painting. However, every successive reproduction is altered and moves away from that which is being reproduced according to variations as subtle as they are unpredictable. An expected certainty is at the basis of the work, which in being effected implies a swerve away from the initial norm. This shifting occurs through oblique lines, a tangible sign of the production of difference.

Enzo Cucchi accepts the movement par excellence of art, enscribing the ciphers of his own personal language under the sign of inclination, where no stasis exists but rather a dynamic of figures, signs and colors which reciprocally cross and drip into the sense of a cosmic vision. The painting chews up and absorbs the crash of various elements into the picture's microcosm. Thus, together the microcosm and macrocosm complete a crossing where chaos and cosmos find the deposit and the energy of their combustion.

Nicola De Maria works on the progressive displacement of sensitivity, practiced through the instruments of a painting which tends to offer itself as the exteriorization of a mental state and as the interiorization of possible vibrations which are born during the execution of the work. The result is the foundation of a visual field, of a vision at the intersection of many reference points, in which sensations find a spatial extroversion until they resolve themselves into a kind of interior architecture.

Mimmo Paladino exercises a painting of surfaces, in the sense that he tends to deliver all sensitive data, even the most internal, to a visual emergency. The painting becomes a meeting and expansion place, in the range of vision of cultural motives and sensitive data. Everything is translated into terms of painting, sign and matter. The painting is crossed by different temperatures, hot and cold, lyric and mental, dense and rarefied, which surface at the end of the color's gauging.

Today making art means having everything on the table in a revolving and synchronous simultaneity which succeeds in blending inside the crucible of the work both private and mythic images, personal signs tied to the individual's story and public signs tied to cultural and art history. This crossing also means not mythicizing one's self, but rather inserting the self onto a collision course with other expressive possibilities, thereby accepting the possibility of putting

subjectivity at the intersection of all. "Being is the delirium of many."(Musil)

The shattering of the work means shattering the myth of the unity of the ego, assuming the nomadism of a non-stop "immaginario" without anchorage or reference points. All of this reinforces the notion of Trans-avantgarde since it overturns the avant-garde's attitude of having the privileged of reference points.

Every work becomes a vicissitude carrying and returning to the place of work, crossing multiple fields of reference, using every utensil, a manuality oriented by the grace of color and of many mediums, a thinker who thinks directly through images and crouches down to the bottom of vision, like a temperature which acts as an adhesive, allowing the work's fragments to maintain a mobile relationship which is never bolted and never seeks shelter in the idea of unity.

No demiurgic rule exists ---- only the creative practice of an art which stabilizes all precariousness without transforming it into stabilization and symbolic fixity. The work preserves the flow of its process, of its being active on the outskirts of a subjectivity which never tends to become exemplary but rather to preserve a character of accidentality, of an opening in a field °™ not the avantgarde's romantic intoxication with the infinite, but moving without a center along drifts marked by a unique perspective: mental and sensorial pleasure.

新 主 观 艺 术

阿·博·奥利瓦

60年代的政治狂热把艺术推向了非个性的表现道路，它无法展现隐蔽在创作冲动之后的自我。然而，今天的艺术，特别是基亚、克莱门特、库基、德·玛利亚和帕拉迪诺在意大利所从事的艺术，寻找到了与思想冲动不可分的艺术创作时的操作快感。创作主体利用各种表现工具和语言进行艺术创作，所谓的操作，是指把创作定位在主体周围的能力。

总之，意大利青年艺术家们在创作的过程中保留了按照艺术语言规律进行艺术表现的传统。但是，艺术语言已经不再遵循逻辑性，也不再沿着最近几年它所走过的直线和不变的发展路线前进。新的表现方式植根于悬而不决的、滑动的"游牧"状态之中，不可能以几何推理和因果推理的方式预见它的发展。推动新艺术创作的思想是：自由漂移、无预定方向也无出发点和终点的运动；伴随着这一运动的是一种愿望。即：在作品内部的敏感性循序渐进的移动过程中，一次次地寻找到暂时的停顿点。

主观艺术是通过艺术的分散化、形象的偶然性、世界观念以及伴随世界观念的无限思想而流行起来的。形象的偶然性从来不是一种统一的概念，而永远是一个临时的视觉现象。这里，形象艺术变成了存储以艺术方式所表现出来的潜力，所谓的艺术方式是指优美的、展现灵感的方式。年轻的意大利艺术家们在作品中展现的主要不是个人的自我介绍，而是体现构成主观艺术特点的重要成分，即：多变性、临时性、矛盾性和对局部的喜爱。一种与寻求快感紧密联系的、积极的而不是攻击性的艺术敏感渗透到新的创作之中。

多变性来自于风格的过渡性，继续性和稳定性的思想从来没有保证过风格的不变。事实上，意大利的青年艺术家使用了不同的、有差异的语言，他们参照了距现在已经很遥远的同时又很接近现代的文化。一种扇形的幅度不同的敏感推动形象艺术的变化，形象相互交错跨越，远离了文艺思想和忠于文艺思想的传统。形象艺术处于具象和抽象、形象夸张和抽象性及装饰性的得体的暗示之间。

临时性是艺术创作的另一个特点，创作活动从来不会在学术的完美主义中止步不前，而总是在冲动的创作过程和稳定的创作成果之间匆匆而过。另外，形象艺术总是采集动态的感觉，如：基亚作品中的诙谐、库基作品中的材料感觉、克莱门特作品中的时间暂停、德·玛利亚作品中的色彩音乐和帕拉迪诺作品中的多种性能的主题等。如同不可阻挡的潮流一样的流动时间，变成自身内部已经含有交错跨越征兆的作品形成的时刻。

矛盾性恰恰产生于不想被关闭在一贯不变的严格的几何结构中的愿望，这种结构是与被观念学桎梏住的僵化不变的世界观联系在一起的。形象是取之不尽的存储现象的征兆，存储之物显现时，单一的语言是无法将其留住的。讥讽和悲惨的形象、鲜艳夺目和暗淡的符号，不断地在作品的表面上通过，却从不为希望变动和悬而不决的东西妄下定义。

对局部的喜爱要求抓住细微的感觉和思想。年轻的艺术家们用集中精神的想法去反对伴随整个60年代艺术创作的追求壮观和非凡效果的思想。细节是临时性的落脚点，是在敏感和优美状态的斜面上

运动的艺术的支点。要在一定程度上掌握技巧，就必须有一种反对非凡艺术、主张幽默的家庭艺术的态度。毫不奇怪艺术家们需要不断地进行绘图练习，以便使他们的艺术表现力更加敏锐和难以捉摸，更加流畅和富有活力。图案绘制使人们能够捉住艺术敏感的一闪现，将清超越创作材料和绘画作品的艺术敏感。符号不会遇到障碍，甚至不会过分地渲染形象的出现，然而，却能使形象的出现更加灵活和真切。图案的绘制铲除了人们不容置辩的武断性，使人们具有了暗示性，使人们不须明白确切的描绘便可以展示思想和精神状态。

在基亚、克莱门特、库基、德·玛利亚和帕拉迪诺的作品中，绘画是符号、形象、半身像、线条，是未成形的粗样、阿拉伯式的图案、胡乱的涂抹，是风景、植物、图表、轮廓，是侧影像、装饰图案、插图、人物画像，是缩小的写真、印刷品、剖面图、场景设计，是描摹、漫画、明暗对照、粗糙的岩刻，是刻版画、地图、石板印刷品、彩色粉笔画，是蚀刻画、木版印刷画。他们作画的工具可能是：炭笔、铅笔、钢笔、毛笔、圆规、划线笔、角尺、比例尺、标尺、直尺、擦笔、小模板等。绘画手段可能分为：画出奇异的图案、临摹、组合、复制、擦除、修改、上光、去粗取精等。作品所获得的效果是：底色、轮廓、阴影、装饰、透视、影线等。他们在绘画中使用了许多隐秘的、具有象征意义的符号，其作品通过阴影和色彩渐变试图捕捉住事物的灵魂，假设出在封闭的、单一的日常生活的假象下无法捕捉也无法预料的幻象。另外，他们的作品还总是要表现出具有一种更加广阔、更加具体的形象，一种自愿选择处于不确定状态的形象。不确定的产生，不仅是因为采用了阴影和色彩渐变的手法，也因为创作时占用了很少的空间和时间。

绘画好像总是要把艺术家在洁白无暇的画布（或画纸）上所做的一切毫不掩饰地展示在人们的眼前。这里，公开的和隐秘的吻合在一起了：表现起始于作品中出现任何符号之前，起始于大脑对形象进行构思之时，起始于作者的手在画布上运动和抖动之时。

桑德罗·基亚的创作风格成扇形展开，有许多差别，技巧却总是非常娴熟，其艺术思想是要在艺术内部寻找艺术存在的原因。绘画终于摆脱了"新"的专横的束缚，成为能够利用不同手法达到展现形象之目的的艺术，进行此种绘画创作的快感就是基亚所寻找的艺术存在的原因。他的参照点不胜枚举，从夏加尔到毕加索，从塞尚到德·西里科，从未来派的卡拉到超验的20世纪派的卡拉，他都不拒绝接受。然而，娴熟的技巧和优美的画面使基亚的作品具有很高的质量，掩盖了他对前人风格的模仿。在他的绘画中，操作与构思终于获得了平衡。基亚所创作的形象总是有一个题目作为支持，它具有一段解说词，或者一首直接写在画面上的小诗，其作用是揭示作品的内在结构。绘画的快感伴随着思想诙谐的快感，伴随着对绘画创作的狂热与讥讽的冷静之间的相得益彰。

创作成为传送内部和外部参照信息的"电路"，一切参照信息都是为了创造出在视觉下具有双重价值的形象：它是绘画实体，也是大脑思考的形态。作为前者，形象是由构成它的材料所完成的，作为后者，形象是令人惊奇的思想展现；在艺术创作中，思想只能借助艺术语言才能体现它的存在。基亚的作品中，形象总是光亮清新的。

弗朗西斯科·克莱门特的创作无区别地采用了许多绘画技巧，其风格循序渐进地发生变化。他的创作思想是艺术不应该具有丝毫的戏剧性，它应该在轻微的漂移中有可能创造集重复和差异于一身的形象。重复产生于有意地采用一成不变的方法，参照他人和因袭时尚，这样便能够给艺术带来因袭性。

然而，此类因袭性只是表面现象。因为，形象

从不以机械性和缺乏独立创造精神的方式产生，它总是试图具有细微和无法预料的变化，从而在新产生的形象中引起位移。位移和产生于放慢速度状态中的时间暂停的思想，使我们得出变化不可察觉的结论。克莱门特取得了上述的可能性，是因为他采用了"滑音"的方法，借助了一系列的"半谐音"，即借助了一系列的视觉类比手段，从而使形象摆脱了一切束缚和与其它作品雷同的可能。

克莱门特的艺术创造出一种新的凝视形象的状态，创造出一种宁静，因为形象已经摆脱了传统参照点的喧闹之声，进入了一个不同的、明确的、具有虚假因袭性的发展方向。作品极端的明确，接近它时，人们不须任何努力，也不会有任何困难。新形象好像浸透着东方文化，它表现的不是兴奋，而是宁静的自然状态。

恩佐·库基使绘画艺术激进化，他把绘画作品作为工具，而不是目的。绘画成为各种成分聚集的过程，具象的和抽象的、精神的和物质的、明确的和暗示的都无连续性地组合在一起。在画面上，绘画材料和非绘画材料交融在一起。一切都符合动态原理，符合不可阻挡的运动的需要：这是一种不受任何重力规律左右的牵引着绘画形象和彩色线条的运动。绘画作品是产生形象的能量的临时储存库，绘画材料的浓厚程度和传统画布之外的陶瓷材料的使用范围等，都取决于库中所储存的能量情况。有意地创作出从人类学到文化都与意大利有紧密联系的低微的绘画作品是这种艺术的根源。从视觉语言方面看，库基绘画的参照点好像是西庇阿内和李锡尼。从前者之处，库基继承了飞边用色法；而空间动态感、不参考任何自然主义的手法自由地安排构成形象的成分等，则受到李锡尼的影响。画面或画布的空间不再是形象的背景，而是一种能量的散发，它本身也成了能源。库基的艺术思想是艺术附着于事物之上，同时又在它们之间建立起一系列联系和动态关系，直至用另一种不同形式的符号、一种积极靠拢的符号改变它们的面貌，在这种符号中上下是重叠的。

尼古拉·德·玛利亚试图摆脱绘画作品的框框，冲入到环境空间之中，在许多参照点交会之处建立视觉区域。绘画是表现敏感循序渐进地位移的工具。精神状态和心理状态融合在一个作用于视觉资料零散化的形象之中，其创作结果是形成一种内在的可以容纳作品设计中固有的全部感情震撼和激动的建筑结构。

所有零散资料之间的关系都是动态的，因而不存在优于其它的中心点。德·玛利亚用区域的概念代替了空间的概念；一张动态的、有潜力的关系网，在抽象中找到了视觉的不变常数。运动是音乐式的运动，不存在停顿，只具有一种一节套一节的符号连续性；这便是环境空间绘画，它不断地依赖一个节奏、一种脉搏的跳动，即依赖纯粹的主体脉搏的跳动。

作品的结构可以根据它所处的空间环境一次次地变化。具体化和抽象化是互相交替的，它们根据环境中油漆木制品的摆放和色彩区域的分布情况而变化；色彩区域的分布依赖着难以描述的精神状态和条件。

通过交错使用严格的几何符号和结构符号所产生的艺术语言，试图成为同时展现艺术家敏感条件外在化和内在化的工具，成为歌唱和抒情表演的工具。米莫·帕拉迪诺所从事的是一种表面式的绘画。他的艺术思想是表面便是唯一可能的深化。因此，所有敏感的资料都具有视觉浮现力，那些与文化因素联系在一起的外在资料和那些与心理条件联系在一起的内在资料均不例外。绘画成了把细微的、无法触摸到的东西转变成形象的类似于翻译的过程。在同一个主题和结构之中，交织着以康定斯基和克利作品为典型的抽象的传统符号和比较冗赘的具象

符号。

　　不同程度的敏感，按照自由联合的关系，相互间凝结。每一个不同的程度的稀薄化，无论是精神的，还是物质的，都在表面上寻找到了它们最合适的落脚点。帕拉迪诺从来不试图作自我介绍，因为，一切都变成了绘画的题材。符号几何立即被形象成分的聚集而打断，这些形象成分逐渐地与其它成分结合在一起，没有色调的跳跃。

　　支持形象的构思是零碎的构思，是局部的构思，局部是扩散的，是与其它局部结合在一起的，支持作品的思想状态是创作整体绘画作品的思想状态，因此需要参照艺术史中曾经用过的一系列艺术语言。然而，参照总是被资料内部的复原所淡化。绘画作品的表面变成了形象的明确的阈限，在形象似乎冲出画框和脱离墙壁时也不例外。符号便是装饰绘画作品表皮并为其涂抹颜色的数码。

Nuova Soggettività

Achille Bonito Oliva

L'ebbrezza politica degli anni sessanta aveva spinto l'arte verso un'impersonalità dell'espressione che non poteva coniugare l'io, sempre appostato dietro la pulsione creativa dell'immagine. Ora invece l'arte, quella in particolare praticata in Italia da Chia, Clemente, Cucchi, De Maria e Paladino, ha ritrovato il piacere di una manualità non separata dall'impulso concettuale. La manualità significa capacità di fissare il lavoro dell'arte nelle adiacenze di una soggettività che utilizza tutti gli strumenti espressivi e tutti i linguaggi possibili.

Comunque la giovane arte italiana conserva nel proprio operare la necessità di un'espressione che passa sempre attraverso il rigore del linguaggio. Ma il linguaggio non segue più la logica ed il percorso che le è stato proprio negli ultimi anni, fatto di uno sviluppo rettilineo e coerente. La nuova espressività invece poggia le sue radici in un nomadismo aperto e slittante, che non si lascia catturare nella previsione di uno sviluppo geometrico e conseguente. L'idea che muove il nuovo lavoro è quella della deriva, di un movimento senza direzioni precostituite, senza partenze ed arrivi, ma accompagnato dal desiderio di trovare un ancoraggio provvisorio volta per volta, nello spostamento progressivo della sensibilità, dentro l'opera.

La soggettività si afferma proprio attraverso il suo frantumarsi, il suo affermarsi attraverso l'accidentalità dell'immagine che non si pone mai come momento unitario e totalizzante ma sempre come visione precaria che non coglie, e non vuole farlo, il senso del mondo e l'idea dell'infinito che lo accompagna. Qui l'immagine diventa il deposito di una potenzialità appena accennata, espressa nei modi dell'arte, che sono poi quelli della grazia e del furore. Della soggettività i giovani artisti italiani trasmettono nell'opera non tanto il momento autobiografico e privato, quanto gli elementi strutturali che la caratterizzano: la mutevolezza, la provvisorietà, la contraddizione e l'amore per il particolare. Una sensibilità attiva e non aggressiva, legata ad una prospettiva di piacere, permea il nuovo lavoro,

collegata all'idea di un'interna garanzia dell'arte, quella di riuscire a fondare la realtà minoritaria, in quanto legata alla pulsione individuale, di un'immagine personale.

La mutevolezza è data dal carattere transitorio dello stile che non è mai assicurato dall'idea di continuità e di stabilità. Infatti i giovani artisti italiani usano linguaggi differenti e differenziati, rimandi a culture lontane nel tempo ed anche vicine alla contemporaneità. Una sensibilità a ventaglio promuove immagini che si scavalcano tra loro e si allontanano dal criterio della poetica e di una tradizionale fedeltà ad essa. Naturalmente l'immagine corre tra il figurativo e l'astratto, tra il rimando ad una figurazione ridondante e l'equilibrata reticenza del motivo astratto e decorativo.

La provvisorietà è nella fattura dell'opera che non si attarda mai in un perfezionismo accademico ma è sempre in transito tra la pulsione del fare e la stabilità del risultato. Inoltre l'immagine coglie sempre sensazioni mobili, come il motto di spirito nell'opera di Chia, il senso della materia in quella di Cucchi, la sospensione del tempo in Clemente, la musica del colore in De Maria, e la polivalenza dei motivi in Paladino. Il tempo come flusso inarrestabile diventa il momento affermativo di un'opera che contiene dentro di sé già sintomi del suo scavalcamento.

La contraddizione nasce proprio dal desiderio di non lasciarsi chiudere nella geometria di una coerenza legata ad un'idea del mondo fissa, bloccata dall'ideologia. Le immagini sono i sintomi di un deposito inesauribile che nel manifestarsi non si lascia fermare da un linguaggio univoco. Immagini ironiche e drammatiche, segni squillanti e neutri transitano continuamente sulla superficie dell'opera, senza mai connotare e definire ciò che vuole rimanere mobile ed aperto.

L'amore per il particolare è l'esigenza di cogliere piccole sensazioni e piccoli pensieri. Questi artisti oppongono l'idea della concentrazione a quella monumentale ed eroica che accompagna tutto il lavoro degli anni sessanta. Il dettaglio è l'ancoraggio della provvisorietà, il punto d'appoggio di un'arte

che opera sul piano inclinato della sensibilità e dello stato di grazia. La umile perizia della tecnica detta anche un comportamento antieroico ed ironicamente domestico. Non è casuale in questi artisti il ricorso continuo al disegno, che permette loro un'espressione assottigliata e sfuggente, dinamica e scorrevole. Il disegno permette di cogliere il veloce transito della sensibilità, il suo dipanarsi oltre l'impaccio della materia e della pittura. Il segno non trova ostacoli, anzi permette immagini che non drammatizzano la propria apparizione ma la rendono agile e cordiale. Il disegno permette di essere allusivi senza essere perentori, permette l'affermazione dello stato d'animo, anche mentale, senza il bisogno della descrizione definitiva e categorica.

Il disegno nei lavori di Chia, Clemente, Cucchi, De Maria e Paladino è segno, frego, immagine, effigie, linea, abbozzo, arabesco, girigoglio, paesaggio, pianta, diagramma, profilo, silhouette, vignetta, illustrazione, figura, scorcio, stampa, spaccato, bozzetto, calco, caricatura, chiaroscuro, graffito, incisione, mappa, litografia, pastello, acquaforte, silografia. Gli strumenti possono essere: carboncino, matita, penna, pennello, lapis, compasso, tiralinee, squadra, pantografo, regolo, riga, sfumino, stampino. Il processo può essere: arabescare, calcare, comporre, copiare, cancellare, correggere, lucidare, ricavare. Il risultato: campo, contorno, ombra, ornato, prospettiva, tratteggio.

Spesso in questi artisti il disegno produce segni intimi ed emblematici, opera attraverso l'ombra e lo sfumato, tende a cogliere un'anima seconda nelle cose, a sospettare visioni imprendibili ed imprevedibili sotto l'apparente visione di un quotidiano che sembra chiuso ed univoco. D'altronde tende sempre a darsi come traccia di un'immagine più ampia e concreta, di un'immagine che sceglie di rimanere in un voluto stato d'incertezza. L'incertezza nasce non soltanto dal ricorso all'ombra od allo sfumato, ma anche dall'esigua occupazione di spazio e tempo, per quanto riguarda l'esecuzione.

Il disegno sembra sempre mettere a nudo l'assalto dell'artista allo spazio immacolato del foglio. Qui pubblico e privato coincidono: la soglia dell'espressione comincia già prima di qualsiasi segno messo in opera, inizia già nel momento di elaborazione mentale dell'immagine, nel movimento e nel tremito della mano sul foglio.

Sandro Chia opera su un ventaglio di stili, sempre sostenuto da una perizia tecnica e da un'idea dell'arte che cerca dentro di sé i motivi della propria esistenza. Tali motivi consistono nel piacere di una pittura finalmente sottratta alla tirannìa della novità ed anzi affidata alla capacità di utilizzare diverse «maniere» per arrivare all'immagine. I punti di riferimento sono innumerevoli, senza esclusione alcuna, da Chagall a Picasso, da Cézanne a De Chirico, da Carrà futurista a Carrà metafisico e novecentista.

Ma il richiamo stilistico è subito riassorbito dalla qualità del risultato, all'incrocio tra perizia tecnica e stato di grazia. La pittura diventa il campo dentro cui manualità e concetto trovano finalmente un equilibrio. In Chia l'immagine è sempre sostenuta dalla necessità del titolo, di una didascalia o di una piccola poesia dipinta direttamente sul quadro, che serve a svelarne il meccanismo interno. Il piacere della pittura è accompagnato dal piacere del motto di spirito, dalla capacità di integrare il furore della fattura del quadro con il preventivo distacco dell'ironia.

L'opera diventa un circuito mobile di riferimenti interni ed esterni, tutti al servizio di un'immagine che si offre allo sguardo di una doppia valenza: come sostanza pittorica e come forma mentale. Nel primo caso l'immagine è appagata dalla materia che la costituisce, nel secondo caso essa si pone come dimostrazione stupefacente di un'idea: un'idea nell'arte esiste soltanto se incarnata nel tessuto del linguaggio. In Chia l'immagine è sempre lampante.

Francesco Clemente opera sullo spostamento progressivo dello stile, sull'uso indifferenziato di molte tecniche. Il lavoro è accompagnato e sostenuto da un'idea dell'arte per niente drammatica che riesce a trovare nel nomadismo della leggerezza la possibilità di un'immagine in cui si incrociano ripetizione e differenza. La ripetizione nasce dall'uso intenzionale di stereotipi, di riferimenti e stilizzazioni che permettono di portare nell'arte anche l'idea della convenzionalità.

Ma tale convenzionalità è soltanto apparente, in quanto la riproduzione dell'immagine non avviene mai in maniera meccanica e pedissequa. Anzi tende a realizzare sempre delle variazioni sottili ed imprevedibili che creano nella immagine riprodotta uno spostamento. Lo spostamento, l'idea di una sospensione temporale, che nasce da uno stato di allentamento, portano ad un risultato che punta su impercettibili differenze. Tale possibilità è data dal fatto che Clemente lavora sullo slittamento del significante, su una catena di assonanze, di analogie visive che liberano l'immagine da ogni obbligo e riferimento.

Tutto questo crea un nuovo stato contemplativo dell'immagine, una sorta di quiete, in quanto essa è stata sottratta al rumore dei suoi tradizionali riferimenti e portata nella posizione di un diverso orientamento, esplicito e falsamente convenzionale. L'estrema esplicitazione tende a produrre un'immagine che non dichiara alcuno sforzo e nessuno impaccio per gli accostamenti entro cui si trova a vivere. Come imbevuta in una disciplina orientale, la nuova immagine non tradisce emozioni ma un naturale stato di calma.

Enzo Cucchi radicalizza la pratica pittorica, assumendo il quadro come uno strumento e non come un fine. La pittura diventa un processo di aggregazione di vari elementi, figurativi ed astratti, mentali ed organici, espliciti ed allusivi, combinati tra loro senza soluzione di continuità. Materia pittorica ed extrapittorica si incrociano sulla superficie del quadro. Tutto risponde ad una dinamica, ad un movimento inarrestabile che trascina figure dipinte e linee di colore fuori da ogni legge di gravità. Il quadro è un deposito provvisorio di energie che suscitano immagini, spessori di materia pittorica ed estensioni di ceramica fuori dal tradizionale supporto di tela. La radice di tale lavoro trova le sue ascendenze nel tessuto di una pittura volutamente minore, legata ad un territorio antropologico e culturale strettamente italiano. Sul piano del linguaggio visivo Scipione e Licini sembrano i punti di riferimento della pittura di Cucchi. Del primo il giovane artista riprende l'uso del colore come sbavatura.

Di Licini ritroviamo il senso dinamico dello spazio, la libertà di collocare gli elementi figurali fuori da qualsiasi riferimento naturalistico. Lo spazio del quadro o del foglio non è sfondo dell'immagine, ma un'emanazione ed esso stesso sorgente di energia. L'idea è quella di un'arte che aderisce alle cose e nello stesso tempo instaura una catena di contatti e di relazioni mobili tra loro, fino al punto di trasfigurarle in segni di un'altra posizione, quella di un approdo dinamico, in cui alto e basso coincidono.

Nicola De Maria tende a sconfinare dalla cornice del quadro e ad uscire nello spazio ambientale, dove realizza un campo visivo all'incrocio di molti rimandi. La pittura è uno strumento di rappresentazione dello spostamento progressivo della sensibilità. Stato mentale e stato psicologico si fondono in un'immagine che opera sulla frammentazione dei dati visivi. Il risultato è una sorta di architettura interiore, che accoglie dentro di sé tutte le vibrazioni e le emozioni insite nel progetto dell'opera.

Ogni frammento vive un sistema di relazioni mobili, in modo che non esistano punti privilegiati e centrali. Alla nozione di spazio De Maria sostituisce quella di campo, una rete dinamica e potenziale di rapporti che trovano la loro costante visiva nell'astrazione. Il movimento è quello della musica, in cui non esistono soste ma un continuum coinvolgente di segni, una pittura ambientale che rimanda incessantemente ad un ritmo, ad una pulsazione, quella della pura soggettività.

L'architettura dell'opera è flessibile, asseconda volta per volta lo spazio entro cui si colloca. Concretezza e rarefazione si alternano mediante la collocazione di elementi di legno dipinto, che scandiscono l'ambiente, e la presenza di zone compatte di colore, che rimandano silenziosamente a stati indescrivibili ed a condizioni mentali, colte nella loro assolutezza.

Il linguaggio impiegato, mediante l'uso alternato di segni geometrici ed organici, tende a darsi nello stesso tempo come esteriorizzazione e come interiorizzazione della condizione sensibile dell'artista, come strumento di canto e di rappresentazione lirica. Mimmo Paladino realizza una pittura di superficie. Egli pratica un'idea di superficie come unica profondità possibile. Così hanno emergenza visiva tutti i dati della sensibilità, quelli più esteriori legati a rimandi culturali e quelli più interni legati alla condizione psicologica. La pittura diventa il luogo della traduzione in immagine di motivi sottili ed impalpabili. Segni della tradizione astratta, la cui matrice è l'opera di Kandinsky e di Klee, e quelli più ridondanti della figurazione si intrecciano in un motivo unico ed organico.

Le diverse temperature della sensibilità si condensano tra loro secondo un legame aperto alla libera associazione. La rarefazione di ogni temperatura diversa, mentale e materica, trova sulla superficie il luogo adeguato. Paladino non tende mai a dichiarare la propria autobiografia, in quanto tutto diventa motivo di pittura. La geometria del segno è immediatamente interrotta dall'addensamento di elementi figurativi che si integrano dolcemente, senza salti di tono cromatico, col resto della composizione.

L'idea che sostiene l'immagine è quella del frammento, del particolare che si dilata e si aggrega ad altro particolare. Lo stato d'animo che regge la composizione è lo stato della

pittura totale, sostenuta da una serie di rimandi a linguaggi attinti all'indietro nella storia dell'arte. Ma il rimando è sempre attenuato da un recupero interiore del dato, nel senso di una sua assimilazione dentro la temperatura del soggetto. La superficie del quadro diventa la soglia esplicita dell'immagine, anche quando questa sembra sconfinare dalla cornice e dal muro. I segni sono cifre che colorano e decorano la pelle della pittura.

New Subjectivity

Achille Bonito Oliva

The political inebriety of the 70s pushed art towards an impersonal expression excluding the self, ever lurking behind the creative drive of the image. Now instead art has discovered the pleasure of handicraft undivided from conceptual impulses. This particularity in Italy with the works of Chia, Clemente, Cucchi, De Maria and Paladino. Working with your hands means knowing how to place the task of art alongside a subjectivity which utilizes every possible expressive instrument and language.

However, in its procedures young Italian art has preserved the need for an expression ever passing through the rigor of language. But language no longer follows the logic or the mainstream of recent years, characterized by rectilinear and consistent development. New expressiveness instead sinks its roots into an open and drifting nomadism ---- without getting trapped into geometric and consequent development. The idea propelling this new work is drifting: a movement with no preconstituted directions, no departure and no arrivals, but accompanied by the desire to find a different provisory anchorage each time around in the sensibility's movements.

This subjectivity is asserted in its very fragmentation. This through the accidental nature of an image which never poses as a unitary and totalizing moment, but always as a precarious vision which doesn't gather, and doesn't even want to, the sense of the world's being accompanied by an idea of the infinite. Here the image becomes the store-house of a barely allude to potentiality, expressed with the grace and the furor of art.

In their works the young Italian artists transmit a subjectivity which is not private or autobiographical but more made up of the structural elements which characterize subjectivity: changeability, provisionality, contradiction and love of detail. An active and not aggressive sensibility tied to a belief in pleasure permeates these new works. All of this can be connected to art's internal guarantee to found a minority reality mainly because art depends on the individual drive of a personal image.

Changeability is brought about by the transitory nature of the style, never reassured by continuity or stability. The young Italian artists use different and differentiated languages recalling cultures both remote from and near to the present day. A whirlwind sensibility promotes images which climb over each other, distancing themselves from the criteria of a poetic and from faithfulness to the same. Naturally the image runs from the figurative to the abstract, from a recall of redundant figuration to the reticent equilibrium of an abstract and decorative motif.

The provisionality lies in the making of a work which never gets stuck in an academic perfectionism but is always in transit between the desire to make and the stability of the result. Furthermore the image always grasps mobile sensations, like the spirit motto in Chia's work, the sense of material in Cucchi's, the suspension of time in Clemente, the music of color in De Maria, and the polyvalence of motifs in Paladino. Time as unstoppable flux becomes the affirmative moment of a work which itself contains the symptoms of its own supplanting.

This contradiction is born from the desire not to let yourself get closed into the geometry of a consistency, of a fixed belief in a world blocked by ideology. The images are symptoms of an inexhaustible store-house which in showing itself off doesn't let a univocal language stop it. Ironic and dramatic images, blaring and neutral signs, continuously run across the work's surface without ever once distinguishing and defining what would remain mobile and open.

The love of detail is the need to gather small sensations and little thoughts. These artists answer to the monumental and heroic ideas of accompanying all the art of the 60s with a belief in concentration. Detail is the anchor of provisionality, the crutch of an art working on the inclined plane of sensibility and the state of grace. The humble skillfulness of the technique itself dictates an anti-heroic and ironically domestic attitude.

The constant resorting to drawing on the part of these artists is not at all casual. It allows them a subtle and fleeing expression, both dynamic and flowing. Drawing helps them to grasp the sensibility as it rushes by, unraveling beyond the hindrances of medium and painting. The sign runs into no obstacles. Instead it releases images which don't dramatize their own appearance but rather make it agile and cordial. Drawing lets you be allusive without being peremptory, affirm a state of mind without requiring a definitive and categorical description.

Drawing in the works of Chia, Clemente, Cucchi, De Maria and Paladino is sign, stroke, image, effigy, line, rough draft, arabesque, landscape, blueprint, diagram, profile, silhouette, cartoon, illustration, figure, foreshortening, printing, vertical section, model, mould, caricature, chiaroscuro, graphite, engraving, maps, lithography, pastels, acquaforte, wood-cut. The tools can be: charcoal, pencil, pen, brush, lapis, compass, drawing-pen, square, pantograph, ruler, straight edge, stump, stencil. The process can be: arabesque, tracing, composing, copying, erasing, correcting, polishing, figuring out. The result: field, contours, shadow, ornate, perspective, hatch.

With these artists, drawing often produces intimate and emblematic signs, working through shadow and shading, trying to grasp a second heart in things, to question impregnable and unforseeable visions under the appearance of an everyday vision which seems closed and univocal. On the other hand it tends ever more to offer itself as a trace of a wider and more concrete image which has chosen to remain in a deliberate state of uncertainty. This uncertainty is born not only from resorting to shadow or shading, but can also come about as a result of the exiguous occupying of space and time in the execution of the work itself.

The drawing seems to bare the artist's assault on the immaculate space of the sheet of paper. Here the public and the private coincide: the threshold of expression begins even before any sign starts to work. It has already begun in the moment of the mental elaboration of the image, in the movement and trembling of the hand over the sheet.

Sandro Chia operates a whole windmill of styles, yet is always sustained by a technical skill and an idea of art which searches out the reasons for its existence within itself. These reasons consist in the pleasure of a painting which has finally been freed from under the tyranny of novelty and has instead been entrusted with knowing how to use different manners to arrive at the image. There are countless reference points, excluding none, from Chagall to Picasso, Cézanne to De Chirico, the futuristic Carrà to the metaphysical Carrà.

But the stylistic recall is immediately reabsorbed by the quality of the result, at the cross-roads of technical skill and state of grace. Painting becomes the field within which handicraft and concept finally land in equilibrium. In Chia the image is always sustained by the need for a title, a by-line or a small poem painted directly on the painting to reveal its internal mechanism. The pleasure of painting is accompanied by the pleasure of spirit mottos, by the ability to integrate the manual furor of making the painting with the preventative distancing of irony.

The work becomes a mobile circuit of internal and external references, all at the service of an image which offers itself up to your stares with a double valence: as pictorial substance and mental form. In the first case the image is fulfilled by its constituting medium, in the second it presents itself as the stupefying demonstration of an idea: in art an idea exists only if it is incarnated in the fiber of language. In Chia the image is always clear.

Francesco Clemente works on progressive movements of style and on the undifferentiated use of many techniques. The work is accompanied and sustained by an idea of art which is not in the least bit dramatic, finding in the lightness of nomadism the possibility of an image at the cross-roads of repetition and difference. Repetition arises from the deliberate use of stereotypes, references and stylizations which help to bring even the idea of conventionalism into art.

But this conventionalism is only appearance because the reproduction of the image never takes place in a mechanical and slavish way. It rather tends to realize subtle and unforseeable variations which create a movement in the image reproduced. This alienating a temporal suspension born from a state of slowing-down, leads to a result playing on imperceptible differences. This possibility is created by Clemente's works with the shifting of meaning, of visual analogies which free the image of every obligation and every reference.

All of this creates a new, contemplative sense of the image, a sort of calm carrying it away from the noise of traditional references and placing in a different position, explicit and falsely conventional. Its extreme outspokenness produces an

image which declares neither effort nor obstacle to its surroundings. Almost as if it were imbued with Oriental discipline, the new image betrays no emotion — only a natural state of calm.

Enzo Cucchi radicalizes pictorial practices, using the painting itself as a tool and not as an end. Painting becomes a process of aggregating various elements, figurative and abstract, mental and organic, explicit and allusive, combined with no continuous settlements. Pictorial and extra-pictorial medium run across the surface of the painting. Everything answers to a dynamic, to an unstoppable movement which drags painted figures and colored lines beyond the law of gravity.

The painting is a provisory storehouse of energy stirring up images, textures of pictorial medium and ceramic extensions running off the traditional canvas support. This work is rooted in a deliberately minor painting, from a strictly Italian anthropological and cultural territory. On the level of visual language Scipione and Licini seem to be the references points of Cucchi's painting. From the former the young artist gets his dribbling use of color. From Licini he gets his dynamic sense of space, his freedom in gathering together figurative elements way beyond any naturalistic reference. The space of the canvas or the sheet isn't the background for the image, but an emanation which is itself a source of energy. The idea is that of an art which sticks to things and at the same time installs a series of contacts and mobile realtionships between them, to the point of transfiguring the image into signs of another position, that of a dynamic landing where both high and low coincide.

Nicola De Maria tends to break out of the confines of the picture frame and break into the space surrounding it, in the midst of a field of vision at the cross-roads of many associations. Painting is a tool representing the progressive shiftings of the sensibility. Mental state and psychological state fuse together in an image working on the fragmentation of visual data. The result is a kind of interior architecture, gathering within itself all the vibrations and emotions inherent to the work project.

Each fragment lives a system of mobile relationships, in such a way that no privileged or central project exists. De Maria substitutes the notion of space with that of field, a dynamic and potential network of relationships which find their visual constant in abstraction. The movement is that of

music, where no rests exist but only a continuum of signs, an environmental painting incessantly recalling the rhythm and pulsion of pure subjectivity.

The work's architecture is flexible, seconding each new time around the space it is situated in. Concreteness and rarefaction alternate through the situation of elements of painted wood which highlight the environment, and through the presence of compact zones of color, silently recalling indescribable conditions to mental states grasped in their absoluteness.

The language used, through the alternating use of geometric and organic signs, tends to offer itself as both the exteriorization and the interiorization of the artist's sensible condition, as both the instrument of song and the lyric representation.

Mimmo Paladino realizes a painting of surfaces. He practices a belief in surface as the only possible profundity. In this way all sensible data knows a visible emergence, both those furthest outside tied to cultural reminiscences and those deepest inside wrapped around individual psychology. Painting becomes the place of translation into images of subtle and impalpable motifs. Signs from the abstract tradition, whose matrix is the work of Klee and Kandinsky, are entwined with the most redundant signs of figuration in a unique, organic motif.

The different temperature of the sensibility are condensed according to the open rules of free association. The rarefaction of every different temperature, mental and material, finds the right place for itself on the surface. Paladino never states his own autobiography but rather makes it into pictorial motif. The geometry of sign is immediately interrupted by the thickening of figurative elements which docilely blend in with the rest of the composition, avoiding leaps of chromatic tone.

The idea sustaining the image is that of the fragment, of the particular which dilates and aggregates with other details. The state of mind holding up the composition is the state of the total painting, sustained by a series of recalls to a language taken from behind art history. But the recall is always subdued by an inside recovery of data, in the sense of an assimilation within the temperature of the subject. The painting's surface becomes the outspoken threshold of the image, even when it seems to break out of the confines of the frame and the wall. The signs are figures which color and decorate the skin of painting.

Sandro Chia
意大利超前卫艺术

桑德罗·基亚
Sandro Chia

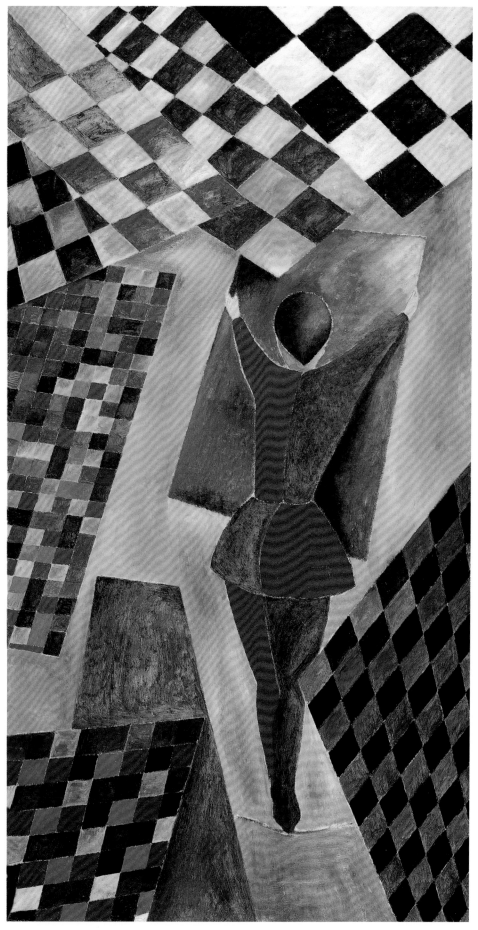

卖棋盘的女人　1976，216 × 112.5cm，布面油画，瑞士 Guntis Brands 收藏
The womtn of sell chessboard　1976，216 × 112.5cm, Oil on canvas, Coll.Guntis Brands,Switzerland
La mercante di scacchiere　1976，216 × 112.5cm, Olio su tela, Coll.Guntis Brands,Switzerland

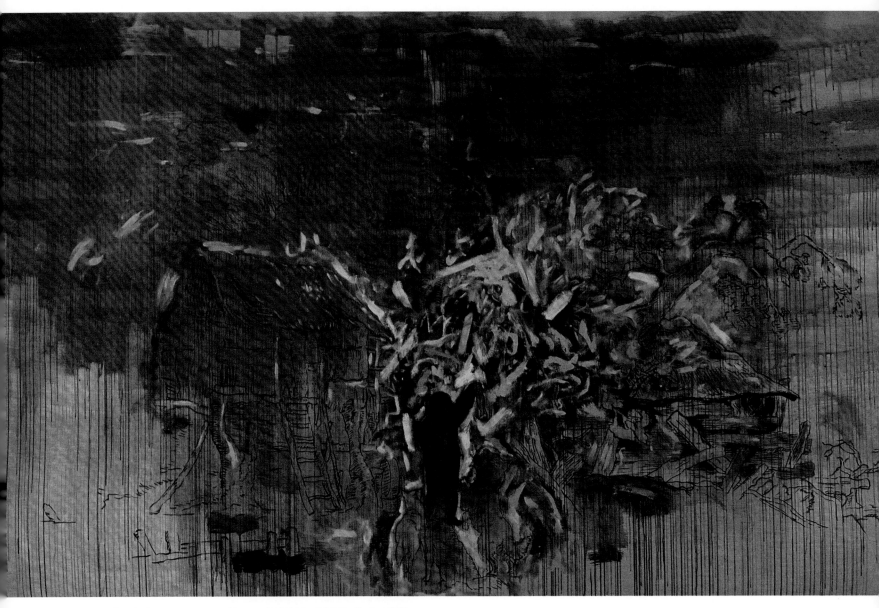

可爱而荒谬的幼稚者　1979, 200 × 307cm, 布面油画，罗马 Berlingieri 收藏
Dear imperinent simpleton　1979, 200 × 307cm, Oil on canva, Coll.Berlingieri,Rome
Caro stordito sempliciotto　1979, 200 × 307cm, Olio su tela, Coll.Berlingieri,Roma

无题　1979, 198 × 136cm, 布面油画，莫德纳 Mazzoli 皇家画廊，Carpi(Mo)Ettore Magnanini 收藏
Untitled　1979, 198 × 136cm, Oil on canvas, Coll.Ettore Magnanini,Carpi(Mo),Courtesy Gallery Mazzoli,Modena
Senza titolo　1979, 198 × 136cm, Olio su tela, Coll.Ettore Magnanini,Carpi(Mo),Courtesy Galleria Mazzoli,Modena

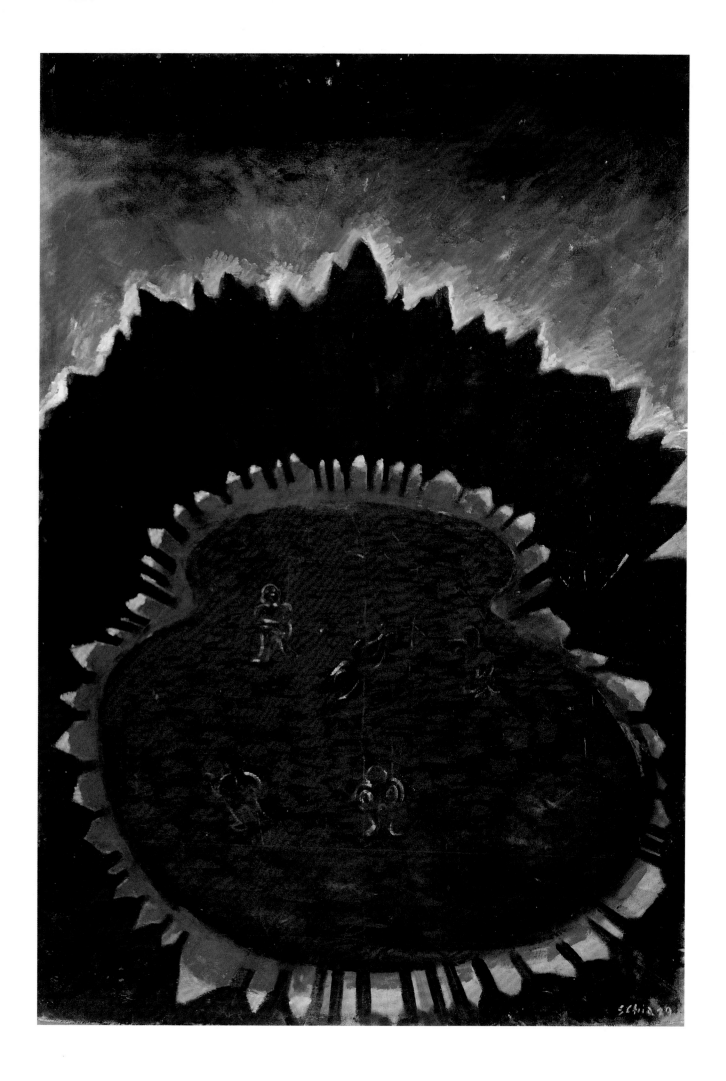

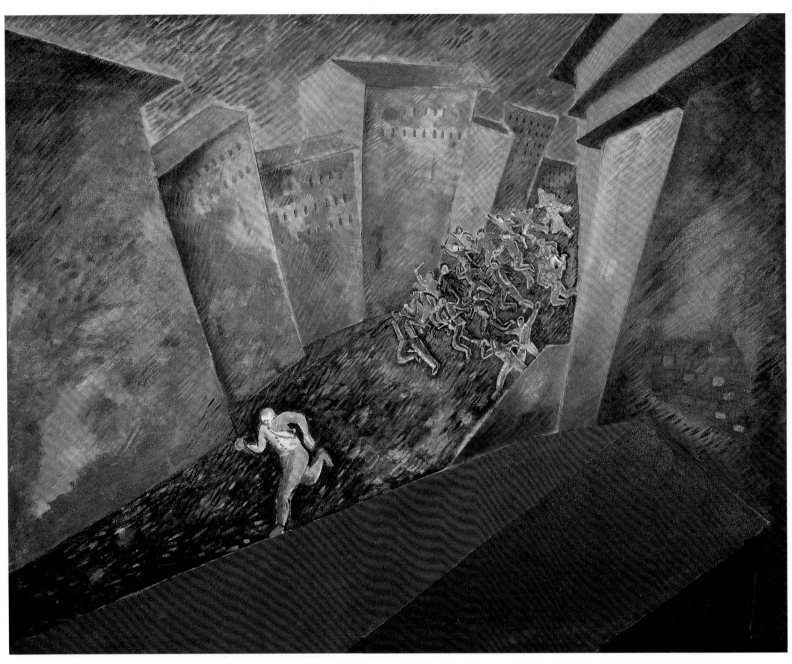

路上屋顶　1979, 195 × 157cm, 布面油画，萨尔茨堡 Ropac 皇家画廊
On the roof on the way　1979, 195 × 157cm, Oil on canvas,Courtesy Gallery Ropac,Salzburg
Sul tetto sulla strada　1979, 195 × 157cm, Olio su tela,Courtesy Galerie Ropac,Salzburg

谎言　1979-1980, 148 × 130cm, 布面油画，罗马 Franchetti 收藏
The lie　1979-1980, 148 × 130cm, Oil on canvas, Coll.Franchetti,Rome
La bugia　1979-1980, 148 × 130cm, Olio su tela, Coll.Franchetti,Roma

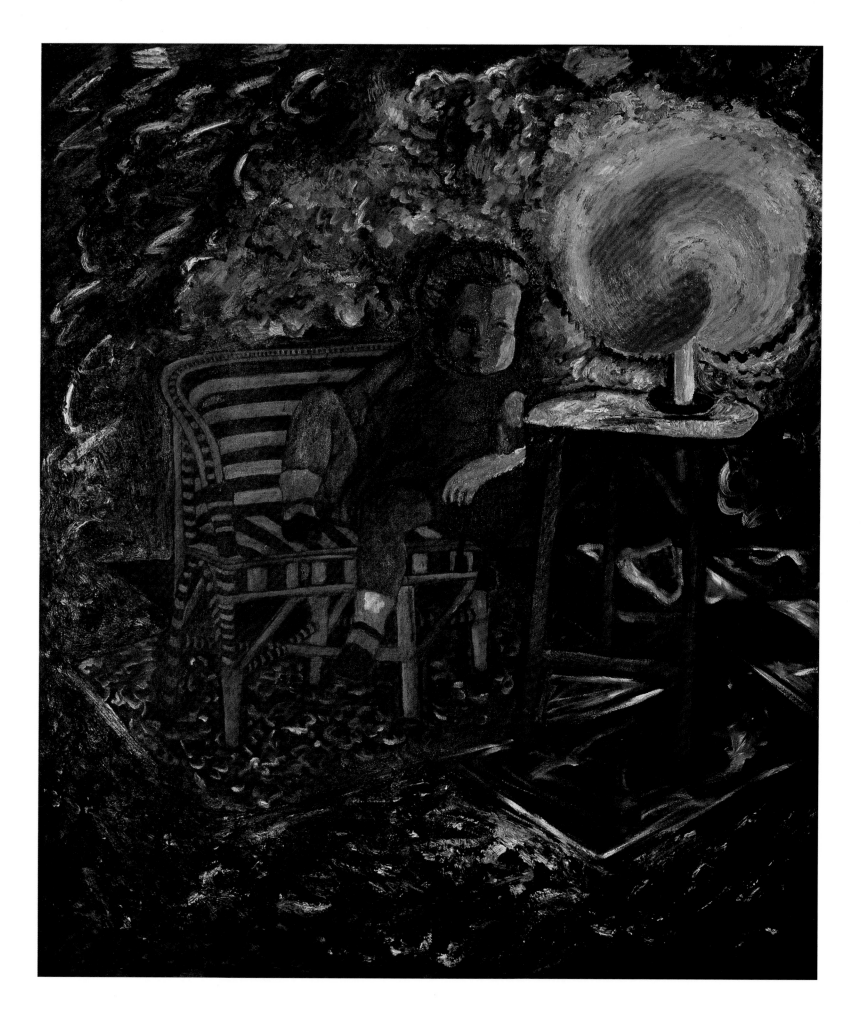

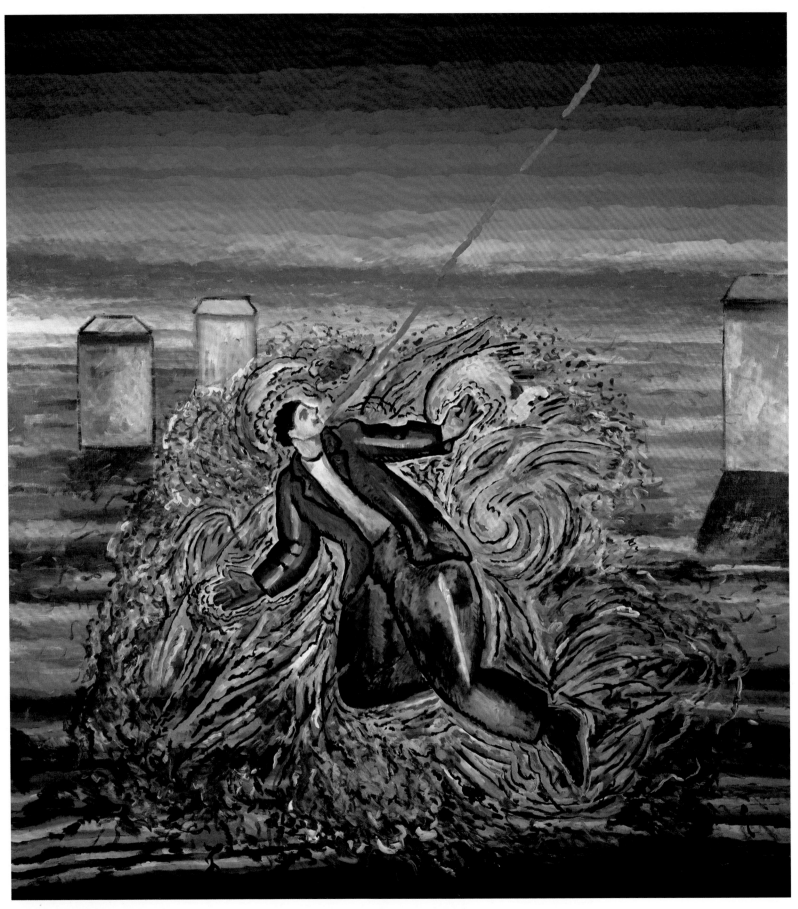

与烟花爆竹共舞是烟火制造者之福　1970-1980, 220 × 202cm, 布面油画，萨尔茨堡 Ropac 皇家画廊
It is nice for pyrotechnist to explode with his fire　1970-1980, 220 × 202cm, Oil on canvas,Courtesy Gallery of Ropac,Salzburg
E' bello per l'artificiere saltare con i propri fuochi　1970-1980, 220 × 202cm, Olio su tela,Courtesy Galerie Ropac,Salzburg

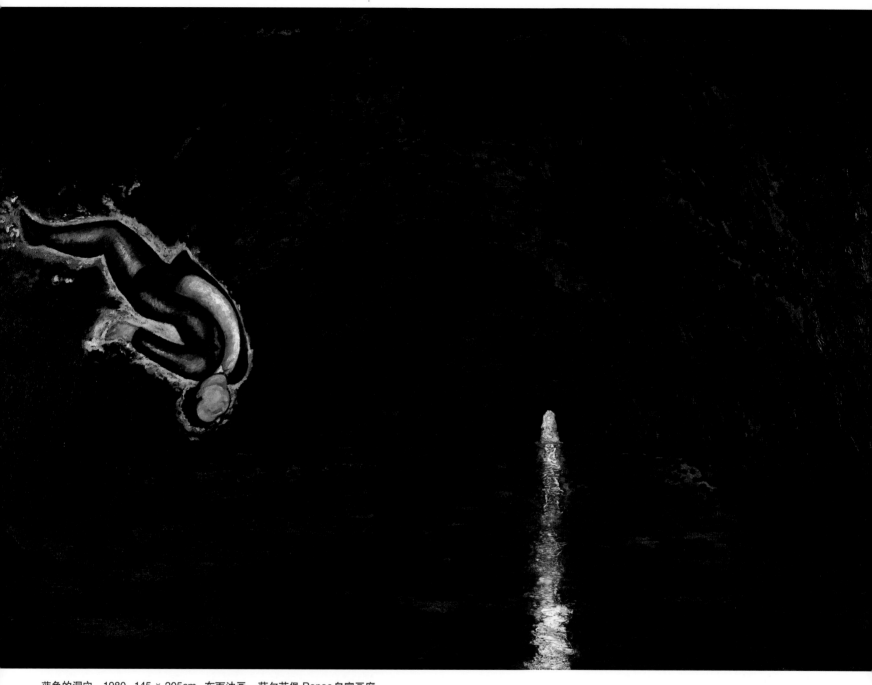

蓝色的洞穴　1980，145 × 205cm，布面油画，萨尔茨堡 Ropac 皇家画廊
Blue grotto　1980，145 × 205cm，Oil on canvas,Courtesy Gallery of Ropac,Salzburg
Grotta azzurra　1980，145 × 205cm，Olio su tela,Courtesy Galerie Ropac,Salzburg

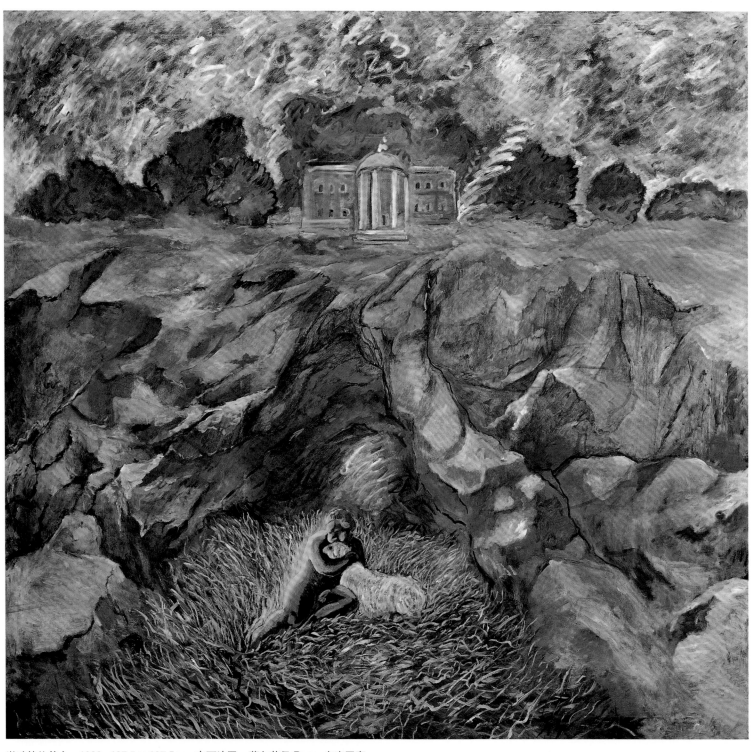

激动的牧羊人　1980, 187.5 × 197.5cm, 布面油画，萨尔茨堡 Ropac 皇家画廊
Exited shepherd　1980, 187.5 × 197.5cm, Oil on canvas,Courtesy Gallery of Ropac,Salzburg
Pastorello eccitato　1980, 187.5 × 197.5cm, Olio su tela,Courtesy Galerie Ropac,Salzburg

不完整的交响乐　1980, 200 × 148cm, 布面油画，锡耶那 Alessandro Bagnai 皇家画廊
Incomplete symphony　1980, 200 × 148cm, Oil on canvas,Courtesy Alessandro Bagnai,Siena
Sinfonia incompiuta　1980, 200 × 148cm, Olio su tela,Courtesy Alessandro Bagnai,Siena

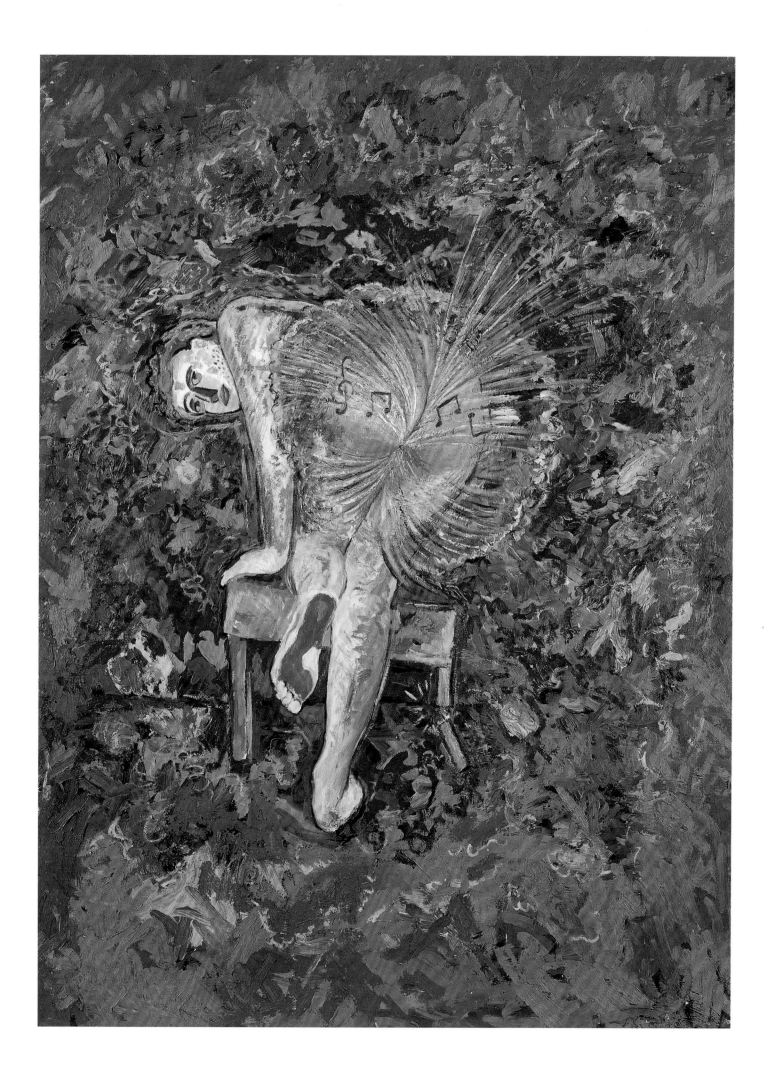

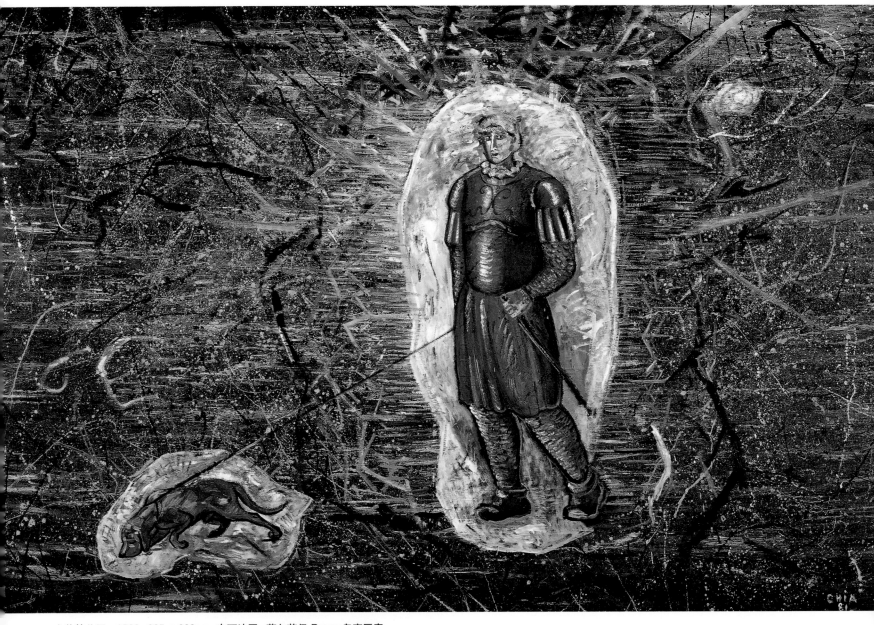

女仆的儿子　1980, 225 × 382cm, 布面油画, 萨尔茨堡 Ropac 皇家画廊
The boy of maid　1980, 225 × 382cm, Oil on canvas,Courtesy Gallery of Ropac,Salzburg
Il figlio della serva　1980, 225 × 382cm, Olio su tela,Courtesy Galerie Ropac,Salzburg

蛙桥不是桥　1980, 200 × 160cm, 布面油画, 罗马 Franchetti 收藏
Bridge of forg without the forg　1980, 200 × 160cm, Oil on canvas, Coll.Franchetti,Rome
Ponte di rane senza il ponte　1980, 200 × 160cm, Olio su tela, Coll.Franchetti,Roma

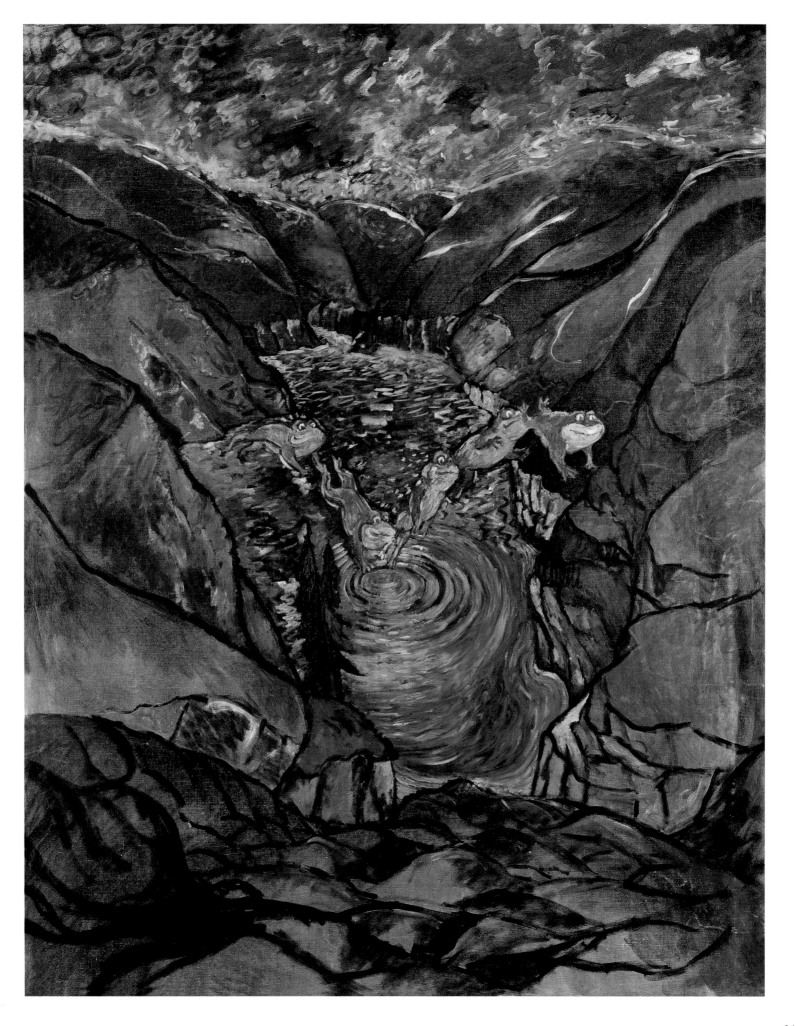

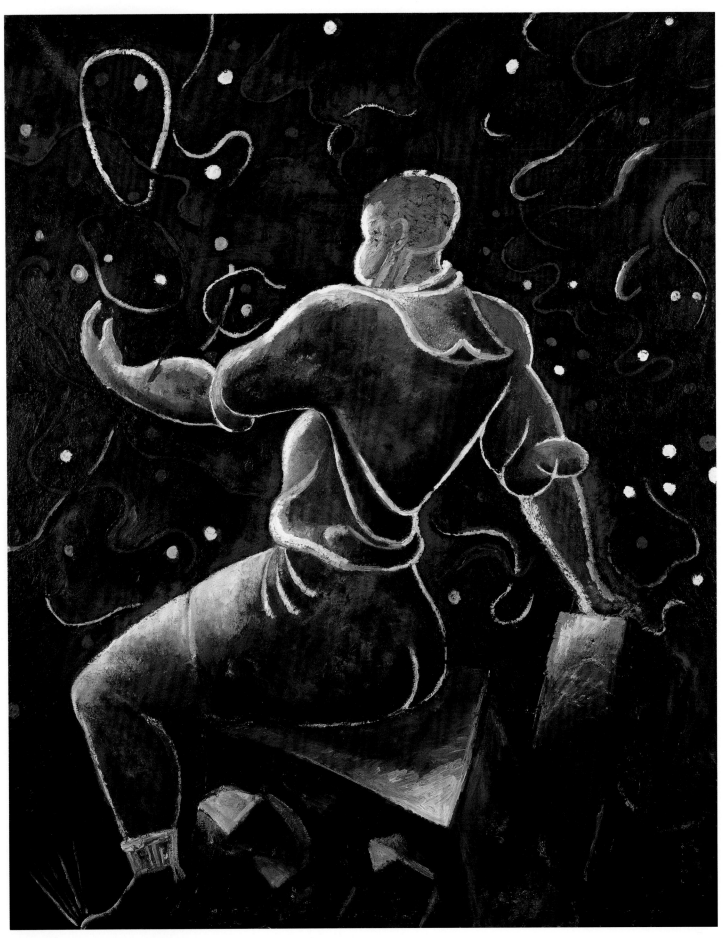

沉思　1981，160 × 106cm，布面油画
Meditation　1981，160 × 106cm，Oil on canvas
Meditazione　1981，160 × 106cm，Olio su tela

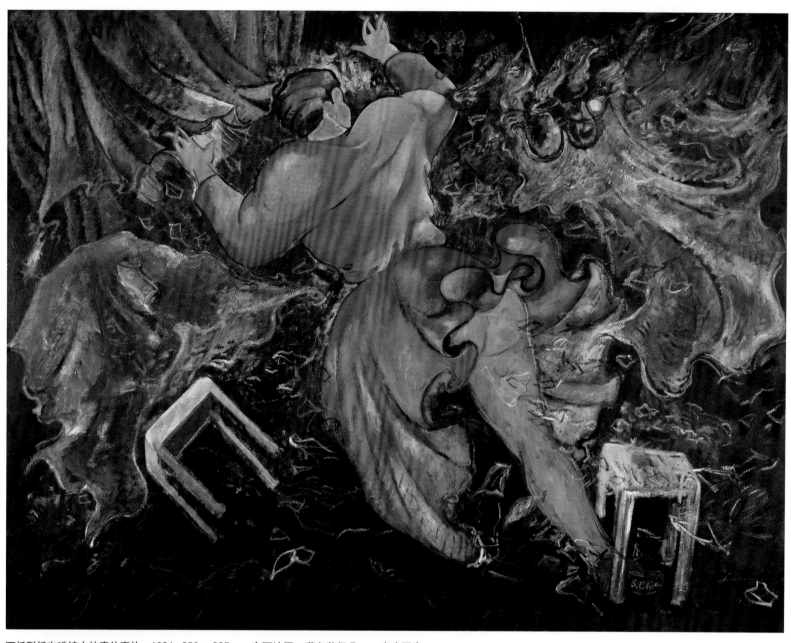

丁托列托咖啡馆中的意外事故　1981, 250 × 335cm, 布面油画，萨尔茨堡 Ropac 皇家画廊
Incident at the Cafe Tintoretto　1981, 250 × 335cm, Oil on canvas,Courtesy Gallery of Ropac,Salzburg
Incidente al caffè Tintoretto　1981, 250 × 335cm, Olio su tela,Courtesy Galerie Ropac,Salzburg

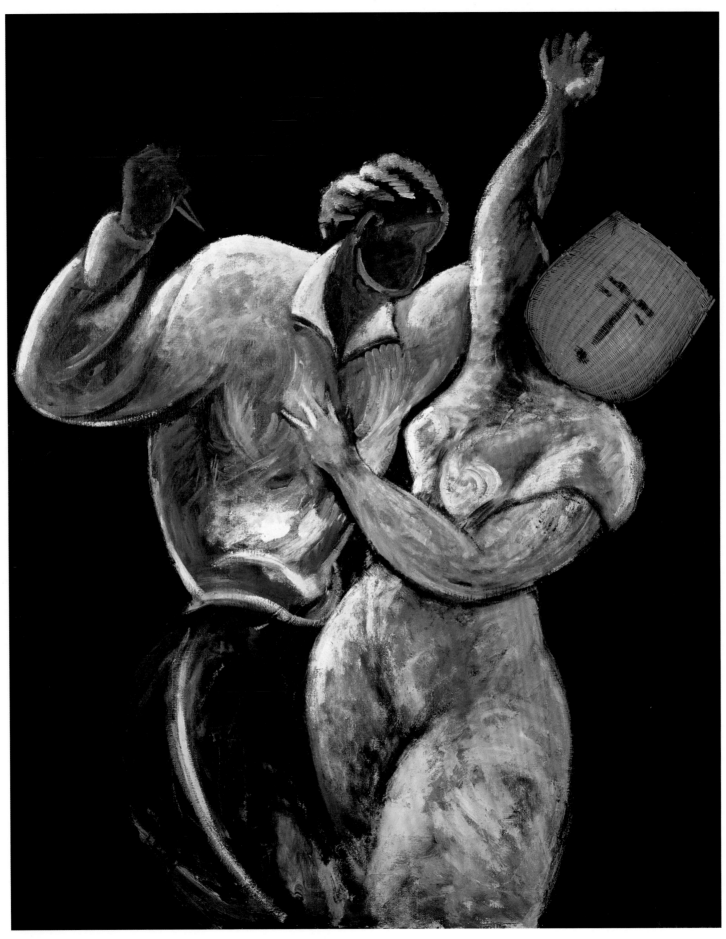

丑恶的面目　1981，160 × 127.5cm，布面油画，萨尔茨堡 Ropac 皇家画廊
The scandal face　1981，160 × 127.5cm，Oil on canvas ,Courtesy Gallery of Ropac,Salzburg
Il volto scandaloso　1981，160 × 127.5cm，Olio su tela ,Courtesy Galerie Ropac,Salzburg

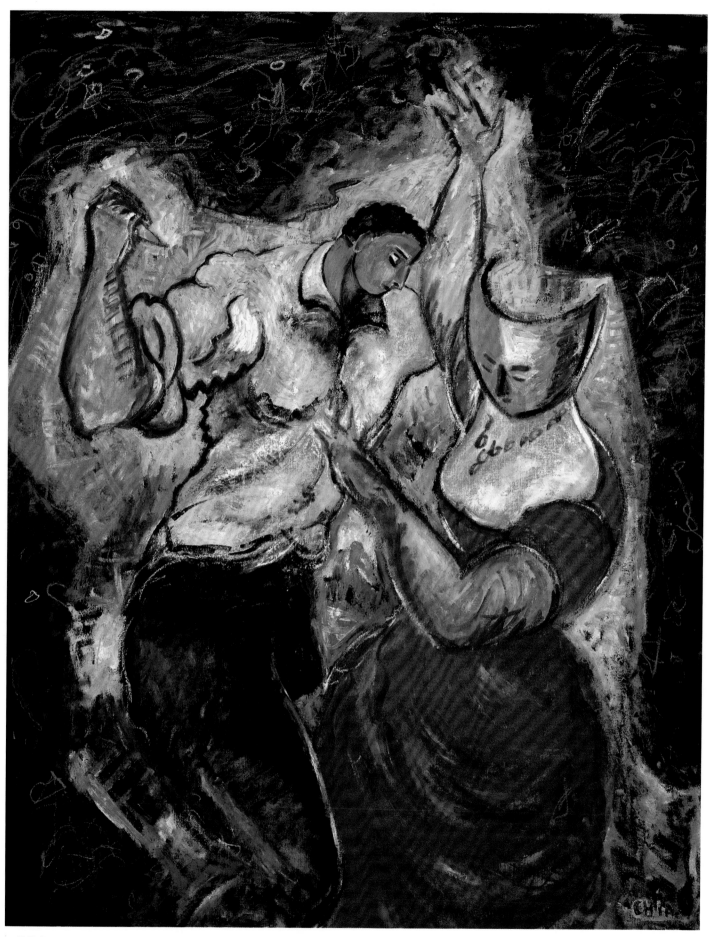

手的游戏 1981，181 × 145cm，布面油画，萨尔茨堡 Ropac 皇家画廊
Hand game 1981，181 × 145cm，Oil on canvas,Courtesy Gallery of Ropac,Salzburg
Hand game 1981，181 × 145cm，Olio su tela,Courtesy Galerie Ropac,Salzburg

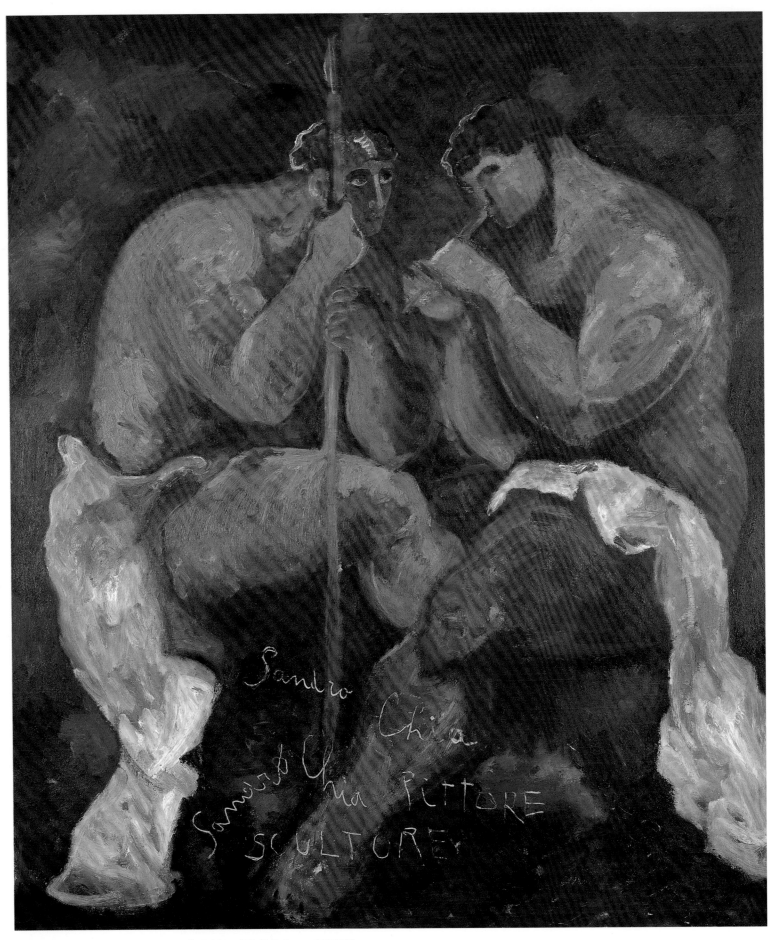

画家及雕塑家　1982，230 × 195cm，布面油画，萨尔茨堡 Ropac 皇家画廊

Painter and sculptor　1982，230 × 195cm, Oil on canvas,Courtesy Gallery of Ropac,Salzburg

Pittore scultore　1982，230 × 195cm, Olio su tela,Courtesy Galerie Ropac,Salzburg

无题 1982，78 × 70cm，纸板油画，莫德纳 Mazzoli 皇家画廊
Untitled 1982，78 × 70cm, Oil on cardboard,Courtesy Gallery Mazzoli,Modena
Senza titolo 1982，78 × 70cm, Olio su cartone,Courtesy Galleria Mazzoli,Modena

湖的女人　1983, 196 × 225cm, 布面油画，萨尔茨堡 Ropac 皇家画廊
The woman of the lake　1983, 196 × 225cm. Oil on canvas ,Courtesy Gallery of Ropac,Salzburg
La donna del lago　1983, 196 × 225cm, Olio su tela,Courtesy Galerie Ropac,Salzburg

哭泣的画家　1983, 250 × 140cm, 莫德纳 Mazzoli 皇家画廊，Vicenza 私人收藏
Painter that is crying　1983, 250 × 140cm, Oil on canvas, Coll. Privata of Vicenza,Courtesy Gallery Mazzoli,Modena
Pittore che piange　1983, 250 × 140cm, Oilo su tela, Coll. privata Vicenza,Courtesy Galleria Mazzoli,Modena

弃置的玩具　1984，175 × 295cm，莫德纳 Mazzoli 皇家画廊
Toys corner　1984，175 × 295cm，Oil on canvas,Courtesy Gallery Mazzoli,Modena
Toys corner　1984，175 × 295cm，Olio su tela,Courtesy Galleria Mazzoli,Modena

面包和葡萄酒　1984，170 × 150cm，布面油画，萨尔茨堡 Ropac 皇家画廊
Bread and wine　1984，170 × 150cm，Oil on canvas,Courtesy Gallery of Ropac,Salzburg
Pane e vino　1984，170 × 150cm，Olio su tela,Courtesy Galerie Ropac,Salzburg

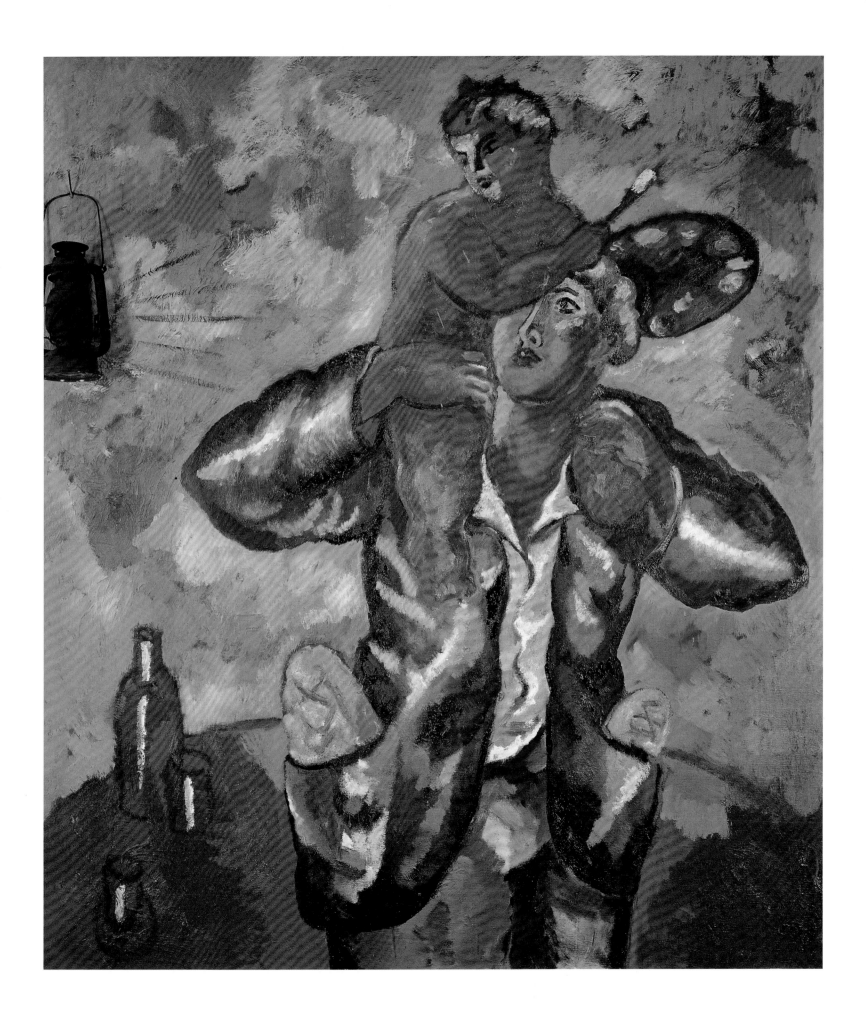

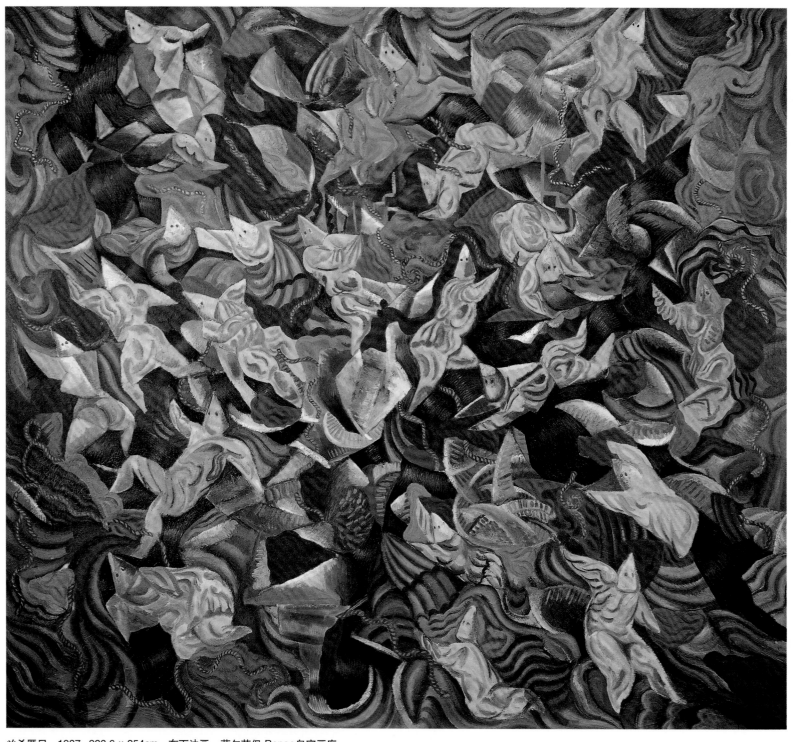

凶杀匿尸　1987，228.6 × 254cm，布面油画，萨尔茨堡 Ropac 皇家画廊
The crime was hidden　1987，228.6 × 254cm，Oil on canvas,Courtesy Gallery of Ropac,Saliburgo
Lupare　1987，228.6 × 254cm，Olio su tela,Courtesy Galerie Ropa Salzburg

无题　1987，78.5 × 58cm，纸板混合画法，莫德纳 Mazzoli 皇家画廊
Untitled　1987，78.5 × 58cm，Mixed media on cardboard,Courtesy Gallery Mazzoli,Modena
Senza titolo　1987，78.5 × 58cm，Tecnica mista su cartone,Courtesy Galleria Mazzoli,Modena

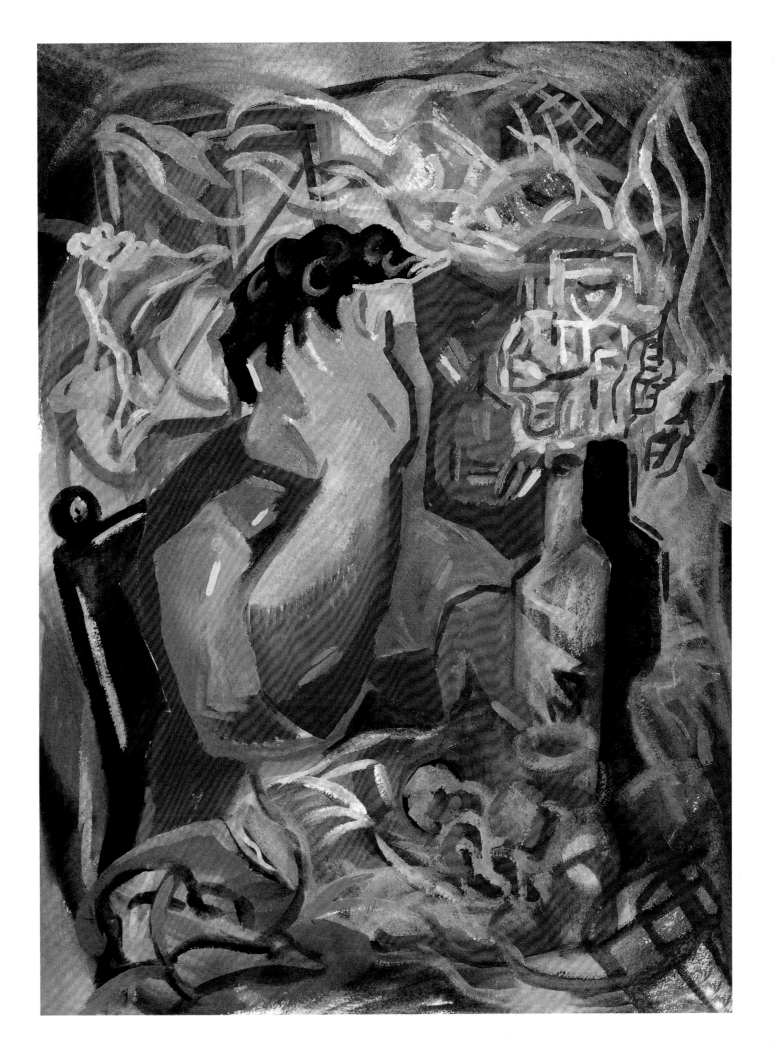

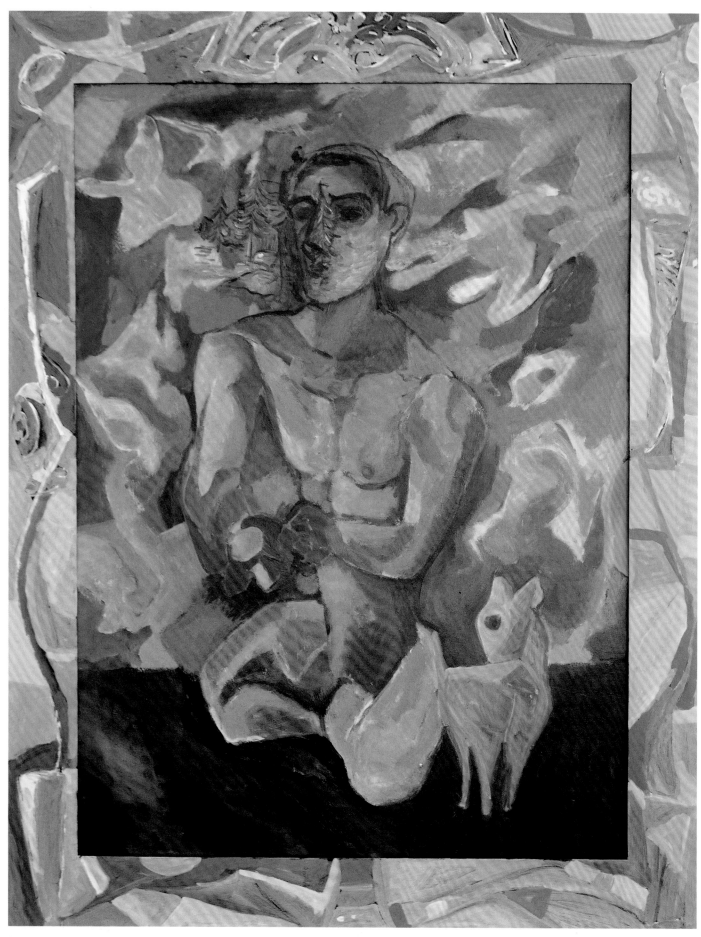

与狗玩耍的画像　1989，183 × 143.5cm，布面油画，萨尔茨堡 Ropac 皇家画廊
Playing figure with dog　1989，183 × 143.5cm, Oil on canvas,Courtesy Gallery of Ropac,Salzburg
Figura che gioca con cane　1989，183 × 143.5cm, Olio su tela,Courtesy Galerie Ropac,Salzburg

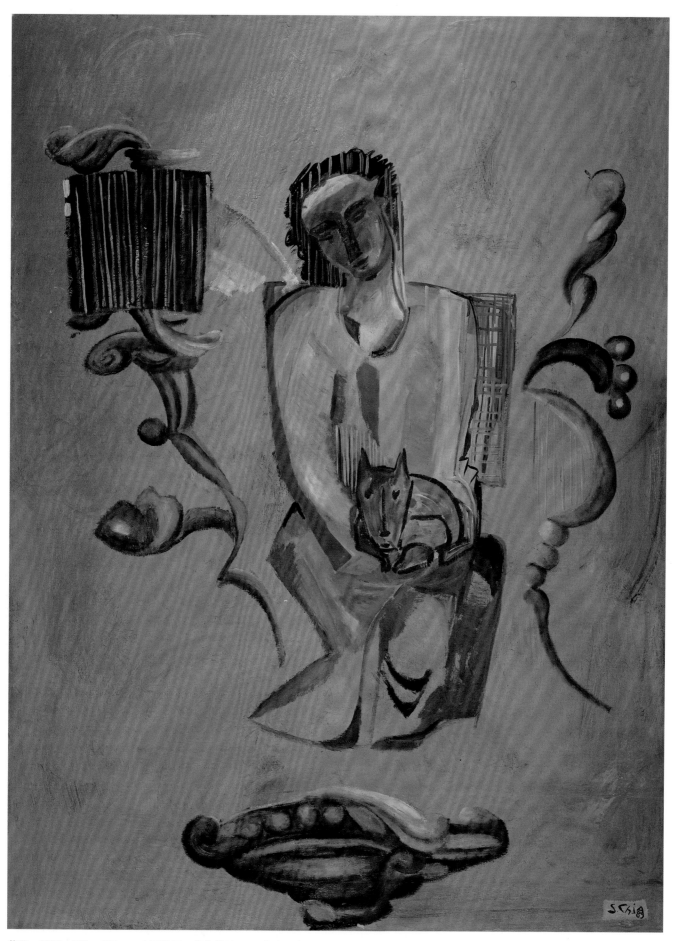

苦蛋　1989, 155 × 200cm, 布面油画，莫德纳 Mazzoli 皇家画廊，Giuliano Gibertini(Mo) 收藏

The bitter egg　1989, 155 × 200cm, Oil on canvas, Coll.Giuliano Gibertinii(Mo),Courtesy Gallery Mazzoli,Modena

L'Uovo amaro　1989, 155 × 200cm, Oilo su tela, Coll.Giuliano Gibertinii(Mo),Courtesy Galleria Mazzoli,Modena

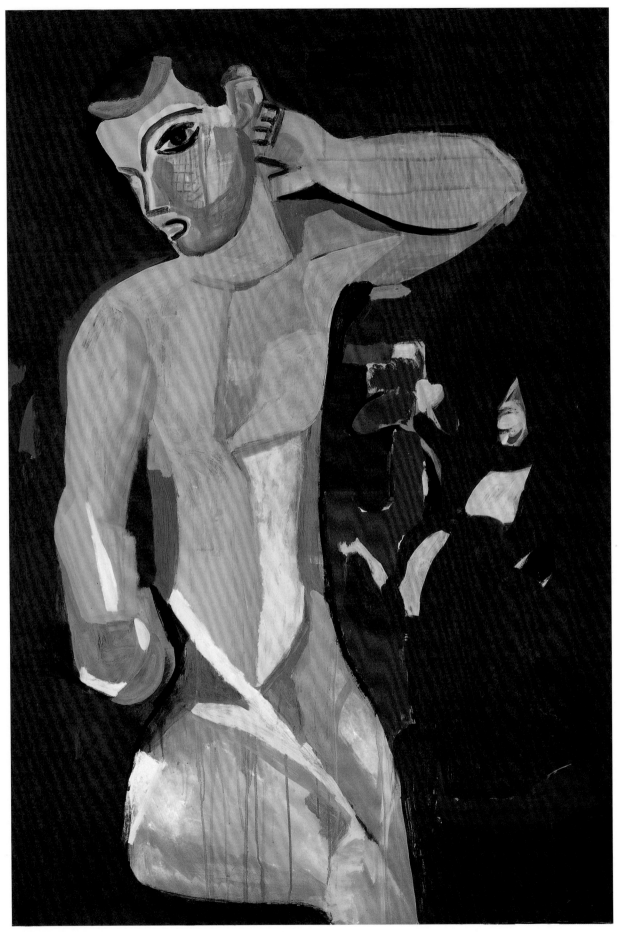

无题　1990-1991，180 × 110cm，布面油画和在纸上的综合画法，莫德纳 Mazzoli 皇家画廊
Untitled　1990-1991，180 × 110cm，Oil and mixed media on paper mounted on canvas,Courtesy Gallery Mazzoli,Modena
Senza titolo　1990-1991　180 × 110cm，Olio e tecnica mista su carta montata su tela,Courtesy Galleria Mazzoli,Modena

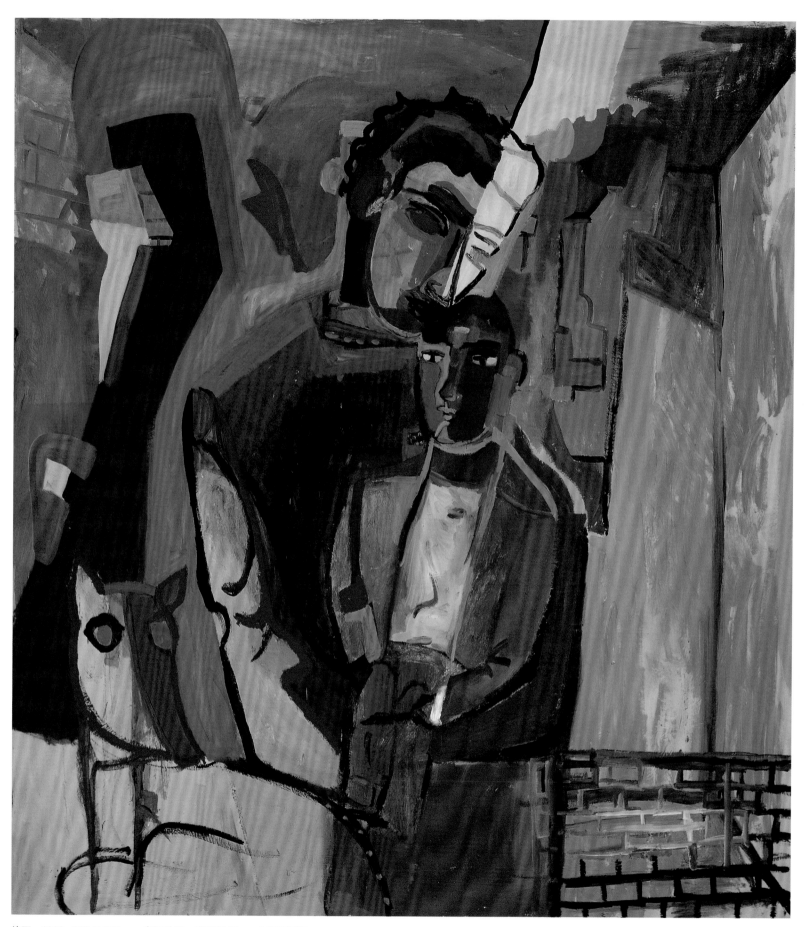

仲夏　1992, 200 × 180cm, 布面油画，莫德纳 Mazzoli 皇家画廊
Midsummer　1992, 200 × 180cm, Oil on canvas,Courtesy Gallery Mazzoli,Modena
Mezza Estate　1992, 200 × 180cm, Olio su tela,Courtesy Galleria Mazzoli,Modena

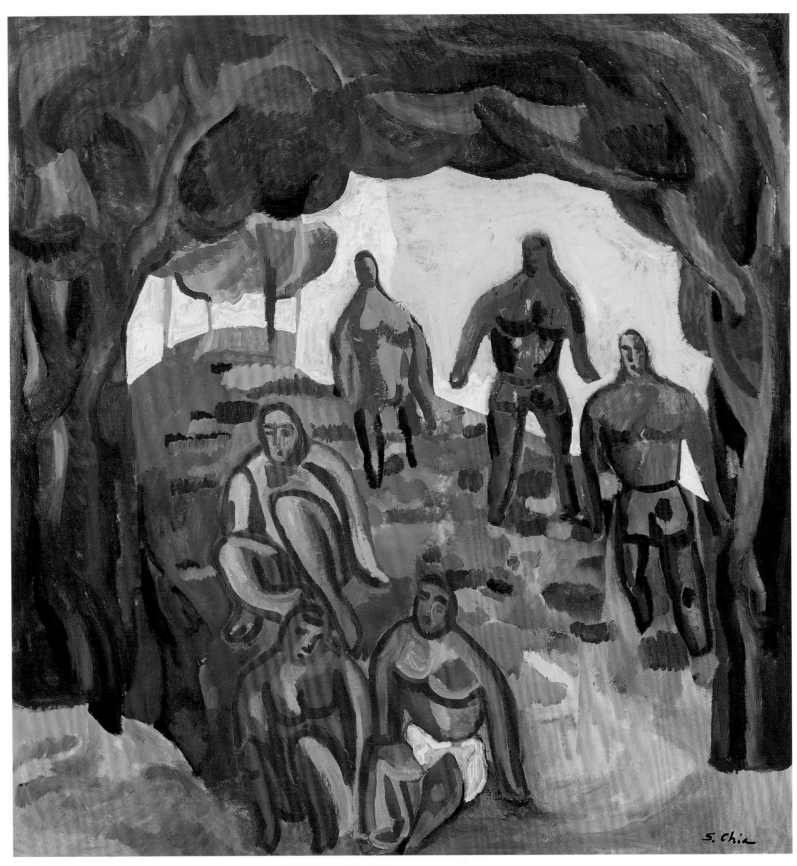

95′ 超前卫运动的诞生　1995，120 × 116cm，布面油画，莫德纳 Mazzoli 皇家画廊
The birth of movement of avant-gard'95　1995，120 × 116cm，Oil on canvas,Courtesy Gallery Mazzoli,Modena
La nascita del movimento transavanguardia'95　1995，120 × 116cm，Olio su tela,Courtesy Galleria Mazzoli,Modena

无题　1997，115 × 146.5cm，布面油画、混合画法，锡耶纳 Alessandro Bagnai 皇家画廊
Untitled　1997，115 × 146.5cm，Oil and mixed media on canvas,Courtesy Alessandro Bagnai,Siena
Senza titolo　1997，115 × 146.5cm，Olio e tecnica mist su tela,Courtesy Alessandro Bagnai,Siena

彩色画家　1999，107 × 81cm，布面油画，萨尔茨堡 Ropac 皇家画廊
Coloured painter　1999，107 × 81cm，Oil on canvas,Courtesy Gallery of Ropac,Salzburg
Pittore colorato　1999，107 × 81cm，Olio su tela,Courtesy Galerie Ropac, Salzburg

弗朗西斯科·克莱门特
Francesco Clemente

Francesco Clemente
意大利超前卫艺术

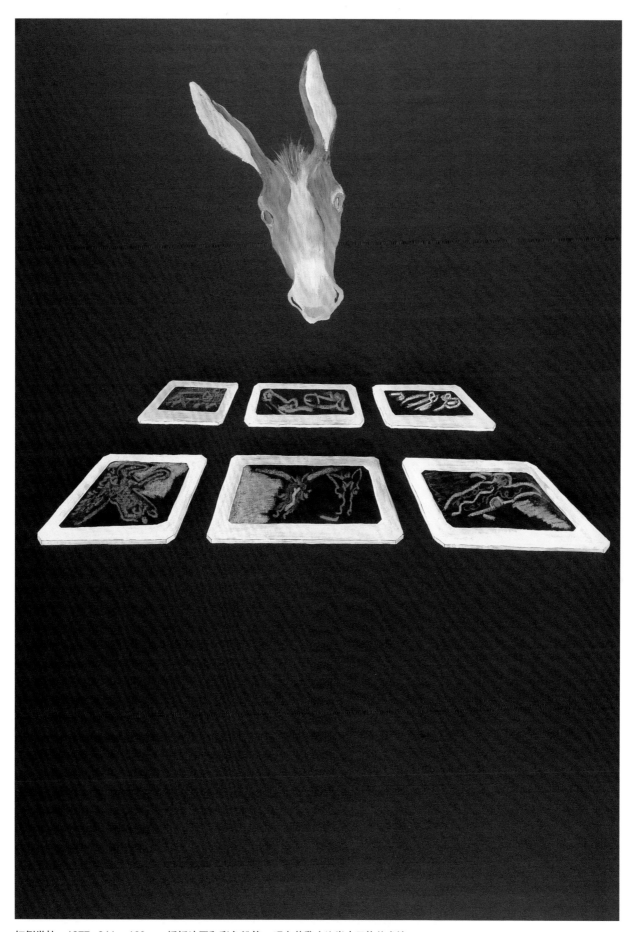

打倒学校　1977，244 × 163cm，纸板油画和彩色粉笔，现存苏黎士比肖夫贝格美术馆
Down with the school　1977, 244 × 163cm, Oil and pastel on paper, Courtesy Galerie Bishofberger,Zurigo
Abbasso la scuola　1977, 244 × 163cm, Olio e pastello su carta, Courtesy Galerie Bishofberger,Zurigo

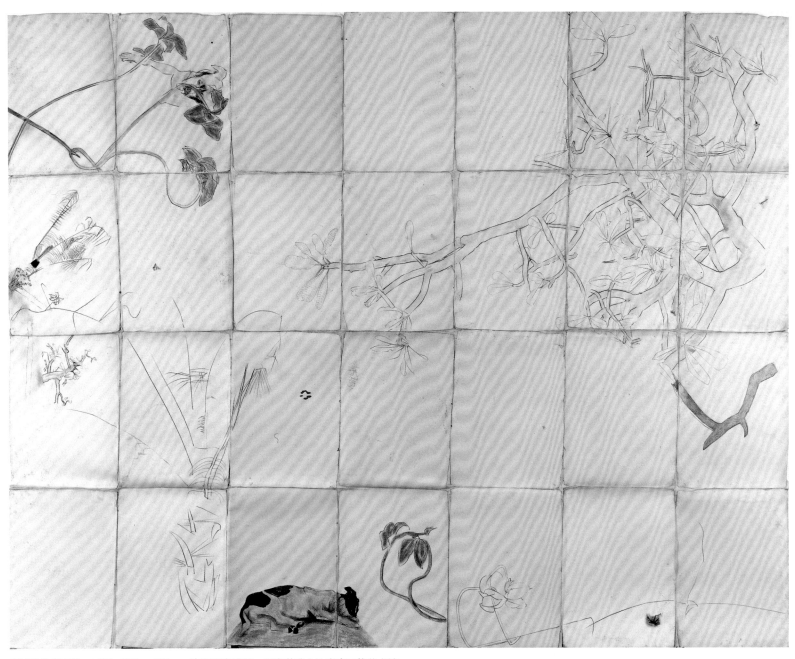

庭院似的自画像 1979, 320 × 400cm, 布面混合涂料，现存苏黎士比肖夫贝格美术馆
Self-portrait like a garden 1979, 320 × 400cm, Mixed media on canvas, Courtesy Galerie Bishofberger,Zurigo
Autoritratto come un giardino 1979, 320 × 400cm, Tecnica misto su tela, Courtesy Galerie Bishofberger,Zurigo

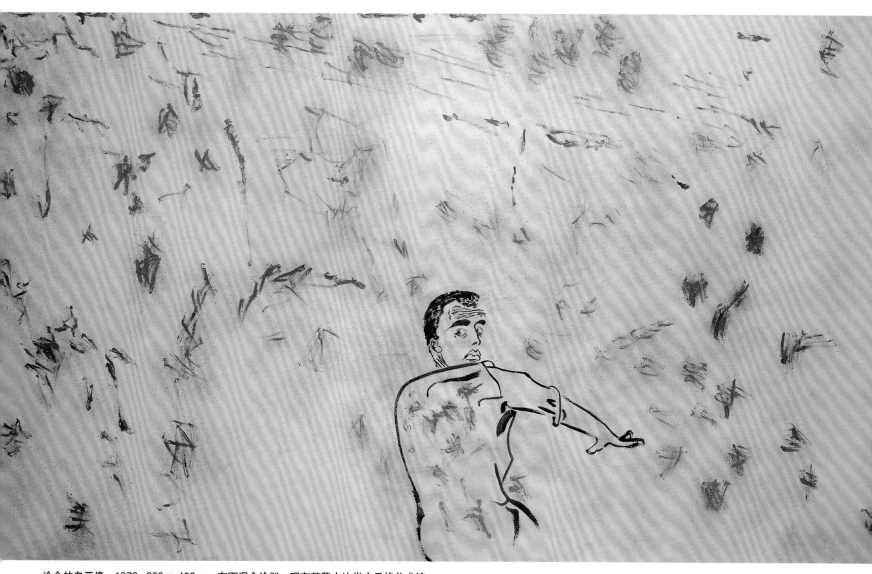

涂金的自画像　1979, 200 × 400cm, 布面混合涂料, 现存苏黎士比肖夫贝格美术馆
Self-portrait with gold　1979, 200 × 400cm, Mixed media on canvas, Courtesy Galerie Bishofberger,Zurigo
Autoritratto con oro　1979, 200 × 400cm, Tecnica misto su tela, Courtesy Galerie Bishofberger,Zurigo

早晨　1981, 36 × 51cm, 纸上水彩画，现存苏黎士比肖夫贝格美术馆
Morning　1981, 36 × 51cm, Watercolour on paper, Courtesy Galerie Bishofberger,Zurigo
Morning　1981, 36 × 51cm, Acquerello su carta, Courtesy Galerie Bishofberger,Zurigo

朱利安·施纳贝尔的肖像　1981, 210 × 145cm, 湿壁画，现存苏黎士比肖夫贝格美术馆
Portrait of Julian schnabel　1981, 210 × 145cm, Fresco, Courtesy Galerie Bishofberger,Zurigo
Portrait of Julian schnabel　1981, 210 × 145cm, Affresco, Courtesy Galerie Bishofberger,Zurigo

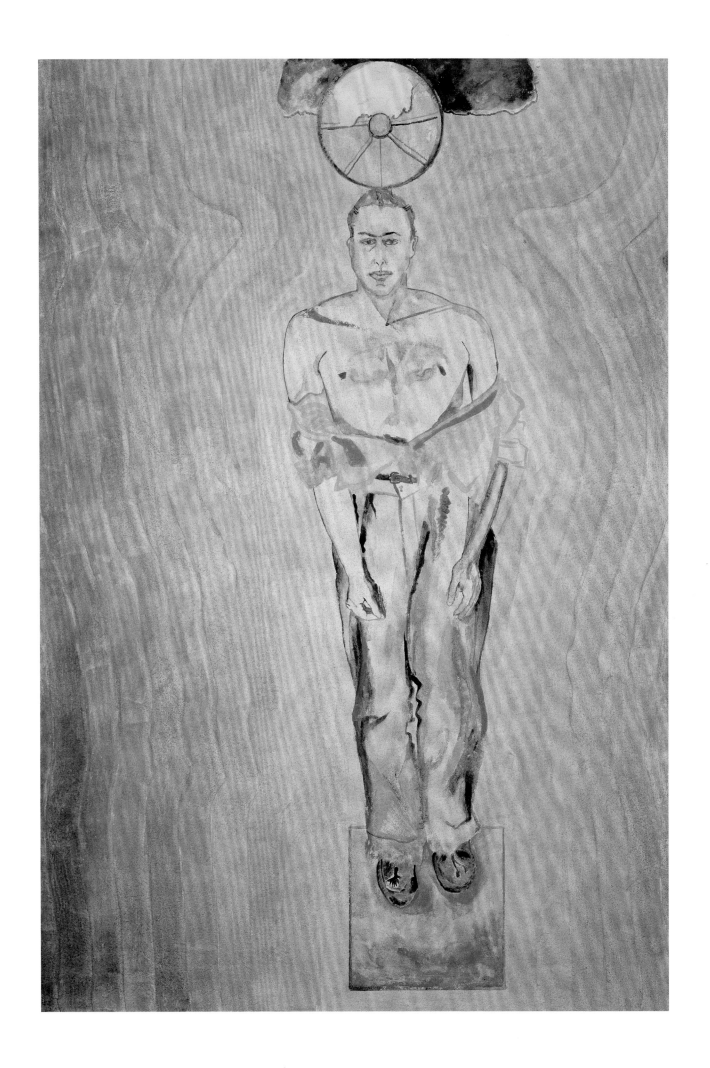

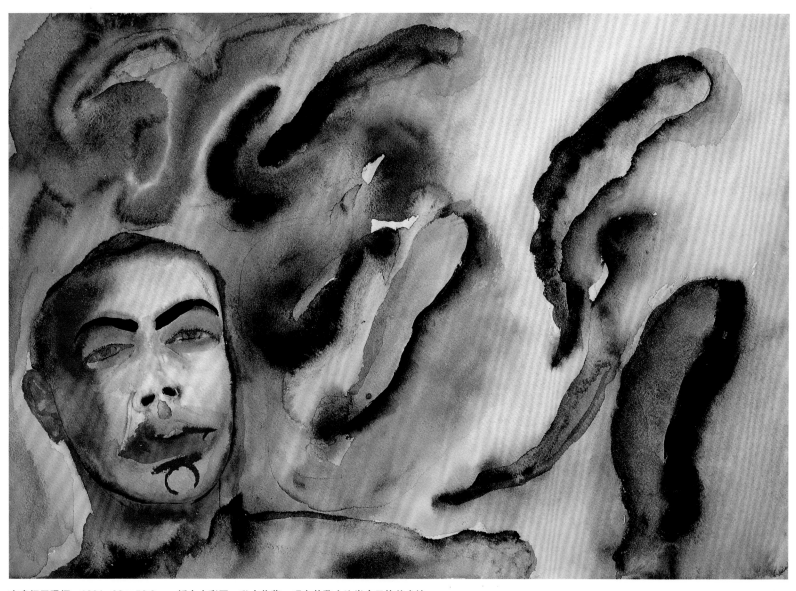

在房间里吸烟　1981, 36 × 50.9cm, 纸上水彩画，私人收藏，现存苏黎士比肖夫贝格美术馆
Smoke in the room　1981, 36 × 50.9cm, Watercolour on paper, Coll.privata, Courtesy Galerie Bishofberger,Zurigo
Smoke in the room　1981, 36 × 50.9cm, Acquerello su carta, Coll.privata, Courtesy Galerie Bishofberger,Zurigo

过桥的人　1981, 210 × 144cm, 湿壁画，私人收藏，现存苏黎士比肖夫贝格美术馆
Man crossing the bridge (Portrait of Keith Haring)1981, 210 × 144cm, Fresco, Coll.privata, Courtesy Galerie Bishofberger,Zurigo
Man crossing the bridge　1981, 210 × 144cm, Affresco, Coll.privata, Courtesy Galerie Bishofberge,Zurigo

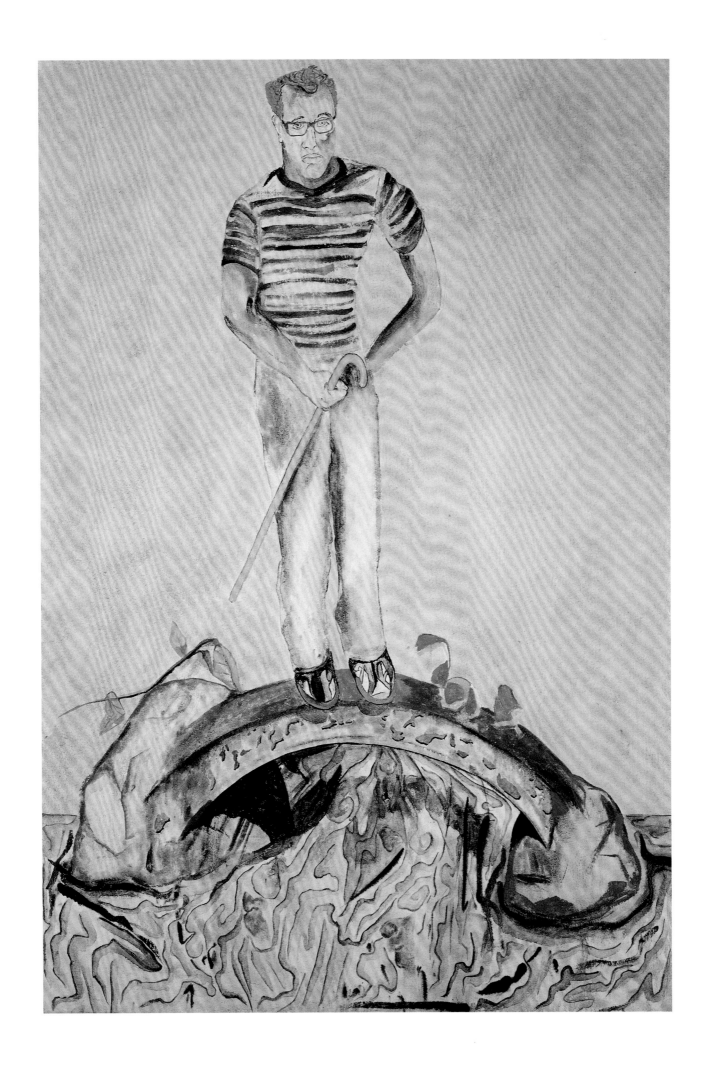

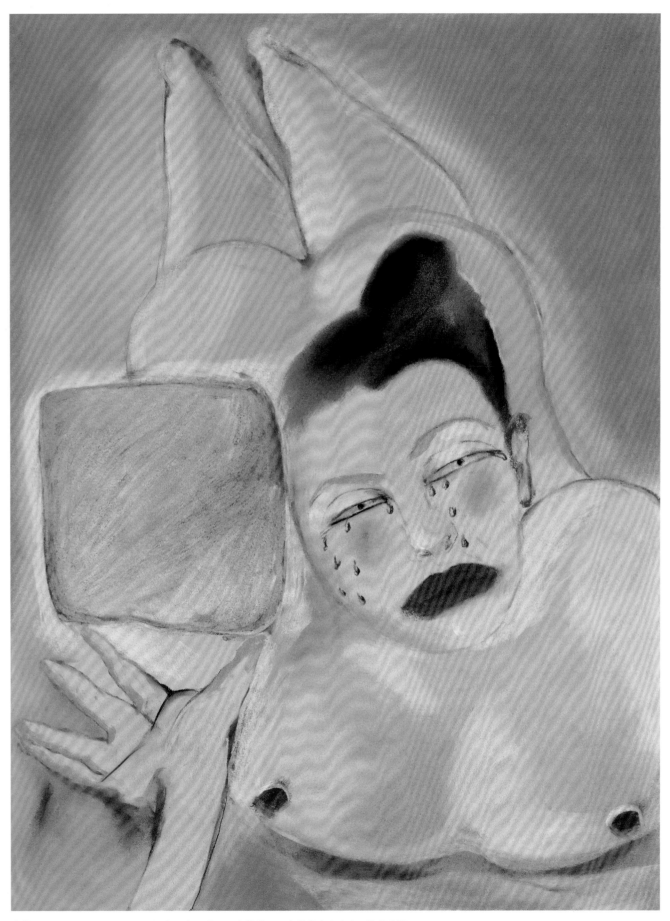

我的眼泪　1982，60 × 45cm，纸上混合画法，私人收藏，现存苏黎士比肖夫贝格美术馆
My tear　1982, 60 × 45cm, Mixed media on paper, Coll.privata, Courtesy Galerie Bishofberger,Zurigo
Mie lacrime　1982, 60 × 45cm, Tecnica matita su carta, Coll.privata, Courtesy Galerie Bishofberger,Zurigo

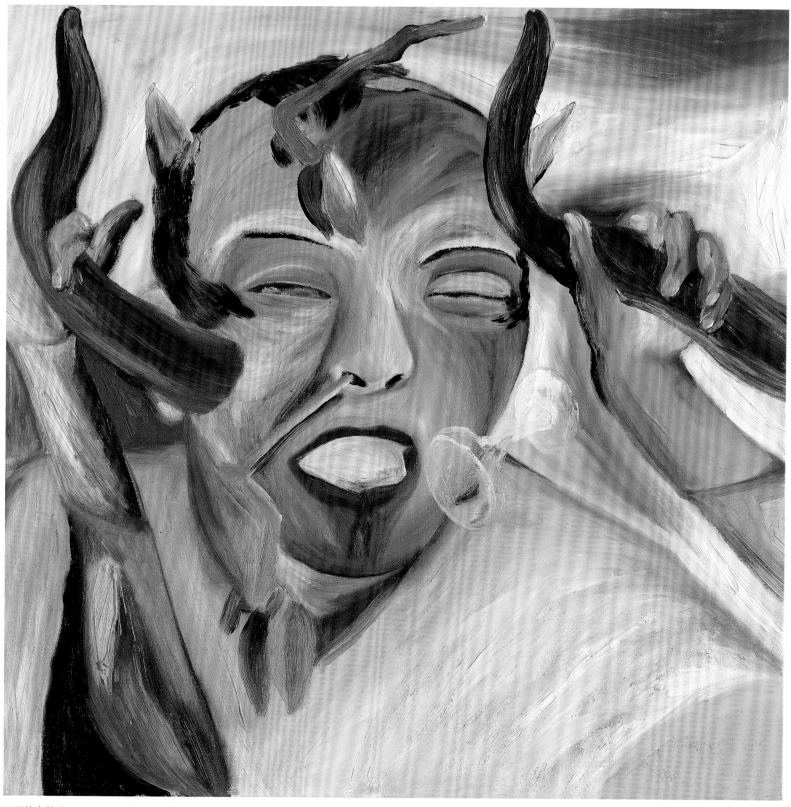

三月的卡兰达 1982, 66 × 68cm, 布面油画, 私人收藏, 现存苏黎士比肖夫贝格美术馆
Calanda of March 1982, 66 × 68cm, Oil on canvas, Coll.privata,Courtesy Galerie Bishofberger,Zurigo
Calanda Marz 1982, 66 × 68cm, Olio su tela, Coll.privata,Courtesy Galerie Bishofberger,Zurigo

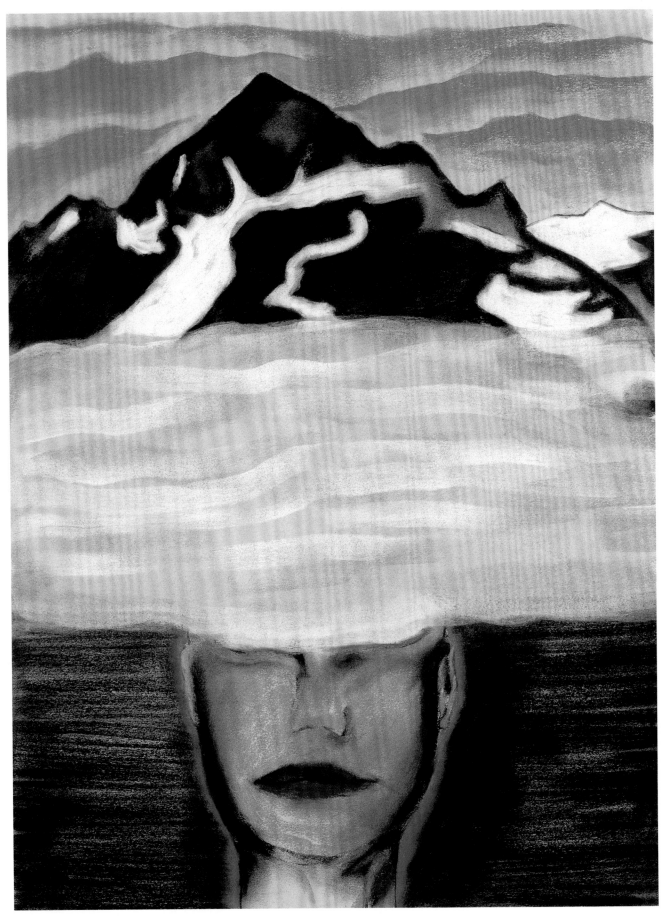

你不记得了　1982, 61 × 45cm, 纸上彩色粉笔画，私人收藏，现存苏黎士比肖夫贝格美术馆

Don't you remember　1982, 61 × 45cm, Pastel on paper, Coll.privata,Courtesy Galerie Bishofberger,Zurigo

Non ti ricordi　1982, 61 × 45cm, Pastello su carta, Coll.privata,Courtesy Galerie Bishofberger,Zurigo

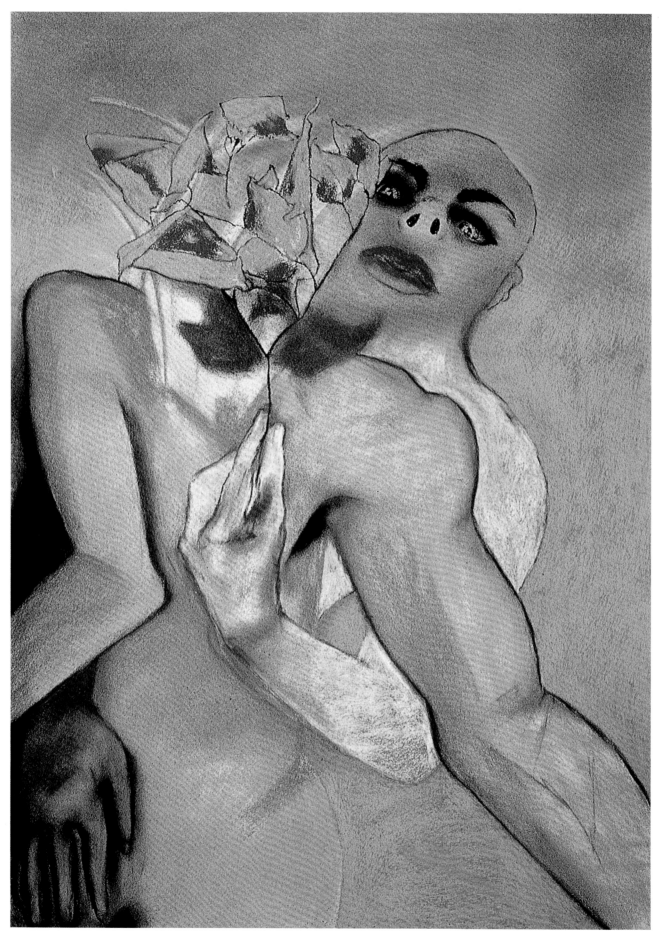

拥抱　1983，61×46cm，纸上彩色粉笔画，私人收藏，现存苏黎士比肖夫贝格美术馆
Embrace　1983, 61 × 46cm, Pastel on paper, Coll.privata,Courtesy Galerie Bishofberger,Zurigo
Abbraccio　1983,61 × 46cm, Pastello su carta, Coll.privata,Courtesy Galerie Bishofberger,Zurigo

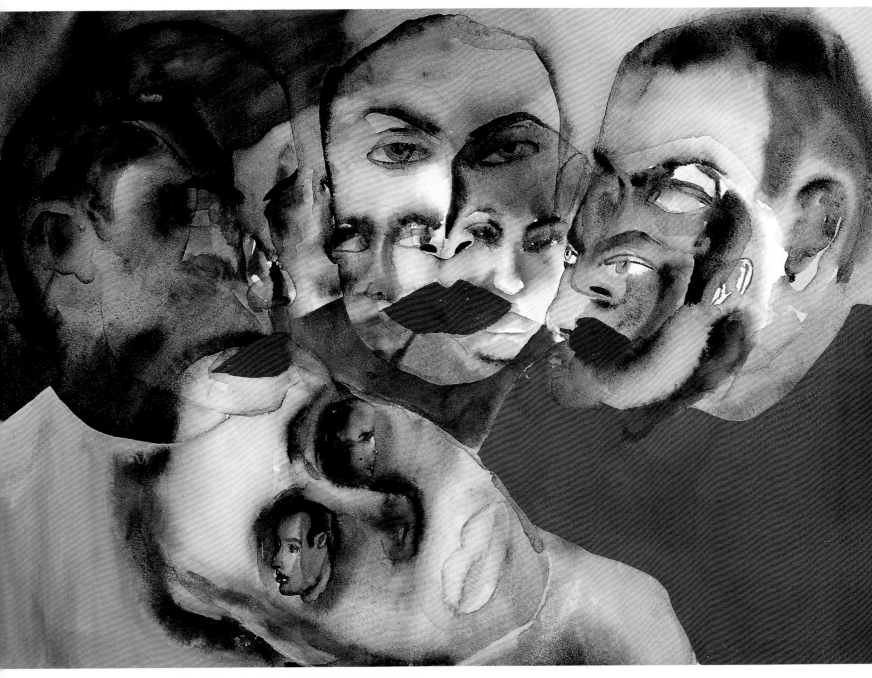

利兹　1983, 36 × 51cm, 纸上水彩画, 私人收藏, 现存苏黎士比肖夫贝格美术馆
Ritz　1983, 36 × 51cm, Watercolour on paper, Coll.privata,Courtesy Galerie Bishofberger,Zurigo
Ritz　1983, 36 × 51cm, Acquerello su carta, Coll.privata,Courtesy Galerie Bishofberger,Zurigo

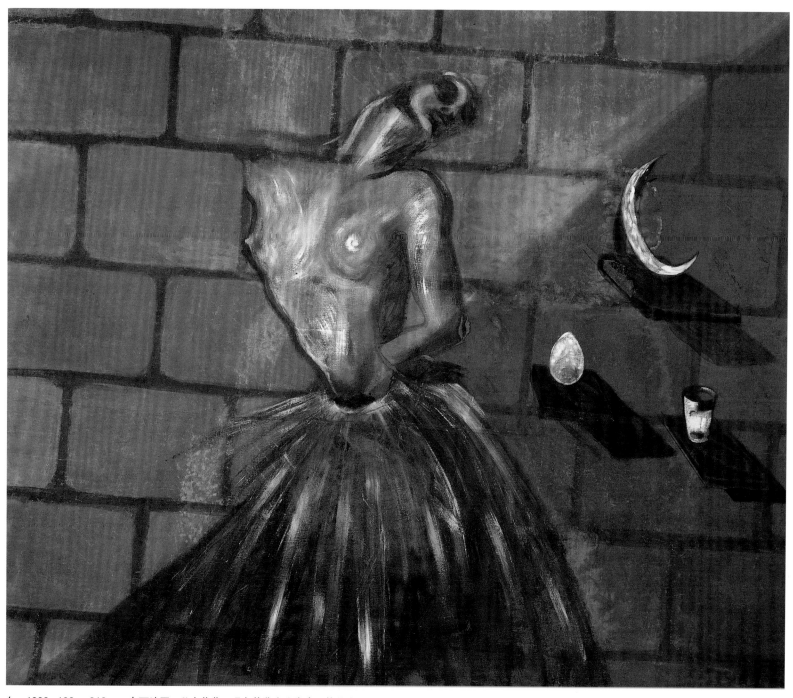

白 1983, 198 × 213cm, 布面油画，私人收藏，现存苏黎士比肖夫贝格美术馆
White 1983, 198 × 213cm, Oil on canvas, Coll.privata,Courtesy Galerie Bishofberger,Zurigo
Bianchi 1983, 198 × 213cm, Olio su tela, Coll.privata,Courtesy Galerie Bishofberger,Zurigo

图腾　1985，67 × 48cm，纸上彩色粉笔画，画家收藏，现存苏黎士比肖夫贝格美术馆
Totem　1985，67 × 48cm，Pastel on paper，Coll.dell'artista,Courtesy Galerie Bishofberger,Zurigo
Totem　1985，67 × 48cm，Pastello su carta，Coll.dell'artista,Courtesy Galerie Bishofberger,Zurigo

阿尔卑斯山的魅力　1987, 187 × 465cm, 布面油画, 私人收藏, 现存苏黎士比肖夫贝格美术馆
Alpine grip　1987, 187 × 465cm, Oil on canvas, Coll.privata,Courtesy Galerie Bishofberger,Zurigo
Alpine grip　1987, 187 × 465cm, Oilo su tela, Coll.privata,Courtesy Galerie Bishofberger,Zurigo

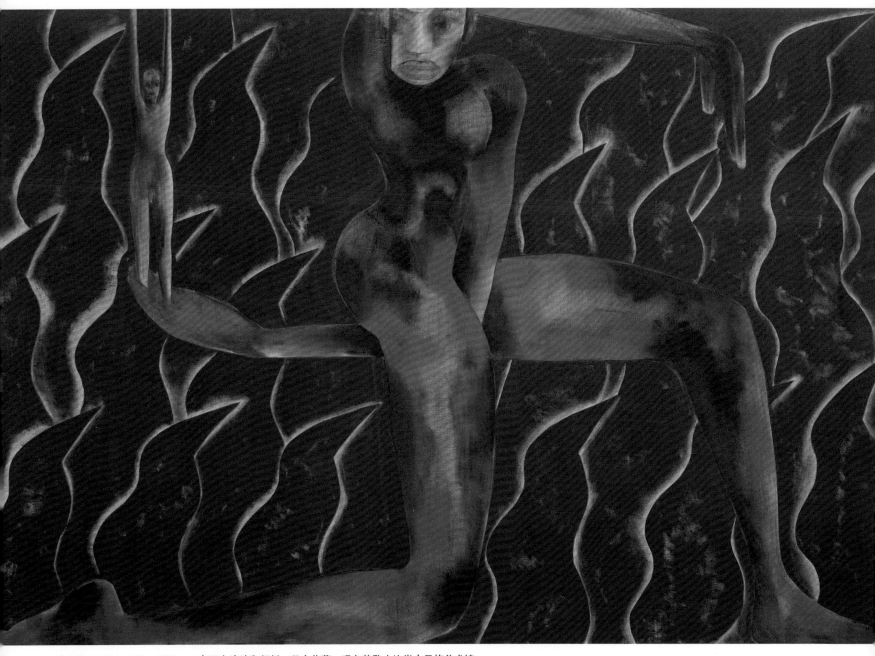

太阳画　1991, 112 × 136cm, 布面上涂油和颜料，私人收藏，现存苏黎士比肖夫贝格美术馆
Solar painting　1991, 112 × 136cm, Oil and pigment on canvas, Coll.privata,Courtesy Galerie Bishofberger,Zurigo
Dipinto Solare　1991, 112 × 136cm, Olio pigmento su tela, Coll.privata,Courtesy Galerie Bishofberger,Zurigo

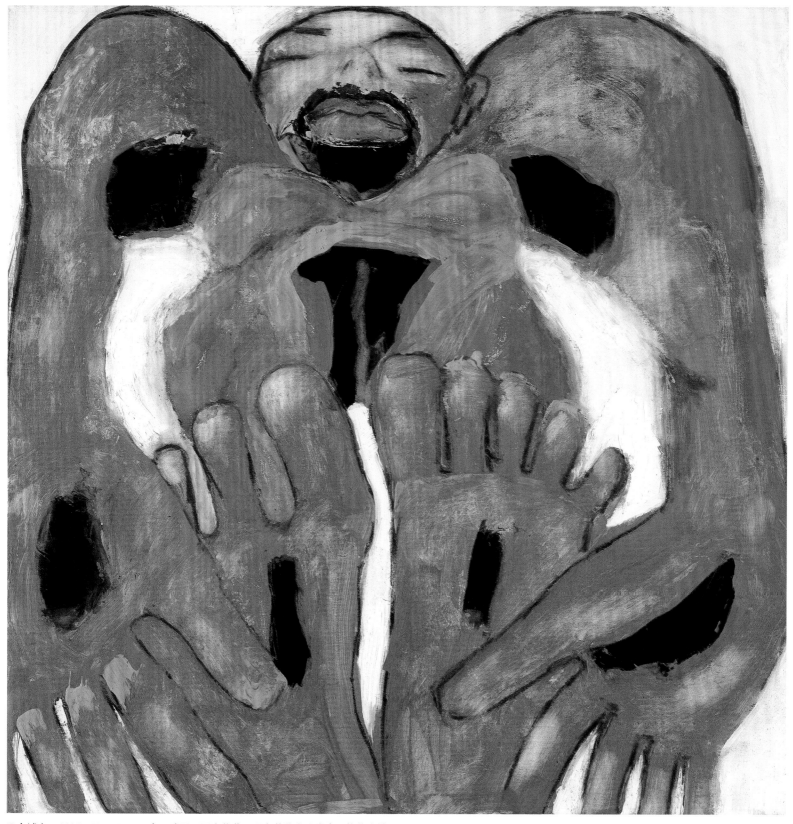

八个城市　1992，77 × 77cm，布面油画，画家收藏，现存苏黎士比肖夫贝格美术馆
Eight cities　1992，77 × 77cm，Oil on canvas，Coll.dell'artista,Courtesy Galerie Bishofberger,Zurigo
Otto città　1992，77 × 77cm，Olio su tela，Coll.dell'artista,Courtesy Galerie Bishofberger,Zurigo

字母表 1994, 67 × 48cm, 纸上彩色粉笔画, 画家收藏, 现存苏黎士比肖夫贝格美术馆
Alphabet 1994, 67 × 48cm, Pastel on paper, Coll.dell'artista,Courtesy Galerie Bishofberger,Zurigo
Alphabet 1994, 67 × 48cm, Pastello su carta, Coll.dell'artista,Courtesy Galerie Bishofberger,Zurigo

半女自在天　1994, 67 × 48cm, 纸上混合画法，画家收藏，现存苏黎士比肖夫贝格美术馆
Ardharinesvara　1994, 67 × 48cm, Mixed media on paper, Coll.dell'artista,Courtesy Galerie Bishofberger,Zurigo
Ardharinesvara　1994, 67 × 48cm, Tecnica matita su carta, Coll.dell'artista,Courtesy Galerie Bishofberger,Zurigo

缪斯女神石像　1994，200 × 300cm，湿壁画，私人收藏，现存苏黎士比肖夫贝格美术馆
lapis Muse　1994，200 × 300cm，Fresco，Coll.privata,Courtesy Galerie Bishofberger,Zurigo
lapis Muse　1994，200 × 300cm，Affresco，Coll.privata,Courtesy Galerie Bishofberger,Zurigo

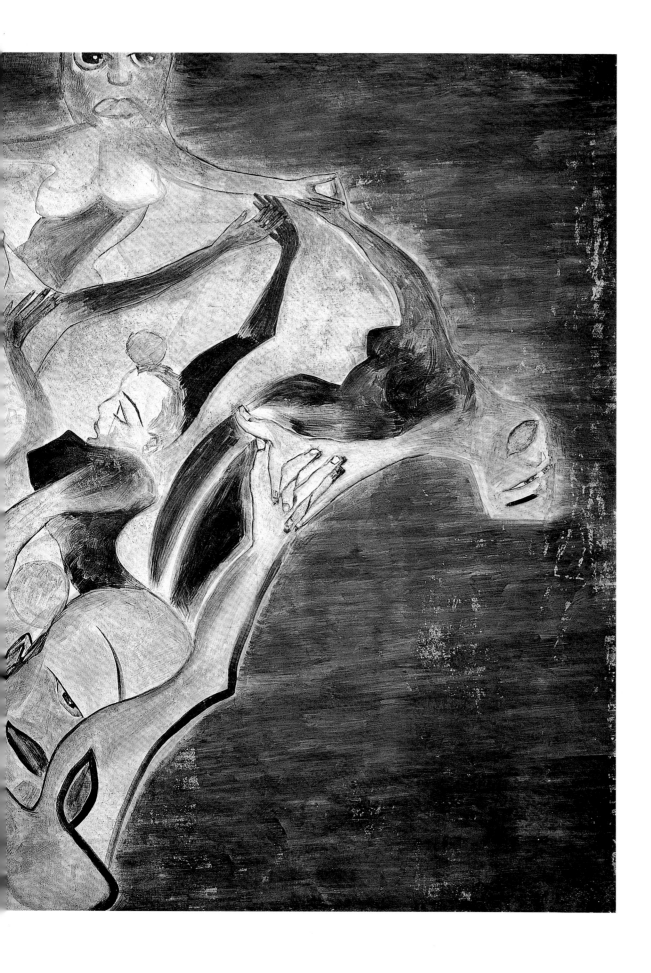

范例　1994, 67 × 48cm, 纸上铅笔画、粉彩，画家收藏，现存苏黎士比肖夫贝格美术馆

Paradigm　1994, 67 × 48cm, Pencil and pastel on paper, Coll.dell'artista,Courtesy Galerie Bishofberger,Zurigo

Paradigm　1994, 67 × 48cm, pastello e matita su carta, Coll.dell'artista,Courtesy Galerie Bishofberger,Zurigo

在别处　1994-1995, 67 × 48cm, 纸上粉彩画，私人收藏，现存苏黎士比肖夫贝格美术馆
Altrove　1994-1995, 67 × 48cm, Pastel on paper, Coll.privata,Courtesy Galerie Bishofberger,Zurigo
Altrove　1994-1995, 67 × 48cm, Pastello su carta, Coll.privata,Courtesy Galerie Bishofberger,Zurigo

山　1994-1995，67 × 48cm，纸上彩色粉笔画，私人收藏，现存苏黎士比肖夫贝格美术馆
The mountain　1994-1995，67 × 48cm, Pastel on paper, Coll.privata,Courtesy Galerie Bishofberger,Zurigo
The mountain　1994-1995，67 × 48cm, Pastello su carta, Coll.privata,Courtesy Galerie Bishofberger,Zurigo

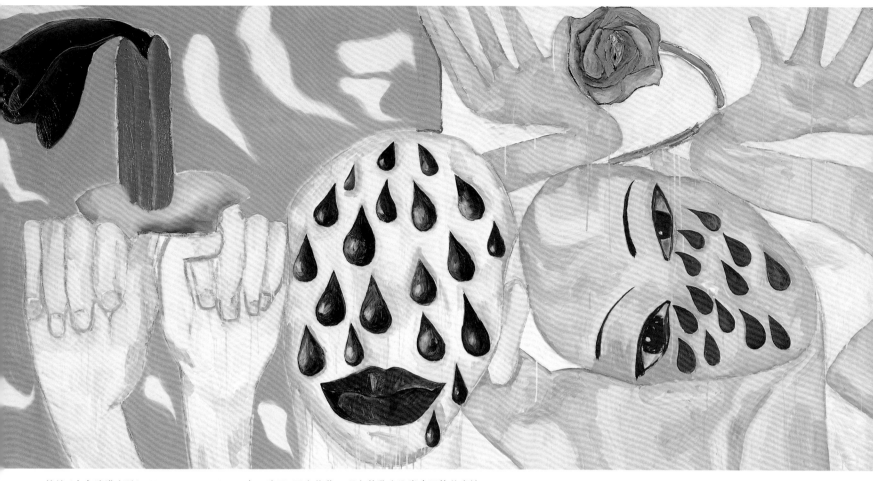

丛林（来自沙漠之歌）1995, 107 × 213cm, 布面油画, 画家收藏, 现存苏黎士比肖夫贝格美术馆
Jungle (From desert Song) 1995, 107 × 213cm, Oil on canvas, Coll.dell'artista,Courtesy Galerie Bishofberger,Zurigo
Jungle (From desert Song) 1995, 107 × 213cm, Olio su tela, Coll.dell'artista,Courtesy Galerie Bishofberger,Zurigo

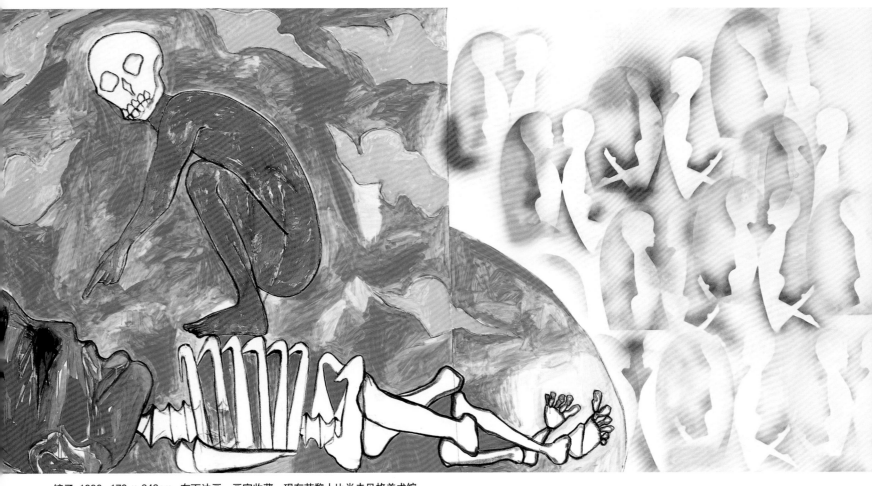

镜子 1996, 178 × 343cm, 布面油画, 画家收藏, 现存苏黎士比肖夫贝格美术馆
Mirror 1996, 178 × 343cm, Oil on canvas, Coll.dell'artista,Courtesy Galerie Bishofberger,Zurigo
Mirror 1996, 178 × 343cm, Olio su tela, Coll.dell'artista,Courtesy Galerie Bishofberger,Zurigo

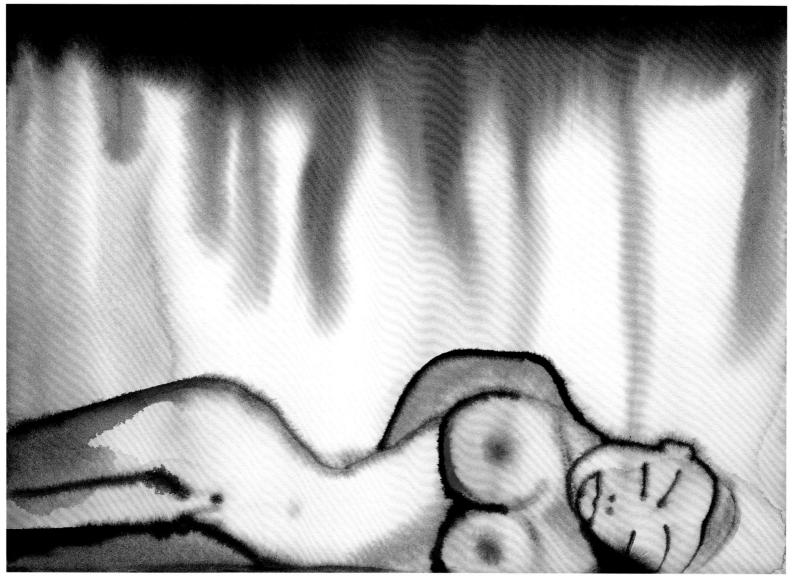

缪斯女神第五号　1996, 36 × 50.8cm, 纸上水彩画 , 画家收藏 , 现存苏黎士比肖夫贝格美术馆

Muse n.5　1996, 36 × 50.8cm, Watercolour on paper,　Coll.dell'artista,Courtesy Galerie Bishofberger,Zurigo

Muse No.5　1996, 36 × 50.8cm, Acquerello su carta, Coll.dell'artista,Courtesy Galerie Bishofberger,Zurigo

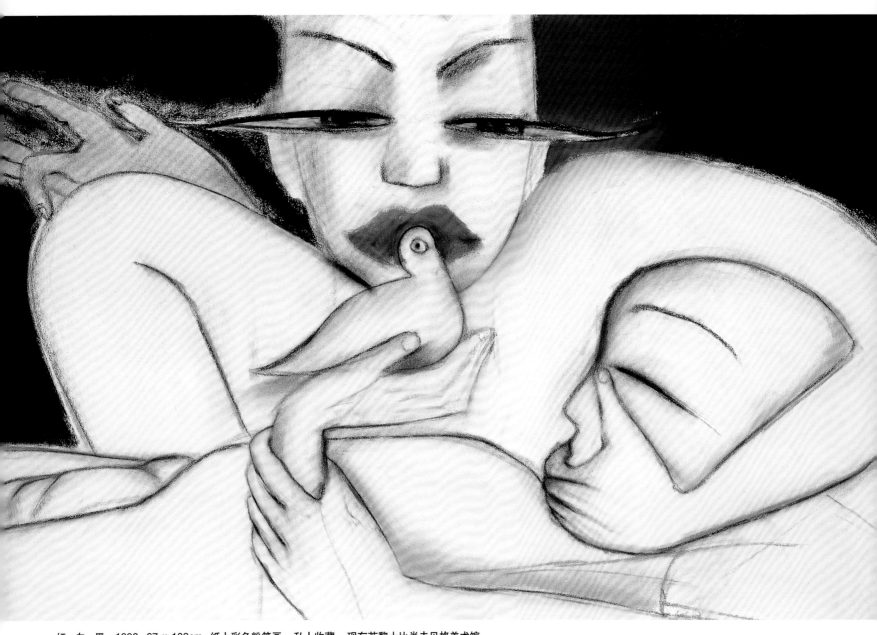

红、白、黑　1998, 67 × 102cm, 纸上彩色粉笔画，私人收藏，现存苏黎士比肖夫贝格美术馆
Red,White,Black　1998, 67 × 102cm, Pastel on paper, Coll.privata,Courtesy Galerie Bishofberger,Zurigo
Red,White,Black　1998, 67 × 102cm, Pastello su carta, Coll.privata,Courtesy Galerie Bishofberger,Zurigo

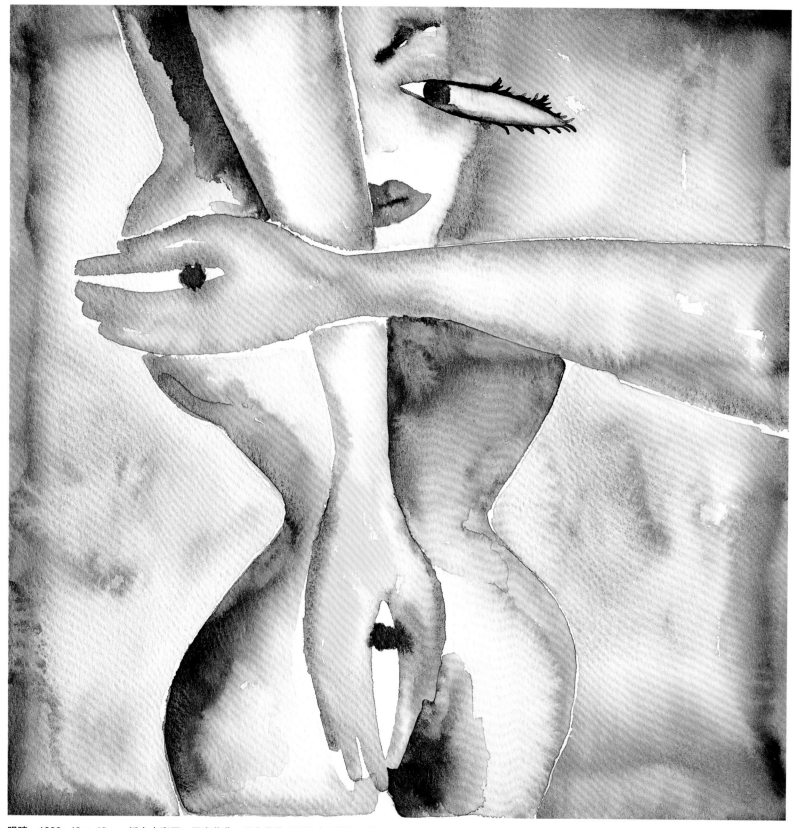

眼睛 1999, 42 × 42cm, 纸上水彩画，画家收藏，现存苏黎士比肖夫贝格美术馆

Eyes 1999, 42 × 42cm, Watercolour on paper, Coll.dell'artista,Courtesy Galerie Bishofberger,Zurigo

Occhi 1999, 42 × 42cm, Acquerello su carta, Coll.dell'artista,Courtesy Galerie Bishofberger,Zurigo

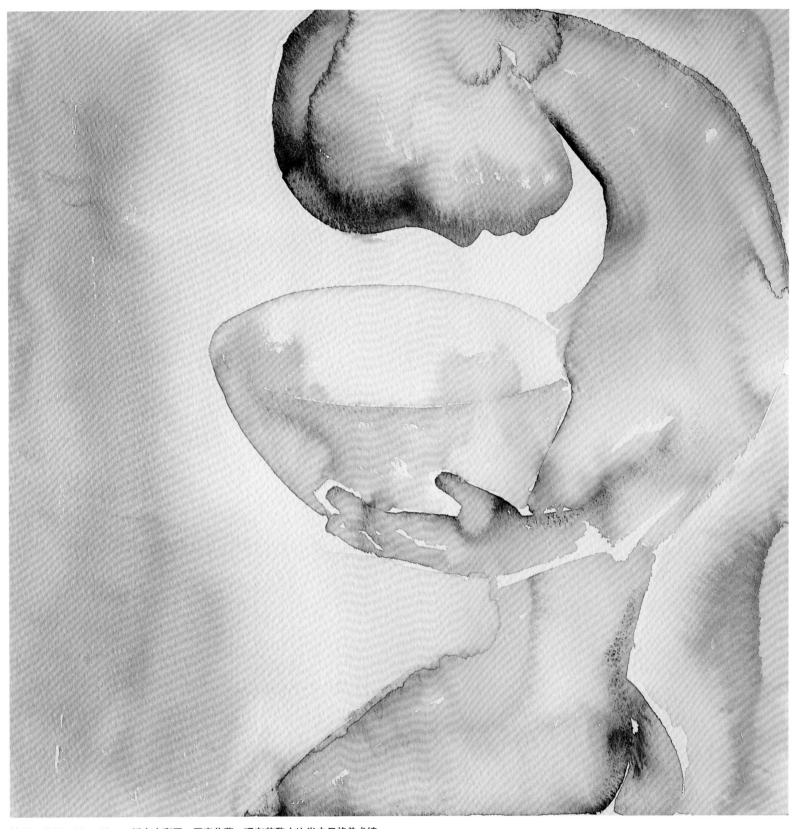

镜子　1999，42 × 42cm，纸上水彩画，画家收藏，现存苏黎士比肖夫贝格美术馆
Specchio　1999，42 × 42cm，Watercolour on paper，Coll.dell'artista,Courtesy Galerie Bishofberger,Zurigo
Specchio　1999，42 × 42cm，Acquerello su carta，Coll.dell'artista,Courtesy Galerie Bishofberger,Zurigo

Enzo Cucchi
意大利超前卫艺术

恩佐·库基
Enzo Cucchi

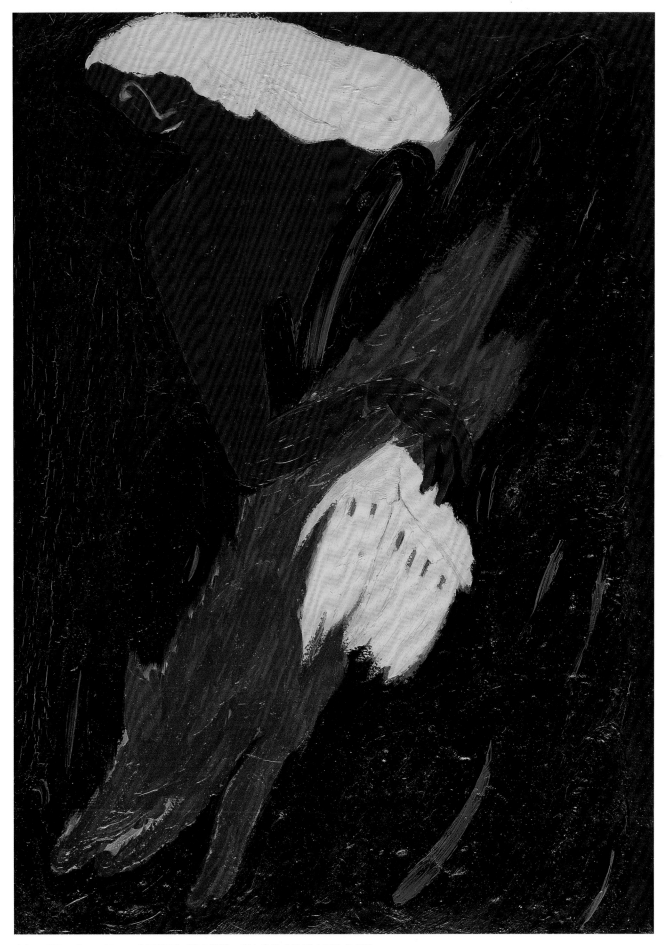

大灯　1977，35 × 25cm，布面油画，画家收藏，现存苏黎士比肖夫贝格美术馆
Big lamp　1977，35 × 25cm，Oil on canvas, Coll.dell'artista,Courtesy Galerie Bishofberger,Zurigo
Lumella　1977，35 × 25cm，Olio su tela, Coll.dell'artista,Courtesy Galerie Bishofberger,Zurigo

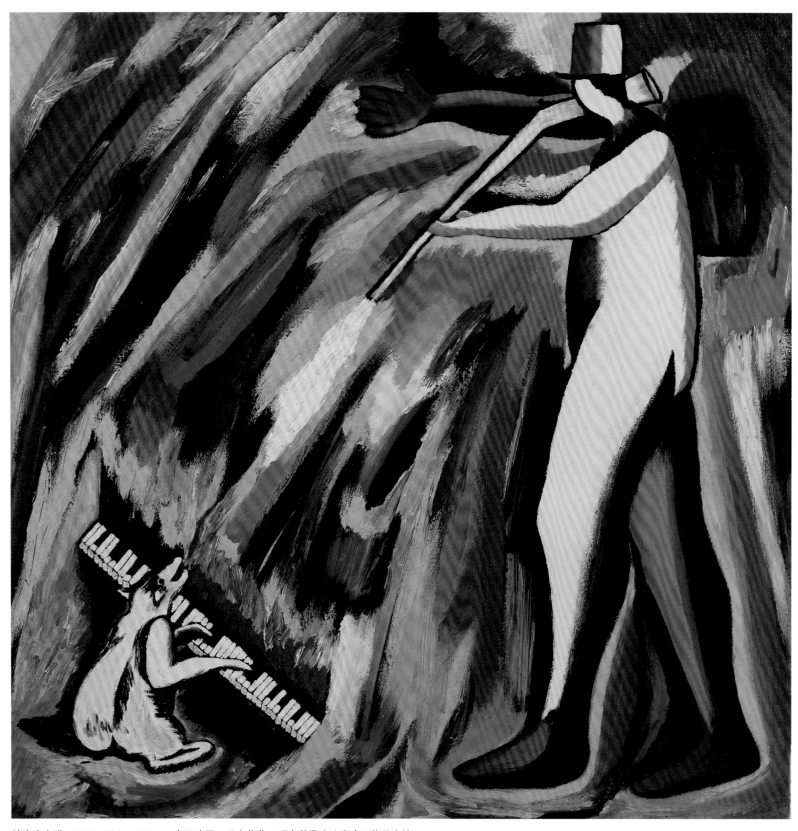

地中海之猎　1979，100 × 100cm，布面油画，私人收藏，现存苏黎士比肖夫贝格美术馆
To hunt mediterranean　1979，100 × 100cm, Oil on canvas, Coll.privata,Courtesy Galerie Bishofberger,Zurigo
Caccia mediterranea　1979，100 × 100cm, Olio su tela, Coll.privata,Courtesy Galerie Bishofberger,Zurigo

房屋在倒退　1979-1980，200 × 150cm，布面油画和瓷釉，私人收藏，现存苏黎士比肖夫贝格美术馆
The homes go behind　1979-1980，200 × 150cm, Oil on canvas with ceramic, Coll.privata,Courtesy Galerie Bishofberger,Zurigo
Le case vanno indietro　1979-1980，200 × 150cm, Olio su tela con ceramica, Coll.privata,Courtesy Galerie Bishofberger,Zurigo

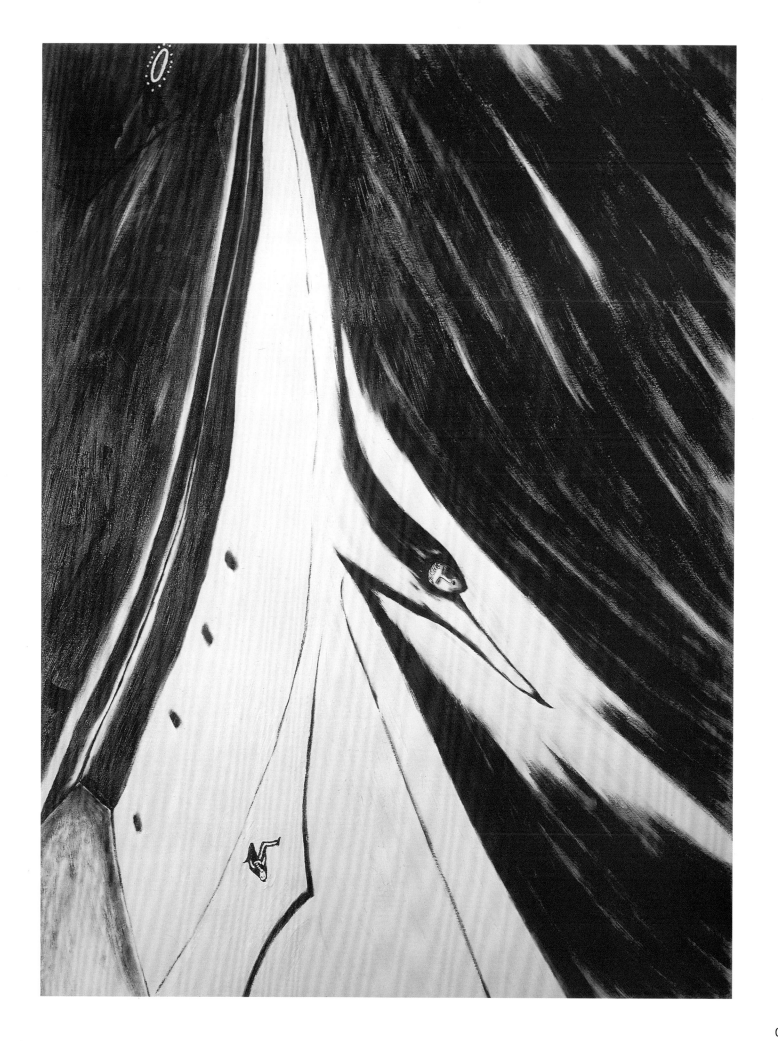

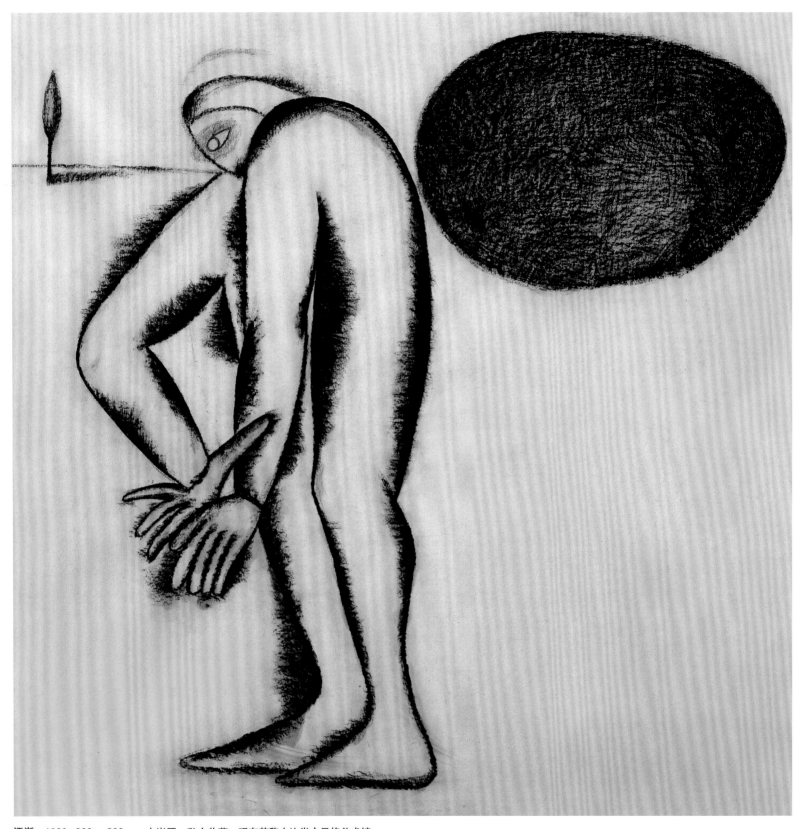

逐渐　1980, 200 × 200cm, 木炭画，私人收藏，现存苏黎士比肖夫贝格美术馆
Step by step　1980, 200 × 200cm, Charcoal on paper, Coll.privata,Courtesy Galerie Bishofberger,Zurigo
A mano a mano　1980, 200 × 200cm, Carboncino su carta, Coll.privata,Courtesy Galerie Bishofberger,Zurigo

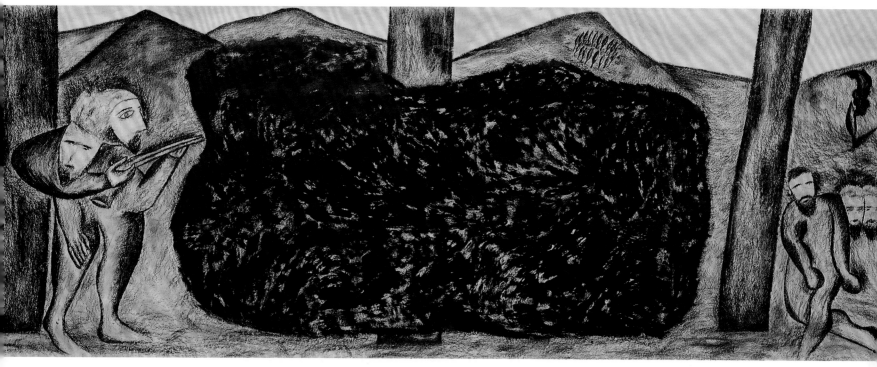

石头车　1980, 200 × 525cm, 裱在布上的木炭画，私人收藏，现存苏黎士比肖夫贝格美术馆
Wagon of stone　1980, 200 × 525cm, Charcoal on paper mounted on canva, Coll.privata,Courtesy Galerie Bishofberger,Zurigo
Carro di pietra　1980, 200 × 525cm, Carboncino su carta montato su tel, Coll.privata,Courtesy Galerie Bishofberger,Zurigo

大海的夜色景象　1980，206 × 357cm，布面油画，私人收藏，现存苏黎士比肖夫贝格美术馆
The maritime scenery during night　1980，206 × 357cm, Oil on canvas, Coll.privata,Courtesy Galerie Bishofberger,Zurigo
Quadro al buio sul mare　1980，206 × 357cm, Olio su tela, Coll.privata,Courtesy Galerie Bishofberger,Zurigo

无题　1980，30 × 30cm，布面油画，私人收藏，现存苏黎士比肖夫贝格美术馆
Untitled　1980，30 × 30cm，Oil on canvas，Coll.privata,Courtesy Galerie Bishofberger,Zurigo
Senza titolo　1980，30 × 30cm，Olio su tela，Coll.privata,Courtesy Galerie Bishofberger,Zurigo

耻辱　1980，208 × 135cm，布面油画，私人收藏，现存苏黎士比肖夫贝格美术馆
The stigmata　1980，208 × 135cm, Oil on canvas, Coll.privata,Courtesy Galerie Bishofberger,Zurigo
Le stimmate　1980，208 × 135cm, Olio su tela, Coll.privata,Courtesy Galerie Bishofberger,Zurigo

大山的沉思　1982, 275 × 350cm, 布面油画, 私人收藏, 现存苏黎士比肖夫贝格美术馆

The thinking of mountain　1982, 275 × 350cm, Oil on canvas, Coll.privata,Courtesy Galerie Bishofberger,Zurigo

Il pensiero della montagna　1982, 275 × 350cm, Olio su tela, Coll.privata,Courtesy Galerie Bishofberger,Zurigo

消逝的罗马　1983，240 × 310cm，布面油画，私人收藏，现存苏黎士比肖夫贝格美术馆
Disappeared Rome　1983，240 × 310cm，Oil on canvas，Coll.privata,Courtesy Galerie Bishofberger,Zurigo
Roma morta　1983，240 × 310cm，Olio su tela，Coll.privata,Courtesy Galerie Bishofberger,Zurigo

波浪的叹息　1983，300 × 400cm，布面油画，私人收藏，现存苏黎士比肖夫贝格美术馆
The sing of a wave　1983，300 × 400cm，Oil on canvas，Coll.privata,Courtesy Galerie Bishofberger,Zurigo
Il sospiro di un'onda　1983，300 × 400cm，Olio su tela，Coll.privata,Courtesy Galerie Bishofberger,Zurigo

大地之巨画　　1983，300 × 600cm，木材混合画法，私人收藏，现存苏黎士比肖夫贝格美术馆

Great painting of the world　　1983，300 × 600cm，Mixed media on wood，Coll.privata,Courtesy Galerie Bishofberger,Zurigo

Grande disegno della terra　　1983，300 × 600cm，Misto su legno，Coll.privata,Courtesy Galerie Bishofberger,Zurigo

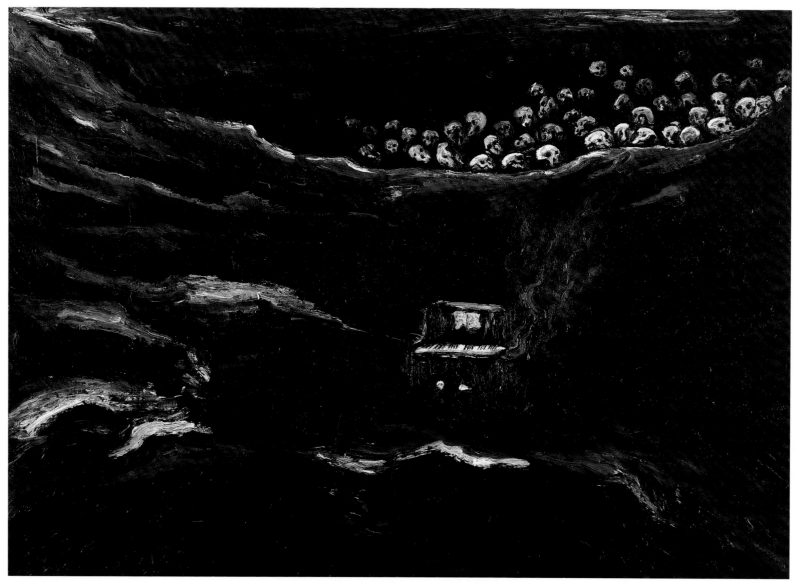

发生在冒着黑色火焰的钢琴声中　1983, 207 × 291cm, 布面油画，私人收藏，现存苏黎士比肖夫贝格美术馆
Following the flame of the pianoforte　1983, 207 × 291cm, Oil on canvas, Coll.privata,Courtesy Galerie Bishofberger,Zurigo
Succede ai pianoforti di fiamma nera　1983, 207 × 291cm, Olio su tela, Coll.privata,Courtesy Galerie Bishofberger,Zurigo

无题　1986，290 × 390cm，布上涂油、金属片和铜，私人收藏，现存苏黎士比肖夫贝格美术馆
Untitled　1986，290 × 390cm，Oil，sheets of metal and copper on canvas，Coll.privata,Courtesy Galerie Bishofberger,Zurigo
Senza titolo　1986，290 × 390cm，Olio，fogli di metallo e rame su tela，Coll.privata,Courtesy Galerie Bishofberger,Zurigo

画就是树木　1990-1993，64 × 58cm，混合画法，私人收藏，现存苏黎士比肖夫贝格美术馆
The painting are trees　1990-1993，64 × 58cm，Oli and gesso on canvas ink on paper and ceramic，Coll.privata,Courtesy Galerie Bishofberger,Zurigo
I quadri sono alberi　1990-1993，64 × 58cm，Olio e gesso su tela,inchiostro su carta e ceramica，Coll.privata,Courtesy Galerie Bishofberger,Zurigo

季节之口　1995, 200 × 230cm, 湿壁画，私人收藏，现存苏黎士比肖夫贝格美术馆
The seasonal mouth　1995, 200 × 230cm, Fresco, Coll.privata,Courtesy Galerie Bishofberger,Zurigo
La Bocca della stagione　1995, 200 × 230cm, Affresco, Coll.privata,Courtesy Galerie Bishofberger,Zurigo

头心　1995, 296.5 × 276cm，布面油画，私人收藏，现存苏黎士比肖夫贝格美术馆

Heart of head　1995, 296.5 × 276cm, Charcoal, oli resin on paper mounted on canvas, Coll.privata,Courtesy Galerie Bishofberger,Zurigo

Cuore di testa　1995, 296.5 × 276cm, Carboncino, olio, resina su carta montata su tela, Coll.privata,Courtesy Galerie Bishofberger,Zurigo

葡萄树　1996, 25.3 × 25.1cm, 布面油画，私人收藏，现存苏黎士比肖夫贝格美术馆
Grape　1996, 25.3 × 25.1cm, Oil on canvas, Coll.privata,Courtesy Galerie Bishofberger,Zurigo
Uvo　1996, 25.3 × 25.1cm, Olio su tela, Coll.privata,Courtesy Galerie Bishofberger,Zurigo

飞行中的光线　1996，100 × 120cm，湿壁画，私人收藏，现存苏黎士比肖夫贝格美术馆
Light in flight　1996，100 × 120cm，Fresco，Coll.privata,Courtesy Galerie Bishofberger,Zurigo
Luce in Volo　1996，100 × 120cm，Affresco，Coll.privata,Courtesy Galerie Bishofberger,Zurigo

射向阴处的光线　1996，120 × 150cm，板上混合画法，画家收藏，现存苏黎士比肖夫贝格美术馆
The light going to shade　1996，120 × 150cm，Mixed media on wood，Coll.dell'artista,Courtesy Galerie Bishofberger,Zurigo
La Luce va all'Ombra　1996，120 × 150cm，Tecnica mista su tavola，Coll.dell'artista,Courtesy Galerie Bishofberger,Zurigo

洋娃娃　1996，30 × 40cm，布面油画，私人收藏，现存苏黎士比肖夫贝格美术馆
Big doll　1996，30 × 40cm，Oil on canvas，Coll.privata,Courtesy Galerie Bishofberger,Zurigo
Bambola alata　1996，30 × 40cm，Olio su tela，Coll.privata, Courtesy Galerie Bishofberger,Zurigo

可爱的家乡　1996, 100 × 120cm, 湿壁画，画家收藏，现存苏黎士比肖夫贝格美术馆
Lovely country　1996, 100 × 120cm, Fresco, Coll.dell'artista,Courtesy Galerie Bishofberger,Zurigo
Paese amato　1996, 100 × 120cm, Affresco, Coll.dell'artista,Courtesy Galerie Bishofberger,Zurigo

烟...眼睛　1996，30 × 35cm，布面油画，画家收藏，现存苏黎士比肖夫贝格美术馆
smoke... Eyes　1996，30 × 35cm, Oil on canvas, Coll.dell'artista,Courtesy Galerie Bishofberger,Zurigo
Fumo...occhio　1996，30 × 35cm, Olio su tela, Coll.dell'artista,Courtesy Galerie Bishofberger,Zurigo

中了妖术的柱子　1997，209 × 246cm，布面油画，画家收藏，现存苏黎士比肖夫贝格美术馆
Bewitched column　1997，209 × 246cm，Oil on canvas，Coll.dell'artista,Courtesy Galerie Bishofberger,Zurigo
Colonna stregata　1997，209 × 246cm，Olio su tela，Coll.dell'artista,Courtesy Galerie Bishofberger,Zurigo

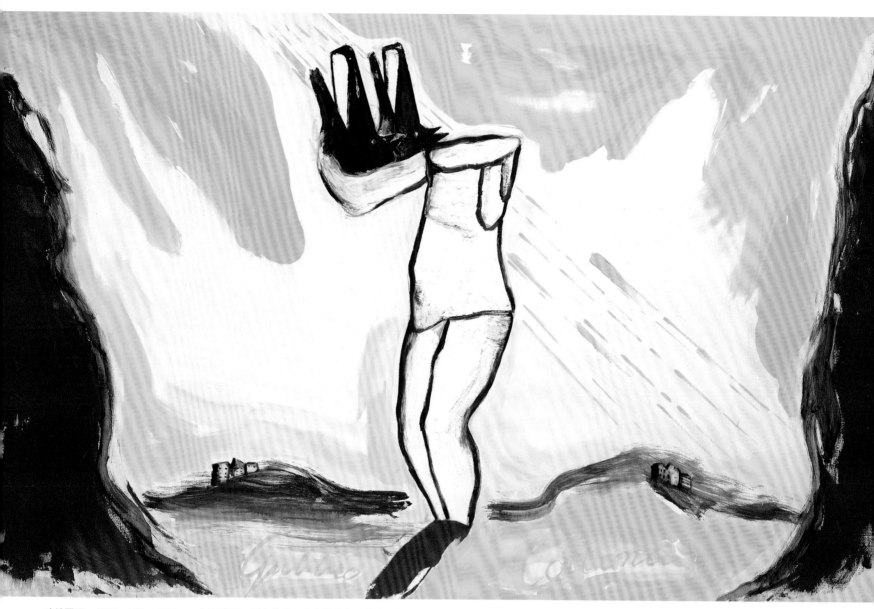

凶杀匿尸　1997，168 × 267cm，布面油画，画家收藏，现存苏黎士比肖夫贝格美术馆
The crime was hidden　1997，168 × 267cm，Oil on canvas，Coll.dell'artista,Courtesy Galerie Bishofberger,Zurigo
Lupare　1997，168 × 267cm，Olio su tela，Coll.dell'artista,Courtesy Galerie Bishofberger,Zurigo

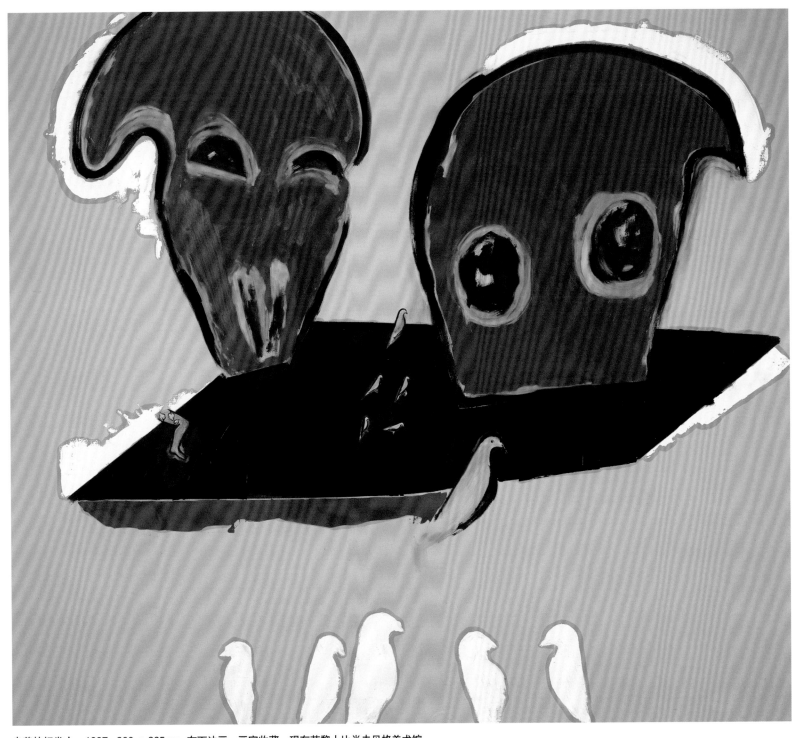

坐着的红发人　1997，300 × 365cm，布面油画，画家收藏，现存苏黎士比肖夫贝格美术馆
Sitting man with red hair　1997, 300 × 365cm, Oil on canvas, Coll.dell'artista,Courtesy Galerie Bishofberger,Zurigo
Rosso seduto　1997, 300 × 365cm, Olio su tela, Coll.dell'artista,Courtesy Galerie Bishofberger,Zurigo

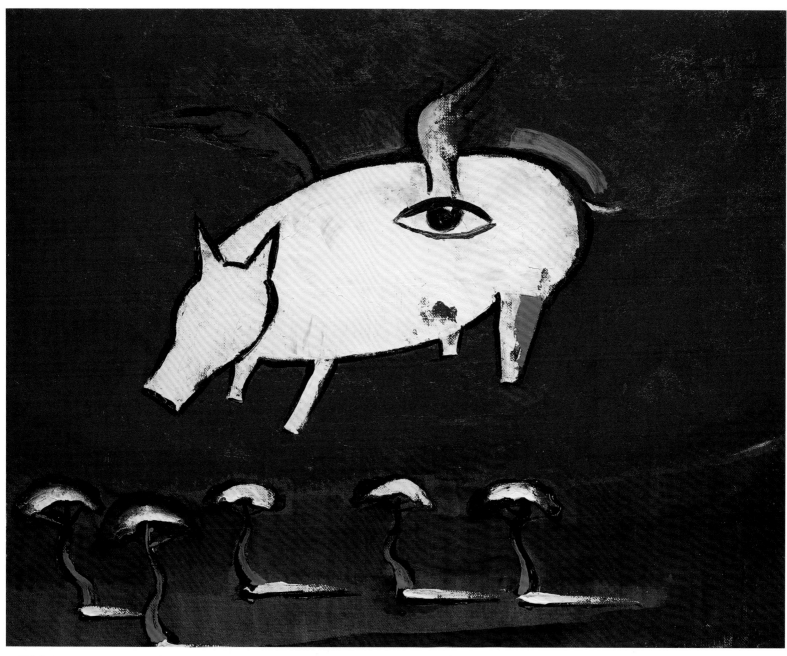

飞越地中海　1997, 72 × 91cm, 布面油画，画家收藏，现存苏黎士比肖夫贝格美术馆
To fly mediterranean　1997, 72 × 91cm, Oil on canvas, Coll.dell'artista,Courtesy Galerie Bishofberger,Zurigo
Volo mediterraneo　1997, 72 × 91cm, Olio su tela, Coll.dell'artista,Courtesy Galerie Bishofberger,Zurigo

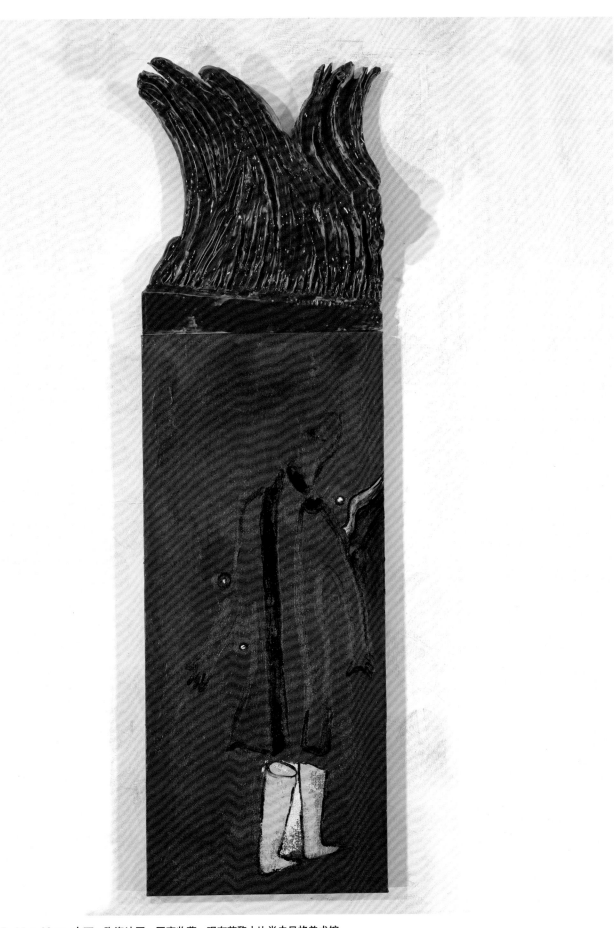

亲昵　1997，85 × 38cm，布面・陶瓷油画，画家收藏，现存苏黎士比肖夫贝格美术馆
Familiarty　1997，85 × 38cm，Oil on canvas and ceramic，Coll.dell'artista,Courtesy Galerie Bishofberger,Zurigo
Dimestichezza　1997，85 × 38cm，Olio su tela e ceramica，Coll.dell'artista,Courtesy Galerie Bishofberger,Zurigo

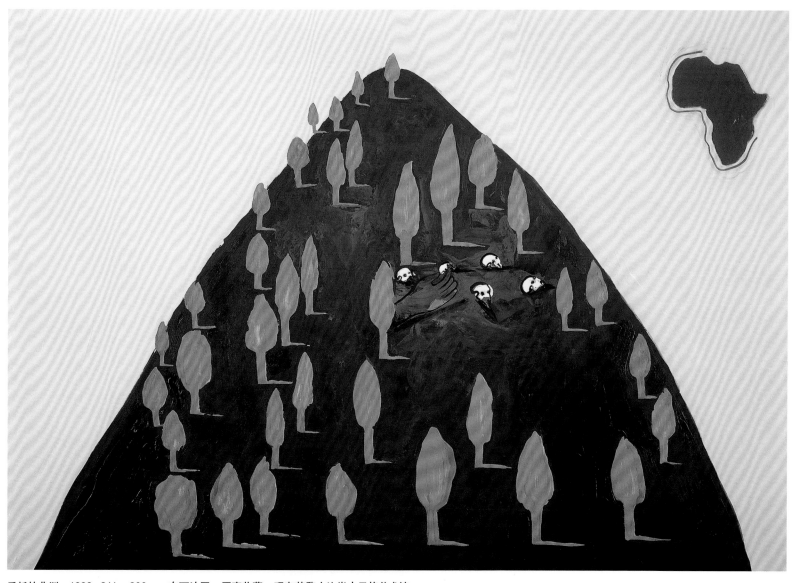

乔托的非洲　1998, 211 × 300cm, 布面油画，画家收藏，现存苏黎士比肖夫贝格美术馆

Giotto of Afica　1998, 211 × 300cm, Oil on canvas, Coll.dell'artista,Courtesy Galerie Bishofberger,Zurigo

Africa di Giotto　1998, 211 × 300cm, Olio su tela, Coll.dell'artista,Courtesy Galerie Bishofberger,Zurigo

有限的书 1998-1999, 105 × 145cm, 布面油画，画家收藏，现存苏黎士比肖夫贝格美术馆
Conditioned book 1998-1999, 105 × 145cm, Oil on canvas, Coll.dell'artista,Courtesy Galerie Bishofberger,Zurigo
Libro condizionato 1998-1999, 105 × 145cm, Olio su tela, Coll.dell'artista,Courtesy Galerie Bishofberger,Zurigo

Nicola De Maria
意大利超前卫艺术

尼古拉·德·玛利亚
Nicola De Maria

七个月亮（当"七个月亮"出现时，墙倒塌） 1975, 1980年Kunsthalle Basel
Seven moons (When these seven moons turn up,wall will break down) 1975, Kunsthalle Basel,1980
Le sette lune(Quando 'le sette lune' appare,il muro cade) 1975, Kunsthalle Basel,1980

传说 1976-1977，米兰 Franco Toselli 画廊
The legend 1976-1977， Gallery Franco Toselli, Milan
La Leggenda 1976-1977, Galleria Franco Toselli, Milano

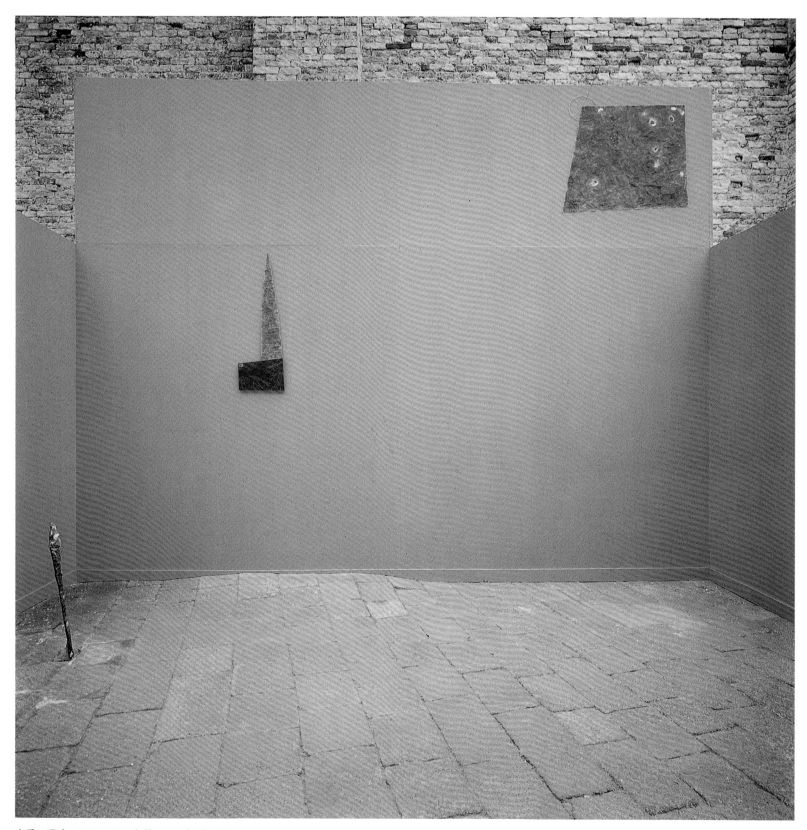

音乐－眼睛　1978，1980 年第 39 届威尼斯双年展
Music-Eyes　1978，the 39th Biennale of Venice,1980
Musica-Occhi　1978，39° Biennale di Venezia,1980

遮盖宇宙的画　1979-1980，1981 年都灵 Giorgio Persano 画廊展出
Painting that covers universe　1979-1980，Show at the Gallery Giorgio Persano,Torino,1981
Dipinti che avvolgono l'universo　1979-1980，Mostra alla Galleria Giorgio Persano,Torino,1981

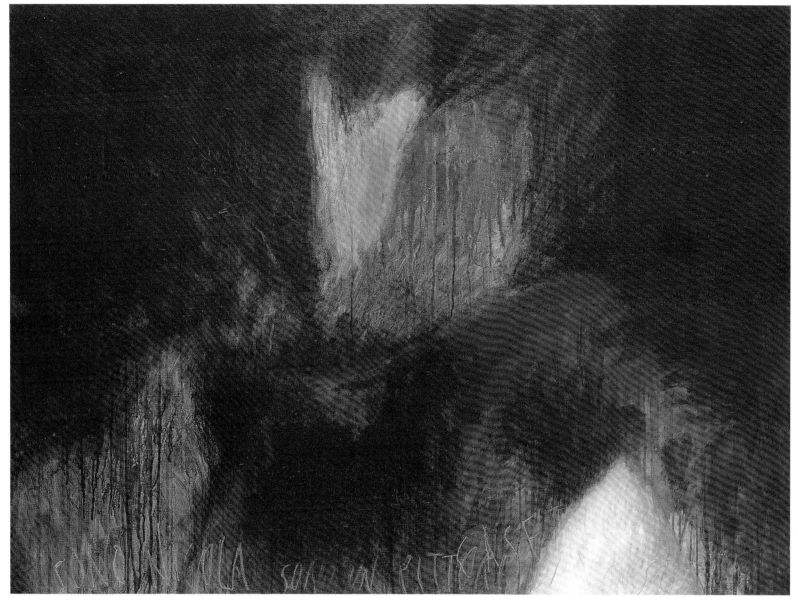

我是尼古拉　1981，110 × 150cm，布面油画，罗马 Benazzo 收藏
I am Nicola　1981，110 × 150cm，Oil on canvas，Coll.Benazzo,Rome
Sono Nicola　1981，110 × 150cm，Olio su tela，Coll.Benazzoi,Roma

爆裂的塔楼－7月14－值班画廊　1982年Spoleto Marilena Bonomog 画廊展出

Explosion Tower-July 14-Gallery on duty　Show at the Gallery Marilena Bonomo, Spoleto,1982

Torre a scoppio-14 luglio Galleria del tuono　Mostra alla Galleria Marilena Bonomo, Spoleto,1982

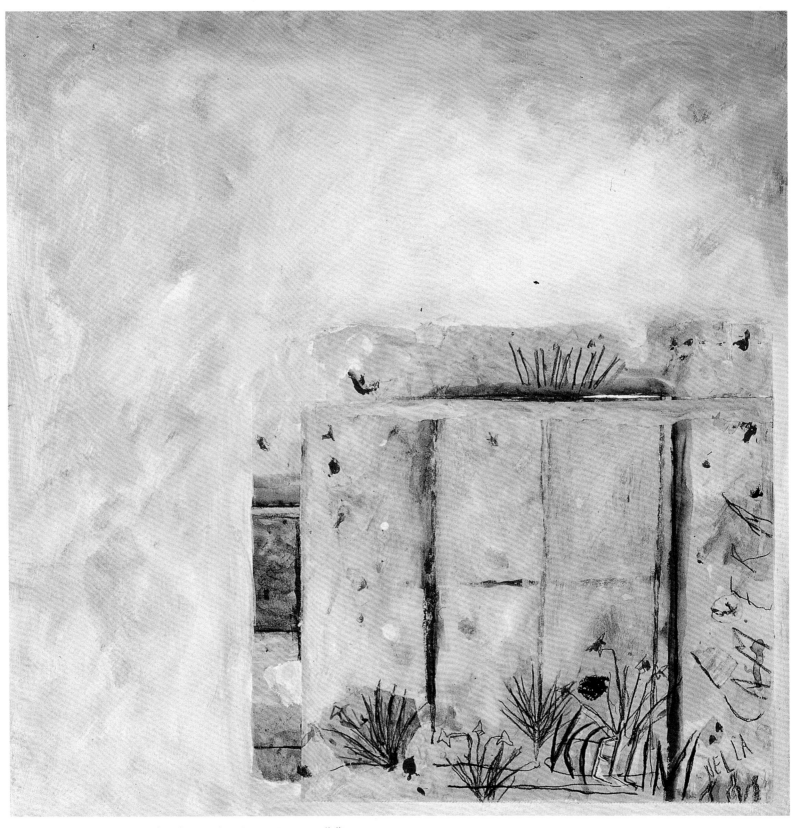

笼中之鸟 1982，50 × 50cm，布面油画、混合画法，罗马 Benazzo 收藏
Birds within chamber 1982, 50 × 50cm, Oil and mixed media on canvas, Coll.Benazzo,Rome
Uccellini nella camera 1982, 50 × 50cm, Olio e tecnica mista su tela, Coll.Benazzo,Roma

长发——荷马史诗中的妇女们　1983, 215 × 180 cm, Krefeld Haus Lang 博物馆
Very very Long hairs-Onero women　1983, 215 × 180 cm, Acrylic on canvas, Showed at the Museum Haus Lang,krefeld, courtesy Marilena Bonomo
Capelli lunghissimi-Donne di Omero　1983, 215 × 180 cm, Acrilico su tela, Esposto al Museum Haus Lang,krefeld,courtesy Marilena Bonomo

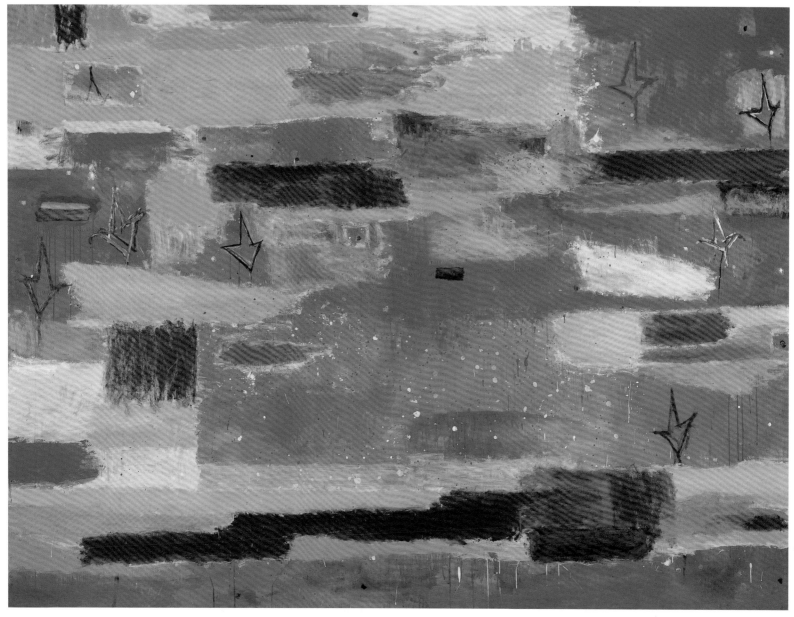

花的王国 1984-1985, 240 × 320cm, 布面混合画法, 莫德纳 Mazzoli 皇家画廊

Kingdom of flowers 1984-1985, 240 × 320cm, Mixed media on canvas, Courtesy Gallery Mazzoli, Modena

Regno dei fiori 1984-1985, 240 × 320cm, Tecnica mista su tela, Courtesy Galleria Mazzoli, Modena

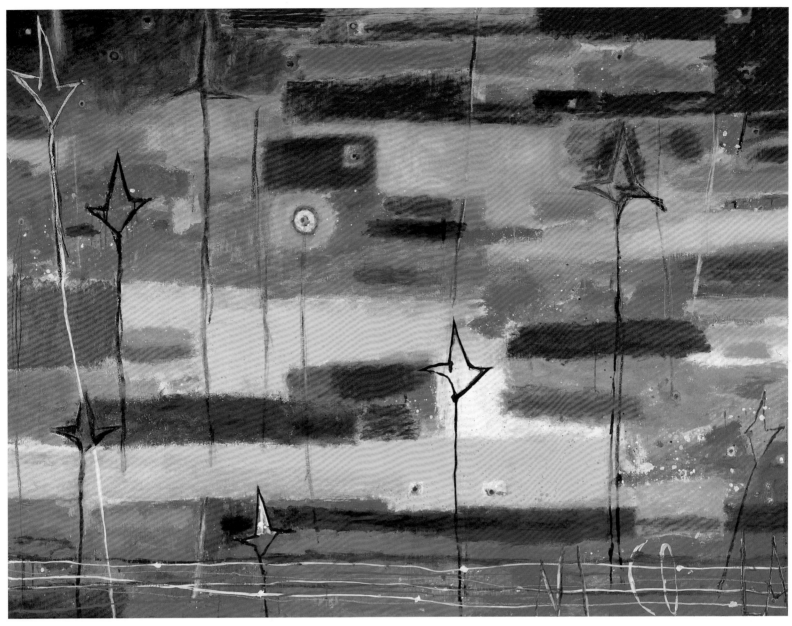

花的王国　1984-1985，180 × 240cm，布面混合画法，莫德纳 Mazzoli 皇家画廊
Kingdom of flowers　1984-1985，180 × 240cm, Mixed media on canvas, Courtesy Gallery Mazzoli,Modena
Regno dei fiori　1984-1985，180 × 240cm, Tecnica mista su tela, Courtesy Galleria Mazzoli,Modena

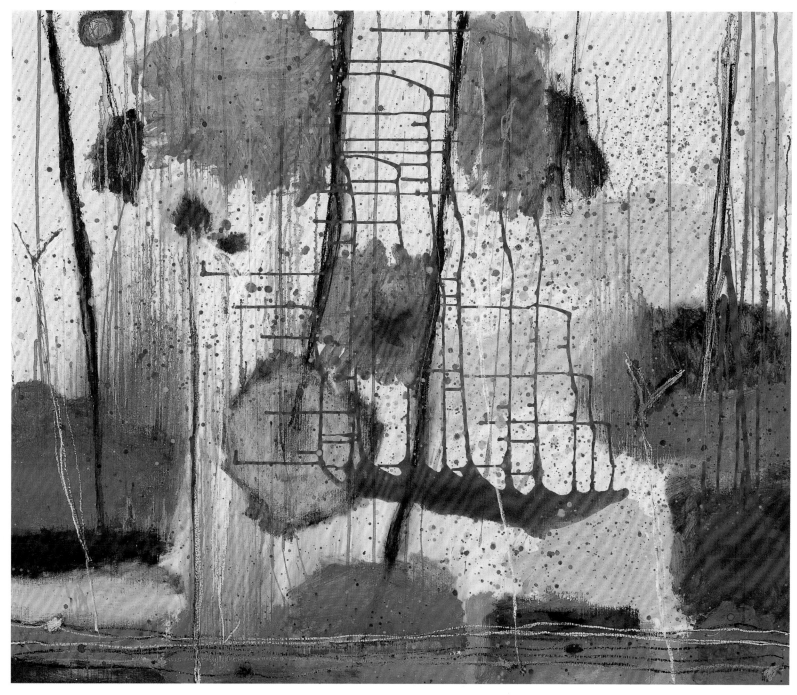

花的王国　1984-1985，100 × 120cm，布面混合画法，莫德纳 Mazzoli 皇家画廊
Kingdom of flowers　1984-1985，100 × 120cm，Mixed media on canvas，Courtesy Gallery Mazzoli,Modena
Regno dei fiori　1984-1985，100 × 120cm，Tecnica mista su tela，Courtesy Galleria Mazzoli,Modena

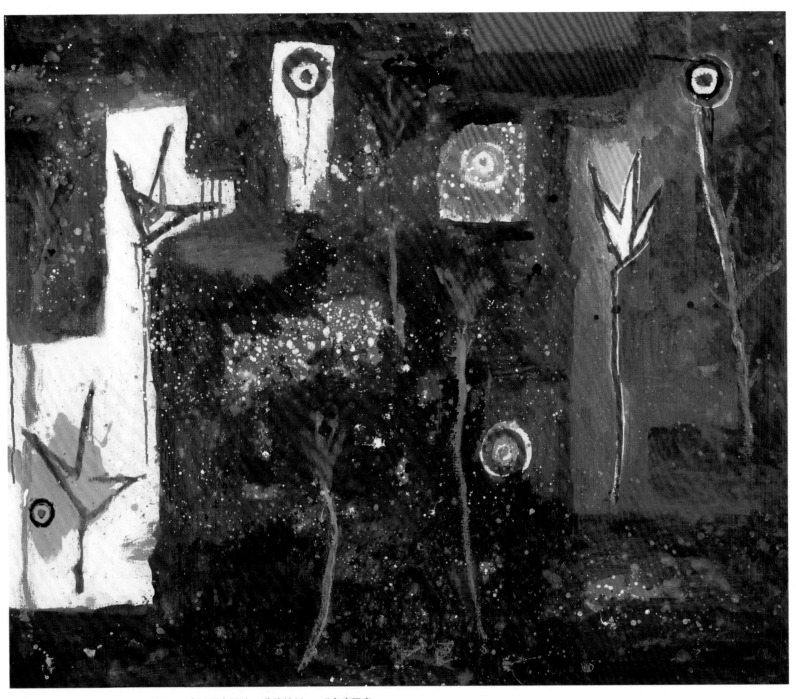

花的王国　1984-1985，100 × 120cm，布面混合画法，莫德纳 Mazzoli 皇家画廊
Kingdom of flowers　1984-1985，100 × 120cm, Mixed media on canvas, Courtesy Gallery Mazzoli,Modena
Regno dei fiori　1984-1985，100 × 120cm, Tecnica mista su tela, Courtesy Galleria Mazzoli,Modena

笑容　1984-1985，190 × 140cm，布面混合画法，莫德纳 Mazzoli 皇家画廊
Smiling face　1984-1985，190 × 140cm, Mixed media on canvas, Courtesy Gallery Mazzoli,Modena
Sorridi faccia　1984-1985，190 × 140cm, Tecnica mista su tela, Courtesy Galleria Mazzoli,Modena

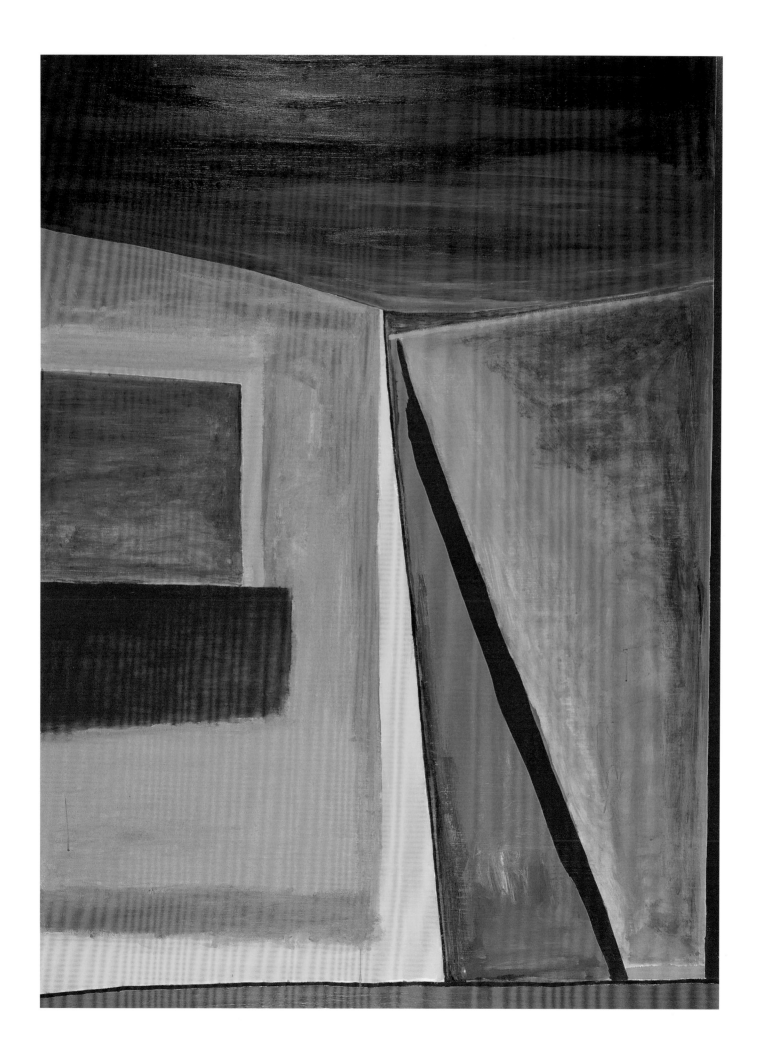

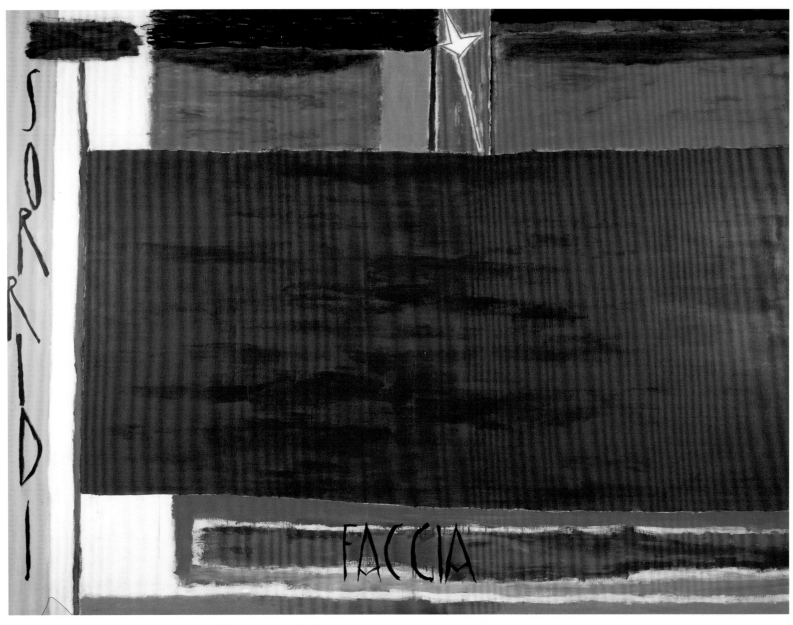

笑容　1985，240 × 320cm，布面混合画法，莫德纳 Mazzoli 皇家画廊
Smiling face　1985，240 × 320cm，Mixed media on canvas, Courtesy Gallery Mazzoli,Modena
Sorridi faccia　1985，240 × 320cm，Tecnica mista su tela, Courtesy Galleria Mazzoli,Modena

音乐眼睛　1984-1985，100 × 120cm，布面混合画法，莫德纳 Mazzoli 皇家画廊
For musical eye　1984-1985, 100 × 120cm, Mixed media on canvas, Courtesy Gallery Mazzoli,Modena
Per musica occhi　1984-1985, 100 × 120cm, Tecnica mista su tela, Courtesy Galleria Mazzoli,Modena

没有炸弹的宇宙，花的王国　1986, Amis 画室展出 (Jacqueline Meersman e Ann Van Keer),Gent
The word without bomb, the world of flowers　1986, Show at Chamber of Amis(Jacqueline Meersman e Ann Van Keer), Gent
L'universo senza bombe il Regno dei fiori　1986, Mostra 'Chambes d' Amis(casa di Jacqueline Meersman e Ann Van Keer), Gent

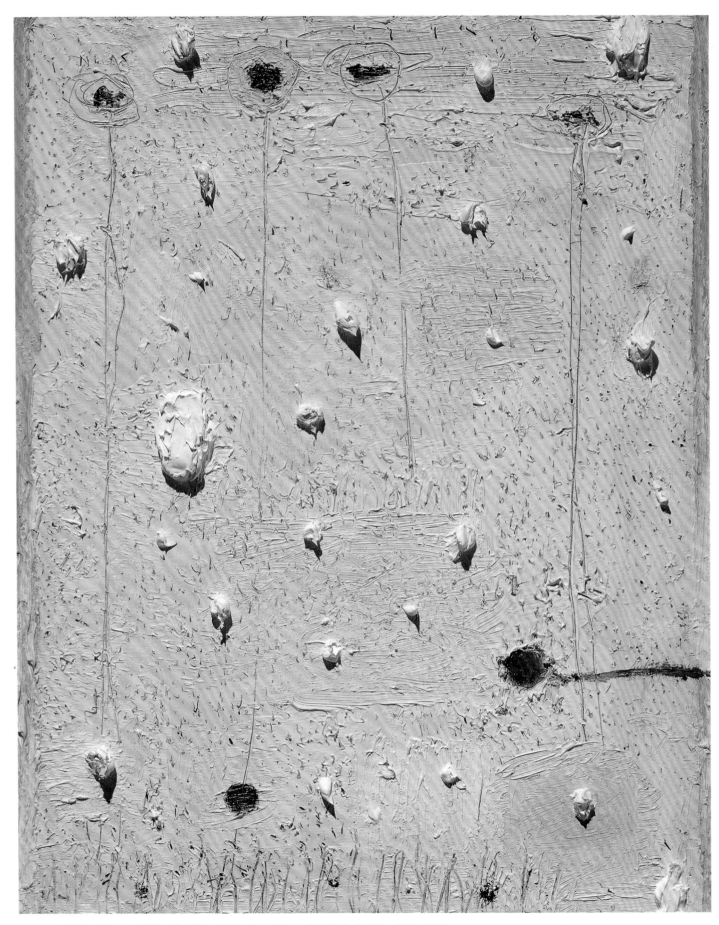

美丽天使的欢快头像，天使的情感和荣耀　1986, 50 × 40cm, 布面油画，米兰 Cardi 皇家画廊
The cheerful head of a beautiful angel-Angelic passion and glory　1986, 50 × 40cm, Oil on canvas, Courtesy Gallery Cardi,Milan
La Testa Allegra di un Angelo Bello-Passione e gloria angelica　1986, 50 × 40cm, Olio su tela, Courtesy Gallery Cardi,Milano

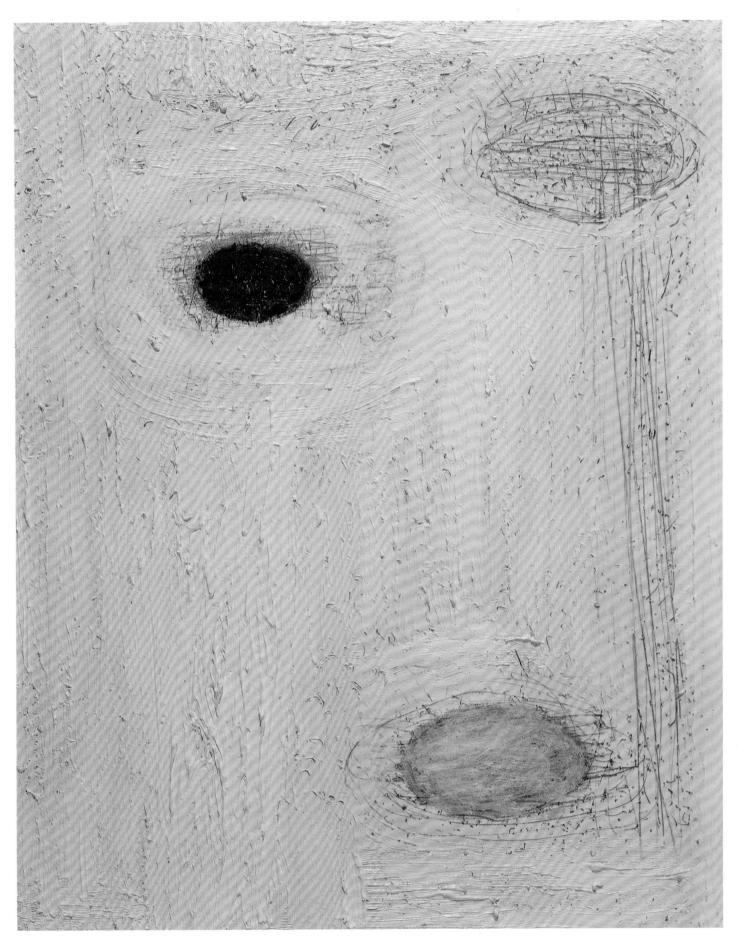

美丽天使的欢快头像，亲切无比的天使头像　1987，50 × 40cm，布面油画，米兰 Cardi 皇家画廊
The cheerful head of a beautiful angel,very very sweet angelic face　1987，50 × 40cm，Oil on canvas，Courtesy Gallery Cardi,Milan
La testa allegra di un angelo bello,testa angelica dolcissima　1987，50 × 40cm，Olio su tela，Courtesy Galleria Cardi,Milano

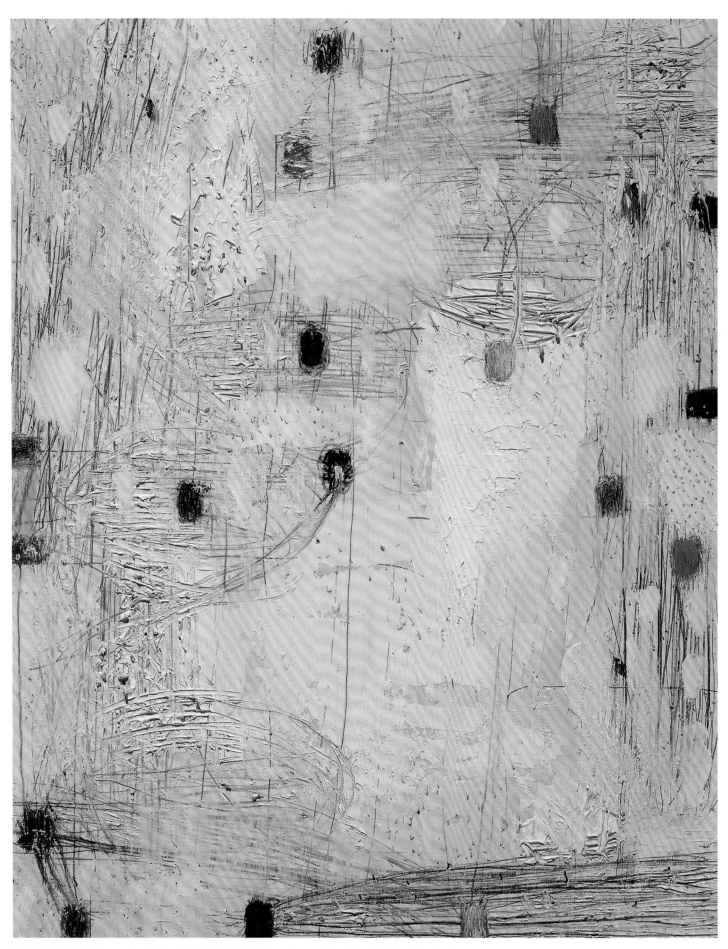

美丽天使的欢快头像，天堂、欢乐、爱和命运　1987, 50 × 40cm, 布面油画，米兰 Cardi 皇家画廊
The cheerful head of a beautiful angel-Heaven,Happiness,Love and fortune　1987, 50 × 40cm, Oil on canvas, Courtesy Gallery Cardi,Milan
La Testa Allegra di un Angelo Bello Paradiso,Gioia ,Amore,Fortuna　1987, 50 × 40cm, Olio su tela, Courtesy Gallery Cardi,Milano

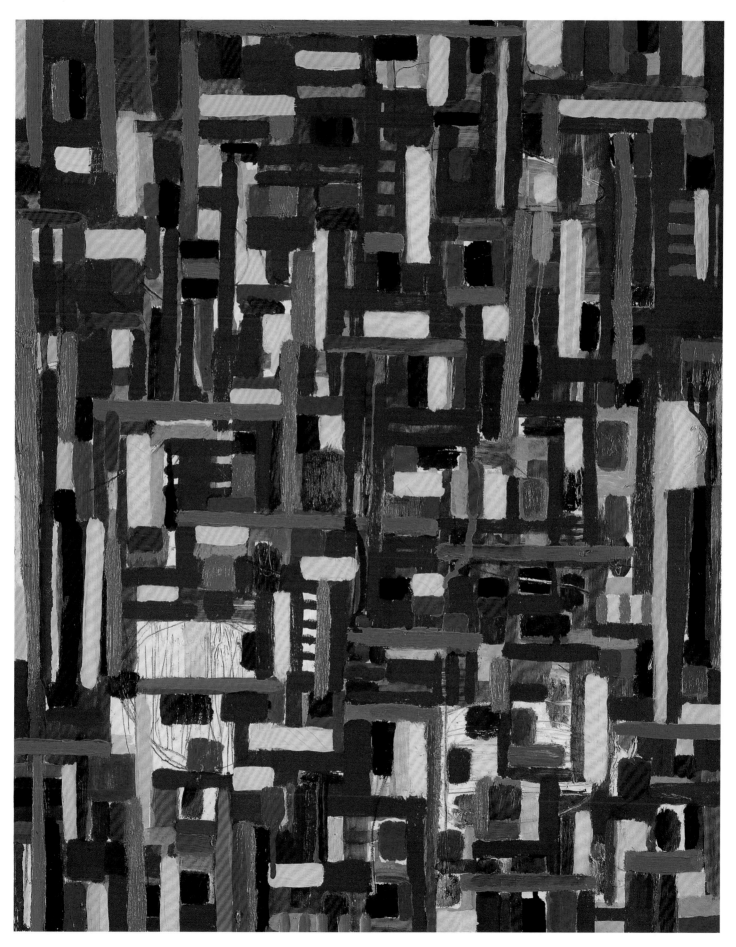

画家的头像　1987-1988，50 × 40cm，布面油画，米兰 Cardi 皇家画廊
Head of artist　1987-1988, 50 × 40cm, Oil on canvas, Courtesy Gallery Cardi,Milan
Testa dell'artista pittore　1987-1988, 50 × 40cm, Olio su tela, Courtesy Galleria Cardi,Milano

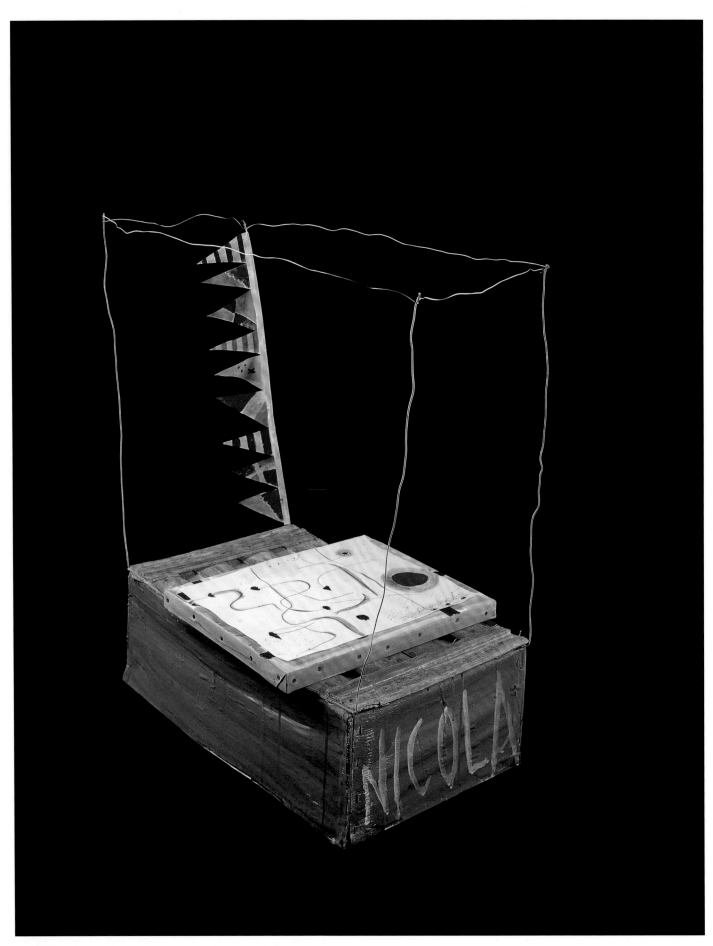

美丽图画之卧榻　1988，60 × 50 × 30cm，巴黎 Lelong 皇家画廊
Bed for sleep with lot of beautiful drawings　1988，60 × 50 × 30cm，Courtesy Gallery Lelong,Paris
Letto per il sonno dei bei disegni　1988，60 × 50 × 30cm，Courtesy Galerie Lelong,Paris

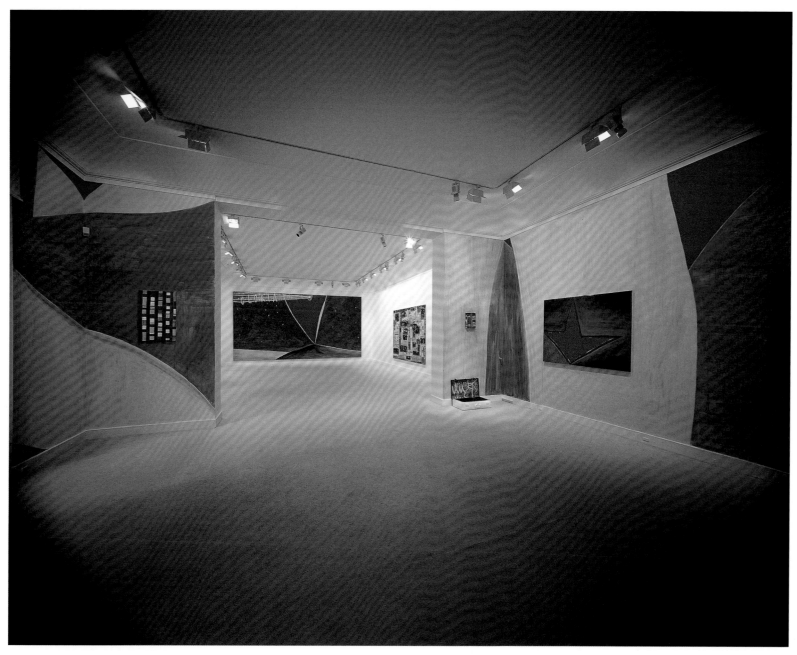

无题 1988，巴黎 Lelong 皇家画廊
Untited 1988, Courtesy Gallery Lelong, Paris
Senza titolo 1988, Courtesy Galerie Lelong, Paris

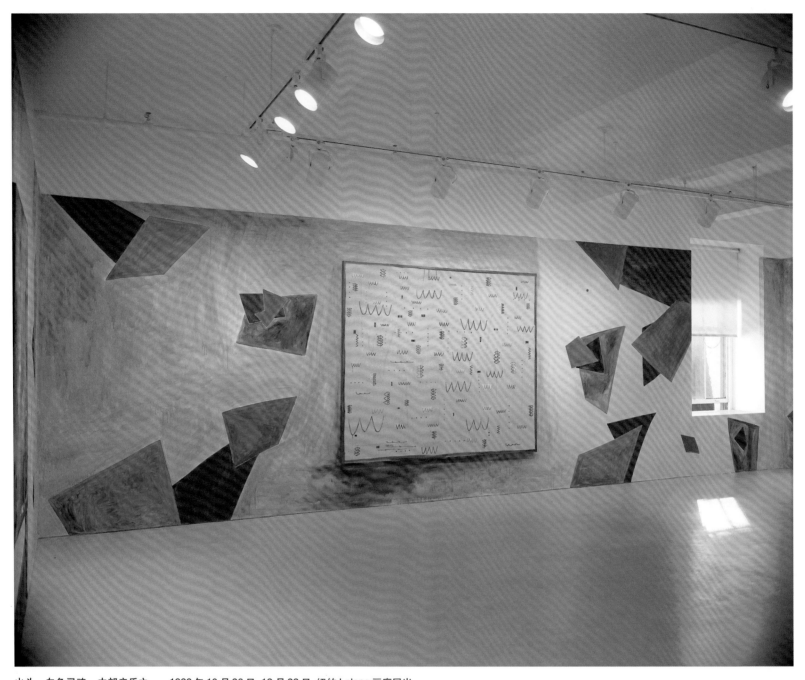

火头、白色灵魂、内部音乐之一　1989年10月26日-12月23日 纽约 Lelong 画廊展出
N°1 Head of fire,white sprit,internal music　Oct 26-Dec 23,1989 Galerie Lelong,New York
N°1 Testa di fuoco,Spirito bianco,Musica interna　Oct 26-Dec 23,1989 Galerie Lelong,New York

俄尔甫斯的头像　1990，40 × 30cm，布面油画，罗马 Benazzo 收藏
Head of Orfico　1990，40 × 30cm, Oil on canvas, Coll.Benazzo ,Rome
Testa orfica　1990，40 × 30cm, Olio su tela, Coll.Benazzo,Roma

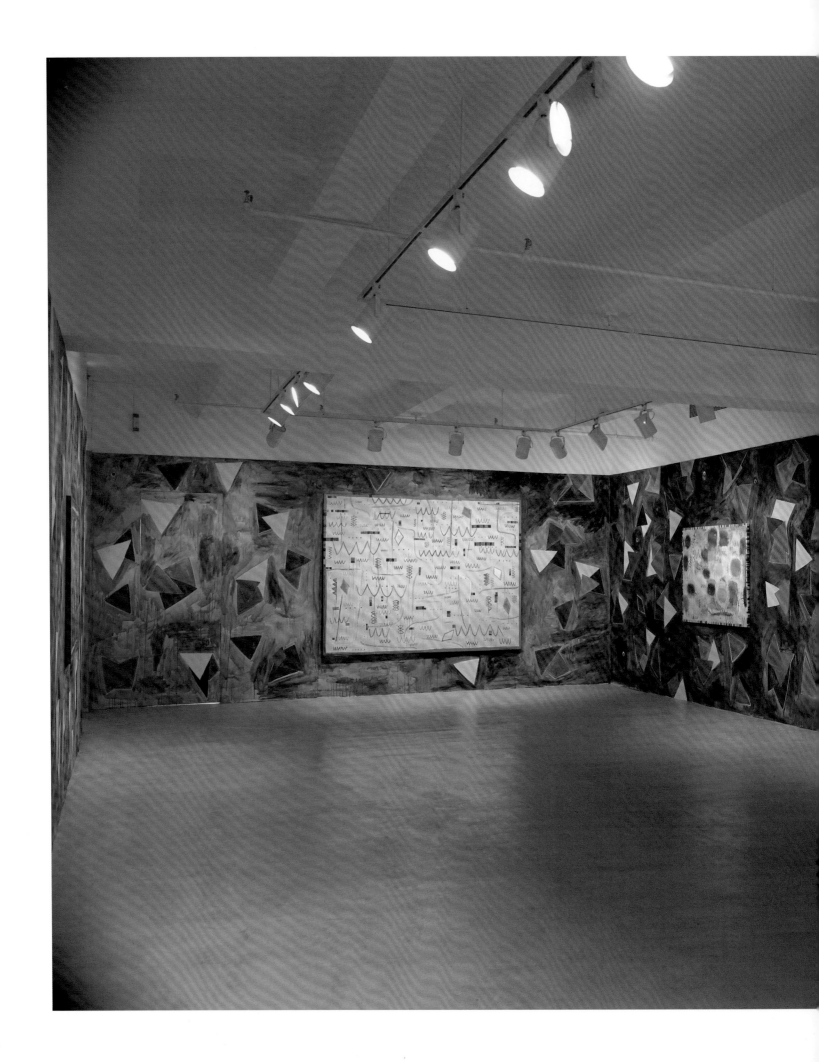

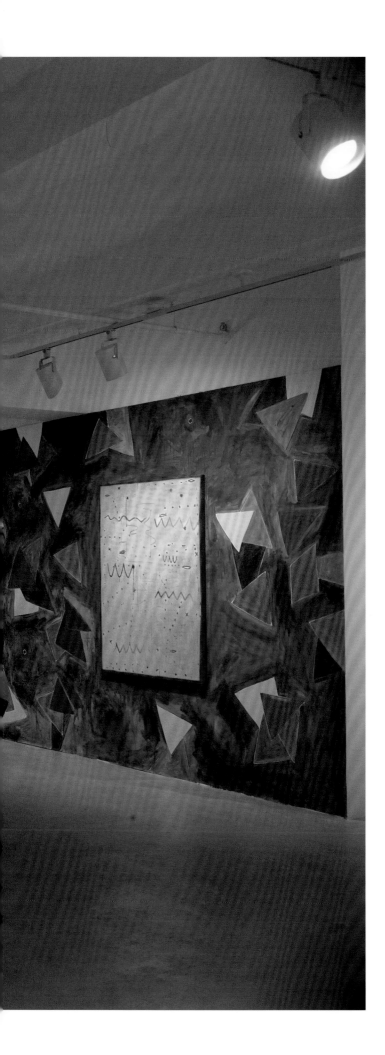

火头，白色灵魂，内部音乐之二　1989 年 10-12 月纽约 Lelong 画廊展出
N°2　Head of fire,white sprit,internal music　Show at the Gallery Lelong,New York,Oct-Dec1989
N°2　Testa di fuoco Spirito bianco Musica interna　Mostra alla Galleria Lelong,New York,Oct-Dec1989

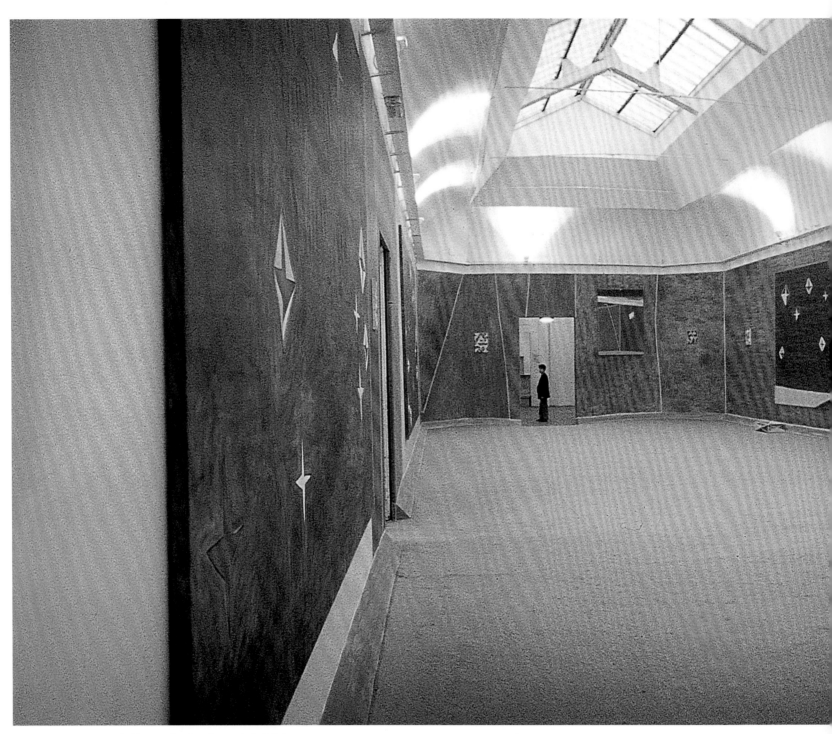

俄尔甫斯的头像　1990 年第 44 届威尼斯双年展，意大利展厅
Head of Orfico　The 44th Biennale of Venice, Italian Pavilion,1990
Testa orfica　44° Biennale di Venezia, Padiglione Italia,1990

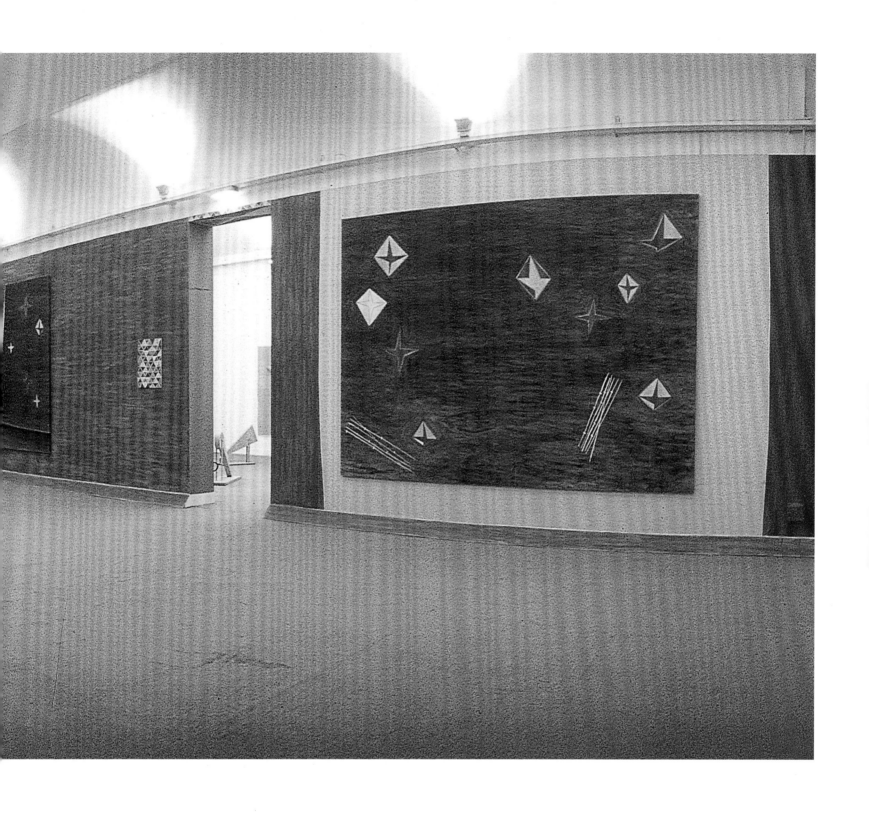

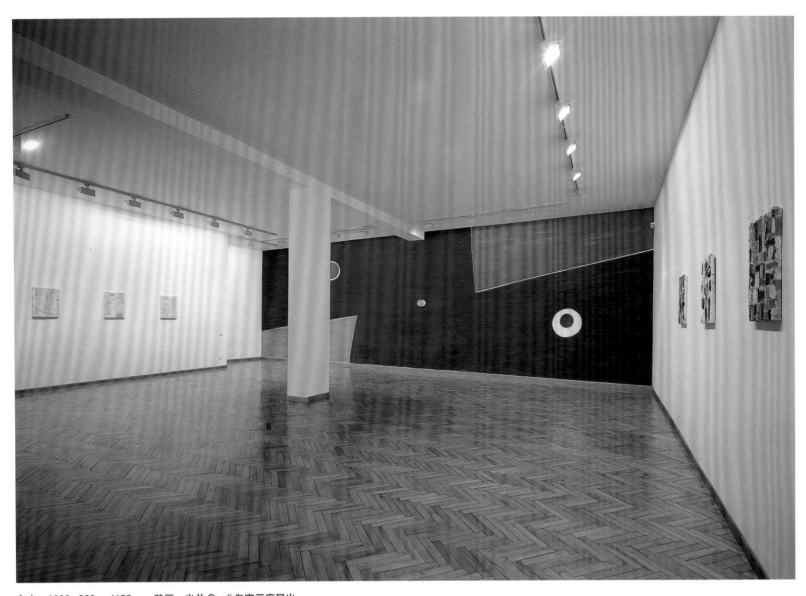

自由　1998，360 × 1150cm，壁画，米兰 Cardi 皇家画廊展出
Liberty　1998，360 × 1150cm，Fresco，Courtesy Gallery Cardi,Milan
Libertà　1998，360 × 1150cm，Affresco，Galleria Cardi,Milano

Mimmo Paladino
意大利超前卫艺术

米莫·帕拉迪诺
Mimmo Paladino

贝壳红 1979, 130 × 160cm, 布面油画 , 艺术家自己收藏
Red Shell 1979, 130 × 160cm, Oli on canvas, Coll.of artist
Rosso conchiglia 1979, 130 × 160cm, Oilo su tela, Coll.dell'artista

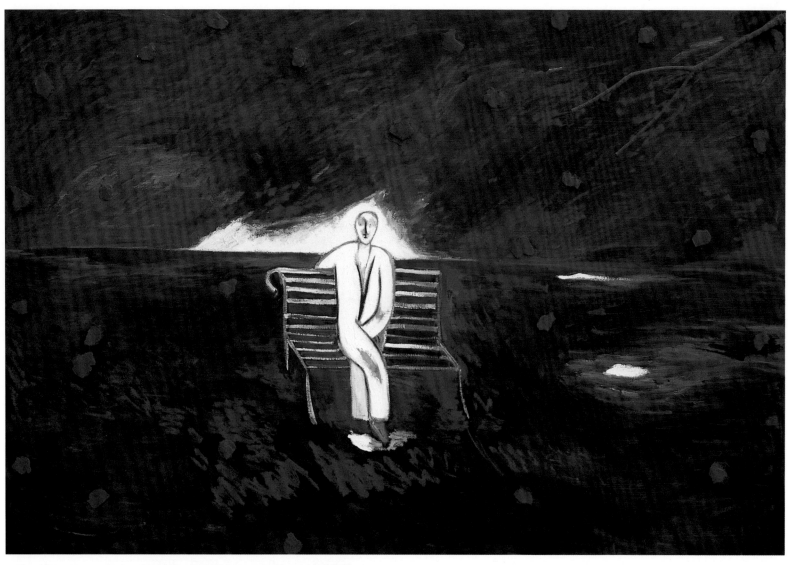

沉默　1979, 150 × 220cm, 布面油画　锡耶那 Alessandro Bagnai 皇家画廊
Silence　1979, 150 × 220cm, Oil and wood on canvas,Courtesy Alessandro Bagnai Siena
Silenzioso　1979, 150 × 220cm, Oil e legno su tela,Courtesy Alessandro Bagnai Siena

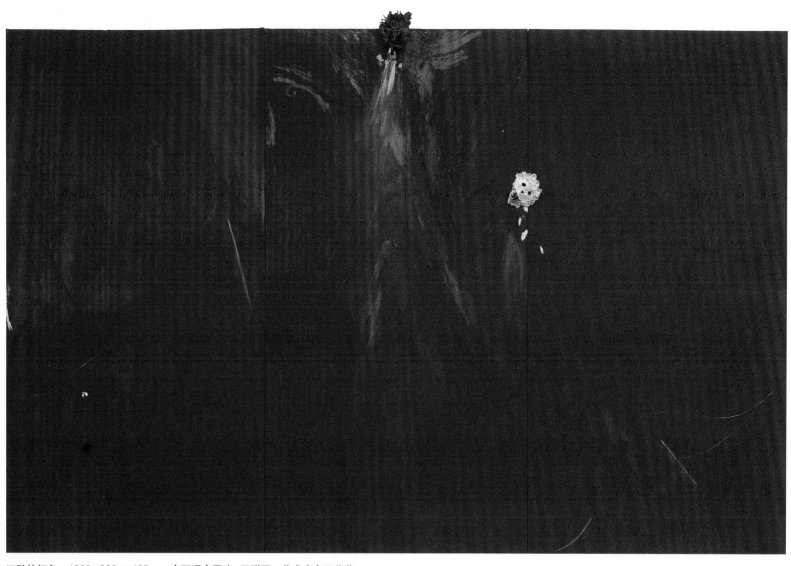

沉默的红色　1980，300 × 465cm，布面混合画法，三联画，艺术家自己收藏
Silent red　1980, 300 × 465cm, (Trittico)Mixed media on canvas, Coll.of artist
Rosso silenzioso　1980, 300 × 465cm, (Trittico)Tecnica mista su tela, Coll.dell'artista

如此近看　1980，200 × 300cm，布面油画、混合画法，罗马 Benazzo 画廊收藏
So near　1980，200 × 300cm，Oil and mixed media on canvas，Coll.Benazzo,Rome
Così da vicino　1980，200 × 300cm，Oilo e tecnica mixed su tela，Coll.Benazzo,Roma

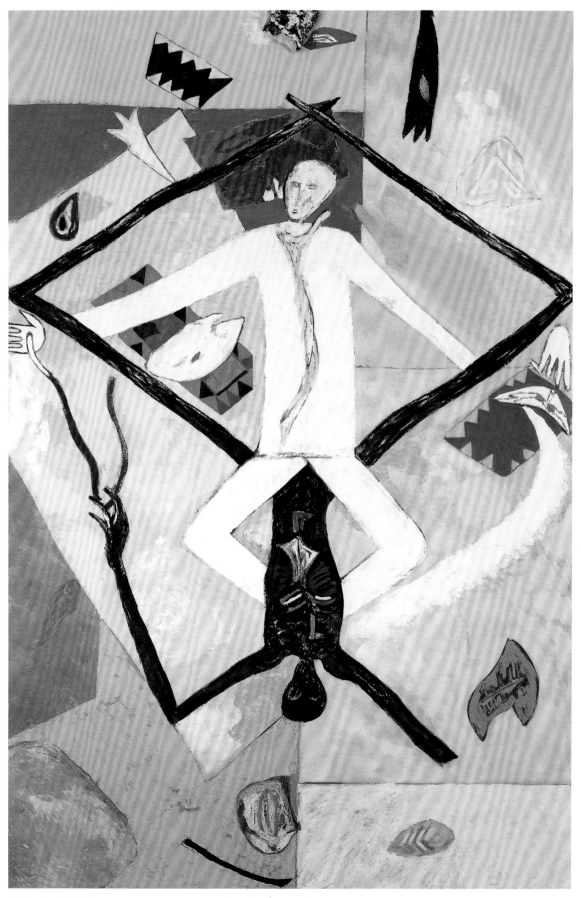

失去权力后被杀的国王　1981，300 × 200cm，布面油画，艺术家自己收藏
King killed for losing force　1981，300 × 200cm，Oil on canvas, Coll.of artist
Re uccisi alla perdita della forza　1981，300 × 200cm，Oil su su tela, Coll.dell'artista

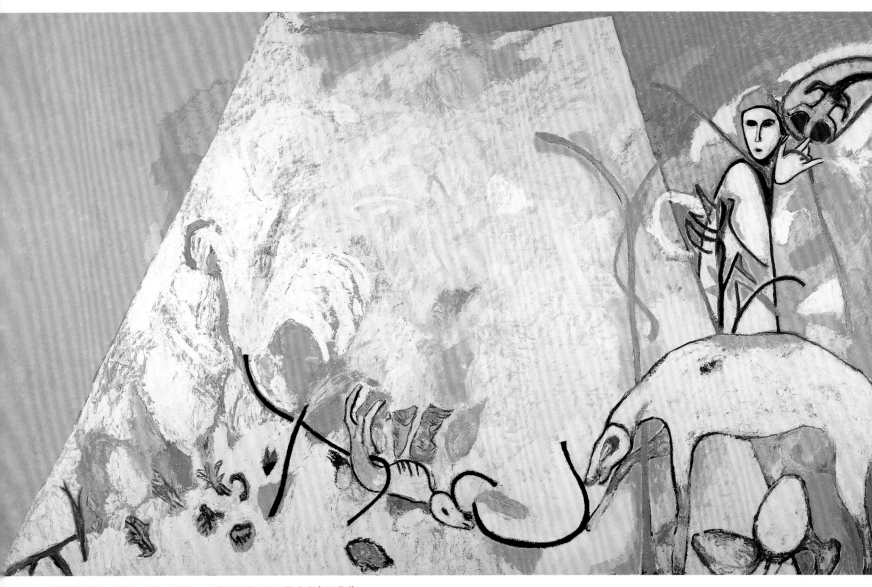

黎明的曙光　1981，200 × 330cm，布面混合画法，艺术家自己收藏
For the first light of dawn　1981，200 × 330cm，mixed media on canvas，Coll.of artist
Alle prime luci dell'alba　1981，200 × 330cm，Tecnica mixed su tela，Coll.dell'artista

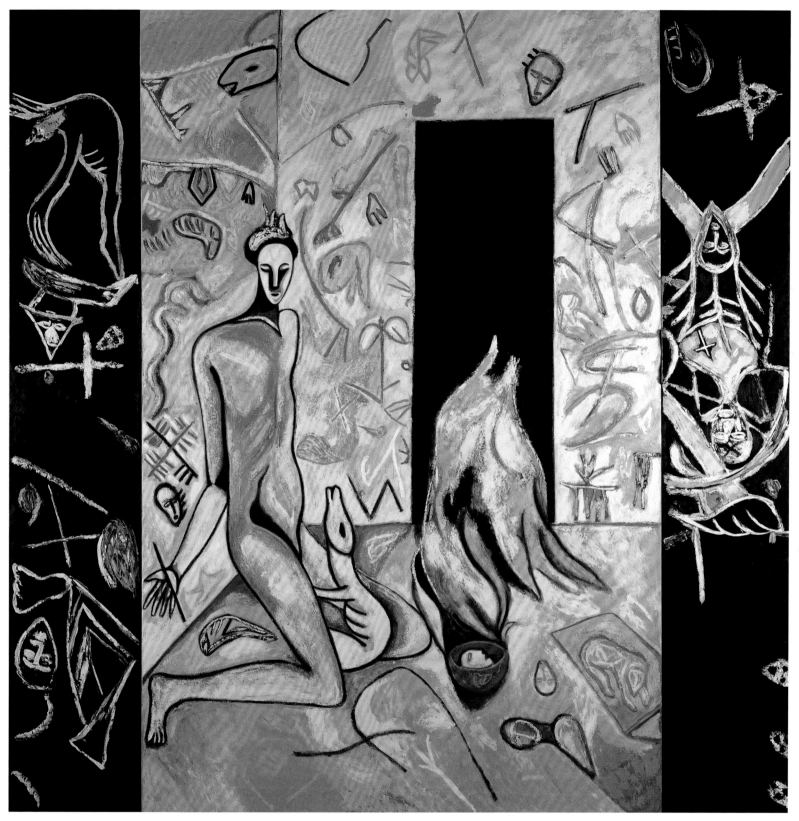

门　1982，300 × 300cm，布面油画，莫德纳 Mazzoli 皇家画廊
Door　1982，300 × 300cm，Oil on canvas,Courtesy Gallery Mazzoli, Modena
La porta　1982，300 × 300cm，Oilo su tela,Conrtesy Galleria Mazzoli, Modena

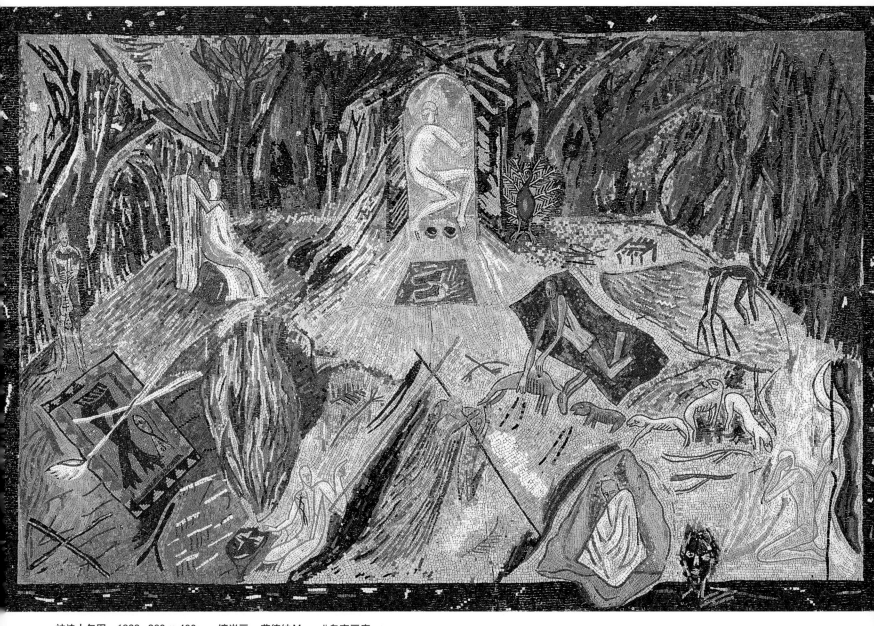

被诗人包围　1983，260 × 400cm，镶嵌画，莫德纳 Mazzoli 皇家画廊
Besieged by poets　1983，260 × 400cm，Mosaic,Courtesy Gallery Mazzoli, Modena
Assediato dai poeti　1983，260 × 400cm，Mosaico,Conrtesy Galleria Mazzoli, Modena

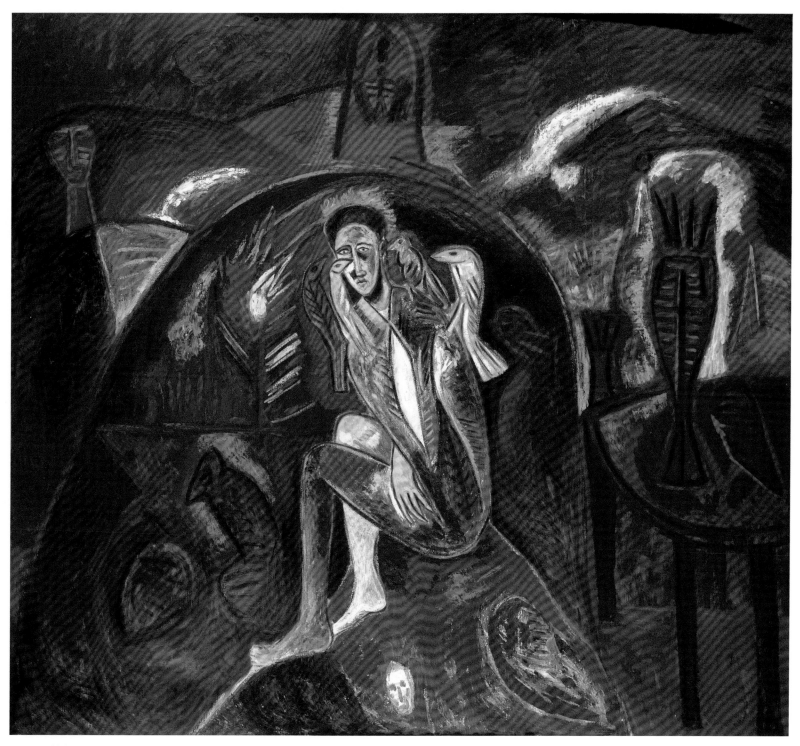

暴风雨下的房间　1984, 242.6 × 264.2 × 12.7cm, 布面油画，艺术家自己收藏
Room in tempest　1984, 242.6 × 264.2 × 12.7cm, Oil on canvas, Coll.of artist
Camera in tempesta　1984, 242.6 × 264.2 × 12.7cm, Oilo su su tela, Coll.dell'artista

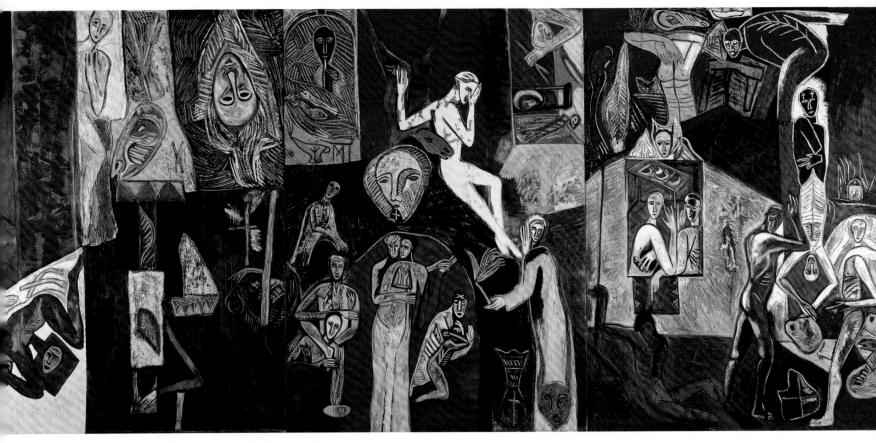

要走的和留下来的　1984，400 × 900cm，布面油画、三联画，艺术家自己收藏
Those go who away and those who remain　1984，400 × 900cm，Oil on canvas(Trittico)，Coll.of artist
Quelli che vanno e quelli che restano　1984，400 × 900cm，Olio su tela(trittico)，Coll.dell'artista

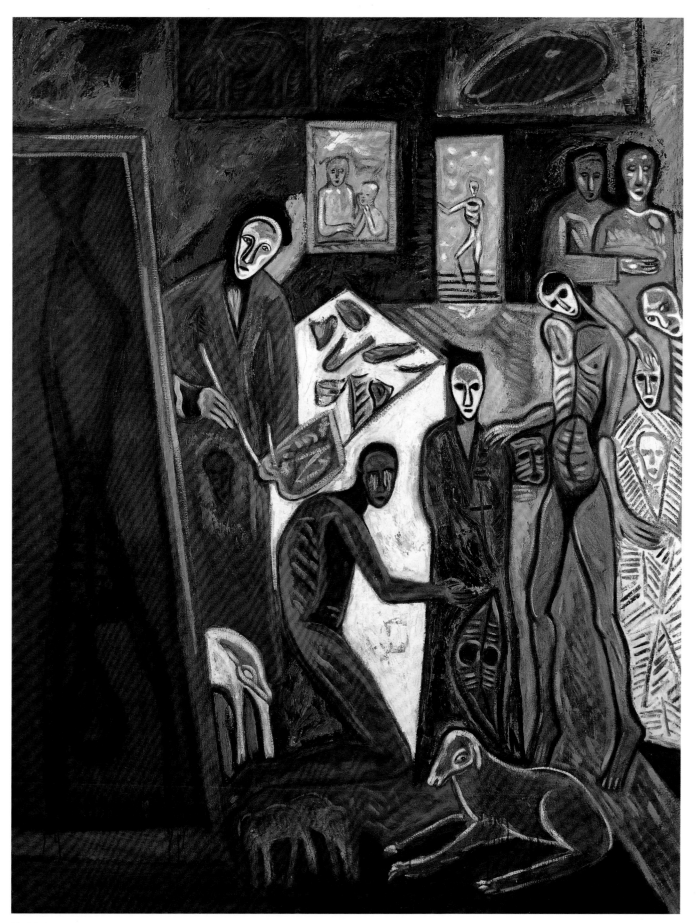

傍晚来客（G.F.）肖像　1985，200 × 155cm，布面油画，罗马 Franchetti 收藏
The visitor of evening (Portrait of G.F.)　1985，200 × 155cm，Oil on canvas，Coll.Franchetti,Rome
Il visitatore della sera (ritratto di G.F.)　1985，200 × 155cm，Oil su tela，Coll.Franchetti,Roma

不会有头衔　1985，280 × 800 × 100cm，综合材料——青铜、木板、布面油画，艺术家自己收藏
Don't have title　1985，280 × 800 × 100cm, Bronze and oli on canvas , Coll.of artist
Non avrà titolo　1985，280 × 800 × 100cm, Bronzo e olio su tela e legno, Coll.dell'artista

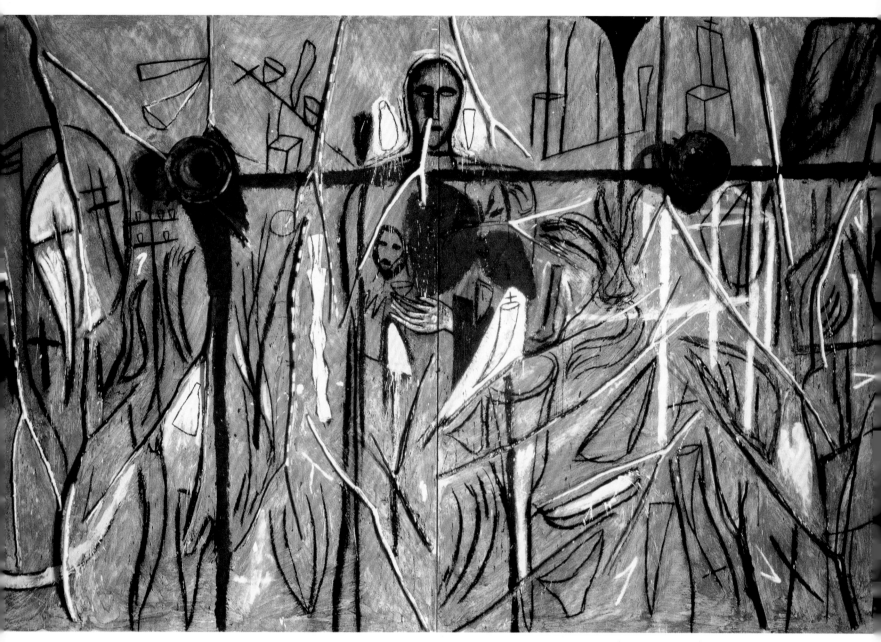

无题　1987, 240 × 359.5 × 40cm, 板上混合画法，艺术家自己收藏
Untited　1987, 240 × 359.5 × 40cm, Mixed media on wood, Coll.of artist
Senza titolo　1987, 240 × 359.5 × 40cm, Tecnica mista su legno, Coll.dell'artista

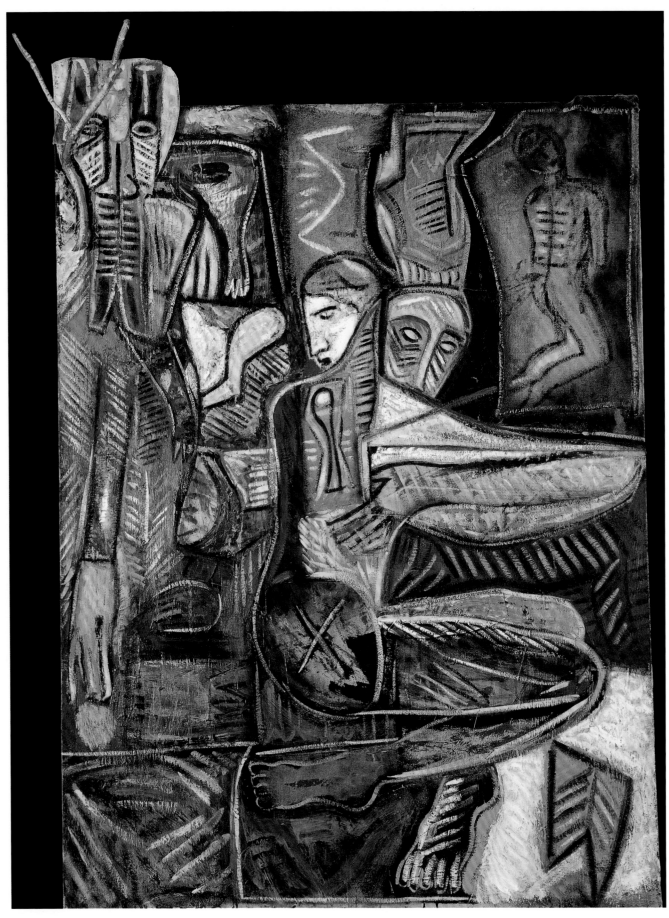

夜出的小动物　1989，75 × 55cm，布面油画，瑞士 Guntis Brands 收藏
Small animal of night　1989，75 × 55cm，Oil on canvas，Coll.Guntis Brands,Switzerland
Piccolo animale della notte　1989，75 × 55cm，Oilo su tela，Coll.Guntis Brands,Svizzera

无题　1989, 108 × 88 × 15cm, 布面油画，艺术家自己收藏
Untited　1989, 108 × 88 × 15cm, Oil on canvas，Coll.of artist
Senza titolo　1989, 108 × 88 × 15cm, Oilo su tela, Coll.dell'artista

偶像　1989, 55 × 75cm, 布面油画、木板，瑞士 Guntis Brands 收藏
Icon　1989, 55 × 75cm, Oil on canvas and wood, Coll.Guntis Brands,Switzerland
Icona　1989, 55 × 75cm, Oilo su tela e legno, Coll.Guntis Brands,Svizzera

无题　1990, 200 × 300cm, 板上混合画法，艺术家自己收藏
Untited　1990, 200 × 300cm, Mixed media on wood, Coll.of artist
Senza titolo　1990, 200 × 300cm, Tecnica mista su legno, Coll.dell'artista

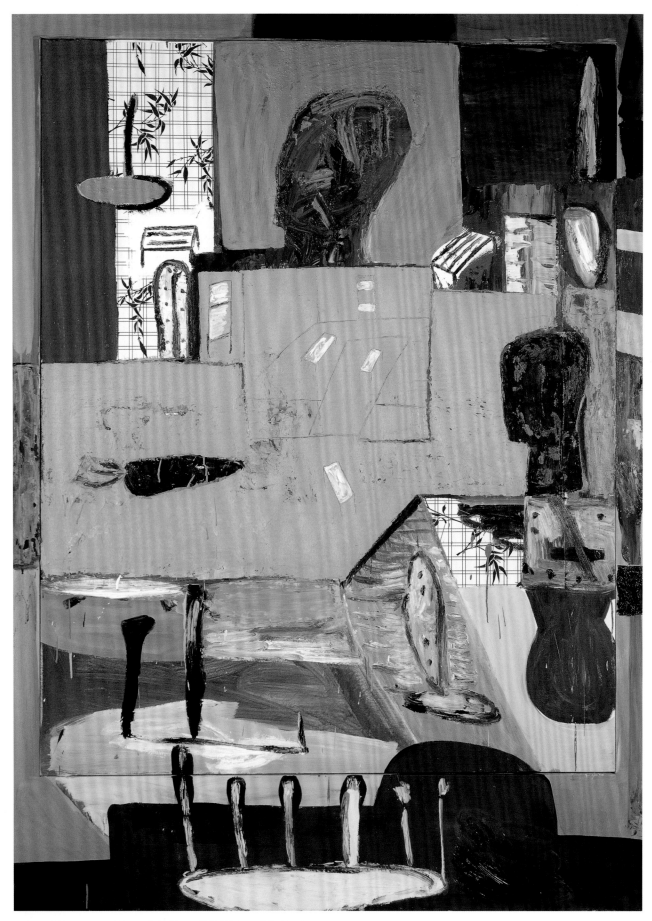

无题 1991，198 × 144cm，布面油画，莫德纳 Mazzoli 皇家画廊
Untited 1991，198 × 144cm，Oil on canvas,Courtesy Gallery Mazzoli,Modena
Senza titolo 1991，198 × 144cm，Oilo su tela,Conrtesy Galleria Mazzoli,Modena

安古路斯　1991，150 × 110cm，布面油画，莫德纳 Mazzoli 皇家画廊
Angulus　1991，150 × 110cm，Oil on canvas,Courtesy Gallery Mazzoli,Modena
Angulus　1991，150 × 110cm，Oilo su tela,Conrtesy Galleria Mazzoli,Modena

现世　1994，170 × 100cm，布面油画，Salisburgo Ropac 皇家画廊
Sine Tempore　1994，170 × 100cm，Oil on canvas,Courtesy Gallery of Ropac,Salisburgo,
Sine Tempore　1994，170 × 100cm，Oilo su tela,Courtesy Galleria of Ropac,Salisburgo,

被包围的　1995, 106 × 125cm × 155cm, 青铜
Besieged　1995, 106 × 125cm × 155cm, Bronze
Assediato　1995, 106 × 125cm × 155cm, bronzo

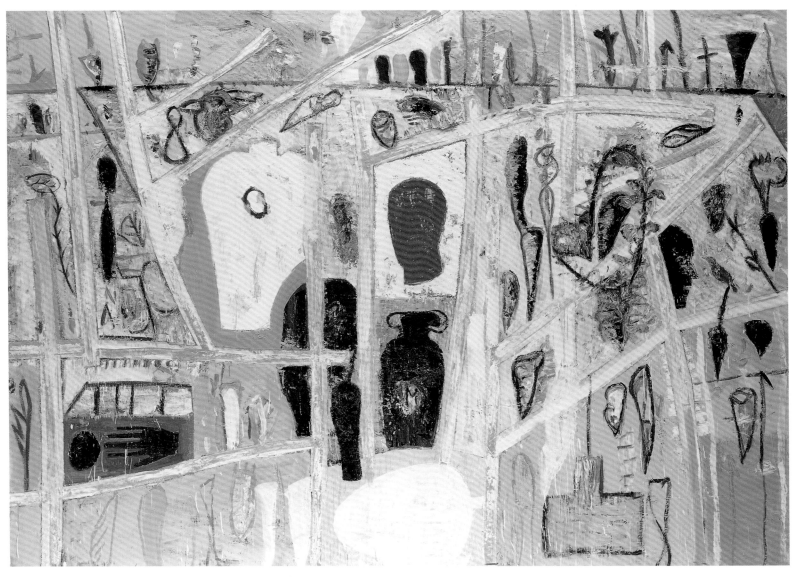

奇迹 I　　1995，226 × 324cm，布面油画，米兰 Cardi 皇家画廊
Miracle I　　1995，226 × 324cm，Oil on canvas,Courtesy Gallery Cardi,Milan
Miracolo I　　1995，226 × 324cm，Oilo su tela ,Courtesy Galleria Cardi,Milano

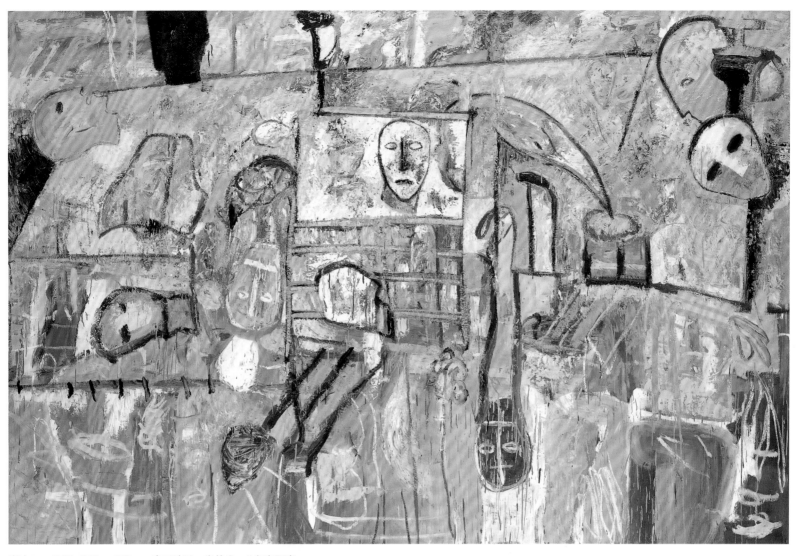

奇迹 II 1996, 200 × 300cm, 布面油画, 米兰 Cardi 皇家画廊

Miracle II 1996, 200 × 300cm, Oil on canvas, Courtesy Gallery Cardi, Milan

Miracolo II 1996, 200 × 300cm, Oilo su tela, Courtesy Galleria Cardi, Milano

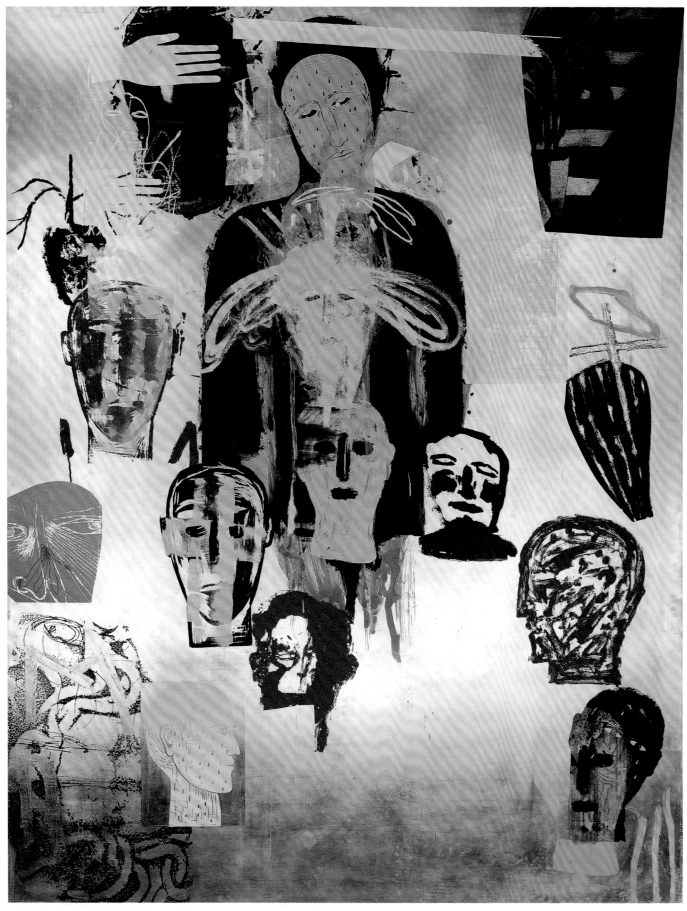

赞美诗 IV 1997, 250 × 195 × 5cm, 镀银板上混合画法, 伦敦 Waddington 画廊
Anthem IV 1997, 250 × 195 × 5cm, Mixed media on silver-plated panel,Courtesy Waddington Gallery,London
Corale IV 1997, 250 × 195 × 5cm, Tecnica mixed su pannello argentato,Courtesy Waddington Galleria, London

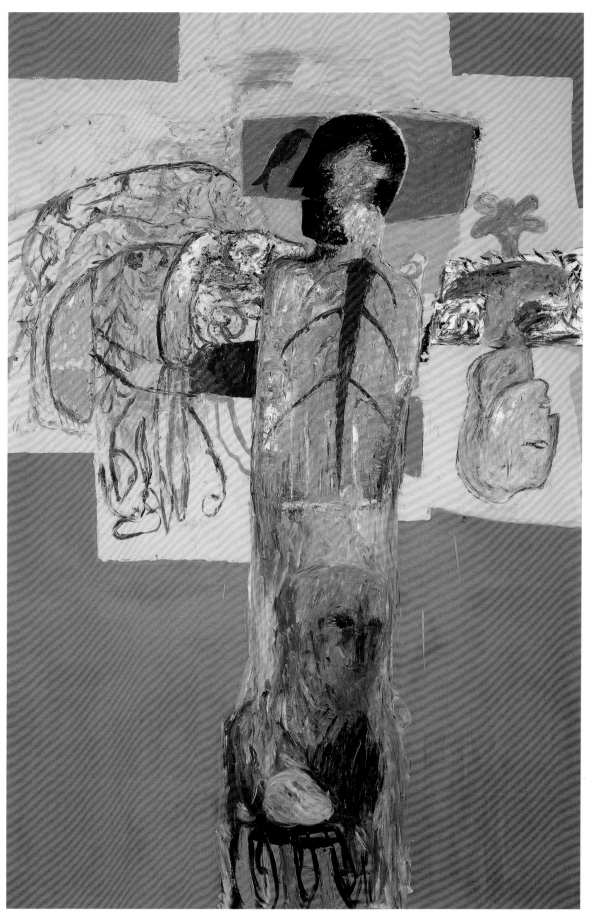

冒险 1997，195 × 130cm，布面油画，米兰 Cardi 皇家画廊
Adventure 1997，195 × 130cm，Oil on canvas ,Courtesy Gallery Cardi,Milan
Cimento 1997，195 × 130cm，Oilo su tela ,Courtesy Galleria Cardi,Milano

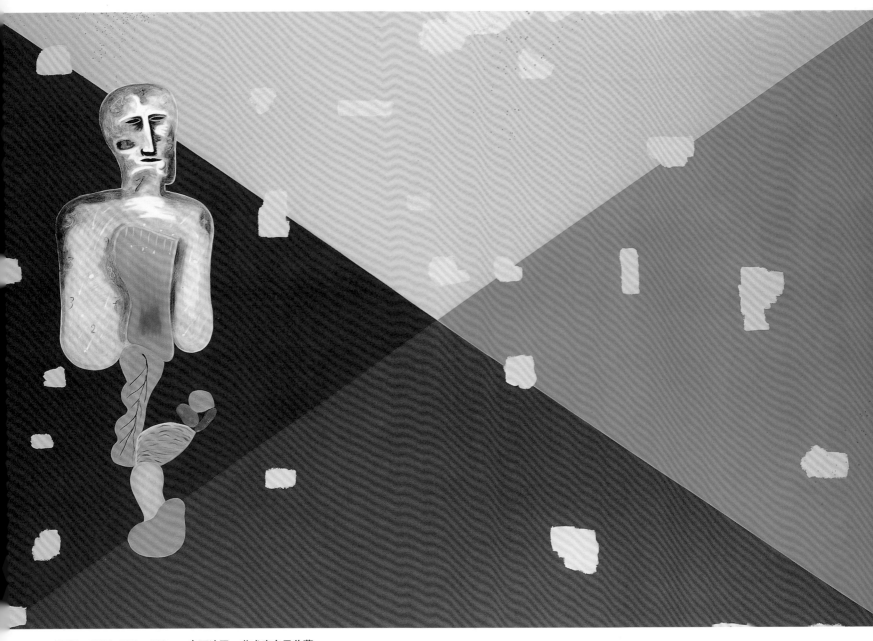

无题　1997, 200 × 300cm, 布面油画，艺术家自己收藏
Untitled　1997, 200 × 300cm, Oil on canvas, Coll.of artist
Senza titolo　1997, 200 × 300cm, Oilo su tela, Coll.dell'artista

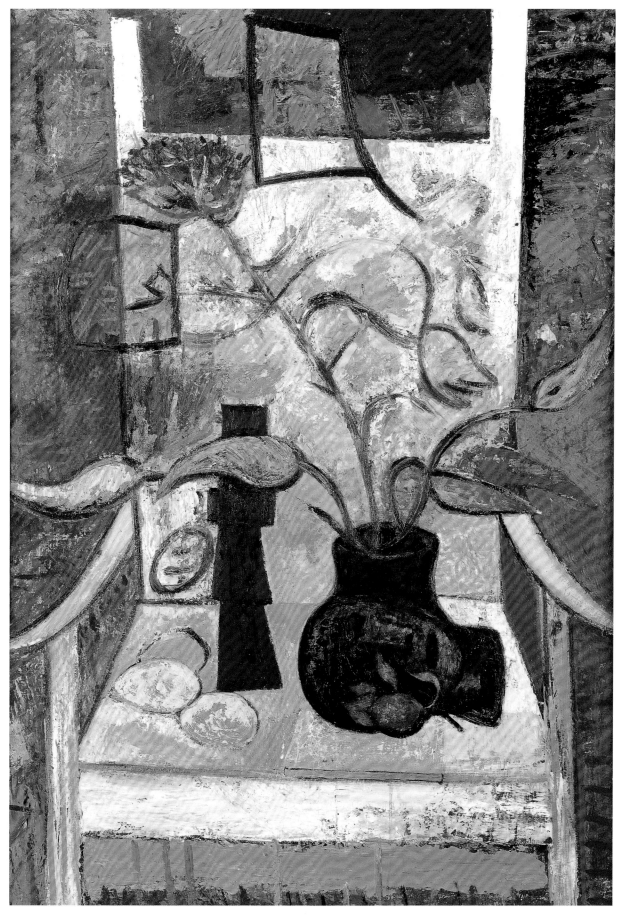

阅读练习一　1997，130 × 92cm，布面油画．莫德纳 Mazzoli 皇家画廊
Reading exercise Ⅰ　1997，130 × 92cm，Oil on canvas，Courtesy Gallery Mazzoli,Modena
Esercizio di lettura N°1　1997，130 × 92cm，Oilo su tela，Conrtesy Galleria Mazzoli,Modena

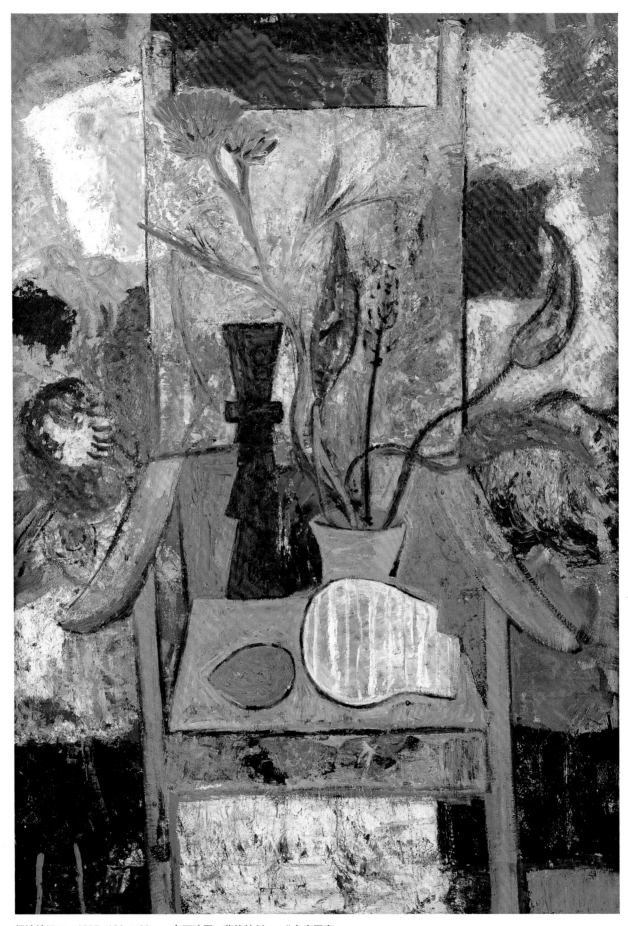

阅读练习二　1997，130 × 92cm，布面油画，莫德纳 Mazzoli 皇家画廊
Reading exercise II　1997，130 × 92cm，Oil on canvas,Courtesy Gallery Mazzoli,Modena
Esercizio di lettura N°2　1997，130 × 92cm，Oilo su su tela,Conrtesy Galleria Mazzoli,Modena

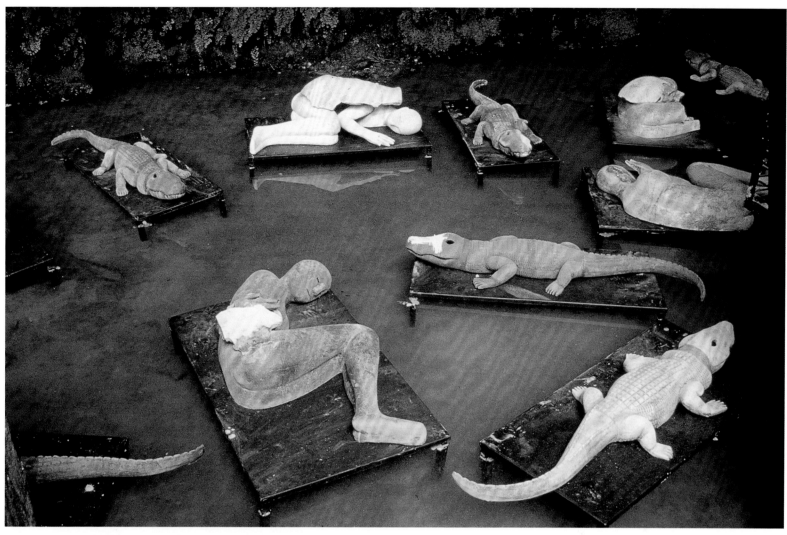

睡眠者　1998，仙女泉装饰，36件不同大小的陶器作品放在铁桌上

Sleeper　1998, Installtion with font of fairy, Poggibonsi(yes)for"art for art's sake",1998,36 elements in fired earth on iron table, different dimensions,Courtesy Gallery Continua, S.Gimignano(yes)

Dormienti　1998, Installazione alla fonte delle fate, Poggibonsi(Si) per"Arte all' Arte", 1998,36 elementi in terracotta su tavoli in ferro,dimensioni variabili Courtesy Galleria Continua, S.Gimignano(Si)

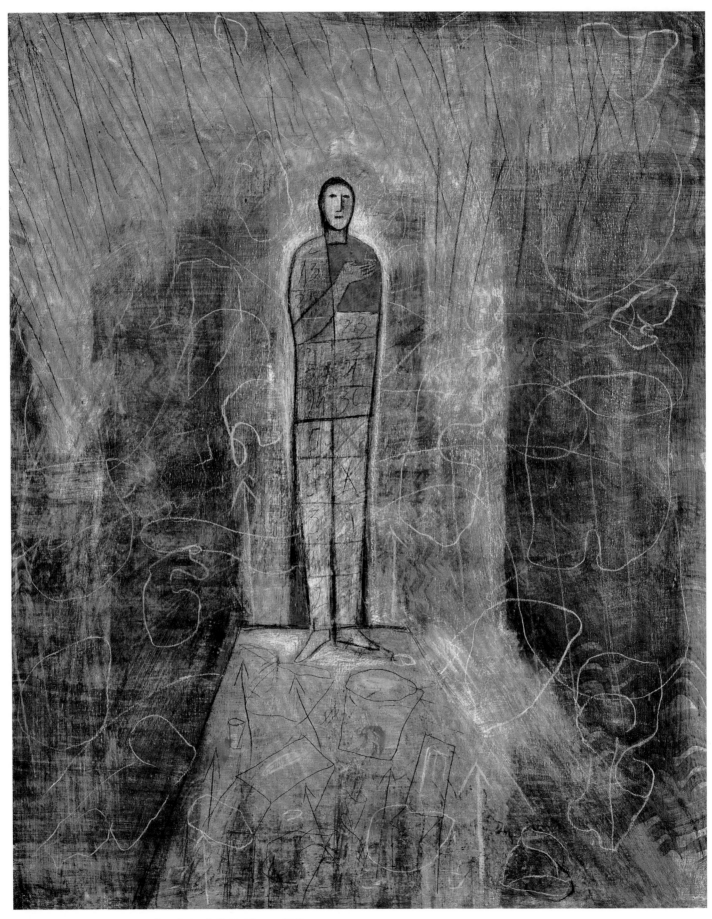

暴风雨　1999, 81.5 × 65cm, 布面油画，伦敦 Waddington 画廊
Tempest　1999, 81.5 × 65cm, Oil on canvas,Courtesy Waddington Gallery,London
La tempesta　1999, 81.5 × 65cm, Oilo su tela,Courtesy Waddington Galleria,London

阿奇莱·博尼托·奥利瓦
Achille Bonito Oliva

Achille Bonito Oliva
意大利超前卫艺术

阿奇莱·博尼托·奥利瓦肖像
Achille　Bonito　Oliva　Portrait

Francesco　Clemente　弗朗西斯科·克莱门特　作

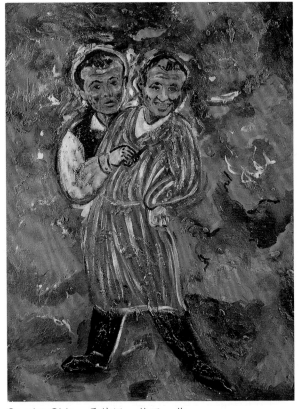

Sandro Chia　桑德罗·基亚　作

Nicola　De　Maria　尼古拉·德·玛利亚　作

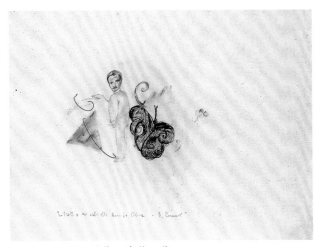

Enzo　Cucchi　恩佐·库基　作

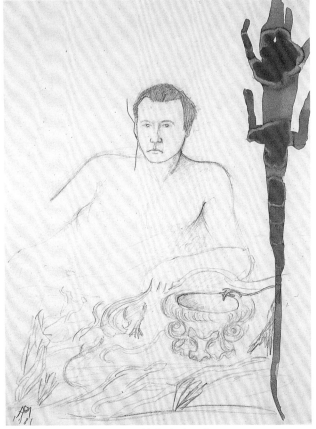

Mimmo　Paladino　米莫·帕拉迪诺　作

阿奇莱·博尼托·奥利瓦

1939年11月4日阿奇莱·博尼托·奥利瓦出生在意大利的卡贾诺市，1961年毕业于法律专业，后进入大学文学院学习，开始对诗歌产生浓厚的兴趣。1967年他携名为《产生于母亲》的首部诗集参加了法诺诗会。1968年以后，奥利瓦移居罗马，并开始了他的艺术评论生涯，同时在罗马大学建筑学院教授当代艺术史；除《产生于母亲》（1967）之外，他的作品还有《故事诗》（1968）、《示意图》（1969）和《视觉诗选》（1966）。

奥利瓦在国内外组织过无数次艺术展览会，如:"我的爱"（1970）、"底片的活力"（1970）、"人"（1971）、"第七届巴黎双年展"意大利展团（1971）、"现实的批评"（1971）、"胶片的表现力"（1972）、"关于意大利形象的信息"（1972）、"微妙的棋盘"、"第八届巴黎双年展"意大利展团（1973）、"当代艺术"（1973）、"图画—透明"（1975）、"布鲁内莱斯基和我们"（1977）、"艺术之特性—自然之艺术的六个栖所"（1978）、"视野"（1978）、"超现实主义和美洲绘画的艺术取材"（1978）、"艺术作品"（1979）、"室"（1979）、"迷宫"（1979）、"意大利：新的形象"（1980）、"70年代的艺术"（1980）、"80年代的开端"（1980）、"天才之所在"（1980）、"轻率的形象"（1981）、"向基里科风格发展的沃霍尔"（1981）、"进入迷宫"（1981）、"绝妙的艺术"（1981）、"81年三角形"（1981）、"艺术展览"（1981）、"宝库"（1981）、"保罗·克利"（1981）、"塞巴斯蒂昂·马塔艺术展"（1982）、"批评与艺术"（1982）、"意大利和美洲超前卫艺术展"（1982）、"68年至77年前卫与超前卫艺术展"（1982）、"地狱"（1982）、"悉尼双年展"意大利展团（1982）、"交错"（1982）、"雅典学院"（1983）、"画室"（1983）、"四重奏"（1984）、"杰作"（1984）、"第十三届巴黎双年展"（1985）、"期盼"（1985）、"1970年至1985年意大利艺术"（1985）、"撤离那不勒斯"（1985）、"神圣的艺术"（1986）、"飘忽不定的行程"（1986）、"新的艺术区域—欧洲、美洲"（1987）、"欧洲艺术"（1987）、"过渡"（1987）、"富丽堂皇的宫殿"（1987）、"雕塑的死语言"（1988）、"塔诺·费斯塔1960年至1987年作品展"（1988）、"新肖像画"（1988）、"弗拉维奥·焦亚·阿马尔菲所发明的罗盘并无益于纠正艺术的偏航"（1989）、"特里贡艺术展"（1989）、"1945年至1989年意大利艺术之研究"（1989）、"欧洲艺术"（1989）、"意大利—西班牙"（1989）、"艺术之证明"（1989）、"当代艺术中的奇才"（1989）、"阿尔童"（1989）、"第九十个"（1990）、"艺术是金钱吗?"（1991）、"必修课"（1991）、"咏叹调"（1991）、"艺术"（1991）、"出版许可"（1992）、"保罗·乌切洛：20世纪的艺术之战"（1992）、"莫斯科……莫斯科"（1992）、"废墟之风光"（1992）、"保罗·乌切洛：在人民所拥戴的皇帝陛下的罗马地区所进行的20世纪艺术大战"（1993）、"条条大路通罗马吗?"（1993）、"搁置一边"（1993）、"艺术之圣殿"（1993）、"我更希望说'不'：五个处于艺术与萧条之间的房间"（1994）、"阿西亚纳"（1995）、"艺术东方之写照"（1995）、"艺术之营养"（1995）、"帕索利尼与死"（1995）、"俄罗斯艺术"（1995）、"东京的耐基"（1995）、"95年之开端"（1995）、"意大利之游：沃

霍尔"（1996）、"圣保罗双年展"（1996）、"最简式抽象艺术"（1997）、"分解"（1997）、"美洲岩刻艺术"（1997）、"临界艺术"（1997）、"差别：雄性、雌性及其他"（1998）、"达喀尔艺术展"（1998）、"乔治·德·基里科艺术展"（1998）、"内、外、交替"（1998）、"以马里奥·斯基法诺为例"（1998）、"超凡者的路程"（1998）、"卢乔·阿梅利奥的地动"（1998）、"埃托雷·斯帕莱蒂艺术展"（1999）。

此外，奥利瓦还是"国际艺术会展"（罗马，1970年至1978年）和"电子艺术咖啡"（罗马，1994年至1997年）等活动的出版负责人和第四十五期威尼斯双年鉴"艺术指南"的总出版负责人。他还曾与著名的意大利周刊《快报》合作，为其撰稿。奥利瓦出版过许多著作和文章，其中包括:《奇妙的国土》（1971）、《艺术的手段和体系》（1975）、《叛逆者的思想》（1976）、《蒙苏·德西代里奥生平》（1976）、《不同的前卫，欧洲—美洲》（1976）、《通过前卫，自我批评，自我移动》（1977）、《斜视的步伐》（1978）、《阿尔桑博尔多》（1978）、《符号商人蒙苏·德西代里奥的手稿》（1978）、《批评的自主性和创造性》（1980）、《意大利的超前卫》（1980）、《蒙苏·德西代里奥》（1981）、《艺术的梦》（1980）、《符号的预报：保罗·克利》（1982）、《国际超前卫》（1982）、《飞行手册》（1982）、《艺术家的对话》（1984）、《小手法》（1985）、《甜蜜的设想》（1986）、《厌恶》（1987）、《超级艺术》（1988）、《阿喀琉斯的脚跟》（1988）、《2000年之前的艺术》（1991）、《所有的人都这样做：这绝对是艺术》（1991）、《艺术宣传》（1992）、《戏剧对话》（1993）、《维姆·文德斯《（1993）、《解剖学课程：艺术的躯体》（1995）、《蒙苏·德西代里奥》（1997）。

奥利瓦的录像作品有:《向孩子们讲解艺术》（1995）、《当代艺术的自画像》（1992-1996）。

奥利瓦曾荣获过的大奖有:"国际艺术批评奖"（1982）、"帕杜拉卡尔特修会国际新闻奖"（1985）、"首次台伯河国际奖"（1986）、"布索蒂歌剧舞剧奖"（1988）、"瓦伦蒂诺国际批评金奖"（1991）、"法兰西共和国艺术及文学骑士勋章"（1992）、"洛迦诺欧洲节奖"（1995）、"吉弗尼瓦莱皮亚纳艺术节奖"（1996）、"皮诺·帕斯卡里艺术批评奖"（1997）。

Achille Bonito Oliva

Achille Bonito Oliva was born on November 4, 1939, at Caggiano (Salerno).He studied the Classics and later earned his degree in Law in 1961. He subsequently studied literature where he pursued his first interest, poetry. He participated in the Fano meeting of the Gruppo 63 with his first book of poetry, *made in mater*, of 1967. He has been living in Rome since 1968, where he began his adventure as an art critic and where he teaches Contemporary Art at the Architecture Department of "La Sapienza." In addition to *Made in mater* (1967), he published *Fiction poems* (1968), *Mappe* (1969) and *Antologia della poesia visiva* (1966).

He has organized numerous exhibitions in Italy and abroad, including: Amore mio (1970), Vitalità del negativo (1970), Persona (1971), the Italian section of the 7th Paris Biennial (1971), Critica in atto (1971), Filmperformance (1972), Informazione sulla presenza italiana(1972), La delicata scacchiera (1973), the Italian section of the 8th Paris Biennial (1973), Contemporanea (arte)(1973), Disegno/Trasparenza(1975), Brunelleschi e noi (1977), Fluxus come Fluxus (1978), Sei stazioni per Arte Natura la natura dell'arte (1978), Perimetri (1978), La materia dell'arte tra Surrealismo e pittura americana (1978), Opere fatte ad arte (1979), Le stanze (1979), Labirinto (1979), Italia: nuova immagine (1980), Arte degli anni '70(1980), Aperto '80 (1980), Genius Loci (1980), L'immagine stordita (1981), Warhol verso de Chirico (1981), In Labirinto (1981), Arte Maestra (1981), Trigon 81 (1981), Mostra d'arte (1981), Tesoro(1981), Paul Klee (1981), Sebastian Matta (1982), Critica ad arte (1982), Transavanguardia italiana e americana (1982), Avanguardia transavanguardia 68-77 (1982), Terrae Motus (1982), the Italian section of the Sydney Biennial (1982), Intrecci (1982), La scuola di Atene (1983), Ateliers (1983), Quartetto (1984), Capodopera (1984), the 13th Paris Biennial (1985), Desideretur (1985), Arte Italiana 1970-1985 (1985), Evacuare Napoli (1985), Arte Santa (1986), Erratici percorsi (1986), Nuovi territori dell'arte-Europa/America (1987), Arte Europea (1987), Transizioni (1987), Palazzo Regale (1987), La lingua morta della scultura (1988), Tano Festa. Opere dal 1960 al 1987 (1988), Nuove Iconografie (1988), Inutilità della bussola, inventata da Flavio Gioia di Amalfi, nelle derive dell'arte (1989), Trigon (1989), La ricerca artistica in Italia 1945-1989 (1989), Euro Arte (1989), Italia/Spagna (1989), La deposizione dell'arte (1989), Il genio differente nell'arte contemporanea (1989), Artoon (1989), Ubi Fluxus ibi motus (1990), Phormakon '90 (1990), Novantesimo (1990), Art is money? (1990), De Europa (1991), Scuola d'obbligo (1991), Ariae (1991), Artae (1991), Imprimatur (1992), Paolo Uccello:le battaglie nell'arte del XX secolo (1992), A Mosca...Mosca (1992), Paesaggio con rovine (1992), Paolo Uccello: le battaglie nell'arte del XX secolo nei luoghi romani di S.M. del Popolo (1993), Tutte le strade portano a Roma? (1993), A prescindere (1993), Gran delubro l'arte (1993), Preferirei di no: 5 stanze tra arte e depressione (1994), Terrae motus terrae motus (1994), La dimora dei corpi gravi (1994), Asiana (1995), Fotografia ad Oriente dell'arte (1995), Nutrimenti dell'arte (1995), Pasolini e la morte (1995), Arte Russia (1995), Le Nike di Tokyo (1995), In Aperto '95 (1995), Viaggio in Italia:Warhol (1996), Biennale di San Paolo (1996), Minimalia (1997), Decomposizioni (1997), American Graffiti (1997), Arte terminale (1997), Disidentico: maschile, femminile e oltre (1998), Biennale di Dakar (1998), Giorgio de Chirico (1998), Interno Esterno Alterno (1998), Per esempio, Mario Schifano (1998), Percorsi del sublime (1998), Terrae motus di Lucio Amelio (1998), Basquiat a Venezia (1999), Ettore Spalletti (1999), Minimalia a New York(1999), Francesca Woodmann (2000), Statue e segreti(2000).

He is the author of the following books:*Il territorio magico* (1971), *Arte e sistema dell'arte* (1975), *L'ideologia del traditore* (1976), *Vita di M.D.*(1976), *Le avanguardie diverse. Europa-America* (1976), *Autocritico, Automobile, attraverso le avanguardie* (1977), *Passo dello strabismo* (1978), *Arcimboldo* (1978), *Il mercante del segno: scritti da M.D.* (1978),

Autonomia e creatività della critica (1980), *La transavanguardia italiana* (1980), *Monsù Desiderio* (1981), *Il sogno dell'arte* (1981), *L'Annunciazione del segno:Paul Klee* (1982), *La transavanguardia internazionale* (1982), *Manuale di volo* (1982), *Dialoghi d'artista* (1984), *Minori maniere* (1985), *Progetto dolce* (1986), *Antipatia* (1987), *Superarte* (1988), *Il tallone d'Achille* (1988), *L'Arte fino al 2000* (1991), *Così fan tutti:l'arte assolutamente* (1991), *Propaganda Arte* (1992), *Conversation pieces* (1993), *Wim Wenders* (1993), *Lezioni di anatomia: il corpo dell'arte* (1995), *Oggetti di turno* (1997), *M.D.* (1997), *L'ideologia del traditore. Arte, Maniera, Manierismo* (1998), *Gratis a bordo dell'arte* (2000).

Produced the video:*Totòmodo, l'arte spiegata anche ai bambini* (1995), *Autoritratto dell'arte contemporanea* (1992-1996). Conceived the T.V. Art program:*A.B.O. Collaudi d'Arte* (1999). He was curator of the 45th Venice Biennale (Punti cardinali dell'Arte".1993), He contributes to L'Espresso magazine and the daily La Repubblica. Bonito Oliva is cultural curator for "Incontri Internazionali d'Arte" (Rome) and of the "Electronic Art Cafè" (Rome).

Achille Bonito Oliva received the "critic's award" from Flash Art International (1982), the international journalism award from the "Certosa di Padula" (1985), the first international "Tevere" prize (1986), the "Bussotti Opera Ballet" prize (1988), the "Valentino d'oro" critic's award (1991), knight of the Order of Arts and Letters of the French Republic (1992), the "Europa Festival" prize of Locarno (1995), the "Oasi d'oro" award at the Pantelleria multimedia festival (1995), the "Festival" di Giffoni Vallepiana award (1996), the "Pino Pascali" for art criticism at Polignano a Mare (1997), the "Giffoni Valle Piana" (1998) award and the "Cortocircuito-Naples" award (1998).

附有节选书目的生平

Biographies with selected bibliography

SANDRO CHIA

Born in Florence, April 20, 1946

One – man Exhibitions

1971
"L'ombra e il suo doppio", Galleria
La Salita, Rome

1972
"Copia", Galleria La Salita, Rome

1973
"Autoritratto(with Notargiacomo)",
Palazzo delle Esposizioni, Rome

1974
"L'opera descrivibile", Galleria La
Salita, Rome

1975
"Graziosa Girevole", Galleria
Lucrezia Domizio, Pescara

1976
"Sandro Chia", Studio Antonio Tucci
Russo, Turin
"Due monelli guardano nell'imo un
limone", Galleria La Salita, Rome
"Ometto quando ti sentirai a tuo agio
visto che sei a casa tua", Galleria La
Salita, Rome

1977
Galleria Fiorino, Genoa
Galleria Gian Enzo Sperone, Rome
"Pupa. Preliminari per una mostra a
Roma", Galleria La Salita, Rome

1978
"Intorno a sé", Galleria Giuliana De
Crescenzo, Rome
"Per organi", Paul Maenz, Cologne
Galleria dell'Oca, Rome
Studio Antonio Tucci Russo, Turin

1979
Mario Diacono, Bologna
Paul Maenz, Cologne
"Adulti non lasciatevi orinare in faccia
dai più piccoli", Framart Studio, Naples
Galleria Gian Enzo Sperone, Rome

1980

"Sandro Chia", Sperone Westwater
Fischer, New York
Art & Project, Amsterdam
Paul Maenz, Cologne

1981
"Sandro Chia", Sperone Westwater
Fischer, New York
Bruno Bischofberger, Zürich
Anthony d'Offay, London

1982
The James Corcoran Gallery, Los
Angeles
Sperone Westwater, New York

1983
"Sandro Chia", Stedelijk Museum,
Amsterdam
Mario Diacono, Rome
"Sandro Chia. Disegni, acquarelli,
pastelli, tempere", Palazzo Grassi,
Venice
Leo Castelli, New York
Fruitmarket Gallery, Edinburgh
Galerie Daniel Templon, Paris
Natalie Seroussi, Paris
Gallery Five, Stockholm
Galerie Silvia Menzel, Berlin
"Sandro Chia, Mönchengladbach
Journal", Städtisches Museum
Abteiberg, Mönchengladbach

1983 – 1984
"Sandro Chia Bilder, 1973 – 1983",
Kestner Gesellschaft, Hannover

1984
Staatliche Kunsthalle, Berlin
"Sandro Chia Peintures 1976 – 1983",
Musée d'Art Moderne de la Ville de
Paris, Paris
Mathildenhöhe, Darmstadt
The Mezzanine Gallery, Metropolitan
Museum of Art, New York
Kunstverein für Rheinlande und
Westfalen, Düsseldorf
Akira Ikeda Gallery, Tokyo
Schellmann und Klüser, Munich
Galerie Daniel Templon, Paris
Sima, Venice
Gaierie Ascan Crone, Hamburg
James Corcoran Gallery, Los Angeles

"Venator Intrepidus", Galleria
Mazzoli, Modena

1985
Leo Castelli Gallery, New York
Galerie Bruno Bischofberger, Zürich
Galerie Michael Haas, Berlin
Galerie Thaddaeus Ropac, Salzburg

1986
Akira Ikeda Gallery, Tokyo
Kunsthalle Bielefeld, Bielefeld

1987
"Five Poems for Five Works on
Paper and One Sculpture", Akira
Ikeda Gallery, Tokyo
Mario Diacono, Boston
Sperone Westwater Fischer, New
York
Galleria Gian Enzo Sperone, Rome
Fischer Fine Art, London

1988
"Sandro Chia Oeuvres recents",
Galerie Daniel Templon, Paris
"Sandro Chia", former church of San
Nicolò, XXI Festival dei Due Mondi,
Spoleto
Sperone Westwater Fischer, New
York

1989
"Novanta spine al vento", Museum
Moderner Kunst, Vienna
ICC, Antwerp
Museo della Biennale, Venice
Museum Schloss Rheda, Wiedenbrück
Museo Rufino Tamayo, Mexico
Museum of Moterrey, Moterrey
Galerie Thaddaeus Ropac, Salzburg
AC&T Corporation, Tokyo
Sperone Westwater Fischer, New
York
Yoshimitsu Hijikata Gallery, Nagoya

1990
Sabine Wachters Deurle Fine Arts,
Deurle
Yoshimitsu Hijikata Gallery, Nagoya
Foncazione Mudima, Milan
Galerie Daniel Templon, Paris

1991
"Dipinti, Disegni, sculture", Galerie
Thaddaeus Ropac, Salzburg
"Sandro Chia. Dipinti e titoli
recenti", Palazzo Medici Riccardi,
Florence
"Works on Paper", Kunstverein
Sundern, Sundern

1992
Badischer Kunstverein, Karlsruhe
"Retrospective", Nationalgalerie,
Berlin
"Works on Paper", Galerie Hilger,
Vienna

1993
"Sandro Chia", Espace des Arts,
Chalon sur Saône
Desert Museum of Art, Palm Springs
Michael Kohn Gallery, Los Angeles
Galerie Thaddaeus Ropac, Paris
Larry Gagosian/Leo Castelli, New York

1994
"Sandro Chia: Small Bronze
Sculptures", Grand Salon, New York
"Sandro Chia: Neo Paintings", 65
Thompson Street, New York
"Sandro Chia", Waddington
Galleries, London

1995
"Elektra", Galerie Thaddaeus Ropac,
Salzburg
"Sandro Chia", Academie de France,
Villa Medici, Rome

1996
"Sandro Chia: New Paintings",
Sydney
Janis Gallery, New York
"Sandro Chia: Recent work", Galerie
Thaddaeus Ropac, Paris

1997
Galeria Civica, Siena Palazzo
Sforzesco, Milan
M.O.M.A., Boca Raton, Florida
Galerie Thaddaeus Ropac, Salzburg
Akira Ikeda Gallery, Tokyo
"Sandro Chia", Arengario di Palazzo
Reale, Milan

1998
Pepperdine University, Weismann
Foundation, Malibu, California
Galerie Thaddaeus Ropac, Paris

Lutz Gallery, Germany

1999
Tony Shafrazzi Gallery, New York
Magazzini D'Arte Contemporanea,
Italy

2000
Museo di Ravenna, Italy Velge &
Noirhomme, Brussels

Group Exhibitions

1971
"Burri···Colla···Chia···Scialoja···
Sordini", Galleria La Salita, Rome

1972
"Chia, De Filippi, Fabro, Pisani",
Galleria La Salita, Rome

1973
Sandro Chia, "ex libris"; Feruccio De
Filippi, "Narcisco"; Gianfranco
Notargiacomo, "Ipotesi per una
metrica", Galleria La Salita, Rome
"Sandro Chia, Gianfranco
Notargiacomo", Galleria La Salita,
Rome

1974
"Chia, De Filippi, Kounellis,
Mattiacci, Notargiacomo", Galleria La
Salita, Rome

1975
"24h su 24h", Galleria l'Attico, Rome
"Boetti, Chia, Fabro, Pistoletto",
Galleria La Salita, Rome

1976
A. Boetti, "Collo rotto braccia lunghe";
S. Chia, "Immobilità vari affetti"; F.
Clemente, "Coppia di inganno"; V.
Pisani, "Oriente occidente", Framart
Studio, Naples

1977
"10th Biennale de Paris", Musée d'Art
Moderne de la Ville de Paris, Paris
"S. Chia/G. Paolini/Salvo", Galleria
Gian Enzo Sperone, Rome
"1957 – 1977 (manifesto on the occasion
of 20 years of activity of the gallery)",
Galleria La Salita, Rome

1979
"Europa 79", Stuttgart

"Associazione dissociazione dissenzione
dell'arte – L'Estetico e il selvaggio",
Galleria Comunale, Modena
"XIII Rassegna Internazionale d'arte.
Opere fatte ad arte", Palazzo di città,
Acireale
"Le Stanze", Castello Colonna,
Genazzano
"XV Biennale", Museu de Arte, São
Paulo

1980
"Die Enthauptete Hand, 100
Zeichnungen aus Italien (Chia,
Clemente, Cucchi, Paladino)", Bonner
Kunstverein, Bonn; touring to
Wolfsburg and Groningen
"Sandro Chia, Francesco Clemente,
Enzo Cucchi, Nicola De Maria, Mimmo
Paladino", Francesco Masnata, Genoa
"Chia, Cucchi, Merz, Calzolari", Gian
Enzo Sperone, Turin
"Egonavigatio", Mannheimer
Kunstverein, Mannheim
"La nuova immagine italiana", Loggetta
Lombardesca, Ravenna
"7 junge Kunstler aus Italien. Chia,
Clemente, Cucchi, De Maria, Ontani,
Paladino, Tatafiore", Kunsthalle, Basel;
touring to Essen and Amsterdam
"Prime opere", Galleria La Salita, Rome
"Après le classicisme", Musée d'Art et
Industrie, St-Etienne
"Biennale di Venezia, Aperto 80",
Venice
"Sandro Chia, Francesco Clemente,
Enzo Cucchi", Sperone Westwater
Fischer, New York

1981
Galerie Daniel Templon, Paris
"Linne della ricerca artistica in Italia
1960/1980", Palazzo delle Espoziono,
Rome
"Recent Acquisitions: Drawings",
Museum of Modern Art, New York
"A New Spirit in Painting", The Royal
Academy of Arts, London
"Westkunst heute", Rheinhallen der
Kolner Messe, Cologne
"Sandro Chia, Francesco Clemente,
Enzo Cucchi, Carlo Mariani, Malcolm
Morley, David Salle, Julian Schnabel
(drawings)", Sperone Westwater
Fischer, New York
"New York by Chia, Cucchi, Disler,
Penck (graphics)", Bernard Jacobson
Ltd., Los Angeles

"New York", Anthony d'Offay Gallery, London
"Figures: Forms and Expressions", Albright-Knox Art Gallery, Cepa Gallery and Hallwalls, Buffalo, New York
"La memoria e l'inconscio", Studio La Torre Pistoia
"Tesoro", Emilio Mazzoli, Modena
"Aspects of Post-Modernism", The Squibb Gallery, Princeton, New Jersey

1982
"De la catastrophe", Centre d'Art Contemporain, Geneva
"Italian Art Now: An American Perspective", Exxon International Exhibition, The Solomon R. Guggenheim Museum, New York
"Documenta 7", Kassel
"The Pressure to Paint", Marlborough Gallery, New York
"Hommage to Leo Castelli", Galerie Bruno Bischofberger, Zürich
"Five Painters: Chia, Clemente, Kiefer, Salle, Schnabel", Anthony d'Offay Gallery, London
"Transavanguardia Italia/America", Galleria Civica, Modena
"Scultura andata, scultura storna", Galleria Emilio Mazzoli, Modena
"Avanguardia, transavanguardia 68-77", Mura Aureliane, Rome
"Zeitgeist", Internationale Kunstausstellung, Berlin
"Chia, Cucchi, Lichtenstein, Twombly", Sperone Westwater Fischer, New York
"Mythe, Drame, Tragedie", Musée d'Art et d'Industrie, St-Etienne
Galleria Giuliana De Crescenzo, Rome
"Vision in Disbelief", IV Sydney Biennale, Sydney

1983
"Tema Celeste", Museo Civico d'Arte Contemporanea, Gibellina
"New Art at the Tate Gallery", Tate Gallery, London
"New Italian Art", The New Gallery of Contemporary Art, Cleveland
"Trustees' Choice", The Aldrich Museum of Contemporary Art, Ridgefield, Connecticut
"Opere su carta", Centro d'arte contemporanea, Siracusa
"Sandro Chia, Francesco Clemente, Enzo Cucchi: Bilder", Kunsthalle Bielefeld, Bielefeld

"La Transavanguardia", Caja de Pensiones, Madrid
"Concetto-Imago: Generationswechsel in Italien", Bonner Kunstverein, Bonn
Galerie Bruno Bischofberger, Zürich
"Recent European Painting", The Solomon R. Guggenheim Museum, New York
"Sculpture", Leo Castelli Gallery, New York
"Drawings/Photography", Leo Castelli Gallery, New York
"Bonjour Monsieur Manet", Centre Georges Pompidou, Musée National d'Art Moderne, Paris
Emilio Mazzoli, Modena
Galerie Munro, Hamburg
"Ars 83 Helsinki", Ateneumin Taidemuseo, Helsinki
"Marathon'83", International Running Center, New York
Bonnier Gallery, New York
"The First Show, Painting and Sculpture from Eight Collections", Museum of Contemporary Art, Los Angeles Anthony d'Offay Gallery, London
"Sakowitz Festival del Disegno italiano", Sakowitz, Houston Galerie Thomas, Munich
"Expressive Malerei Nach Picasso", Galerie Beyeler, Basel

1984
"SIx in Bronze", 1954 Gallery, Williams College Museum of Art, Williamstown, Massachusetts
"The European Attack", Gallery Barbara Farber American Graffiti, Amsterdam
Galerie Léger, Malmö
"Totem", Bonnier Gallery, New York
"Modern Expressionists", Sidney Janis, New York
"Via New York", Musée d'Art Contemporain, Montreal
"Det Italienska Transavangardet", Stockholm Art Fair and Lunds Konsthall, Lund
"R.O.S.C.'84", Guinness Hop Store, Dublin
Gallozzi-La Placa, New York
Galerie Thomas, Munich
Jeffrey Hoffeld, New York
Galerie France Antiope, Paris
"Arte allo specchio", Giardini, Biennale, Venice
Sperone Westwater, New York
"Portraits", Galerie Silvia Menzel,

Berlin
"Drawings", Galerie Daniel Templon, Paris
"Contemporary Italian Masters", The Chicago Public Library Cultural Center, Chicago
"The Human Condition, Biennial III", San Francisco Museum of Modern Art, San Francisco
"Terrae Motus", Villa Campolieto, Naples
"Current Expression", Fuller Goldeen Gallery, San Francisco
"Artists choose Artists", CDS Gallery, New York
"An International Survey of Recent Painting and Sculpture", Museum of Modern Art, New York
"XLI Biennale di Venezia", Venice

1984 – 1985
"Six in Bronze", The Newport Harbor Art Museum, Newport Beach, California; touring to The Brooklyn Museum, New York
"Dialog", Gulbenkian Foundation, Lisbon

1985
Dracos Art Center, Athens
"7000 Eichen", Kunsthalle Tübingen, Tübingen
"Anniottanta", "States of War", Galleria Comunale d'Arte Moderna, Bologna
"States of War", Seattle Art Museum, Seattle
"Selection from William J. Hokin Collection", Museum of Contemporary Art, Chicago
Nicola Jacobs Gallery, London
"Drawings", Galerie Silvia Menzel, Berlin
"Ouverture", Castello di Rivoli, Turin
"Wolfgang Amadeus Mozart", Thaddaeus Ropac, Salzburg

1985 – 1986
"New Art from Italy", Contemporary Art Center, Cincinnati; touring to Joslyn Art Museum, Omaha and Dade County Cultural Center, Miami
"A New Romanticism", Hirshhorn Museum and Sculpture Garden, Washington D.C.; The Akron Art Museum, Akron
"An International Survey 13 Points of View", Yares Gallery, Scottsdale,

Arizona

1986
Anthony d'Offay Gallery, London
Galerie Zero, Stockholm
Eugene Binder Gallery, Dallas
Galerie Mustad, Molnycke
Stadtische Galerie im Lenbachhaus, Munich
"XI Quadriennale di Roma", Rome
"Philadelphia Collects Art since 1940", Philadelphia Museum of Art, Philadelphia
"International Art Show for the End of World Hunger", International Monetary Fund Visitor's Center, Washington
"Focus on the Image", Museum of Art, University of Oklahoma, and touring

1987
Ascan Crone, Hamburg
"Painting in Europe", Karl Pfefferle, Munich
"Tridente Due Roma 1987", Galleria Giuliana De Crescenzo, Rome
"The great drawing show", Michael Kohn, Los Angeles
"Art against AIDS", Sperone Westwater, New York
"The Re-emergent Figure-Seven Sculptors at the Storm King Art Center", The Storm King Art Center, Mountainville, New York
"Selections from the Frederick R. Weisman Collection", Academy of the Fine Arts, Philadelphia
"Italie hors d'Italie", Musée des Beaux Arts, Nimes
"Watercolors plus", Nora Haime Gallery, New York
"Works on Paper", Galerie Bernd Kluser, Nunich
"Disegno italiano del dopoguerra", Galleria Civica, Modena
"Relief and Sculpture", Akira Ikeda Gallery, Nagoya
Eugene Binder Gallery, Dallas
"Hommage a Leo Castelli", Galerie Daniel Templon, Paris
"International Art Show for the End of World Hunger", Minnesota Museum of Art, Saint Paul (touring)

1988
"Dal ritorno all'ordine al richiamo della pittura. Continuità figurativa nella pittura italiana 1920-1987", Kunstnernes Hus, Oslo(traveling)
"Le scuole romane sviluppie continuità", Palazzo Forti, Galleria d'Arte Moderna e Contemporanea, Verona
"XLIII Biennale di Venezia", Venice
The Marshall Frankel Collection, Museum of Contemporary Art, Chicago
"Fables and Fantasies, From the collection of Susan Kasen and Robert D.
Summer", Duke University Museum of Art, Durham, North Carolina
"City of Sale", National Academy of Design, Huntington Room, New York

1989
"Italian Art", Royal Academy of Arts, London
"S.Chia/E. Cucchi,"Akira Ikeda Gallery, Nagoya
"1979-1989 American, Italian, Mexican
Art from the Collection of Francesco Pellizzi", Western Gallery, Western Washington University, Bellingham
Sperone Westwater, New York
"Wiener Diwan-Sigmund Freud-Heute", Museum des 20 Jahrhunderts, Vienna
"Meta-Menphis", Fondazione Querini Stampalia, Venice

1990
"Sperone Westwater Group Exhibition", ARCO'90 Art Fair, Madrid
"Number One 1990", Galeria Dau al Set, Barcelona
"Artists for Amnesty", Blum Helman Gallery and Germans van Eck Gallery, New York
"Group Exhibition", Galerie Enrico Navarra, Paris
"Tra Mito e Stereotipo", Galleria INARCO, Turin
"Dreams of Artists' Furniture", "121" Art Galley, Antwerp

"Lo Zingaro Blu", Galleria Pieroni, Rome
"Pharmakon'90", Nippon Convention Center, Chiba

1991
"Festival of Salzburg", with Arnulf Rainer and Roy Lichterstein, Salzburg

1992
Ho-Am Museum, Seoul

1992 – 1993
"Transavanguardia: Chia, Clemente, Cucchi, De Maria, Paladino: Works from 1977-90", Gian Ferrari Arte Contemporanea, Milan

1993
"Chia, Clemente, Paladino, Salvo: Works on Paper", Galerie Delta, Rotterdam
"Utopia. Arte Italiana 1950-1993", Galerie Thaddaeus Ropac, Salzburg & Galerie Thaddaeus Ropac, Paris

1994
"Chia, De Maria, Paladino", Galleria Cardi, Milan
"New Prints by Contemporary Masters", Salama-Caro Gallery, London

1995
"Die Muse?", Galerie Thaddaeus Ropac, Salzburg & Galerie Thaddaeus Ropac, Paris

1996
"Pablo Picasso: Ein zeitgenossischer Dialog", Galerie Thaddaeus Ropac, Salzburg & Galerie Thaddaeus Ropac, Paris

1997
Galerie Thaddaeus Ropac

1999
Tony Shafrazzi Gallery, New York

2000
Museum of Modern Art, New York

Bibliography

1971

"Sandro Chia", L'Espresso, Rome, 23 May

1975

"Sandro Chia", Casabella, Milan, November

1978

"Intorno a sé", edited by G. De Crescenzo, writings by S. Chia and A. Bonito Oliva, Rome
P. Bocacci, "A caccia dell'immaginario", paese Sera, Rome, 2 November
"Tre o quattro artisti secchi", edited by E. Mazzoli, Modena

1979

"Sandro Chia", exhibition catalogue, Bologna, Galleria Mario Diacono, "La nuova icona e la ramificazione dei segni"
L. Cherubini, "Espongono a Napoli", Avanti!, Rome
S. Chia & A. Bonito Oliva, "Mattinata all'opera", Modena
I. Mussa, "Duetto artistacritico", Avanti!, Rome, 15 July
A. Bonito Oliva, "La transavanguardia italiana", Flash Art, Milan, Oct-Nov
"Operefatte ad arte", exhibition catalogue, edited by A. Bonito Oliva, Acireale, Palazzo di Città
"Le Stanze", exhibition catalogue, edited by A. Bonito Oliva, Genazzano, Castello Colonna Galleria dell'Oca, Rome

1980

F. Vincitorio, "Dice Sandro Chia", L'Espresso, Rome, 3 February
F. Alinovi, R. Barilli, R. Daolio, "Dove va l'arte italiana. Inchiesta sugli anni' 80. La mamma mi ha regalato una scatola di colori", Bolaffi. La rivista dell'Arte, XII, 96, March, pp. 25-30
"Il primo catalogo degli artisti nuovi-nuovi", ibid., pp. 24-29
A. Bonito Oliva, "Dove va l'arte italiana. Inchiesta sugli anni' 80. Gil Anni' 80 ci portano l'arte casual (l'arte intercambiabile)", Bolaffi, La rivista dell'Arte, XII, 97, April, pp. 25-30
A. Bonito Oliva, "La mappa degli artisti degli anni' 80", ibid., pp. 30-33
"Egonavigatio", exhibition catalogue, Manheim, Manheimer Kunstverein, with writings by J. C. Ammann, A. Bonito Oliva, G. Celant, W. Max Faust, M. Jochimsen
"Sandro Chia, Francesco Clemente, Enzo Cucchi, Nicola De Maria, Luigi Ontani, Mimmo Paladino, Ernesto Tatafiore", exhibition catalogue, edited by J. C. Ammann, texts by J. C. Ammann, A. Bonito Oliva, G. Celant, Zdenek Felix with a publication for each artist: S. C., Basel, Kunsthalle
G. C. Argan, "Computer il giovane maestro del XX secolo", L'Espresso, Rome, 4 May
G. Celant, "Une histoire de l'arte contemporain en italie", Art Press, Paris, 3-7 May
"Biennale di Venezia Aperto' 80", exhibition catalogue, Venice, Jun-Sept
D. Micacchi, "Il nuovo è tutto già visto", L'Unità, Rome, 1 June
G. Testori, "Quel pasticciaccio brullo della Biennale", Corriere della Sera, Milan, 1 June
S. Pinto, "La pittura spaccata in due", Il Popolo, Rome, 3 June
G. Dorfles, "Parzialità delle scelte", Alfabeta, Milan, July
G. Celant, "Biennale 80: sogni e risvegli", Domus, 608, Milan, July-Aug, pp. 48-50
R. Pincus Witten, "Entries if Even in Fractions", Arts Magazine, 1 September, pp. 116-119
F. Vincitorio, "Il critico e l'artista", L'Espresso, 37, Rome, 4 September
W. Zimmer, 'Italian Iced', The Soho Weekly News, Vol. 8, No. 2, New York, 8-14 October, p. 45
P. Restany, "La fiera dei pittori del sabato sera", D'Ars, XXI, 94, Milan, December, pp. 8-22

1981

"A New Spirit in Painting", exhibition catalogue, London, Royal Academy of Arts
"Linee della ricerca artistica in Italia 1960/1980", exhibition catalogue, edited by N. Ponente, Rome, Palazzo delle Esposizioni
A. Seymour, "The Daughter of Dr. Jekyll", London, Anthony d'Offay (then in 'Sandro Chia Bilder 1976 – 1983', exhibition catalogue, Hanover, 1983 – 1984, and Paris, 1984)
A. Ratcliff, "A new wave from Italy: Sandro Chia", Interview Magazine, June-July, pp. 83-85
T. Trucco, "Sensation of Year", Portpolio, Sept-Oct, pp. 42-47
M. Krugman, "Sandro Chia at Sperone Westwater Fischer", Art in America, October, pp. 144-145
"Sandro Chia", exhibition catalogue, forward by M. Diacono, "Qualcosa di interessante (il servo e l'artista)", Rome, Galleria Mario Diacono, 11 Sept-10 Oct
D. Micacchi, "L'oste assassino e la pittura di un primordio selvaggio", L'Untià, Rome, 8 October
G. Glueck, "Fresh Talent, New Buyers Brighten Art Outlook in USA", International Herald Tribune, 19 November
"Après le classicisme", exhibition catalogue, edited by J. Beuffet, B. Ceysson, D. Semin, Musée de l'Art et Industrie, St-Etienne
"Figures Forms and expressions", exhibition catalogue, Buffalo, New York, Albright-Knox Gallery
G. Celant, "Identité italienne depuis 1959", Florence, Centro Di

1982

D. Berger, "Sandro Chia in His Studio: An Interview", The Print Collector's Newsletter, 6, Jan-Feb, pp. 168-169
"Italian Art Now: An American Perspective", 1982 Exxon International Exhibition, exhibition catalogue, edited by D. Waldman, texts by L. Dennison, D. Waldman, foreward by T. Messer, The Solomon R. Guggenheim Museum, New York
R. Vincitorio, "Questi magnifici sette rappresentano l'arte italiana oggi", in Tuttolibri, supplement of La Stampa, Turin, 13 March
G. Glueck, "Art. At the Guggenheim, 7 Italians Show in One", The New York Times, New York, 2 April
V. Apuleio, "Quel dolce sapore di nichilismo", Il Messaggero, Rome,

21 April
"Avanguardia Transavanguardia",
exhibition catalogue, edited by A.
Bonito Oliva, Mura Aureliane, Rome
"Dialogue between Giulio Carlo
Argan and Achille Bonito Oliva,
Avanguardia e Transavanguardia",
Interarte, 8, june, pp.3-32
I. Panicelli, "Italian Art Now: an
American Perspective", Artforum, New
York, June, p.3 and Flash Art
International, 108, Summer, p.64
"Documenta 7", exhibition catalogue,
edited by R.H.Fuchs, Kassel
C. Ratcliff, "On iconography and
Some Italians", Art in American, 8,
September, pp.152-159
"Sandro Chia/Enzo Cucchi: Scultura
andata, scultura storna", Emilio
Mazzoli, Modena
G. Parise, "Un mostro acquatico fatto
a quattro mani", Corriere della Sera,
Milan, 8 October; then in Artisti,
Rome, 1984
G. Glueck, "Sandro Chia", The New
York Times, New York, 12
November

1983
S.A.Harris, "Sandro Chia" Art
Magazine, 5, January, pp.28-29
M. Kohn, "Sandro Chia", Flash Art,
110, January
B. Rose, "In Berlin. The Spirit of the
Times: Zeitgeist", Vogue, February,
pp.296-301
A. Anderson, "The Bronze Age",
Portpolio, March-April, pp.78-83
"Sandro Chia" Francesco Clemente,
Enzo Cucchi, exhibition catalogue,
edited by H.Bastian, texts by W.F.
Max, Bielefeld, Kunsthalle, 17
February-17 April
"Sandro Chia", exhibition catalogue,
texts by E.de Wild and Sandro Chia,
Stedelijk Museum, Amsterdam
G. Marzorati, "The last hero",
ARTnews, April
"Sandro Chia", exhibition catalogue,
foreward by M.Diacono, Galleria
Mario Diacono, Rome
"Sandro Chia, Disegni, acquarelli,
pastelli, tempere", exhibition
catalogue, edited by G.E.Sperone, I.
Mostra Mercato Internazionale
d'Arte Moderna, Palazzo Grassi,
Venice
R. Smith, "Backward versus

Forward", The Village Voice, New
York, 24 May
"Bonjour Monsieur Manet",
exhibition catalogue, Centre Georges
Pompidou, Musée National d'Art
Moderne, Paris
"Sandro Chia Mönchengladbach
Journal", exhibition catalogue, edited
by J.Cladders, Mönchengladbach,
Stadtisches Museum Abteiberg
R. de Fusco, "Storia dell'arte
contemporanea", Bari
C. Ratcliff, "An interview with
Sandro Chia", Scottish Art Center,
Edinburgh
"New Art at Tate Gallery", exhibition
catalogue, edited by A.Bowness,
Tate Gallery, London
G. Tomasco Liverani, "Un disegno
dell'arte, Galleria La Salita
1957 – 1983", Galleria La Salita,
Rome
"Sandro Chia Bilder 1976 – 1983",
exhibition catalogue, edited by C.
Haenlein, texts by H.Geldzahler, C.
Haenlein, A.Seymour, Kestner
Gesellschft, Hanover

1984
P. Winter, "Die wattierten
Traumnelden", Weltkunst, Munich,
2-15 January, pp.134-135
"Sandro Chia Peintures 1976 – 1983",
exhibition catalogue, texts by C.
Haenlein, H.Geldzahler, A.
Seymour, A.R.C., Musée d'Art
Moderne de la Ville de Paris, Paris
M. Cone, "Sandro Chia: interview",
Artistes, Paris, May
"XLI Biennale di Venezia. Arte allo
specchio", exhibition catalogue,
Venice, June-September
G. Polti, "Sandro Chia", Flash Art,
121, June, pp.14-20
"Sandro Chia", exhibition catalogue,
texts by Sandro Chia and M.Kruger,
Gallery Ascan Crone, Hamburg
"Sandro Chia Prints 1973 – 1984",
exhibition catalogue, The Mezzanine
Gallery, Museum of Modern Art,
New York
S. Chia, "Venator intrepidus", Emilio
Mazzoli, Modena

1985
H. Martin, "Inside Europe: Italy",
ARTnews, 2, pp.26-29
S. Kent, "Critical Images", Flash Art,

121, March, pp.23-27
"Sandro Chia", exhibition catalogue,
foreword by H.Bastian, Galerie
Thaddaeus Ropac, Salzburg, July
"Anni ottanta", exhibition catalogue,
edited by R.Barilli, Galleria
Comunale d'Arte Moderna, Bologna
"New art from Italy (Chia, Clemente,
Cucchi, Paladino)", exhibition
catalogue, edited by H.T.Day,
Joslyn Art Museum, Omaha
H. Szeemann, "Monte verità", Tema
Celeste, 7 November, pp.45-49

1986
"Sandro Chia", exhibition catalogue,
Akira Ikeda Gallery, Tokyo
M. Stevens, "Celebrating the Union
Business and Art", Newsweek, 10
March, pp.72-73
"Sogno italiano. La collezione
Franchetti a Roma", exhibition
catalogue, edited by A.Bonito Oliva,
Castello Colonna, Genazzano

1987
"Sandro Chia. Five Poems for Five
Works on Paper and one Sculpture",
exhibition catalogue, Akira Ikeda
Gallery, Tokyo
G. Polti & G.Di Pietrantono,
"Achille Bonito Oliva, Chia. Una
lunga intervista sulla
transavanguardia e il suo dopo", Flash
Art, 139, May-June, pp.36-40
R. Ottoman, "Sandro Chia. A Pure
Poetry of Figures and Images", Flash
Art International, 136, October,
pp.115-116
J. Neisser, "A Magnificent
Obesession", Art and Auction, 5,
December, pp.108-113
Ten Unusual Questions to Sandro
Chia. An Interview with Wolfgang
George Fischer at Castello
Romitorio, Montalcino, 14
September, published on occasion of
the exhibition Sandro Chia New
York 1986-1987, Fischer Fine Art,
London

1988
E. White, "Ammann of Style", Vanity
Fair, January, pp.71-75
"Dal Ritorno all'ordine al richiamo
della pittura. Continuità figurativa in
Italia 1920 – 1987", exhibition
catalogue, edited by B.Mantura and

P. Vivarelli, Kunstnernes Hus, Oslo
"Le scuole romane. Sviluppi e
continuità", exhibition catalogue,
edited by F. Benzi, E. Mascelloni, R.
Lambarelli, Palazzo Forti, Verona
"XLIII Bienale di Venezia. Il luogo
degli artisti", exhibition catalogue,
Venice
"Sandro Chia", exhibition catalogue,
edited by B. Mantura, former church
of San Nicolò, Spoleto
L. Malen, "Sandro Chia: Sperone
Westwater", ARTnews, Summer

1989
N. Rosenthal, "C.C.C.P. Back to the
Future", exhibition catalogue, in
Italian Art in the 20th Century,
Royal Academy of Arts, London
H. Cumming, "Italian Art Today: a
Survey", Art & Design, Vol.5, 1-2,
pp.30-47
"Novanta spine al vento", exhibition
catalogue, texts by D. Ronte, C.
Haenlein, G. Caradente, Thaddaeus
Ropac Gallery, Salzburg

1990
S. Chia, "Art should be the most
provocative thing in the world", Art
International, 12, August, pp.50-51
S.M.L. Aronson, "Sandro Chia in
Tuscany: Artist's Castello Romitorio

Studio", Architectural Digest, 47,
pp.136-141
G. Polti, "Sandro Chia", Flash Art,
157, Summer, pp.53-59
M. Senaldi, "Sandro Chia", Flash
Art, 158, October-November, p.194
"Sandro Chia", Edit de Ak, Kyoto
Shoin ('Art Andom' 1979)
A. Hicks, "Twilight of the Gods", Art
& Auction, November, pp.226-233

1991
D. Paparoni, "Art in the Belly of the
Whale. Sandro Chia", Tema Celeste
Art Magazine, 29, January-February,
pp.52-57
"Sandro Chia", exhibition catalogue,
foreword by L. Caprile, Galleria
Cesarea, Genoa, May-June
S.M.L. Aronson, "Sandro Chia at
Enterprise Farm", Architectural
Digest, June, pp.100-109
"Sandro Chia-Salzburg 1990",
exhibition catalogue, foreword by W.
Schmied, Thaddaeus Ropac Gallery,
Salzburg

1992
"Sandro Chia", exhibition catalogue,
Badischer Kunstverein Karlsruhe,
Thaddaeus Ropac Gallery, Salzburg

1993

T. Collins & R. Milazzo, "Spotlight:
Sandro Chia: Readymade
Masterpieces", Flash Art, Vol.XXVI,
168, January-February, p.85

1994
D. Stein, "Sandro Chia: Grand
Salon", ARTnews, April, p.162
N. Princethal, "Sandro Chia at 65
Thompson Street", Art in American,
October, pp.139-140
Sandro Chia, "All Around Esthetes",
Artforum, December, p.8
N. Rosenthal, "Where are the angels
now?", exhibition catalogue,
Waddington Galleries, London

1995
J.P. Augremy, "Sandro Chia,
catalogo per l'Accademia di Francia",
Villa Medici, Rome

1996
Sandro Chia, "Three texts by Sandro
Chia and R. Milazzo", Sidney Janis
Gallery, New York

1996
Sandro Chia, "L'indistruttibile
passeggiata", A.B. Oliva, "Le
temperature dell'Arte", exhibition
catalogue, Arengario di Palazzo
Reale, Milano

FRANCESCO CLEMENTE

Born in Neaples, 1952

One-man Exhibitions

1971
Galleria Valle Giulia, Rome

1974
Galleria Area, Florence

1975
Massimo Minnini, Brescia
Franco Toselli, Milan
Gian Enzo Sperone, Turin
Gian Enzo Sperone, Rome

1976
Lucrezia de Domizio, Pescara,
Gian Enzo Sperone, Rome

1977
Paola Betti, Milan

1978
Centre d'Art Contemporain, Geneva,
Gratis, Artist's book.
Galerie Paul Maenz, Cologne,
Francesco Clemente P.M.F.C
Art & Project, Amsterdam, Undae
Clemente Flamina Pulsae,
Artist's book.

1979
Galleria d'Arte Contemporanea Emilio
Mazzoli, Modena, Italy, Vetta,
Artist's book with text by Achille
Bonito Oliva.
Giuliana de Crescenzo, Rome
Art & Project, Amsterdam, Emblemi e
colpi della pittura di fortuna Catalogue.
Lucio Amelio, Naples
Lisson Gallery, London
Gian Enzo Sperone, Turin, Non Scopa,
Artist's book.

1980
Padiglione d'Arte Contemporanea,
Milan, Francesco Clemente
Catalogue with text by Germano Celant.
Sperone Westwater Fischer, New York
Galerie Paul Maenz, Cologne,
Francesco Clemente Catalogue.
Gian Enzo Sperone, Rome, and Mario

Diacono, Rome
Art & Project, Amsterdam, New
Works Catalogue.

1981
Sperone Westwater Fischer, New York
Art & Project, Amsterdam, Frescoes
University Art Museum, University of
California, Berkeley, Francesco
Clemente/Matrix 46; The Art Museum
and Galleries, California State
University, Long Beach, Centric I:
Francesco Clemente Wadsworth
Atheneum, Hartford, Connecticut,
Francesco Clemente/Matrix 70, 1982.
Brochure with text by Mark Rosenthal.
Anthony d'Offay Gallery, London,
Francesco Clemente Pinxit
Artist's book.
Galerie Bruno Bischofberger, Zürich,
Francesco Clemente: New Works
Catalogue with text by Rainer Crone.

1982
Galerie Daniel Templon, Paris
Galerie Paul Maenz, Cologne,
Francesco Clemente: It viaggiatore
napoletano.
Artist's book with texts by Rainer
Crone and Paul Maenz.
Galerie Bruno Bischofberger, Zürich,
Francesco Clemente: Watercolours
Artist's book with text by Rainer
Crone.

1983
Akira IKeda Gallery, Tokyo, Paintings
Catalogue.
Whitechapel Art Gallery, London,
Francesco Clemente: The Fourteen
Stations; Groninger Museum,
Groningen, Badischer
Kunstverein, Karlsruhe; Galerie d'Art
Contemporain des Musées de Nice;
Moderna Museet, Stockholm.
Catalogue with foreword by Nicholas
Serota and texts by Mark Francis and
Henry Geldzahler.
Anthony d'Offay Gallery, London,
Francesco Clemente: The Midnight Sun
A Space, Toronto, Francesco
Clemente: Drawings
Sperone Westwater, New York and

Mary Boone Gallery, New York,
Francesco Clemente.
Kunsthalle Basel, White Shroud
Catalogue.

1984
The Institute of Contemporary Art,
Boston, Currents: Francesco Clemente,
Brochure with text by Elisabeth
Sussman.
Nationalgalerie, Berlin, Francesco
Clemente, Pastelle 1973 – 1983;
Museum Folkwang, Essen;
Stedelijk Museum, Amsterdam;
Fruitmarket Gallery, Edinburgh;
Kunsthalle Tübingen, Tübingen
Catalogue edited by Rainer Crone with
texts by Crone, Zdenek Felix, Lucius
Grisebach, and Joseph Leo Koerner.
Kunsthalle Basel, Francesco Clemente
Akira Ikeda Gallery, Tokyo, New
Paintings Catalogue.
Arts Council Gallery, Belfast,
Francesco Clemente in Belfast
Catalogue with interview by Giancarlo
Politi.
Kestner-Gesellschaft, Hannover,
Francesco Clemente: Bilder
und Skulpturen, 1985. Catalogue with
text by Carl Haenlein.

1985
Sperone Westwater, New York, Leo
Castelli Gallery, New York, and Mary
Boone Gallery, New York
The Metropolitan Museum of Art, New
York, Francesco Clemente Prints
1981 – 1985. Catalogue with
introduction by Henry Geldzahler
and interview by Danny Berger.
Galerie Bruno Bischofberger, Zürich,
Francesco Clemente: New Paintings
Museum für Gegenwartskunst, Basel, Il
viaggiatore napoletano.
73 Zeichnungen von 1971 – 1978.
John and Mable Ringling Museum of
Art, Sarasota, Florida,
Francesco Clemente; Walker Art
Center, Minneapolis, Dallas Museum of
Art, University Art Musenm, University
of California, Berkeley, Albright-Knox
Art Gallery, Buffalo, The Museum of
Contemporary Art, Los Angeles,

Catalogue with texts by Michael Auping and Francesco Pellizzi in collaboration with Jean-Christophe Ammann.

1986
Akira Ikeda Gallery, Tokyo, Watercolors, Catalogue.
Anthony d'Offay Gallery, London, Recent Paintings.
The Museum of Modern Art, New York, The Departure of the Argonaut, 1987.
Sperone Westwater, New York, Francesco Clemente, 1986 – 1987. Artist's book.

1987
Fundación Caja de Pensiones, Madrid, Francesco Clemente Affreschi: Pinturas al fresco. Catalogue with texts by Diego Cortez, Rainer Crone, and Henry Geldzahler.
Museum für Gegenwartskunst, Basel, Francesco Clemente: Zeichnungen und Aquarelle, 1971 – 1986.
Groninger Museum, Groningen; Ulmer Museum, Ulm; Musée de la Ville de Nice, 1988; Museum Ludwig, Cologne, 1988; Frankfurter Kunstverein, Frankfurt, 1988; Musée Cantonal Beaux-Arts, Lausanne, Switzerland, 1988; Galerie im Taxispalais, Innsbruck, 1888 – 1989. Artist's book with introduction by Dieter Koepplin.
Galerie Bruno Bischofberger, Zürich, Zeichnungen: Verschiedene Werke aus den Jahren 1977 – 1979/Works on Paper 1977 – 1979
Galerie Bruno Bischofberger, Zürich, Neue Werke: Funerary Paintings
The Art Institute of Chicago, The Argentario Paintings

1988
Milwaukee Art Museum, Francesco Clemente: The Graphic Work; The Saint Louis Art Museum; Museo Italoamericano, San Francisco, Cabinet des Estampes, Geneva, Le Départ des Argonautes et autres estampes. Catalogue.
Mario Diacono Gallery, Boston
Museum of Contemporary Art, Chicago, Francesco Clemente: Fourteen Stations of the Cross
Fundació Joan Miro, Barcelona, La Partenza dell'Argonauta

Dia Art Foundation, New York, Funerary Paintings, Artist's book.
Galerie Paul Maenz, Cologne, Francesco Clemente: Major New Work.

1989
Galerie Bruno Bischofberger, Zürich, Francesco Clemente: The Gold Paintings. Artist's book with poem by Gregory Corso.
Galerie Yvon Lambert, Paris, Francesco Clemente: Pastels.
Anthony d'Offay Gallery, London, Francesco Clemente, Story of My Country: Paintings, Sculptures, Frescoes, Tapestries, Pastels, Miniatures. Artist's book.
Dia Art Foundation, Bridgehampton, The Vowels (a e i o u): Paintings by Francesco Clemente. Catalogue with text by Henry Geldzahler.
Fundación Cultural Televisa, Centro Cultural Arte Contemporáneo, Guadalajara, Francesco Clemente: Cinco Tapices Realizados en el Taller Mexicano de Gobelinos (Guadalajara, Jalisco, Mexico). Catalogue with texts by Raymond Foye, Henry Geldzahler, and Sylvia Navarette.

1990
Anthony d'Offay Gallery, London, Francesco Clemente: Pastels.
Vrej Baghoomian Gallery, New York, Francesco Clemente: Ten Bad Mothers.
Sperone Westwater, New York, Francesco Clemente.
Philadelphia Museum of Art, Francesco Clemente: Three Worlds; Wadsworth Atheneum, Hartford, Connecticut, 1991; San Francisco Museum of Modern Art; Royal Academy of Arts, London, 1991. Catalogue with texts by Raymond Foye, Stella Kramrisch, Ann Percy, and Ettore Sottsass.

1991
Kunsthalle Basel, Francesco Clemente: The Black Book. Artist's book.
Perry Rubenstein, New York, Francesco Clemente: Early Self-Portraits.
Galerie Beyeler, Basel, Francesco Clemente. Catalogue with text by Urs Albrecht.
Museum für Moderne Kunst, Frankfurt, Francesco Clemente: Bestiarium, 1992. Catalogue with text by Jean-Christophe Ammann.

Gagosian Gallery, New York, Francesco Clemente: Testa Coda; sept. Museum für Gegenwartskunst, Basel, Kunstverein, Ulm, Artist's book with introduction by Dieter Koepplin and text and interview by Michael McClure.
Galerie Daniel Templon, Paris, Francesco Clemente: Oeuvres Récentes.
First Gallery, Moscow, Francesco Clemente. Two artist's books.

1992
Perry Rubenstein, New York, Francesco Clemente
Leccese Spruth Gallery, Cologne, Francesco Clemente: Works on Paper 1979 – 1983
Galerie Bruno Bischofberger, Zürich, War Usury Pestilence Death
Gagosian Gallery, New York, Francesco Clemente: Watercolors. Artist's book edited by Raymond Foye with discussion by Clemente, Allen Ginsberg, and Peter Orlovsky.
Galerie Michael Haas, Berlin, Francesco Clemente: Gemälde. Aquarelle. Pastelle, Catalogue.

1993
Anthony d'Offay Gallery, London, Francesco Clemente: Paintings, Sculptures and Works on Paper from India.
Catalogue with text by Dieter Koepplin.
Gagosian Gallery, New York, Francesco Clemente: The Black Paintings, Artist's book.

1994
Galerie Bruno Bischofberger, Zürich, Tree of Life.
Sezon Museum of Art, Tokyo, Francesco Clemente: Two Horizons.
Catalogue with interview by Henry Geldzahler and text by Tatsumi Shinoda.
Gagosian Gallery, New York, Francesco Clemente: Purgatorio. Artist's book.
Musée National d'Art Moderne, Centre Georges Pompidou, Paris, Early Morning Exercises: Oeuvres sur papier 1971 – 1994.
Catalogue with preface by Béatrice Salmon and texts by Harry Mathews and Ettore Sottsass.

1995
Museum für Moderne Kunst, Frankfurt,

Mothers of Hope.
Artist's book with introduction by Jean-Christophe Ammann.
Anthony d'Offay Gallery, London, Francesco Clemente: Frescoes and Pastels, 1970 – 1995
Galerie Rigassi, Bern, Francesco Clemente. Catalogue.
Jablonka Galerie, Cologne, Francesco Clemente. Artist's book
Château de Chenonceau, France (organized by Galerie Bruno Bischofberger, Zürich), Ex Libris Chenonceau, Artist's book.
Helsingin Taidehalli, Francesco Clemente. Catalogue with foreword by Silja Rantanen, text by Tatsumi Shinoda, and interview by Barbaralee Diamonstein.
Peter Blum, New York, Francesco Clemente: Works from 1980 to 1990, 1995 – 1996.

1996
Galerie Daniel Templon, Paris, Francesco Clemente
Gagosian Gallery, Beverly Hills, California, Francesco Clemente: New Works
Städtische Galerie Altes Theater, Ravensburg, Germany, Francesco Clemente: The Book of the Arrow, Aquarelle. Catalogue edited by Tilman Osterworld and Thomas Knubben with texts by Dieter Koepplin and Osterworld.
Galerie Bruno Bischofberger, Zürich, Francesco Clemente: Paintings of the Gate.

1997
Galerie Jérôme de Noirmont, Paris, Francesco Clemente: The Paintings of the Gate. Catalogue with text by Démosthènes Davvetas.
The Andy Warhol Museum, Pittsburgh, Francesco Clemente: Portraits.
Anthony d'Offay Gallery, London, Fifty One Days on Mount Abu.
Artist's book with text by Clemente.
Gagosian Gallery, New York, Francesco Clemente: Anamorphosis.
Artist's book edited by Raymond Foye with poems by Robert Creeley.
The Metropolitan Museum of Art, New York, Francesco Clemente: Indian Watercolors, 1997 – 1998;
Modern Art Museum of Fort Worth,

Texas, Indianapolis Museum of Art, 1998 – 1999. Brochure.

1999
Anthony d'Offay Gallery, London, Francesco Clemente: Painter's Wardrobe
Galleria d'Arte Moderna, Bologna, Francesco Clemente: Opere su carta, Catalogue with discussion by Clemente, Danilo Eccher, and Francesco Pellizzi.
Jablonka Galerie, Cologne, Francesco Clemente: Broken Women, Neue Pastelle.
Guggenheim Museum, New York, 1999 – 2000

Group Exhibitions

1973
Museum of the Philadelphia Civic Center, Philadelphia,
Italy Two-Art Around '70. Catalogue with texts by Furio Colombo and Alberto Boatto and Filiberto Menna.

1974
Studenteski Center, Belgrade

1975
Galleria Diagramma, Milan, Campo Dieci
Galleria l'Attico, Rome, 24 ore su 24, Parco Ibirapuera, São Paulo, XIII Bieñal de São Paulo Catalogue.

1976
Galleria Comunale d'Arte Moderna and Sala del Ridotto del Teatro Regio, Parma, Italy, Foto ε Idea. Catalogue.
Gian Enzo Sperone, Rome, Francesco Clemente, Mario Merz, Vettor Pisani.

1977
Studio Cannaviello, Rome, Drawings/Transparency.
Catalogue with text by Achille Bonito Oliva.
Gian Enzo Sperone, Rome
Palais de Tokyo and Musée d'Art Moderne de la Ville de Paris, Xe Biennale de Paris. Catalogue.

1978
Galleria la Salita, Rome, Pas de deux.

1979
Galerie Paul Maenz, Cologne, Arte Cifra.
Catalogue with text by wolfgang Max

Faust.
Kunstaustellungen Gutenbergstrasse, Stuttgart, Europa '79. Catalogue.
Galerie Yvon Lambert, Paris, Parigi: O Cara.
Palazzo di Città, Acireale, Opere Fatte ad Arte Catalogue with text by Achille Bonito Oliva.
Castello Colonna, Genazzano, Le Stanze, 1979 – 1980. Catalogue with texts by Achille Bonito Oliva and Mario Merz.

1980
Bonner Kunstverein, Bonn, Die enthauptete Hand –
100 Zeichnungen aus Italien: Chia, Clemente, Cucchi, Paladino;
Städtische Galerie Schloss Wolfsburg, Wolfsburg, Groninger Museum, Groningen, Catalogue with texts by Achille Bonito Oliva, Wolfgang Max Faust, and Margarethe Jochimsen.
Francesco Masnata, Genoa, Sandro Chia, Francesco Clemente, Enzo Cucchi, Nicola De Maria, Mimmo Paladino
Mannheimer Kunstverein, Mannheim, Egonavigatio: Sandro Chia, Francesco Clemente, Nicola De Maria, Mimmo Paladino. Catalogue with texts by Jean-Christophe Ammann, Achille Bonito Oliva, Germano Celant, Wolfgang Max Faust, and Margarethe Jochimsen.
Kunsthalle Basel, Sandro Chia, Francesco Clemente, Enzo Cucchi, Nicola De Maria, Luigi Ontani, Mimmo Paladino, Ernesto Tatafiore;
Museum Folkwang, Essen,
Stedelijk Museum, Amsterdam,
1980 – 1981. Catalogue with texts by Jean-Christophe Ammann, Achille Bonito Oliva, and Germano Celant.
Venice, XXXIX Biennale di Venezia: L'arte negli anni settanta/Aperto '80. Catalogue with texts by Achille Bonito Oliva, Michael Compton, Martin Kunz, and Harald Szeeman.
Sperone Westwater Fischer, New York, Sandro Chia, Francesco Clemente and Enzo Cucchi
Galerie Rudolph Zwirner, Cologne, Neuerwerbungen.
Galerie Daniel Templon, Paris, La transavantgarde Italienne: Sandro Chia, Francesco Clemente, Enzo Cucchi, Nicola De Maria, Mimmo Paladino, 1980 – 1981.
Galleria la salita, Rome, ritratto

Annina Nosei Gallery, New York, Drawings and Works on Paper, 1980 – 1981.

1981

Rheinhallen der Kölner Messe, Cologne, Westkunst. Catalogue with texts by Marcel Baumgärtner, Laszlo Glozer, and Kasper König.

Musée National d'Art Moderne, Centre Georges Pompidou, Paris, L'Identité Italienne : Art en Italie depuis 1959. Catalogue with introduction by Germano Celant.

Sperone Westwater Fischer, New York, Sandro Chia, Francesco Clemente, Enzo Cucchi, Carlo Mariani, Malcolm Morley, David Salle, Julian Schnabel.

Crown Point Gallery, Oakland, California, Italians and American Italians : Etchings Brochure with text by Kathan Brown.

Galerie Paul Maenz, Cologne, Die Erotik der neuen Kunst.
Catalogue with texts by Jean-Christophe Ammann, Germano Celant, Wolfgang Max Faust, and A. Wildermuth.

Galleria d'Arte Contemporanea Emilio Mazzoli, Modena, Tesoro. Catalogue with text by Achille Bonito Oliva.

Albright-Knox Art Gallery, CEPA Gallery, and Hallwalls, Buffalo, New York, Figures : Forms and Expressions, 1981 – 1982. Catalogue with texts by Robert Collignon, William Currie, Roger Denson, Biff Henrich, Charlotta Kotik, and Susan Krane.

The Squibb Gallery, Princeton, New Jersey, Aspects of Post-Modernism, 1981 – 1982. Catalogue with text by Sam Hunter.

1982

Galleria Civica del Comune di Modena, Modena, Transavanguardia : Italia/ America. Catalogue with text by Achille Bonito Oliva.

Aurelian Wall, Rome, Avanguardia Transavanguardia 68, 77.
Catalogue with text by Achille Bonito Oliva.

Marlborough Gallery, New York, The Pressure to Paint. Catalogue with texts by Diego Cortez and David P. Robinson.

Museum Fridericianum, Kassel, Documenta 7. Catalogue (2 vols.) with texts by Saskia Bos, Germano Celant, Rudi Fuchs, Johannes Gachnang,

Walter Nikkels, Gerhard Storck, and Coosje van Bruggen.

Anthony d'Offay Gallery, London, Five Painters : Chia, Clemente, Kiefer, Salle, Schnabel

The Museum of Modern Art, New York, New Work on Paper 2 : Jonathan Borofsky, Francesco Clemente, Mario Merz, A. R. Penck, Giuseppe Penone. Catalogue with text by Bernice Rose.

Groninger Museum, Groningen, and Kunsthalle Wilhelmshaven, Wilhelmshaven, kunst nu/kunst unserer zeit. Catalogue with introduction by Antje von Graevenitz.

Martin-Gropius-Bau, Berlin, Zeitgeist, 1982 – 1983. Catalogue with foreword by Christos Joachimides and texts by Karl-Heinz Bohrer, Paul Feyerabend, Hilton Kramer, et al.

The Parrish Art Museum, southampton, New York, How to Draw/What to Draw : Works on Paper by Five Contemporary Artists, 1982 – 1983.

1983

Anthony d'Offay Gallery, London, New Paintings and Watercolours.

Fundación Caja de Pensiones, Madrid, Italia : La Transavanguardia. Catalogue with texts by Achille Bonito Oliva and V. Cambalia.

The Museum of Modern Art, New York, Prints from Blocks : Gauguin to Now. Catalogue with text by Riva Castleman.

Bonner Kunstverein, Bonn, Concetto-Imago : Generationswechsel in Italien. Catalogue with texts by Zdenek Felix and Margarethe Jochimsen.

Kunsthalle Bielefeld, Bielefeld, Germany, Sandro Chia, Francesco Clemente, Enzo Cucchi : Bilder, April 29-July 3. Catalogue with texts by Wolfgang Max Faust and Ulrich Weisner and interviews with the artists by Heiner Bastian.

Solomon R. Guggenhim Museum, New York, Recent European Painting.

Galerie Beyeler, Basel, New Work on Paper : Drawings, Watercolors, Collages.

The Parrish Art Museum, Southampton, New York, The Painterly Figure Catalogue with text by Klaus Kertess.

Tate Gallery, London, New Art, Catalogue with text by Michael Compton.

The Boibrino Gallery, Stockholm, Det Italienska Avantgardet. Catalogue with

text by Cecelia Stam.

Galerie Beyeler, Basel Art Fair, Basel, Expressionist Painting Beyond Picasso, Catalogue with text by Siegfried Gohr.

Ateneumin Taidemuseo, Helsinki, Ars' 83 Helsinki. Catalogue with texts by Yrjana Levanto, Barbara J. London, Mats B. J. O. Mallander, Pauli Paaermaa, Leena Peltola, and Matti Ranki.

The Museum of Contemporary Art, Los Angeles, The First Show : Painting and Sculpture from Eight Collections, 1940 – 1980, Catalogue with texts by Julia Brown, Pontus Hulten, Bridget Johnson, and Susan C. Larsen.

Mary Boone Gallery, New York, Paintings.

1984

National Gallery of Art, Washington, D. C., The Folding Image, Catalogue with foreword by Michael Komanecky and texts by Janet W. Adams, Virginia Fabbri, and Komanecky.

Akira Ikeda Gallery, Nagoya, Painting Now : Basquiat, Chia, Clemente, Cucchi, Salome, Schnabel, Catalogue with foreword by Kazuaki Mitsuiki and text by Nobuyuki Hiromoto.

Sidney Janis Gallery, New York, Modern Expressionists : German, Italian, and American Painters, Catalogue.

Musée d'Art Contemporain, Montreal, Via New York, Catalogue with texts by Phillip Evans-Clark, France Gascon, André Menard, and Robert Pincus-Witten.

The Museum of Modern Art, New York, An International Survey of Recent Painting and Sculpture, 19. Catalogue with text by Kynaston McShine.

Mary Boone Gallery, New York, Drawings

BlumHelman Gallery, New York, Francesco Clemente, Bryan Hunt, David Salle

San Francisco Museum of Modern Art, The Human Condition : San Francisco Museum of Modern Art Biennial III, Catalogue.

The Chicago Public Library Cultural Center, Contemporary Italian Masters Catalogue with texts by Henry Geldzahler and Judith Russi Kirshner.

Anthony d'Offay Gallery, London, Beuys, Clemente, Gilbert ε George, Kiefer, Long

The Guinness Hop Store, Dublin, ROSC'

84: The Poetry of Vision. Catalogue with texts by Rosemarie Mulcahy, Patrick J. Murphy, William Packer, Michael Scott, Ronald Tallon, and Dorothy Walker.
Galerie Bruno Bischofberger, Zürich, Collaborations: Basquiat, Clemente, Warhol.
Walker Art Center, Minneapolis, Images and Impressions: Painters Who Print; Institute of Contemporary Art, University of Pennsylvania, Philadelphia, 1985. Catalogue with text on Clemente by Rainer Crone.
Hirshhorn Museum and Sculpture Garden, Smithsonian Institution, Washington, D.C., Content: A Contemporary Focus, 1974 – 1984, Catalogue with foreword by Abram Lerner and texts by Howard Fox and Miranda McClintic.

1985
Kunsthalle Tübingen, Tübingen, 7000 Eichen; Kunsthalle Bielefeld, Bielefeld. Catalogue with texts by G. Adriani, Heiner Bastian, and U. Weisner.
Grande Halle du Parc de la Villette, Paris, La Nouvelle Biennale de Paris. Catalogue with texts by Achille Bonito Oliva, Georges Boudaille, Alanna Heiss, et al.
Castello Colonna, Genazzano, Nuove Trame dell'Arte. Catalogue.
Kunsthalle Basel, Von Twombly bis Clemente: Ausgewahlte Werke einer Privatsammlung/Selected Works from a Private Collection.
Catalogue with texts by Jean-Christophe Ammann and Roman Hollenstein.
Anthony d'Offay Gallery, London, Unique Books.
The Museum Of Modern Art, New York, India and the Contemporary Artist.
Museum of Art, Carnegie Institute, Pittsburgh, The Carnegie International, Catalogue with texts by Benjamin H.D. Buchloh, Hal Foster, Rudi Fuchs, et al.
Joslyn Art Museum, Omaha, Nebraska, New Art of Italy, Dade County Center for the Fine Arts, Miami, 1986; The Contemporary Arts Center, Cincinnati, 1986. Catalogue with text by Holliday T. Day.
Castello di Rivoli, Turin, Ouverture Catalogue with text by Rudi Fuchs.

1986

Whitechapel Art Gallery, London, In Tandem. Catalogue with text by Lynne Cooke.
Städtische Galerie im Lenbachhaus, Munich, Beuys zu Ehren. Catalogue with texts by Johannes Cladders, Bernd Kluser, Armin Zweite, et al.
Museum Ludwig, Cologne, Europa/ Amerika. Catalogue with texts by Rainer Crone, Johannes Gachnang, Siegfried Gohr, et al.
Galerie Bruno Bischofberger, Zürich, Clemente, Salle, Schnabel: Three Large Paintings.
Philadelphia Museum of Art, Philadelphia Collects Art Since 1940. Catalogue with introduction by Mark Rosenthal.

1987
Palais des Beaux-Arts, Charleroi, Belgium, L'Exotisme au Quotidien.
Los Angeles County Museum of Art, Los Angeles, Avant-Garde in the Eighties. Catalogue with text by Howard Fox.
Minnesota Museum of American Art, Saint Paul, The International Exhibition to End World Hunger; Sonia Henie-Neils Onstad Foundation, Høvikodden, Norway, 1987 – 1988; Göteborgs Konstmuseum, Göteborg, 1988; Kölnischer Kunstverein, Cologne, 1988; Musée des Arts Africains et Océaniens, Paris, 1988; Barbican Art Gallery, London, 1988.
Miriam and Ira D. Wallach Art Gallery, Columbia University, New York, 1987 – 1988 Leo Castelli Gallery, New York, and Ileana Sonnabend Gallery, New York, Similia/Dissimilia: Modes of Abstraction in Painting, Sculpture and Photography Today. Catalogue with introduction by Rainer Crone and text on Clemente by Linda Norden.

1988
Galeria Eude, Barcelona, Paladino-Cucchi-Clemente
Winnipeg Art Gallery, Winnipeg, Canada, The Impossible Self. Catalogue with artists' statements.
Museo d'Arte Contemporanea, Prato, Europa Oggi-Europe Now: Arte contemporanea nell'Europa occidentale. Catalogue with texts by Carlo Bertelli, Achille Bonito Oliva, Bruno Corà, Gillo Dorfles, and Helmut Draxlet.
Venice, XLIII Biennale di Venezia: Il

Luogo degli Artisti/Aperto'88. Catalogue with introduction by Giovanni Carandente and texts by Guido Ballo, Achille Bonito Oliva, Pier Luigi Tazzi, et al.
Carnegie Museum of Art, Pittsburgh, The Carnegie International, 1988 – 1989. Catalogue with foreword by Phillip M. Johnson and texts by John Caldwell, Vicky A, Clark, Lynne Coke, Milena Kalinovska, and Thomas McEvilley.
The Museum of Modern Art, New York, For 25 Years: Crown Point Press, 1989. Catalogue with text by Riva Castleman.

1989
Royal Academy of Arts, London, Italian Art in the Twentieth Century. Catalogue with texts by Paolo Baldacci, Carlo Bertelli, Germano Celant, et al.
Rheinhallen der Kölner Messe, Cologne, Bilderstreit Catalogue with texts by Hans Belting, Michael Compton, René Denizot, et al.
Musée National d'Art Moderne, Centre Georges Pompidou, Paris, Magiciens de la Terre. Catalogue with texts by Homi Bhabha, Mark Francis, Pierre Gaudibert, et al.
Museum des 20. Jahrhunderts, Vienna, Wiener Diwan-Sigmund Freud-heute. Catalogue edited by Thomas Zaunschirm with texts by Matthias Boeckl.
Fundación Cultural Televisa, Centro Cultural Arte Contemporáneo, Guadalajara, Mexico, Paul Klee, Francesco Clemente, Papunya Tula.

1990
Franklin Furnace Archives, New York, Contemporary Illustrated Books: Word and Image, 1967 – 1988; The Nelson-Atkins Museum of Art, Kansas City, Missouri; University of Iowa Museum of Art, Iowa City, 1991.
Massimo Audiello Gallery, New York, Disturb Me.
Galerie Bellier, Paris, Renaissance du Polyptique chez les artistes contemporains. Catalogue.
Nippon Convention Center, Makuhari Messe Exhibition Hall International, Tokyo, Pharmakon'90 Catalogue with foreword by Kikuko Amagasaki and texts by Jan Avgikos, Achille Bonito Oliva, and Motoaki Shinohara.

1991

Brooke Alexander Editions, New York, Poets/Painters: Collaborations.
Matthew Marks Gallery, New York, Artists' Sketchbooks.
Catalogue with text by Guy Davenport.
Studio d'Arte Cannaviello, Milan, Clemente, Paladino, Gli Anni '70.
Catalogue.
Louver Gallery, New York, Clemente, Dorner, Iglesias, Mol, Sarmento.
Kunstmuseum Basel, and Berowergut, Riehen, Zeichnungen des 20.
Jahrhunderts: Karl August Burckhardt-Koechlin-Fonds. Catalogue with foreword by Dieter Koepplin.
Museum für Gegenwartskunst, Basel, Emmanuel Hoffmann-Stiftung 1980 – 1990. Catalogue with foreword by Vera Oeri-Hoffman and texts by Jean-Christophe Ammann, Coosje van Bruggen, Dieter Koepplin, et al.
Institute of Contemporary Art, University of Pennsylvania, Philadelphia, Devil on the Stairs: Looking Back to the Eighties, 1991 – 1992; Newport Harbor Art Museum, Newport Beach, California, 1992. Catalogue with texts by Peter Schjeldahl and Robert Storr.
Stedelijk Museum, Amsterdam, Wanderlieder, 1991 – 1992. Catalogue with texts by Wim Beeren, Sir Isaiah Berlin, H. J. A. Hofland, Heiner Müller, and Cees Nooteboom.

1992

The Museum of Modern Art, New York, Allegories of Modernism: Contemporary Drawing. Catalogue with texts by Emily Kies Folpe and Bernice Rose.
Musée d'Art Moderne et d'Art Contemporain de la Ville de Nice, Le portrait dans l'art contemporain.
Kunsthal Rotterdam, Warhol-Kiefer-Clemente: Werken op papier, 1992 – 1993. Catalogue with texts by Ruud Schenk.
Claudia Gian Ferrari Arte Contemporanea, Milan, Transavanguardia: Sandro Chia, Francesco Clemente, Enzo Cucchi, Nicola De Maria, Mimmo Paladino, 1992 – 1993. Catalogue.

1993

Sperone Westwater, New York, The spirit of Drawing.
Tony Shafrazi Gallery, New York,

1982 – 1983, Ten Years After.
Museumsquartier Messepalast and Kunsthalle Wien, Vienna, Der Zerbrochene Spiegel; Deichtorhallen.
Hamburg, 1993 – 1994. Catalogue with introduction by Kasper König and Hans-Ulrich Obrist.
Peggy Guggenheim Collection, Venice, Drawing the Line Against AIDS.
Catalogue with texts by John Cheim, Diego Cortez, Carmen Giménez, and Klaus Kertess.
Salzburger Festspiele and Galerie Thaddaeus Ropac, Salzburg, Utopia: Arte Italiana 1950 – 1993.
National Portrait Gallery, London, The Portrait Now, 1993 – 1994.

1994

Marlborough Gallery, New York, Metamorphosis: Surrealism to Organic Abstraction 1925 – 1993
Luhring Augusting Gallery, New York, The Ossuary.
Anthony d'Offay Gallery, London, Painting, Drawing and Sculpture.
Museum Moderner Kunst Stiftung Ludwig, Vienna, Malfiguren: Francesco Clemente, Jörg Immendorf, Per Kirkeby, Malcolm Morley, Hermann Nitsch, Cy Twombly. Catalogue with texts by Achille Bonito Oliva, Otto Breicha, Rainer Fuchs, Lorand Hegyi, and Edwin Lachnit.
Castel Trento, Trento, L'incanto e la transcendenza. Catalogue with texts by Achille Bonito Oliva, Danilo Eccher, Ermanno Olmi, and Crispino Valenziano.

1995

Museum für Moderne Kunst, Frankfurt, Szenenwechsel.
Venice, XLVI Biennale di Venezia: Identità e alterità. Catalogue with texts by Maurizio Bettini, Marc Fumaroli, Cathrin Pichler, et al.
Galerie Thaddaeus Ropac, Paris, Muses: Transformation de l'image féminine dans l'art contemporain. Catalogue with texts by Alan Jones, Sydney Picasso, Peter Schjeldahl, Caroline Smulders, Elizabeth Stuart, and Barbara Wally.

1996

Sperone Westwater, New York, Francesco Clemente, Julian Schnabel, Cy

Twombly; Three Large Scale Works.
Claudia Gian Ferrari Arte Contemporanea, Milan, Nudo e Crudo corpo sensibile/corpo visibile Catalogue with texts by Manlio Brusatin and Claudia Gian Ferrari.
Museum Fridericianum, Kassel, Collaboratlons: Warbol, Basqulat, Clemente; Museum Villa Stück, Munich; Castello di Rivoli, Turin, 1996 – 1997.
Catalogue with foreword by Tilman Osterwold and texts by Trevor Fairbrother, Mark Francis, Keith Haring, et al.
Art Gallery of New South Wales, Artspace, and Ivan Dougherty Gallery, Sydney, Tenth Biennial of Sydney: Jurassic Technologies, Revenant.
Catalogue with introduction by Lynne Cooke and texts by Leslie Camhi, Jonathan Crary, Sarat Maharaj, and Elisabeth Sussman.

1997

Peter Blum, New York, Drawing the Line and Crossing It.
Claudia Gian Ferrari Arte Contemporanea, Milan, Metamorphosis: Il tempo della mutazione.
Galleria d'Arte Moderna, Bologna, Materiali Anomali
The Museum of Modern Art, New York, On the Edge: Contemporary Art from the Werner and Elaine Dannheiser Collection.
Catalogue with introduction by Kirk Varnedoe and text by Robert Storr.
Guggenheim Museum Bilbao, The Guggenheim Museums and the Art of This Century, 1997 – 1998.
Galleria d'Arte Moderna, Bologna, Arte Italiana: Ultimi quarant'anni, Pittura Iconica, 1997 – 1998.

1998

Museum Würth, Künzelsau, Germany, Transavanguardia. Catalogue.
Culturgest, Lisbon, Anos 80/The Eighties. Catalogue with texts by Dan Cameron, Maria Corral, Jose Gil, and Alexander Melo.

1999

P. S. 1, New York, Minimalia, an Italian view through the XXth century, curated by Achille Bonito Oliva.

Bibliography
Artist's Books

Castelli di sabbia. Naples: L'Arte Tipografica, 1964.

Pierre Menard. Rome: Edizioni GAP, 1973.

6 Fotografie. Brescia, Italy: Banco, 1974.

Gratis. Geneva: Centre d'Art Contemporain, 1978.

Undae clemente flamina pulsae. Amsterdam: Art & Project, 1978. Edition of 800.

Vetta. Modena, Italy: Emilio Mazzoli, 1979. Edition of 1,000.

Non Scopa. Turin: Gian Enzo Sperone, 1979.

Chi pinge figura, si non può esser lei non le può porre. Basel: Kunsthalle Basel, 1980.

Francesco Clemente Pinxit. London: Anthony d'Offay; Rome: Gian Enzo Sperone, 1981. Edition of 500.

Il viaggiatore napoletano, ed. Paul Maenz. Cologne: Gerd de Vries, 1982.

Francesco Clemente: Watercolours. Zurich: Edition Bruno Bischofberger, 1982. Edition of 1,000.

White Shroud. 1983. With poem by Allen Ginsberg. Unique book.

Images from Mind and Space. 1983. With poem by Allen Ginsberg. Unique book.

Black Shroud. 1985. With poem by Allen Ginsberg. Unique book.

Early Morning Exercises. 1985. With poems by John Wieners. Unique book.

The Departure of the Argonaut. New York: Petersburg Press, 1986. With text by Alberto Savinio (trans. George Scrivani). Edition of 200.

Francesco Clemente: The Pondicherry Pastels. London: Anthony d'Offay, 1986. Edition of 1,000.

Francesco Clemente: Two Garlands. New York: Sperone Westwater, 1986.

India. Pasadena, California: Twelvetrees Press, 1986. Edition of 3,050.

Francesco Clemente CVIII: Watercolours Adayar 1985. Basel: Museum für Gegenwartskunst, 1987.

Singular Pleasures. New York: Grenfell Press, 1988. With text by Harry Mathews. Edition of 350.

Funerary Paintings. New York: Dia Art Foundation, 1988.

It. Zurich: Edition Bruno Bischofberger, 1989. With poems by Robert Creeley. Edition of 2,500.

Sixteen Pastels. London: Anthony d'Offay Gallery, 1989. With poems by Rene Ricard. Edition of 1,000.

The Gold Paintings. Zurich: Edition Bruno Bischofberger, 1990. With poem by Gregory Corso. Edition of 1,000.

Testa Coda. New Yrok Gagosian Gallery, 1991.

Mental'nyi limon/The Water's Skeleton, Francesco Clemente: Sixteen Watercolours and Francesco Clemente: Nine Drawings/Andrei Voznesensky: Five Poems. Zurich: Edition Bruno Bischofberger, 1991. With poems by Andrei Voznesensky. Edition of 1,110.

Francesco Clemente: The Black Book. Basel: Kunsthalle Basel, 1991.

Francesco Clemente: Evening Raga and Paradiso. New York: Gagosian Gallery and Rizzoli, 1992.

Cathay. New York: Limited Editions Club, 1992. With poems by Ezra Pound after Li. Po. Edition of 350.

Life ε Death New York: Gtenfell Press, 1993. With poems by Robert Creeley. Edition of 70.

There. New York: Gagosian Gallery, 1994. With poems by Robert Creeley. Edition of 1,000.

Ex Libris Madras. Madras: Kalakshetra Press, 1994. Edition of 2,000.

Francesco Clemente/Peter Handke. Cologne: Jablonka Galerie, 1995. With poems by Peter Handke. Edition of 1,000.

Ex Libris Chenonceau. Madras: Kalakshetra Press, 1995. Edition of 2,000.

Mothers of Hope: Francesco Clemente. Madras: Kalakshetra Press, 1995. Edition of 1,100.

Anamorphosis. New York: Gagosian Gallery, 1997. With poems by Robert Creeley.

Fifty One Days on Mount Abu. London: Anthony d'Offay Gallery, 1997.

Interviews and Statements

"Prezentazione: Francesco Clemente." Domus (Milan), no. 577 (Dec. 1977), pp. 52-54 (in Italian, French, and English).

Ammann, J.C., Paul Groot, Pieter Heynen, and Jan Zumbrink. "Un altre arte." Museumjournaal (Amsterdam) 25, no. 7 (Dec. 1980), pp. 288-301.

Zaya. "Conversación con Francesco Clemente: Sustancia de lo imaginario." Guadalimar (Madrid), no. 56 (1981), pp. 14-15.

White, Robin. "Francesco Clemente." View (Oakland) 3, no. 6 (Nov. 1981), pp. 2-27.

Berger, Danny. "Francesco Clemente at the Metropolitan: An Interview." The Print Collector's Newsletter (New York) 13, no. 1 (March-April 1982), pp. 11-13.

deAk, Edit. "Francesco Clemente." Interview (New York) 12, no. 4 (April 1982), pp. 16-21.

Bastian, Heiner. "Samtale med Francesco Clemente." Louisiana Revy (Humlebaek) 23, no. 3 (June 1983) pp. 40-44.

Clemente, Francesco. Statement in Achille Bonito Oliva. Dialoghi d'artista: Incontri con l'arte contemporanea 1970 – 1984. Milan: Electa, 1984 (in Italian and English).

Politi, Giancarlo. "Francesco Clemente." Flash Art (Milan), international edition, no. 117 (April-May 1984), pp. 12-21.

Courtney, Cathy. Interview with Clemente. Art Monthly (London), no. 100 (Oct. 1986), pp. 39-40.

Clemente, Francesco. Statement in Kynaston McShine, et al. Andy Warhol: A Retrospective (exh. cat.). New York: The Museum of Modern Art, 1987.

Crone, Rainer, and Georgia Marsh. An Interview with Francesco Clemente. New York: Vintage Books, 1987.

Marsh, Georgia. "Francesco Clemente: Faire quelque chose à partir de rien." Art Press (Paris), no. 113 (April 1987), pp. 4-10.

Philipps, Lisa. "Clemente: Les chemins de la sagesse." Beaux Arts Magazine (Paris), no. 69 (June 1989), pp. 90-95.

Kent, Sarah. "Turtles All the Way: Francesco Clemente Interviewed by Sarah Kent." Artscribe (London), no. 77 (Sept.-Oct. 1989), pp. 54-59.

"Manners Entice: A Discussion between Alex Katz and Francesco Clemente." Parkett (Zurich), no. 21 (Sept. 1989), pp. 48-56.

Kuspit, Donald. "Clemente Explores Clemente." Contemporanea (New York) 2, no. 7 (October 1989), pp. 36-43.

Geldzahler, Henry. "Francesco Clemente." Interview(New York)21, no. 11(Nov.1991), pp.54-56.

Burroughs, William S. "The Creative Observer: Conversation with Francesco Clemente." Flash Art(Milan), international edition, no.127(Oct. 1993), pp.36-38.

Clemente, Francesco. Untieled essay. In Jean-Michel Basquiat Portraits(exh. cat.). Zurich: Edition Bruno Bischofberger, 1996.

– "The City and the Painter." In Alex Katz(exh.cat.). Cologne: Jablonka Galerie, 1997.

Sischy, Ingrid. "fc." Interview (New York)27, no.7 (July 1997), pp.74-81.

Articles and Essays

Ammann, Jean-Christophe. "Espansivo-eccessivo: Osservazioni sulla giovane arte italiana." Domus(Milan), no.593 (April 1979), pp.45, VI VII(in Italian, Dutch, and English).

– "Was die siebziger Jahre von den sechzigern unterscheider: Der Weg in die achtziger Jahre." Kunstforum International(Cologne), no.39(March 1980), pp.172-84.

– "Francesco Clemente et l'Inde." Artstudio(Paris), no.7 (winter 1987 – 1988), pp.64-69.

Anderson, Alexandra. "Art Boom in New York: The Sudden Arrival of Francesco Clemente." Harpers and Queen (London), Feb.1983, pp.134-35.

Argan, Giulio Carlo, and Achille Bonito Oliva. "Avanguardia e transavanguardia." Iterarte(Bologna)24, no.8(June 1982), pp.3-32.

Ashbery, John. "Under the Volcano." Interview(New York)18, no.3(March 1988), pp.62-70.

Attias, Laurie. "C'mon Let's Twist Again." Artnews(New York)95, no.10 (Nov.1996), pp.124-26.

Baker, Kenneth. "Clemente Aims for the Heart." San Francisco Chronicle, Nov. 15, 1990, p.E3:1.

– "Clemente Keeps Polishing His Image." San Francisco Chronicle, April 13, 1991, p.C3:2.

Bienek, Horst. "Wenn er traumt, verandert er die Welt." Art, das Kunstmagazin(Hamburg), no.10(Oct. 1988), pp.30-46.

Bonito Oliva, Achille. "Process,
Concept, and Behaviour in Italian Art." Studio International (London), no.979, vol.191(Jan.-Feb.1976), pp.3-10.

– "The Italian Trans-Avantgarde." Flash Art(Milan), international edition, nos.92-93(Oct.-Nov.1979), pp.17-20.

– "The Bewildered Image." Flash Art (Milan), international edition, nos. 96-97(March-April 1980), pp.32-35, 38-39, 41.

– "Francesco Clemente." Domus (Milan), no.613(Jan.1981), pp.52-53 (in Italian and English).

– "La pazienze del vincitore." Segno (Pescara)6, no.29(Nov.1982-Feb. 1983), pp.8-11.

– "Les raisons poétiques de la trans-avantgarde." Artstudio (Paris), no.7 (winter 1987 – 1988), pp.64-69.

Bourdon, David. "Battling the Masters." Geo(New York)4, no.8(August 1982), pp.30-45.

Bozzi, Elisabeth. "Francesco Clemente: En parcourant les mondes, il s'est trouvé lui-même." New Art International (Paris), nos.3-4(May 1987), pp.17-20.

Capetillo, Marta. "A Life with Art." Casa Vogue(Milan), no.261(April 1994), pp.130-37, 230.

Castle, Ted. "A Bouquet of Mistakes." Flash Art(Milan), international edition, no.108(summer 1982), pp.54-55.

Celant, Germano. "The Italian Experience – Touched Upon." In Paul Maenz Jahresbericht, 1978. Cologne: Paul Maenz, 1979.

Cortez, Diego. "Francesco Clemente: L'affresco della Piscina." Domus(Milan), no.684(June 1987), pp.8-9(in Italian and English).

Cotter, Holland. "Francesco Clemente." Parkett(Zurich), nos.40-41(June 1994), pp.6-23.

Cronau, Sabine. "Drei Stars tauschen ihre Leinwande." Art das Kunstmagazin (Hamburg), no.2(Feb.1996), pp.92-93.

Crone, Rainer. "Clemente and His Pictorial Symbolism." Parkett (Zurich). no.9(April 1986), pp.70-81.

Curtis, Cathy. "Straddiling Grace and Decadence: Francesco Clemente." Artweek(San Jose, California), Sept.12, 1981, p.16.

Davvetas, Démosthènes. "Le paradoxe de Clemente." Artstudio (Paris), no.7 (winter 1987 – 1988), pp.56-63.
deAk, Edit. "A Chameleon in a State of Grace." Artforum(New York)19, no.6 (Feb.1981), pp.36-41.

– "The Critic Sees through the Cabbage Patch." Artforum(New York)22, no.8 (April 1984), pp.53-60.

– and Diego Cortez. "Baby Talk." Flash Art(Milan), international edition, no. 107(May 1982), pp.34-38.

– and Ingrid Sischy. "A Light Opportunity." Artforum (New York)23, no.5(Jan.1985), pp.48, 60-63.

de Bure, Giles. "L'art aux bains." Beaux Arts Magazine(Paris), no.136 (July-Aug.1995), pp.108-13, 118.

Di Felice, Attanasio. "Painting with a Past: New Art from Italy." Portfolio(New York)4, no.2(March-April 1982), pp.94-99.

– "The Italian Moderns." Attenzione (New York)4, no.3(March 1982), pp.62-63.

Dubuow, Norman. "Clemente's Farsi degli Amici." Drawing(New York)7, no. 5(Jan.-Feb.1986), p.105.

Eckhoff, Sally, S. "Lit Bits." The Village Voice(New York), Oct.31, 1989, p.67.

Faust, Wolfgang Max. "Arte Cifra? Neue Subjektivität? Trans-Avantgarde?" Kunstforum International(Cologne), no. 39(March 1980), pp.161-71.

Feaver, William. "Dispirit of the Times." Artnews(New York)82, no.2 (Feb.1983), pp.80-83.

García, Aurora. "Vanguardia, retaguardia, transvanguardia." Lapiz (Madrid), no.3(Feb.1983), pp.54-57.

Geldzahler, Henry. "On Tape: Henry Geldzahler, Commissioner of New York City's Department of Cultural Affairs." Express(New York), no.2(spring 1982), pp.4-5.

Groot, Paul. "Alchemy and the Rediscovery of the Human Figure." Flash Art(Milan), international edition, no.126(Feb.-March 1986), pp.42-43.

– "Die achtziger Jahre: Von pathologischer Anatomie, digitalen Arbeiten und Neo-Duchampiana." Jahresring: Jahrbuch für Moderne Kunst (Munich), no.39(1992), pp.192-205.

Hawthorne, Don. "Prints from the Alchemist's Library." Artnews (New York)85, no.2(Feb.1986), pp.89-95.

Hill, Andrea. "Meandering: Francesco Clemente's Pastels." Artscribe (London), no.50(Jan.-Feb.1985), pp.44-47.

Hjort, Oystein. "Firhaendigt med historien: Kort forbemaerkning til tre ung italienske malere." Louisiana-Revy (Humlebaek)23, no.3(June 1983), pp.32-35.

Hughes, Robert. "Raw Talk, but Cooked Painting." Time (New York), April, 3, 1989, pp.77-78.

Hutton, Lauren. "La Dolce Vita." Harper's Bazaar(New York)125, no.3, 370(Oct.1992), pp.80-86.

Jodidio, Philip. "Rigeur et déclin." Connaissance des Arts(Paris), no.406 (Dec.1985), pp.112-19.

Jones, Alan. "Hanuman and His Books." Art Magazine (New York)63, no.3(Nov.1988), pp.13-16.

Keziere, Russell. "Tiresius Unbound." Vanguard(Vancouver)13, no.7(Sept. 1984), pp.8-12.

Kontova, Helena. "From Performance to Painting." Flash Art (Milan), international edition, no.106(Feb.-March 1982), pp.16-21.

Kramer, Hilton. "Expressionism Returns to Painting." The New York Times, July 12, 1981, section 2, pp.D1, D3.

Kuspit, Donald. "The Only Immortal." Artforum(New York)28, no.6(Feb. 1990), pp.111-18.

Larson, Kay. "Between a Rock and a Soft Place." New York Magazine, June 1, 1981, pp.56-58.

– "Their Brilliant Careers." New York Magazine, Oct 24, 1988, pp.150-52.

Lawson, Thomas. "Last Exit: Painting." Artforum(New York)20, no.2(Oct. 1981), pp.40-47.

Levin, Kim. "The Miniature Marauder." The Village Vice (New York), May 20, 1981, p.81.

Marcadé, Bernard. "Francesco Clemente Symboliste." Cardinaux(Paris)2(spring 1987), pp.29-37.

Martin, Henry. "The Italian Art Scene: Dynamic, Argumentative and Highly Charged." Artnews(New York)80, no.3 (March 1981), pp.70-77.

Morera, Daniela. "Artisti nel loro studio: Francesco Clemente." Vogue (Rome), Feb.1988, pp.232-37, 256-59.

Ottmann, Klaus. "Painting in an Age of Anxiety." Flash Art(Milan), international edition, no.118(summer 1984), pp.32-35.

Pellizzi, Francesco. "Images of the Material and the Manner of Taste: Reflexions(from F.C.)." Parkett (Zurich), no.9(April 1986), pp.44-69.

Pernoud, Emmanuel. "Mythologies contemporaines." Nouvelles de l'estampe(Paris), no.122(April-June 1992), pp.63-69.

Perrone, Jeff. "Boy, Do I Love Art or What." Arts Magazine(New York)56, no.1(Sept.1981), pp.72-78.

– "Entrées: Diaretics: Entreaties: Bowing (Wowing)Out." Arts Magazine(New York)59, no.8(April 1985), pp.78-83.

Phillips, Deborah C, "No Island Is an Island: New York Discovers the Europeans." Artnews(New York)81, no. 8(Oct.1982), pp.66-71.

Pincus-Witten, Robert. "Becoming American." Arts Magazine (New York) 60, no.2(Oct.1985), pp.101-03.

Pohlen, Annelie. "Eine Minderheit auf dem Weg zum morgen im gestern und heute: Zum italienischen Beitrag für "Europa79.'"Kunstforum International (Cologne), no.36(June 1979), pp.88-156.

– "Cosmic Visions from North and South." Artforum (New York)23, no.7 (March 1985), pp.76-81.

Ratcliff, Carter. "On Iconography and Some Italians." Art in America(New York)70, no.8(Sept.1982), pp.152-59.

– "Dramatis Personae, Part II: The Scheherazade Tactic." Art in America (New York)73, no.10(Oct.1985), pp.9-13.

Ricard, Rene. "Not About Julian Schnabel." Artforum(New York)19, no. 10(June 1981), pp.74-80.

Robbins, D.A. "The Meaning of'New' – The'70s/'80s Axis: An Interview with Diego Cortez." Arts Magazine(New York)57, no.5(Jan.1983), pp.116-21.

Rubinstein, Meyer Raphael. "Singular Volumes: Artists' Collaborations with Harry Mathews." Arts Magazine (New

York)64, no.7(March 1990), pp.29-34.

Russell, John. "The New European Painters." The New York Times Magazine, April 24, 1983, pp.28-33, 36, 40-41, 71-73.

Schjeldahl, Peter. "Treachery on the High Cs." The Village Voice(New York), April 27, 1982, p.96.

– "Up Against the Wall." Vanity Fair (New York)46, no.2(April 1983), pp.92-97.

Schwarze, Dirk. "Collaborations: Warhol, Basquiat, Clemente." Kunstforum International (Cologne), no.134(May-Sept.1996), pp.416-18.

Shapiro, David. "Maxima Moralia: On the Art of Francesco Clemente." Parkett (Zurich). no.9(April 1986), pp.16-43.

Smith, Roberta. "Healthy Egos." The Village Voice(New York), March 3, 1983, p.100.

– "Clemente: Slouching Towards Anonymity." The New York Times, Dec. 2, 1990, pp.2, 41.

Stevens, Mark. "Revival of Realism: Art's Wild Young Turks." Newsweek (New York). June 7, 1982, pp.64-70.

Storr, Robert. "Realm of the Senses." Art in America(New York)75, no.11 (Nov, 1987), pp.132-45, 194.

Strasser, Catherine. "Francesco Clemente: Le son du corps." Art Press (Paris), no.59(May 1982), pp.24-25.

Taylor, Paul. "How Europe Sold the Idea of Postmodern Art." The Village Voice (New York), Sept.22, 1987, pp.99-102.

Tomkins, Calvin. "The Art World: Seminar." The New Yorker, June 7, 1982, pp.120-25.

Tucker, Marcia. "An Iconography of Recent Figurative Painting: Sex, Death, Violence, and the Apocalypse." Artforum (New York)20, no.10(June 1982), pp.70-75.

Venturi, Luca. "Nuovi Artisti." Data: Practice and Theory of Art (Milan)4, no.14(winter 1974), pp.68-79.

Vetrocq, Marcia E. "Utopias, Nomads, Critics." Arts Magazine(New York)63, no.8(April 1989), pp.49-54.

ENZO CUCCHI

Born in Morro d'Alba, November 14, 1949

One-man-exhibitions (and corresponding publications)

1977
Ritratto di casa, Incontri internazionali d'arte, Palazzo Taverna, Rome
Montesicuro Cucchi Enzo giù, Luigi de Ambrogi Galleria, Milan
Mare mediterraneo, Giuliana de Crescenzo Galleria, Rome

1978
Alla lontana alla francese, Galleria Giuliana de Crescenzo, Rome
Tre o quattro artisti secchi (with Sandro Chia), Galleria Emilio Mazzoli, Modena (Catalogue)

1979
La cavalla azzurra, Galleria Mario Diacono, Bologna (Catalogue)
La pianura bussa, Galleria Emilio Mazzoli, Modena
Sul marciapiede, durante la festa dei cani, Galleria Tucci Russo, Turin

1980
Duetto (with Mario Passi), A.A.M. Architettura Arte Moderna, Rome (Catalogue; Texts by A.B.Oliva, F. Moschini, M.Passi and the artist)
Uomini con una donna al tavolo, Galleria Dell'Oca, Rome
Cinque monti sono santi, Paul Maenz Galerie, Cologne

1981
Diciannove disegni, Gallery Emilio Mazzoli, Modena (Catalogue; text by the artist)
Enzo Cucchi, Gallery Sperone Westwater Fischer, New York
Enzo Cucchi, Neue Bilder, Galerie Bruno Bischofberger, Zurich
Enzo Cucchi, Galleria Mario Diacono, Rome (Catalogue; text by M.Diacono)
Enzo Cucchi, Galleria Gian Enzo

Sperone, Rome
Viaggio delle lune/Reise der Monde, Paul Maenz Galerie, Cologne; Art & Project, Amsterdam (Catalogue; texts by D.Cortez and the artist)

1982
Scultura andata, scultura storna (with Sandro Chia), Gallery Emilio Mazzoli, Modena (Catalogue; texts by the artists)
Enzo Cucchi. Zeichnungen, Kunsthaus Zurich; (Enzo Cucchi. Tekeningen) Groninger Museum, Groningen (Catalogue; texts by U.Perucchi and the artist)
Enzo Cucchi, Galleria Pio Monti, Macerata
Enzo Cucchi, Un'immagine oscura, Museum Folkwang, Essen (Catalogue; texts by Z.Felix and the artist)

1983
Enzo Cucchi: Giulio Cesare Roma, Stedelijk Museum, Amsterdam (Catalogue; texts by the artists); traveling exhibition
Enzo Cucchi Album: La scimmia, Sperone Westwater Gallery, New York (Catalogue; text by the artist)
Cucchi, Galerie Buchmann, St.Gallen (Catalogue; text by Armin Wildermuth)
Enzo Cucchi. Works on Paper, Galerie Schellmann & Klüser, Munich
La città delle mostre, Galerie Bruno Bischofberger, Zurich
Enzo Cucchi, Gallerie Anna d'Ascanio, Rome

1984
Enzo Cucchi. New Works, Akira Ikeda Gallery, Tokyo (Catalogue; interview by G.Politi and H.Kontova, text by the artist)
Enzo Cucchi: Giulio Cesare Roma, Kunsthaus Zurich (Catalogue; texts by the artists)
Vitebsk/Harar, Mary Boone/Michael Werner Gallery, New York (Catalogue; text by M.Diacono)
Vitebsk/Harar, Sperone Westwater Gallery, New York (Catalogue; text by M.Diacono)

Enzo Cucchi. Tetto, Galleria Mario Diacono, Rome (Catalogue; text by M. Diacono)
Enzo Cucchi. Currents 1984, The Institute of Contemporary Art, Boston (Catalogue; text by E.Sussman)
Italia, Anthony d'Offay Gallery, London (Catalogue; text by the artist)

1985
Enzo Cucchi. 34 disegni cantano, Galerie Bernd Klüser, München (Catalogue in two volumes; text by J.-C.Ammann)
Enzo Cucchi. Il deserto della scultura, Louisiana Museum, Humlebaek (Catalogue in two volumes; texts by J.-C.Ammann, K.W.Jensen and B. Klüser); Fundación Caja de Pensiones, Madrid; capc Musée d'art contemporain, Bordeaux
Enzo Cucchi. Arthur Rimbaud au Harar, Daniel Templon Gallery, Paris (Catalogue; text by the artist)
Zeichnungen leben in der Angst vor der Erde, Kunstmuseum, Düsseldorf (Catalogue; text by the artist)
Solchi d'Europa, Galerie Bernd Klüser, Munich
Solchi d'Europa, Incontri Internazionali d'Arte, Rome
Drawings for "Solchi d'Europa", Galleria Franca Mancini, Pesaro
Enzo Cucchi, Galleri Zero, Stockholm
Enzo cucchi, Fundación Caja de Pensiones, Madrid; capc Musée d'Art contemporain, Entrepot Lainé, Bordeaux (Catalogue; texts by C. Bernárdez, B.Corà, M.Diacono, J.-L.Froment, S.Penna, F.de Quevedo and the artist)
Drawings and Prins in Black and White by Enzo Cucchi, Galleri Wallner, Malmö

1986
Enzo Cucchi, The Solomon R. Guggenheim Museum, New York (Catalogue; texts by D.Waldman and the artist. Edition Rizzoli, New York); Musée national d'art moderne, Centre Georges Pompidou, Paris (Catalogue; texts by D.Bozo, B.Corà, E.

Darragon, M.Roche and the artist)
Eliseo Mattiacci. Enzo Cucchi, Galleria
Franca Mancini, Pesaro (Catalogue;
text by P.Volponi)
Enzo Cucchi. Roma, Galleria Gian
Enzo Sperone, Rome (Catalogue; text
by A.B.Oliva)

1987
Enzo Cucchi: Testa, Städtische Galerie
im Lenbachhaus, Munich; The
Fruitmarket Gallery, Edinburgh;
Musée de la Ville de Nice, Nice
(Catalogue; texts by A.Boatto, H.
Friedel, G.Testori)
Enzo Cucchi. Guida al Disegno,
Kunsthalle, Bielefeld; Staatsgalerie
Moderner Kunst, Munich(Catalogue;
texts by A.B.Oliva, M.Diacono, C.
Schulz-Hoffmann and U.Weiser.
Edition Hirmer, Munich)
L'Ombra vede, Crousel-Hussenot
Gallery, Paris (Catalogue; texts by D.
Davvetas, M.Schwander. Editions
Chantal Crousel, Paris)
L'elefante di Giotto, Mario Diacono
Gallery, Boston (Catalogue; text by
Mario Diacono)
Cucchi.Testori, Compagnia del
Disegno, Milan (Catalogue; text by G.
Testori)
Fontana vista, Galleria Emilio Mazzoli,
Modena (Catalogue; text by G.Testori)
Enzo Cucchi, Beyeler Galerie, Basel
(Catalogue; texts by A.B.Oliva, G.
Ripanti, M.Schwander)
Enzo Cucchi, Galerie Bernd Klüser,
Munich

1988
Enzo Cucchi: Scala Santa, Galleria
Nazionale d'Arte Moderna (ex-
monastero of Santa Chiara), San Marino
(Catalogue; text by A.B.Oliva)
La Disegna. Zeichnungen 1975 bis
1988, Kunsthaus, Zurich; Louisiana
Museum, Humlebaek;
Kunstmuseum, Dusseldorf (Catalogue;
texts by U.Perucchi-Petri and T.
Vischer)
Enzo Cucchi, Lawrence Oliver Gallery,
Philadelphia (Catalogue; text by K.
Ottman)
L'Italia parla agli uccelli, Marlborough
Gallery, New York(Catalogue; text by
D.Cortez.)
Enzo Cucchi. Raumgestaltung. Wiener
Secession. Vienna (Catalogue; texts by

E.Köb, G,Testori)
Enzo Cucchi, Michael Haas Gallery,
Berlin (Catalogue)
Album delle grafiche con cenni storici
···1988.Cucchi fugge da Roma···era
l'epoca in cui, 2RC
Edizioni d'Arte, Milan/Rome
(Catalogue)
Enzo Cucchi. Scultura 1982 – 1988,
Musée Horta, Brussels (Catalogue; text
by M.Schwander)
Uomini, Galerie Bruno Bischofberger,
Zurich (Catalogue)

1989
Enzo Cucchi,42 Drawings 1978 – 1988,
Istituto Italiano di Cultura, Toronto; Art
Gallery of Windsor, Canada
(Catalogue; texts by A.B.Oliva and F.
Valente)
Enzo Cucchi, Museo d'Arte
Contemporanea Luigi Pecci, Prato
(Catakogue; txet by the artist)
Enzo Cucchi, Akira Ikeda Gallery,
Tokyo(Catalogue in two volumes; text
by the artist)
Enzo Cucchi, Deweer Art Gallery,
Otegem(Catalogue; text by J.Coucke)
Enzo Cucchi, Dibuixos, Galería Joan
Prats, Barcelona (Catalogue)
Medardo Rosso.Enzo Cucchi, Cleto
Polcina Arte Moderna, Rome
(Catalogue; texts by A.B.Oliva and L.
Caramel)
Enzo Cucchi, Galerie Bernd Klüser,
München

1990
Enzo Cucchi.Roma. Palazzina dei
Giardini Pubblici, Modena; Galleria
Civica d'Arte Contemporanea, Trento;
(Catalogue; texts by A.B.Oliva, D.
Eccher, F.Gualdoni.Edition Nouva
Alfa, Bologna);
Fundaciò Joan Miró, Barcelona
(Catalogue; texts by A.B.Oliva, D.
Eccher, F.Gualdoni. Edition Nouva
Alfa, Bologna and Polígrafa S.A.,
Barcelona)
Enzo Cucchi e il Palazzo dei Pupazzi di
Via Capolecase, Galleria Il Segno,
Rome (Catalogue)
Mostra di disegni di Enzo Cucchi. Sala
Esposizioni dell'Infiorata 1990, Palazzo
Comunale di Genzano, Rome
(Catalogue; texts by A.Trombadori,
M.Apa)
Le Parole di Enzo Cucchi, Galleria Pio

Monti, Rome
Drawings 1990, Galerie Bernd Klüser,
Munich
Cucchi, Mikkola + Rislakki Gallery,
Helsinki (Catalogue; text by J.Petaja)

1991
Roma, Kunsthalle Hamburg, Hamburg
Roma, Fundació Juan Miró, Barcelona
Enzo Cucchi, Disegno, Carré d'Art,
Musée d'Art Contemporain, Nîmes
(Catalogue in two volumes; texts by R.
Calle, Bernd Klüser, M.Reithmann and
the artist)
Enzo Cucchi:Mosaici, Cleto Polcina
Arte Moderna, Rome; Galleria Philippe
Daverio, Milan; Galerie
Bernd Klüser, Munich(Catalogue; text
by A.B.Oliva) Attenti agli uccelli,
Edicola Notte, Rome
La Porta Santa, Galleria Del Cortile,
Rome
Izbor risb, iz obdobja 1975 – 1989,
Moderna Gallerija, Ljublijana
(Catalogue, text by the artist)

1992
Enzo Cucchi.Roma, Hamburger
Kunsthalle, Hamburg(Catalogue; text
bei H.Hohl, U.M.Schweede and the
artist. Edition Cantz, Hamburg)
Enzo Cucchi.Neue Arbeiten, Galerie
Bernd Klüser, Munich(Catalogue;text
by A.B.Oliva)
La frontiera del primo foglio, 2RC
Edizioni d'Arte, Rome(Catalogue;
discussion with A.B.Oliva, W.Rossi
and the artist)

1993
Enzo Cucchi, Castello di Rivoli Museo
d'Arte Contemporanea, Turin
(Catalogue; texts by A.B.Oliva and
G.Verzotti, interview by Ida Gianelli.
Edizioni Charta, Milan)
Arte-Libro.Enzo Cucchi, Galleria,
Milena Ugolini Rome(Catalogue;
interview by Milena Ugolini, text by the
artist)
Enzo Cucchi.Mostra moderna, Galleria
Emilio Mazzoli, Modena(Catalogue;text
by A.B.Oliva)
Idoli, Oddi Baglioni Gallery; Galleria
Del Cortile; Studio Bocchi, Rome
Via Tasso Enzo Cucchi, Museo Storico
della Liberazione di Roma, Rome
(Catalogue; interview by L.Pratesi.
Edition Carte Segrete, Rome)

Enzo Cucchi. Idoli, Daniel Templon Gallery, Paris (Catalogue)

1994

Cucchi, Ernst Museum, Budapest (Catalogue; interview by I. Gianelli, text by A.B. Oilva)
Mario Bo tta-Enzo Cucchi. La Cappella del Monte Tamaro, Museo Cantonale d'Arte, Lugano; Kunsthaus, Zurich (Catalogue; texts by F. Irace, U. Perucchi-Petri, G. Pozzi, M. Kahn Rossi. Edition Umberto Allemandi, Turin)
Enzo Cucchi, Galleria Emilio Mazzoli, Modena
Enzo Cucchi. Cumbattimende di parole, Galleria Cesare Manzo, Pescara (Catalogue; text by G. di Pietrantonio)
Ercole Botanico, Galerie Bruno Bischofberger, Zurich
Sicilia è artista, Reggia di Caserta, Caserta
Regioni d'Italia, Reggia di Caserta-Cappella Palatina, Caserta
Museo d'Arte Contemporanea, Pirano, Capo d'Istria

1995

Cucchi, Obalne Galerije, Pirano, Slovenia (Catalogue; texi by A. Fonda, A. Medved and the artist)
Enzo Cucchi. Poeta da lavoro, Galleria Carlo Virgilio, Rome (Catalogue)
Cucchi, Sara Hildénin Taidemuseo, Tampere, Finland (Catalogue; text by G. Romano, interview by R. Valorinta)
Enzo Cucchi, Museo di Palazzo Reale Arengario, Milan (Catalogue; text and cassette by the artist. Edition Umberto Allemandi, Turin)
Enzo Cucchi, Pièce Unique Gallery, Paris (Catalogue; text by A.B. Oliva)
Enzo Cucchi. The Titans of the Third Millenium, Nicosia Municipal Arts Center, Nicosia, Cyprus; Pierides Museum of Contemporary Art, Athens (Catalogue; texts by L. Monachesi, D.Z. Pierides and Y. Toumazis)
Prima bella Mostra Italiana (with Sandro Chia), Galleria Emilio Mazzoli, Modena (Catalogue; texts by the artists)
Enzo Cucchi, Galerie Bruno Bischofberger, Zurich
Enzo Cucchi. Michelangelo Pistoletto. Avamposto spirituale, Cesare Manzo

Gallery, Pescara (Catalogue)

1996

Enzo Cucchi, Sezon Museum of Art, Tokyo; Fukuyama Museum of Art, Fukuyama; Kawamura Memorial Museum of Art, Sakura (Catalogue; texts by N. Hiromoto, F. Tanifuzi)
Enzo Cucchi, Akira Ikeda Gallery, Tokyo and Nagoya
Picass..., Galerie Bruno Bischofberger, Zurich (Catalogue)
Sandro Chia. Enzo Cucchi. Prima bella Mostra Italiana, Logge dei Balestrieri and Museum S. Franceso, San Marino (Catalogue; texts by A.B. Oliva and the artists. Edition TXT, Rimini)
Arnaldo Pomodoro, Enzo Cucchi. A quattro main, 2 RC Edizioni d'Arte, Rome (Catalogue; texts by artists)
Enzo Cucchi, II Falconiere Gallery, Ancona
Enzo Cucchi, Opere grafiche, Arts Center Zamalek, Egypt (Catalogue)
Dei, Santi e Viandanti (with Martial Raysse), Museo Civico Medievale, Bologna (Catalogue; text by A.M. Sauzeau. Edition Mondadori, Ravenna)
SIMM'NERVUSI, Museo di Capodimonte, Naples (Catalogue; texts by A.B. Oliva, N. Spinosa, A. Tecce)
Enzo Cucchi, Gana Beaubourg Gallery, Paris (Catalogue; text by G. Appella)

1997

Sipario Staged Art. Balla, De Chirico, Savinio, Picasso, Paolini, Cucchi. Castello di Rivoli, Museo d'Arte Contemporanea, Torino (Catalogue; texts by I. Gianelli, M. Fagiolo dell' Arco, E. Gigli, L. Cherubini, A. Mousseigne, G. Verzotti, D. Lancioni. Edition Charta, Milan)
Città d'Ancona Enzo Cucchi, Mole Vanvitelliana, Ancona (Catalogue; texts by M. Polverari, U. Schneider. Edition Electa, Milano)
Più vicino alla Luce. Näher zum Licht. Closer to the Light, Suermondt-Ludwig-Museum, Aachen (Catalogue; text by U. Schneider. Edizioni Charta, Milano)
SIMM'NERVUSI, Tony Shafrazi Gallery, New York (Catalogue; texts by L. Marenzi, D. Meier and C. Ratcliff)
...Eneide, galerie bruno bischofberger at Art Fair 28'97, Basel; Galerie Bruno Bischofberger, Zürich (Catalogue; text by L. Marenzi)

Enzo Cucchi, Centro Cultural Recoleta, Buenos Aires (Catalogue; text by I. Katzenstein)

1998

Enzo Cucchi, Soggetti Impossibili, Galleria Nazionale d'Arte Moderna, Roma (Catalogue)
Enzo Cucchi, Disegno Doppio Vita, Magazzion d'Arte Moderna, Roma
Enzo Cucchi, Les Sujets Impossibles, Château de Chenonceau
Enzo Cucchi Galeria Fernando Santos, Porto (Catalogue; text by Alexandre Melo)

1999

Enzo Cucchi, Altrove Si Rinasce, Borromini Arte Contemporanea, Ozzano Monferrato (Catalogue; text by Tommaso Trini)
Enzo Cucchi, Berge Menschen Licht, Deichtorhallen Hamburg, Hamburg (Catalogue; text by Zdenek Felix)
Mosaico di Tel Aviv, The Tel Aviv Museum of Art (Catalogue; text by Mordechai Omer)
Enzo Cucchi + Ettore Sottsass, Galleria Memphis, Roma (Catalogue)
Enzo Cucchi, Artiscope, Bruxelles (Catalogue; text by Guy Gilsoul)

2000

Enzo Cucchi, Mosaico nella stazione Termini, Roma (Catalogue; text by Paola Magni)
Enzo Cucchi, Galleria Gioacchini, cortina d'Ampezzo
Enzo Cucchi, Galleria Gioacchini, Ancona
Enzo Cucchi, Galleria Poggiali & Forconi, Firenze (Catalogue; text by Aldo Busi)
Enzo Cucchi, Teatro di Roma, Galleria del Teatro India, Roma (Catalogue; text by Alessandra Maria Sette)
Enzo Cucchi, Ceramics, Galerie Bruno Bischofberger, Zurich
Enzo Cucchi, Tony Shafrazi Gallery, New York (Catalogue, text by Carter Ratcliff)

Selected Group Exhibitions

1977

Enzo Cucchi, Ritratto di casa, Incontri Internazionali d'Arte, Palazzo Taverna,

Roma

1979

L'estetico e il selvaggio, Galleria
Civica, Modena
Le alternative del nuovo, Palazzo delle
Esposizioni, Roma
Europa'79, Kunstaustellungen
Gutenbergerstrasse, Stoccarda
XV Bienal Internacional de Sao Paulo,
Padiglione Armando Arruda Pereira,
Parco Ibirapuera, San Paolo, Brazil
Paris, o cara..., Galerie Yvon
Lambert, Paris
Artisti italiani nella XV Biennale di S.
Paolo del Brasile, Quadriennale
Nazionale d'Arte, Roma
Opere fatte ad arte, Palazzo di Città,
Acireale, Catania
Le stanze, Castello Colonna,
Genazzano, Roma
Labirinto, Artra Studio, Milano

1980

Die Enthauptete Hand: 100 Zeichnungen
vom Italien, Kunstverein, Bonn;
Stadtische Galerie, Wolfsburg;
Gröninger Museum, Gröningen
Chia, Cucchi, Merz, Calzolari,
Galleria GianEnzo Sperone, Torino
Italiana: Nuova Immagine, Loggetta,
Lombardesca. Ravenna
Sieben Junge Kuenstler aus Italien,
Kunsthalle, Basel; Museum Folkwang,
Essen; Stedelijk Museum, Amsterdam
XXXIX Biennale di Venezia. Aperto
80, Magazzini del Sale alle Zattere,
Venezia
Sandro Chia Francesco Clemente Enzo
Cucchi, Sperone Westwater Fischer
Gallery, New York
XI Biennale de Paris,
Musée d'Art Moderne de la Ville de
Paris, Paris
Genius Loci, Palazzo di Città,
Acireale, Catania
La Transavantgarde italienne, Galerie
Daniel Templon, Paris
Jonge Italianen, Stedelijk Museum,
Amsterdam
S. Chia, F. Clemente, E. Cucchi, N. De
Maria, M. Paladino, Galleria Francesco
Masnata, Genova

1981

Genius Loci, Palazzo dei Diamanti,
Ferrara
La memoria, l'inconscio, Studio La

Torre, Pistoia
Recent Aquisitions: Drawings, The
Museum of Modern Art, New York
Heute. Westkunst, Museen der Stadt,
Colonia
XI Biennale de Paris, Sara Hildenin
Taidemuseo, Tampere, Finlandia
Chia, Clemente, Cucchi, Mariani,
Morley, Salle, Schnabel, Sperone
Westwater Fischer Gallery, New York
Trigon 81, Neue Galerie am
Landesmuseum Joanneum, Graz
New York by Chia, Cucchi, Disler,
Penck, Bernard Jacobson Ltd., Los
Angeles
Mostra d'Arte, Palazzo di Città,
Acireale
Tesoro(Chia, Clemente, Cucchi, De
Maria, Paladino), Galleria Emilio
Mazzoli, Modena
Talijanska Transavangarda, Galeria
Suvremene Umjetnosti, Zagabria
Aspects of Post Modernism, The Squibb
Gallery, Princeton
Galleria GianEnzo Sperone, Torino
Det Italienska Transavangardet,
Boibrino Gallery, Stoccolma

1982

Contemporary Figurative Prints, Harcus
Krakow Gallery, Boston
Transavanguardia: Italia/America,
Galleria Civica, Modena
Italian Art Now: an American
Perspective, Solomon R. Guggenheim
Museum, New York
Vision in Disbelief. Fourth Biennale of
Sydney, Art Gallery of New South
Wales, Sydney
'60'80 Attitudes/Concepts/Images,
Stedelijk Museum, Amsterdam
Forma senza forma, Galleria Civica,
Modena
Avanguardia/Transavanguardia 68/77,
Nura Aureliane (da Porta Petronia a
Porta Latina), Roma
The Pressure to Paint, Gallery
Marlborough, New York
Documenta 7, Museum Friedericianum,
Kassel
Bilder Sind Nicht Verboten, Stadtische
Kunsthalle, Kunstverein für die
Rheinlande..., Düsseldorf
Mythe Drame Tragédie, Musée d'Art et
d'Industrie, Saint-Etienne
Nove artisti italiani, Limonaia di Villa
Montalvo, Comune di Campi Bisenzio,
Firenze

Grafiek '82, Deweer Art Gallery,
Otegem, Belgio
Zeitgeist, Berlinische Galerie, Martin-
Gropius Bau, Berlin
Drawing: an Exploration of Line,
Maryland Institute in the Meyethoff
Gallery, Baltimora
Chia Cucchi Lichtenstein Twombly,
Galleria Sperone Westwater Fischer,
New York
Selected Works by Chia, Clemente,
Cucchi, Basquiat, Kiefer, Rosa Esman
Gallery, New York
Conseguenze impreviste. Artc, moda,
design: ipotesi di nuova.., Centro
Storico, Prato
Kunst Nu/Kunst Unserer Zeit,
Gröninger Museum, Gröningen;
Kunsthalle, Wilhemshaven
Galerie Crousel-Robelin-Bama, Paris
Galleria Giuliana De Crescenzo, Roma
Galleria Giorgio Persano, Torino
Galerie Bruno Bischofberger, Zürich

1983

New Italian Art, New Gallery of
Contemporary Art, Cleveland
Tema Celeste, Museo Civico d'Arte
Contemporanea, gibellina
Europska & Ameriska. Nova Risba/New
Drawing/Nuovo Disegno, Galleria Loza
in Meduza, Koper; Likovni Salon,
Celje; Galleria Suvremene Umjetnosti,
Zagabria; Cankarjev Dom, Lubiana;
Obalne Galerie, Piran
Italia: la Transavanguardia, Fundación
Caja de Pensiones, Madrid
Sandro Chia, Francesco Clemente,
Enzo Cucchi: Bilder, Kunsthalle,
Bielefeld; Louisiana Museum,
Humlebaek
Artists from Sperone Westwater Fischer,
University of South Florida Art
Galleries, College of Fine Arts,
Tampa, Florida
Peter Blum Edition, Nigel Greenwood at
Sloane Gardens, London
Concetto-Imago. Generationswechsel in
Italien, Bonner Kunstverein, Bonn
Artisti italiani contemporanei
1950 – 1983, Chiesa di San Samuele,
Venezia Intoxication, Monique Knowlton
Gallery, New York
Recent European Painting, Solomon R.
Guggenheim Museum, New York
Il Grande Disegno, Palazzina Mangani,
Fiesole, Firenze
Nell'arte: artisti italiani e francesi a

Villa Medici, Villa Medici, Accademia di Francia, Roma
Bilder der Angst und der Bedrohung, Kunsthaus (Gabinetto dei disegni), Zürich
New Art, The Tate Gallery, London
Chia, Cucchi, De Maria, Kounellis, Galerie Vera Munro, Hamburg
Det Italienska Transavangardet, Galerie Boibrino, Stoccolma
Expressive Malerei nach Picasso, Galerie Beyeler, Basel
Enzo Cucchi-Robert Rauschenberg-Donald Sultan, Blum Helman, New York
Sperone Westwater Gallery, New York
L'Italie & l'Allemagne: nouvelle sensibilites, nouveau marchés, Musée d'Art et d'Histoire, Cabinet des Estampes, Genève
Opere su carta, Centro d'Arte Contemporanes, Siracusa
Expressiver Pathos, Galerie Hummel, Wien
Sakowitz Festival of Italian Design, Sakowitz Gallery, Houston
Marathon '83, The International Running Center, New York
Galleria Emilio Mazzoli, Modena
Leger Gallery, Malmö
Galleria Anna d'Ascanio, Roma
Galerie Chantal Crousel, Paris
Galerie Bruno Bischofberger, Zürich

1984

Painting Now, Akira Ikeda Gallery, Nagoya; Municipal Museum of Art, Kitakyushu
Modern Expressionist: German, Italian and American Painters, Sidney Janis Gallery, New York
Drawings, Sperone Weswater Gallery, New York
Det Italienska Transavangadet, Arte Fiera, Stoccolma; Konsthall, Lunds
Via New York, Musée d'Art Contemporain, Montreal
Der Traum des Orpheus, Stadtische Galerie im Lenbachhaus, Monaco
An International Survey of Recent Painting and Sculpure, The Museum of Modern Art, New York
Skulptur im 20. Jahrhundert, Merianpark, Basilea
The Human Condition: The SFMMA Biennal III Museum of Modern Art, San Francisco
Contemporary Italian Masters, The

Chicago Public Library Cultural Center, Chicago
Rosc'84: The Poetry of Vision, The Guinnes Hope Store, St. James's Gate, Dublin
Selections Peter Blum Edition, Eaton/Shoen, San Francisco
Cucchi, Borofsky, Knoller, Brown, Longobardi, Blais, Book, Galerie Wallner, Malmö
Arbeiten zu Skulpturen, Galerie Schellmann & Klüser, Monaco
Werken op Papier/Oeuvres sur papier/Works on Paper, Deweer Art Gallery, Otegem, Belgique
Content. A Contemporary Focus 1974 – 1984, The Hirshhorn Museum and Sculpture Garden, Smithsonian Instution, Washington
Metaphor and/or Symbol, The National Museum of Modern Art, Tokyo
Enzo Cucchi/Robert Rauschenberg/Donald Sultan, Blum Helman Gallery, New York
La Grande Parade, Stedelijk Museum, Amsterdam
Ouverture, Castello di Rivoli Museo d'Arte Contemporanea, Rivoli, Torino
Sperone Westwater Gallery, New York
20 Jaar Verzamelelen: Aawinsten 1963 – 1984, Stedelijk Museum, Amsterdrm
Quartetto: J. Beuys, E. Cucchi, L. Fabro, B. Nauman, Accademia Foundation, Venezia
Terrae Motus, Villa Campolieto, Napoli
Galerie Ressle, Stoccolma
Portraits, Silvia Menzel, Berlin
Opere su carta, Antiope-France, Paris

1985

Metaphor and/or Symbol, The National Museum of Modern Art, Osaka
The European Iceberg: Creativity in Germany and Italy today, Art Gallery of Ontario, Toronto
Nouvelle Biennale de Paris 1985, Grande Halle du Parc de la Villette, Paris
State of War, Seattle Art Museum, Seattle
Selection from the William J. Hokin Collection, Museum of Contemporary Art, Chicago
Peter Blum Editions, Lorence Monk Gallery, New York
L'Italie aujourd'hui, Centre National d'Art Contemporain, Villa Arson, Nice

Von Twombly bis Clemente, Kunsthalle, Basel
Horses in Twentieth Century Art, Nicola Jacobs Gallery, London
Sperone Westwater Gallery, New York
Peter Blum Editions New York II, Gröninger Museum, Gröningen
A New Romanticism. Sixteen Artists from Italy, Hirshhom Museum and Sculpture Garden, Smithsonian Institut., Washington
XVIII Bienal de Sao Paulo, Padiglione Armando Arruda Pereira, Parco Ibirapuera, San Paolo, Brazil
Raume Heutiger Zeichnung, Staatliche Kunsthalle, Baden-Baden
Ouverture-New Spaces, Deweer Art Gallery, Otegem, Belgique
Walking and Falling. A Labyrinth of Dreams, Plymouth Arts Centre, Plymouth
1985 Carnegie International, Museum of Art, Carnegie Institute, Pittsburgh
Rembrandt's Children, Luhring, Augustine & Hodes Gallery, New York
New Art of Italy. Chia Cucchi Clemente Paladino, Joslyn Art Museum, Omaha; Dade County Center for the Fine Arts, Miami, Florida; The Contemporary Arts Center, Cincinnati, Ohio
Drawings: 1975 – 1985, Barbara Toll Fine Arts, New York
Collector's Choice, Rosa Esman Gallery, New York
Dialog, Gulbenkian Foundation, Lisbona
7000 Eichen, Kunsthalle, Tübingen
Clemente, Cucchi, Twombly, Lichtenstein, Kunsthalle, Basel
Zeichnungen Leben in Angst vor der Erde, Kunstmuseum, Düsseldorf
Chia Clemente Cucchi. Holzschnitte. Lithographien, Radierung, Galerie Rudolf Zwirner, Colonia
Anniottanta, Galleria comunale d'arte moderna, Bologna; Chiostri di San Domenico, Imola Galerie Bruno Bischofberger, Zürich

1986

A propos de dessin, Galerie Adrien Maeght, Paris
Raume Heutiger Zeichnung, Tel Aviv Museum, Tel Aviv, Israele
Walking and Falling. A Labyrinth of Dreams, Kettle's Yard Gallery, Cambridge; Interim Art, London
Gallery Artists: Andre, Andrews,

Baselitz, Beuys, Chia..., Anthony
d'Offay Gallery, London
A New Romanticism. Sixteen Artists
from Italy, Akron Art Museum, Akron,
Ohio
New Art of Italy. Chia Cucchi Clemente
Paladino, Dade County Center for the
Fine Arts, Miami Florida;
Contemporary Arts Center, Cincinnati,
Ohio
Sogno italiano. La collezione Franchetti
a Roma, Castello Colonna, Genazzano,
Roma
The Art of Drawing. Barbara Mathes
Gallery, New York
Peter Blun Edition II, Nigel Greenwood
Gallery, at New Burlington Street,
London
Beuys zu Ehren, Stadtische Galerie im
Lenbachhaus, Monaco
J. Beuys, E. Cucchi, A. Kiefer, J.
Kounellis: Ein Gesprach, Kunsthalle,
Basilea
XLII Biennale di Venezia. Arte e
Scienza. Arte e Alchimia, La
Biennale, Venezia
Lo specchio di Nausicaa immagini
d'arte e di poesia, Palazzo Farnese,
Ortona, Chieti
Prospects 86. Eine Internationale
Austellung Aktueller Kunst, Frankfurter
Kunstverein, Shirn Kunsthalle,
Francoforte
Transavanguardia 77-80, Galleria
Giuliana De Crescenzo, Roma
Chia Clemente Cucchi De Maria
Paladino. Oeuvres sur papier, Musée
Savoisien, Chambery
Terrae Motus 2, Villa Campolieto,
Ercolano, Napoli
Galerie Bruno Bischofberger, Zürich
Galerie Bruno Bischofberger, Zürich
Galerie Bruno Bischofberger, Zürich
Paisatges, Sa Llonja, Palma de
Mallorca
Arbeiten auf papier, Galerie Michael
Haas, Berlin
Disegnata, Loggetta Lombardesca,
Ravenna
Terrae Motus. Naples. Tremblement de
Terre, Grand Palais, Paris
L'époque, la mode, la morale, la
passion, Musée national d'art
moderne, Centre Georges Pompidou,
Paris
Documenta 8, Museum Friedericianum,
Kassel
Il disegno italiano del dopoguerra,

Kunstverein, Francoforte; Galleria
Civica d'Arte Moderna, Modena Italie
hors d'Italie, Carré d'Art, Musée
d'Art Contemporain, Nîmes
Works on paper, Galerie Bernd Klüser,
Monaco
Emerging Artists 1978 – 1986.
Selections from the Exxon Series,
Solomon R. Guggenheim Museum,
New York
Galerie Bruno Bischofberger, Zürich

1988

Mythos Italien Wintermarchen
Deutschland, Bayerische Staatsgemalde-
sammlungen und Austellungsleitung...,
Monaco
Visions/Revisions: Contemporary
Representation, Marlborough Gallery,
New York
Europa Oggi, Museo d'Arte
Contemporanea Luigi Pecci, Prato
Arte italiana del dopoguerra dai musei
Guggenheim. Venezia New York,
Palazzo Ducale, Mantova
XLIII Biennale di Venezia. Il luogo
degli artisti, Padiglione Italia, Giardini
Castello, Venezia
Costellazione Transavanguardia. Chia
Clemente Cucchi Paladino, Provincial
Museum voor Moderne Kunst, Ostenda
Dal ritorno all'ordine al richiamo alla
pittura, Mathildenhoehe, Darmstadt:
Kunsthalle, Bielefeld
Disegno italiano 1908 – 1988,
Stadtische Galerie im Stadelschen
Kunstinstitut, Francoforte;
Kupferstichkabinett Berlin; Staatliche
Museen Preussischer.., Berlin
A.B.O.: ritrati di un nome, Fortezza
da Basso, Firenze
L'art contemporain à La Défense. Les
années 80 vues par 5 galeries, Galerie
La Défense Art 4, Paris La Défense,
Paris

1989

Italian Art in the 20th Century, Royal
Academy of Arts, London
Disegno italiano 1908 – 1988,
Kunsthaus, Zürich
Magiciens de la Terre, Musée national
d'art moderne, Centre Georges
Pompidou, Paris
Arte contemporanea per un museo,
Padiglione d'Arte Contemporanea,
Milano
Drawings since 1960, Stedelijk Museum

Amsterdam; 30 Anni di disegni, Istituto
Universitario Olandese, Firenze
Exposition Inaugurale, Fondation Daniel
Templon, Musée Temporatre, Fréjus
Il genio differente nell'arte
contemporanea da Picasso ad oggi,
Castello di Lerici, Lerici, La Spezia
Xth Anniverary Show, Deweer Art
Gallery, Otegem, Belgique
Artoon, L'influenza del fumetto nelle
arti visive del XX secolo, Palazzo della
Civiltà del Lavoro, Roma
Premio Marche 1989. Biennale d'arte
contemporanea, Palazzo degli Anziani,
Ancona
Estampes et Revolution, 200 ans apres,
Centre National des Arts Plastiques,
Paris
Big Prints from Rome, The Museum of
modern art, Toyama; Navio Museum of
art, Osaka; Koinoura Gallery, Fukuoka
Graphische Sammlung im Städel.
Neuerwerbungen 1983 bis 1988,
Städtische Galerie, Francoforte sul
Meno
Fratelli d'Italia, Galleria Il Sole,
Perugia

1990

Qu'est-ce-qui est contemporain? II,
capc Musée d'art contemporain,
Entrepot-Lainé, Bordeaux
Tra mito e stereotipo, Galleria In Arco,
Torino
Gegenwart Ewigkeit, Martin Gropius
Bau, Berlino
Il mondo delle torri. Da Babilonia a
Manhattan, Palazzo Reale, Milano
Pharmakon '90, Nippon Convention
Center, Makuhari Messe(Giappone)
La Collezione 1988 – 1990, Museo d'
Arte Contemporanea Luigi Pecci, Prato
Mischiare le carta, immagine speculare,
Gian Ferrari Arte Contemporanea,
Milano
Anni Ottanta in Italia, Ex convento di
San Francesco, Sciacca, Agrigento

1991

Collezioni trentine di arte
contemporanea, Galleria Civica di Arte
Contemporanea, Trento
Deus ex charta, Studio d'Arte
Cannaviello, Milano
An Aspect of Contemporary Art,
Setagaya Art Museum, Setagaya-ku,
Tokyo
Nature-Création du peintre, Musée

Cantonal des Beaux-Arts, Lausanne
Mario Ceroli, Enzo Cucchi, Gianfranco
Fini, Studio Spaggiari, Milano
Scuola d'obbligo. Fuori Uso 1991,
Scuole di Marzio, Pescara
Bildlicht: Malerei zwischen Material und
Immaterialität, Museum des 20.
Jahrhunderts, Wien
Sélection, FAE, Musée d'art
contemporain, Pully-Lausanne
Ottanta Novanta, Monastero dei
Benedettini, Montréal

1992

Art d'Eco, Umetnosta Galerija,
Maribor
Profili. Italia 1950 – 1990, XII
Quadriennale, Palazzo delle
Esposizioni, Roma
Le cri et la raison, Espace de l'Art
Concret, Château de Mouans-Sartoux
Paesaggio con rovine, Case di Stefano,
Gibellina
Der Gefrorene Leopard III, Galerie
Bernd Klüser, Monaco
D Identitat: Differenz Tribune Trigon
1940 – 1990, Neue Galerie am
Landesmuseum Joanneum, Graz
Transavanguardia, Galleria Gian Ferrari
Arte Contemporanea, Milano
The artist and the book in Twentieth
century Italy, Museum of Modern Art,
New York
Collection du capc Musée, capc Musée
d'art contemporain, Entrepot-Lainé,
Bordeaux
Terrae Motus alla Reggia di Caserta,
Palazzo Relae, Caserta

1993

Tutte le strade portano a Roma?,
Palazzo delle Esposizioni, Roma
Selected Prints, Galerie Bernd Klüser,
Monaco
XLV Biennale di Venezia. Punti
cardinali d'arte, Padiglione Italia,
Giardini di Castello, Venezia
Utopia. Arte italiana 1950 – 1993, Teatro
del Festival di Salisburgo e Galerie T.
Ropac, Salisburgo
The Body of Drawing. Drawings
by Sculptors, The Graves Art Gallery,
Sheffield
Les pensées bleues (Autour du
monde), capc Musée d'art
contemporain, Entrepot-Lainé,
Bordeaux
Fuori Uso 1993. A Prescindere,

Ex-Opificio Gaslini, Pescara
Uber-Leben, Bonner Kunstverein, Bonn
Il disegno nelle raccolte private
modenesi, Palazzina dei Giardini
Pubblici, Modena
L'Arca di Noè, Trevi Flash Art
Museum, Palazzo Lucarini, Trevi,
Perugia

1994

Baselitz, Cucchi, Paladino, A.R.
Penk. Grafiek, Deweer Art Gallery,
Otegem, Belgique
Arte contemporanea dalla Collezione
della Federazione cooperative Migros,
Museo Cantonale d'Arte, Lugano
Stigma: grafica italiana anni '60 – '80,
Palazzo Agostinelli, Bassano del
Grappa; Gallerie Pohlhammer, Steyr;
Istituto Italiano di Cultura, Wien;
Museo Casabianca, Malo
Di carta e d'altro, Museo d'Arte
Contemporanea Luigi Pecci, Sala
Grafica, Prato
L'incanto e la trascendenza, Castel
Ivano, Ivano Fracena, Trento
Fuori Uso '94. Opera prima, Ex-
Opificio Gaslini, Pescara; Trevi Flash
Art Museum, Palazzo Lucarini, Trevi,
Perugia; Cankariev Dom, Ljubljana,
Slovenia
Four Italian Masters of Contemporary
Art in London, Accademia Italiana di
London, Smith's Galleries di Covent
Garden, London
L'Orizzonte. Da Chagall a Picasso da
Pollock a Cragg, Castello di Rivoli
Museo d'Arte Contemporanea, Rivoli,
Torino
La Collezione, Castello di Rivoli Museo
d'Arte Contemporanea, Rivoli, Torino
Terrae Motus-Terrae Motus
I libri d'artista italiani del Novecento,
Collezione Peggy Guggenheim, Palazzo
Venier dei Leoni, Venezia

1995

Fuoriuso '95 Arte, Ex-Liquorificio
Aurum, Pescara
XL Mostra Nazionale d'Arte
Contemporanea. Disegni del Novecento,
Galleria Civica d'Arte Contemporanea,
Termoli, Campobasso Festival
RomaEuropa, Accademia Tedesca,
Villa Massimo, Roma
L'invenzione del paesaggio, Palazzina
dei Giardini Pubblici, Modena
VII Biennale d'Arte Sacra. L'Arte in

Croce, Museo Diocesano d'Arte Sacra,
Venezia
Titanica, Galleria d'Arte Moderna e
Contemporanea, Repubblica di San
Marino
Risarcimento. Artisti contemporanei per
gli Uffizi, Galleria degli Uffizi,
Gabinetto disegni e stampe, Firenze

1996

Profezia di bellezza. Arte sacra tra
memoria e progetto, Braccio di Carlo
Magno, Colonnato di San Pietro, Città
del Vaticano, Roma
Martiri e Santi, Galleria L'Attico,
Roma
Prima della fine del mondo, Centro
Iniziative Multimediali Diagonale, Roma
Collections du Castello di Rivoli, Le
Nouveau Musée Institut d'art
contemporain, Villeurbanne, Lyon
VIII Biennale Internazionale di scultura,
Accademia di Belle Arti e Piazza
Alberica, Carrara
Artisti a Serre, Centro Civico per l'Arte
Contemporanea "La Grancia", Serre di
Rapolano, Siena
Nuovo luogo per l'arte, Ex Manifattura
Tabacchi, Città Sant'Angelo, Pescara
Antologia, Spazio Herno, Torino; Trevi
Flash Art Museum, Palazzo Lucarini,
Trevi, Perugia
From the Collection Naivety in Art: A
Decade of Exploration, Setagaya Art
Museum, Setagaya-ku, Tokyo
XXIII Bienal Internacional de Sao
Paulo, San Paolo, Brazil
Fuoriuso '96, Ex deposito Gestione
Governativa F.E.A., Pescara
L'ossessione del segno, Studio La
Città, Verona
Prospettiva del passato. Da Van Gogh
ai contemporanei nelle raccolte dello
Stedelijk Museum di Amsterdam, Museo
di Capodimonte, Napoli
Chimériques Polymères. Le Plastiques
dans l'art du Xxème siècle, Musée
d'Art Moderne et d'Art
Contemporain, Nice
Sammlung Marx, Hamburger Bahnof,
Museum für Gegenwart, Berlin
Tradizione e innovazine. L'arte italiana
dal 1945 a oggi, National Museum of
Contemporary Art, Seul, Korea

1997

Collection, découverte, capc Musée
d'art contemporain, Bordeaux

La Collezione Loulakis. Disegni e
fotografie da Klee a Mapplethorpe,
Palazzina dei Giardini Pubblici, Modena
Sipario. Balla, De Chirico, Savinio,
Picasso, Paolini, Cucchi, Castello di
Rivoli Museo d'Arte Contemporanea,
Rivoli, Torino
Arte italiana. Ultimi quarant'anni.
Materiali anomali, Galleria d'Arte
Moderna, Bologna
1980. Chia Clemente Cucchi De Filippi
De Maria Mariani Ontani Paladino,
Galleria Planita, Roma
Odisseo (Ulysses), Stadio della
Vittoria, Bari
Partito preso, Galleria Nazionale d'Arte
Moderna, Roma
Around Europe, Stedelijk Museum,
Amsterdam
Futuro, presente, passato. XLVII

Biennale di Venezia, Giardini di
Castello, Corderie dell'Arsenale,
Venezia
über-Blick. Zeichnungen und
Skulpturen von 1510 bis 1997, Galerie
Arnoldi-Livie, Monaco; Galerie Daniel
Blau, Monaco; Galerie Bernd Klüser,
Monaco
Gefühle der Konstruktion. Künstler in
Italien Seit 1945, Museum
Rabalderhaus, Schwaz; Il sentimento
della costruzione. Artisti in Italia dal
dopoguerra ad oggi, Trevi Flash Art
Museum, Palazzo Lucarini, Trevi,
Perugia
L'arte del XX secolo. La collezione
dello Stedelijk Museum, Museo Civico
Castello Ursino, Catania
Fuori Uso '97 "Perché?", Ex deposito

Gestione Governativa F.E.A., Pescara
Traguardo, Antonio Colombo Arte
Contemporanea, Milano
Arte italiana. Ultimi quarant'anni.
Pittura iconica, Galleria d'Arte
Moderna, Bologna
Cerniera 1980. Chia-Clemente-Cucchi,
Artiscope, Bruxelles
Novecento Nudo, Museo del
Risorgimento, Vittoriano, Roma
Collettiva, Galleria Cesare Manzo,
Pescara

1998
Artenergie: Art in Jeans, Palazzo
Corsini, Firenze
Transavanguardia: Chia, Cucchi,
Clemente, Paladino, Museum Würth,
Künzelsau

NICOLA DE MARIA

Born in Foglianise, December 6, 1954

One-man Exhibitions

1975
Galleria Volpicelli, Naples, organized
by Lucio Amelio
Galeriaforma, Genoa

1976
Lucio Amelio, Naples
Agora Studio, Maastricht
Lucio Amelio, Naples

1977
Franco Toselli, Milan

1978
Paul Maenz, Cologne
Franco Toselli, Bari
Franco Toselli, Milan
Giorgio Persano, Turin

1979
Mario Diacono, Bologna

1980
Giorgio Persano, Turin
Franco Toselli, Milan
Annemarie Verna, Zürich
– Germano Celant, Musica-Occhi
[Music-Eyes], Kunsthalle, Basel;
Folkwang, Essen; Stedelijk Museum,
Amsterdam 1980.

1981
Giorgio Persano, Turin
Annemarie Verna, Zürich
Galleria del Capricorno, Venice
Lisson Gallery, London

1982
Mario Diacono, Rome
Marilena Bonomo, Spoleto
Giorgio Persano, Turin
L'Ariete, Milan

1983
Museum Haus Lange, Krefeld
– Gerhard, Storck, Germano Celant,
Mario Diacono, Franz Meyer, Marianne
Stockebrand, Rudi H. Fuchs, Juslian
Heinen, Jean-Christophe Ammann, EE

AA Stop Campane[EE AA Stop Bells],
Kunstmuseum der Stadt, Krefeld 1983.
Vereniging voor het Museum van
Hedendaagse Kunst, Gent
Annemarie Verna, Basel
Franco Toselli, Milan
Kunsthalle, Basel
– Jean-Christophe Ammann, Libertà
Segreta Segreta [Secret Secret
Freedom], Kunsthalle, Basel 1983.
Franco Toselli, Milan
Karsten Greve, Cologne

1984
Annemarie Verna, Zürich
Karsten Greve, Cologne
– Annelie Pohlen, Johannes Cladders,
Franz Meyer, Respiro nel Mondo [I
Breathe in the World], Galerie Karsten
Greve, Cologne 1984.

1985
Karsten Greve, Cologne
Emilio Mazzoli, Modena
– Nicola De Maria, 1985 Sorridi Faccia
[Smile Face], Emilio Mazzoli, Modena
1985.
Mayor Gallery, London
Maeght-Lelong, Paris
– Jean Frémon, Regno dei Fiori
Universo senza Bombe Baciami. Sì
[Kingdom of Flowers. Universe without
Bombs, Kiss Me. Yes], Galerie
Maeght-Lelong, Paris; Galerie Karsten
Greve, Cologne 1985.
Stedeljik van Abbe Museum, Eindhoven
– Nicola De Maria, Giorni del Secolo
Nuovo [Days of the New Century], van
Abbemuseum, Eindhoven 1985.
Kunsthaus, Zürich
– Ursula Perucchi-Petri, Parole Cinesi
[Chinese Words], Kunsthaus Zürich;
Kunstmuseum, Bonn 1985.
Castello di Rivoli, Turin

1986
Meyer-Ellinger, Frankfurt
Ulysses, Vienna
Stadtisches Kunstmuseum, Bonn
Karin Bolz, Mulheim an der Ruhr
– Piet de Jonge, Nicola De Maria, 40
Ladroni [40 Thieves], Karin Bolz
Gallerie, Mulheim a.d. Ruhr 1986.

Franco Toselli, Milan
Maeght-Lelong, New York

1987
Art Forum Thomas, Munich
Annemarie Verna, Zürich
Karin Bolz, Cologne
Wanda Reiff, Maastricht
Karsten Greve, Cologne
Franco Toselli, Milan
– Franco Toselli, Nicola De Maria,
Trionfo della Carità [Triumph of
Charity], Franco Toselli, Milan 1988.
Galerie Lelong, Paris

1988
Ronald Greenberg, St. Louis
Galleria Pio Monti, Rome
Thomas Segal, Boston
Thomas Wallner, Malmö
Seibu Museum of Modern Art, Tokyo
Daniel Weinberg, Los Angeles
Galerie Lelong, Paris
Galerie Lelong, New York

1989
The Harcus Gallery, Boston
Galerie Thomas, Basel
Galerie Lelong, New York
– Jean Frémon, Nicola De Maria,
Gloria [Glory], Galerie Lelong, Paris
1989.

1990
Franco Toselli, Milan
Saarland Museum, Saarbrucken
– Annelie Pohlen, E.G.Guse, Nicola
De Maria, Fiori Usignoli Miei
[Flowers, My Nightingales], Saarland
Museum, Saarbrucken, 1990.
XLIV Venice Biennale
Musée des Beaux Arts, Nîmes
– Bob Calle, Francois Cheng, Jean
Frémon, Edy de Wilde, Franco Toselli,
Testa Orfica [Orphic Head], Musée des
Beaux Arts, Nîmes 1991.
Galerie Kaess-Weyss, Stuttgart
Galerie Karsten Greve, Cologne
– Jonannes Cladders, Nicola De Maria,
La Testa Allegra di un Angelo Bello
[The Joyful Head of a Beautiful
Angel], Galerie Karsten Greve,
Cologne 1989.

1991
Galerie Lelong, Paris
Galerie Asback, Copenhagen
Galerie Lelong, New York
Galleria Alberto Valerio, Brescia

1992
Galerie Marika Marghescu, Hannover
– Jean Frémon, Uno Due, Tre,
Quattro, Cinque, Sei, Sette, Otto,
Nove, Dieci, Undici, Dodici Fiori
[One, Two, Three, Four, Five, Six,
Seven, Eight, Nine, Ten, Eleven,
Twelve Flowers], Galerie Marika
Marghescu, Hannover 1992.
Galerie Lelong, Paris
– Georges Raillard, Nicola De Maria,
Canto del Mare [Sea Song], Galerie
Lelong, Paris 1992.
Galleria del Sogno, Lugano
Thomas Segal Gallery, Boston
Evangelische Kirchengemeinde,
Bad Soden
Galerie Nieves Gernandez, Madrid
Laura Carpenter Fine Art, Santa Fe

1993
Galerie Lelong, New York
Galerie de l'ancien collège,
Chatellerault

1994
Franco Toselli, Milan
Mario Diacono Gallery, Boston
Galleria Col, Osaka
Kunstverein Ludwigsburg,
Musées et Centre d'art contemporain de
Montbéliard
– Ingrid Mossinger, Jean François
Mozziconacci, Nicola De Maria,
Giorni, Parole, Stelle, Fiori [Days,
Words, Stars, Flowers], Kunstverein
Ludwigsburg 1994.
Galleria Alberto Valerio, Brescia

1995
Galleria Col, Osaka
Galleria Cardi, Milan

1996
Galleria Cardi, Bologna
Galerie Lelong, Zurich
Yokohama Portside Gallery, Yokohama
Galerie Lelong, Paris

1997
Galerie Borkowski, Hannover

Galerie Beck & Eggeling, Dusseldorf
Galleria Col, Osaka
Galleria Cardi, Basel

1998
Neue Galerie der Stadt Linz, Wolfgang
Gurlitt Museum
Liechtensteinische Staatliche
Kunstsammlung, Vaduz
– Peter Baum, Yves Bonnefoy, Jean
Frémont, Nicola De Maria, Poesia
Dipinta [Painted Poem], Neue Galerie
der Stadt Linz; Kunstsammlung,
Vaduz; Obalne Galerije: Mestna
Galerija Piran + Galerija Loza Koper,
1998.
Galleria Col, Osaka
Galleria Cardi, Milan
Galleria Cardi, Basel

1999
Galerija Loza, Koper
Galerie Lelong, Zürich
Galleria A + A, Venice
Galleria Col, Osaka

Bibliography

1980
Musica – Occhi
Kunsthalle Basel; Museum
Folkwang, Essen;
Stedelijk Museum, Amsterdam
Text: Germano Celant

1983
EE AA Stop Campane
Kunstmuseum der Stadt Krefeld
Texts: Gerhard Storck, Germano Celant,
Mario Diacono, Franz Meyer,
Marianne Stockebrand, Rudi
H. Fuchs, Julian Heinen,
Jean – Christophe Ammann

Liberta' Segreta Segreta
Kunsthalle Basel
Text: Jean-Christophe Ammann

1984
Respiro Del Mondo
Galerie Karsten Greve, Koln
Texts: Annelie Pohlen, Johannes
Cladders, Franz Meyer

1985
1985 Sorridi Faccia
Emilio Mazzoli, Modena
Text: Nicola De Maria

Parole Cinesi
Kunsthaus Zurich; Kunstmuseum Bonn
Text: Ursula Perucchi-Petri

1985
Regno Dei Fiori
Universo Senza Bombe
Baciami. Si'
Galerie Maeght-Lelong, Paris; Galerie
Karsten
Greve, Köln
Text: Jean Frémon

1985
Giorni Del Secolo Nuovo
Van Abbemuseum, Eindhoven
Text: Nicola De Maria

1986
40 Ladroni
Karin Bolz Galerie, Mulheim a.d. Ruhr
Texts: Piet de Jonge, Nicola De Maria

1988
Trionfo Della Carita'
Franco Toselli, Milano
Texts: Franco Toselli, Nicola De Maria

1989
La Testa Allegra Di Un Angelo Bello
Galerie Karsten Greve, Köln
Texts: Johannes Cladders,
Nicola De Maria

1989
Gloria
Galerie Lelong, Paris
Texts: Jean Frémon, Nicola De Maria

1990
Fioried Usignoli Miei
Saarland Museum, Saarbrucken
Texts: Annelie Pohlen, E.G. Guse,
Nicola De Maria

1991
Testa Orfica
Musée des, H Beaux-Arts Nimes
Texts: Bob Calle, Francois Cheng, Jean
Frémon,
Edy de Wilde, Franco Toselli

1992
Canto Del Mare
Galerie Lelong, Paris
Texts: Georges Raillard,
Nicola De Maria

1992
Uno Due Tre Quattro Cinque
Sei Sette Otto
Nove Dieci Undici Dodici Fiori
Galerie Marika Marghescu, Hannover
Texts: Jean Frémon

1994
Giorni Parole Stelle Fiori

Kunstverein Ludwigsburg
Musées et Centre d'art Contemporain de
Montbéliard
Texts: Ingrid Mossinger, Jean François
Mozziconacci,
Nicola De Maria

1998
Nicola De Maria Poesia Dipinta

Neue Galerie der Stadt Linz, Wolfgang
Gurlitt Museum
Liechtensteinische Staatliche
Kunstsammlung, Vaduz
Obalne Galerije: Mestna Galerija Piran
+ Galerija Loza Koper
Texts: Peter Baum, Yves Bonnefoy,
Jean Fr, mon

MIMMO PALADINO

Born in Paduli, December 18, 1948

One-man Exhibitions

1969
Studio Oggetto, Caserta

1976
Nuovi Strumenti, Brescia
Galleria Nuova Duemila, Bologna

1977
Galleria de Ambrogi-Cavellini, Milano,
Galleria Lucio Amelio, Napoli
Galleria dell'Ariete, Milano

1978
Galleria Giorgio Persano, Torino
Galerie Paul Maenz, Köln
Galleria Franco Toselli, Milano
Galerie Tanit, München

1979
Centre d'Art Contemporain, Genève
Galleria Lucio Amelio, Napoli
Galerie T Venster, Rotterdam
Galleria Emilio Mazzoli, Modena
Art and Project, Amsterdam

1980
Galerie Paul Maenz, Köln
Galleria Giorgio Persano, Torino
Galerie Annemarie Vama, Zürich
Badischer Kunstverein, Karlsruhe
Marian Goodman Gallery, New York
Annina Nosei, New York
Galleria dell'Ariete, Milano
Galerie Tanit, München
Kunsthalle, Basel
Museum Folkwang, Essen
Stedelijk Museum, Amsterdam
Galleria Franco Toselli, Milano

1981
Galleria Lucio Amelio, Napoli
Galleria Mario Diacono, Roma
Kunstmuseum, Basel
Kestner Gesellschaft, Hannover
Mannheimer Kunstverein, Mannheim
Gröninger Museum, Gröningen
Galleria Comunale d'Arte Moderna,
Bologna
Galleria Franco Toselli, Milano

Schellmann & Klüser, München
Galerie Bruno Bischofberger, Zürich
Galerie Daniel Templon, Paris
121 Art Galerie, Antwerpen

1982
Galerie Buchmann, St. Gallen
Waddington Galleries, London
Louisiana Museum of Modern Art,
Humblebaek
Museumsverein, Wuppertal
Städtische Galerie, Erlangen
Schellmann & Klüser, München
Galleria Lucio Amelio, Napoli
Marian Goodman Gallery, New York
Munro Galerie, Hamburg

1983
Galerija Meduza, Koper
Galleri Engstrom, Stockholm
Ponova Art Gallery, Toronto
Galleria Emilio Mazzoli, Modena
Schellmann & Klüser, München
Sperone Westwater, New York
Gian Enzo Sperone, Roma
Galerie Annemarie Verna, Zürich
Galerie Thomas, München
Newport Harbour Art Museum,
Newport,
Los Angeles
Gallerie Franco Toselli, Milano
Villa Fidelio, Spello

1984
Waddington Galleries, London
Musée St. Pierre, Lyon
Schellmann & Klüser, München
Galerie Thomas, München
Galerie Thaddaeus Ropac, Salzburg
Galleria Franco Toselli, Milano
Galleri Ressle, Stockholm
Galleria Chisel, Genova

1985
Richard Gray Gallery, Chicago
Galleria Lucio Amelio, Napoli
Sperone Westwater, New York
Deweer Art Gallery, Zwevegem-Otegem
Städtische Galerie im Lenbachhaus,
München
Galerie Michael Haas, Berlin
Kunstnemes Hus, Oslo
Galerie Bernd Klüser, München

Dolan/Maxwell Gallery, Philadelphia
Kunstmuseum, Düsseldorf
Galerie Holtmann, Köln
Museum of Fine Arts, Richmond
Virginia

1986
Galleria Gian Enzo Sperone, Roma
Waddington Graphics, London
Richard Gray Gallery, Chicago
Galerie Bernd Klüser, München
Galerie Holtmann, Köln
Sperone Westwater, New York
James Corcoran Gallery, Los Angeles
Marisa del Re, New York
Galeria Comicos, Lisboa
Dolan/Maxwell Gallery, Philadelphia
Galerie Maghi Bettini, Amsterdam
Erika Meyerovich Gallery, San
Francisco
Waddington & Shiell Galleries, Toronto
Waddington & Gorce, Montreal
Galleria Franco Toselli, Milano
Currents Institute of Contemporary Art,
Boston
Galerie Delta, Rotterdam

1987
Fuji TV Gallery, Tokyo
Galerie Thaddaeus Ropac, Salzburg
Judy Youens Gallery, Houston
Salone Villa Romana, Firenze
Eglise S. Augustine, Bruxelles
Galleria Franco Toselli, Milano
Moderne Galerie Rupertinum, Salzburg
Niederösterreichisches Landesmuseum
in der Minoritendkirche, Krems/Stein
Kulturhaus der Stadt, Graz
Greg Kucera Gallery, Seattle
Sagacho Exhibit Space, Tokyo
Beaubourg, FIAC, Paris

1988
Gian Enzo Sperone, Roma
Waddington Galleries, London
Galleria in Arco, Torino
Richard Gray Gallery, Chicago
Galerie Bellarte, Helsinki
Evelyn Aimis Fine Art, Toronto
Galleri Boibrino, Stockholm
Galleri Wallner, Malmö
Kulturhistorisches Museum, Bielefeld
Lippische Gesellschaft für Kunst,

Detmold Lüneburg
Orangerie Schloß Rheda, Rheda-
Wiederburck

1989
Lluc Fluxa Galeria d'Art, Palma
de Mallorca
Galerie Daniel Templon, Paris
Piramide Arte Contemporanea
di Gianpaolo Becherini, Firenze
Galleria Lucio Amelio, Napoli
Sperone Westwater, New York
Cripta di Giulietta, Verona

1990
Galleri Lars Bohman, Stockholm
Galerie Bernd Klüser, München
Drill Hall Gallery, Canberra
Galerie Daniel Gervis, Cannes
Galleria Comunale d'Arte Moderna,
Villa delle Rose, Bologna
Palais des Beaux-Arts, Charleroi
Galerie Hadrien Thomas, Paris
Galerie Pièce Unique, Paris

1991
Duson Gallery & Ana Gallery, Seoul
Art Center, Seoul
Galerie Papieriski, Paris
Waddington Graphics, London
Galleria Gian Enzo Sperone, Roma
Galerie Daniel Templon, Paris
Waddington Galleries, London/Sperone
Westwater, New York
Galleri Lars Bohman, Stockholm
Belvedere of Prague Castle, Praha
Marian Locks, Gallery, Philadelphia
Musées Royaux des Beaux-Arts de
Belgique Art Moderne, Bruxelles
Galerie Bernd Klüser, München
Amelie Brachot, Paris

1992
Galleria Civica di Arte Contemporanea,
Trento
Museu de Arte, São Paulo
Museu de Gravura, Curitiba
Museu de Arte Moderna, Belo Horizonte
Museu de Arte Moderna, Rio de janiero
Museu de Arte Moderna, Brasilia
Galeria Ramis F. Barquet, Monterrey
Convento S. Domenico, Benevento
Galerie Daniel Templon, Paris
Galleria Gian Enzo Sperone, FIAC,
Paris

1993
Forte di Belvedere, Firenze

1994
Waddington Galleries, London
Waddington Graphics, London
Museo de Arte Contemporaneo de
Monterrey
Galerie Thaddaeus Ropac, Salzburg
Galerie Daniel Templon, Paris
National Gallery of Fine Arts, Beijing
Overbeck-Gesellschaft, Lübeck
Galleria Emilio Mazzoli, Modena
Caja de Asturias, Oviedo
Gallery Mario Diacono, Boston
Galleria Arte'92, Milano

1995
Galerie Bernd Klüser, München
Waddington Galleries, London

1995 – 1996
Scuderie di Palazzo Reale-Museo
Pignatelli, Napoli

1996
Sperone Westwater, New York

1997
Fondazione Stelline-Sala del
collezionista, Milano Waddington
Galleries, London

1998
Galleria Cesarea(Mimmo Paladino-Enzo
Cucchi), Genova
Galerie Thaddaeus Ropac, Salzburg

1999
Venice Design
MMMAC-Museo dei Materiali Minimi di
Arte Contemporanea-Paestum
South London Gallery, London

Selected Group
Exhibitions

1965
Circolo Culturale Beneventano,
Benevento

1975
"Da Mezzogiorno al Tramonto", Villa
Volpicelli, Napoli
"Campo Dieci", Galleria Diagramma,
Milano

1977
"Fotografia come Analisi", Teatro
Gobetti, Torino
"Cara Morte", Gavirate, Varese

"Dieci Opere di Pittura", Banco di
Brescia, Brescia

1978
Triennale Internationale du Dessin,
Wroclaw
"Metafisica del Quotidiano", Galleria
d'Arte Moderna, Bologna

1979
"Perspective" Art 10.79., Basel
"Arte Cifra"Galerie Paul Maenz, Köln
"Le Stanze", Castello Colonna,
Genazzano
"Clemente, De Maria, Paladino",
Galerie
Annemarie Verna, Zürich
"Parigi o Cara", Yvon Lambert, Paris
"Opere fatte ad Arte", Acireale
"Europa'79", Kunstmuseum, Stuttgart

1980
"Italia Nuova Immagine", Ravenna
"Die Enthauptete Hand" Bonner
Kunstverein, Bonn
"Linee della Ricerca Artistica in Italia
1960 – 1980", Palazzo
Delle Esposizioni, Roma
"Egonavigatio", Mannheimer
Kunstverein, Mannheim
"7 Junge Künstler aus Italien",
Kunsthalle, Basel
Museum Folkwang, Essen
Stedelijk Museum, Amsterdam
Biennale di Venezia
"Après le Classicisme" Musée d'Art
et d'Industrie, St. Etienne
Gröninger Museum, Gröningen
Badische Kunstverein, Karlsruhe

1981
Biennale de Paris, Musée National
d'Art Moderne, Paris
"A New Spirit in Painting", Royal
Academy of Art, London
"Westkunst", Museen der Stadt, Köln
"Drawings and Paintings on Paper",
Annina Nosei, New York
"Mostra d'Arte", Acireale
"Il Mobile Infinito", Facoltà di
Architettura, Politecnico, Milano

1982
"4th Biennale of Sydney-Vision of
Disbelief", Art Gallery of New South
Wales, Sydney
"Documenta 7", Museum
Friedericianum, Kassel

"Transavanguardia Internazionale",
Galleria Civica, Modena
"Avanguardia Transavanguardia 1968/
1977", Mura Aureliane, Roma
"Portraits et Figures", Galerie
beyeler, Basel
"Giovani Pittori e Scultori Italiani",
Rotonda della Besana, Milano
"Forma Senza Forma", Galleria Civica,
Modena-Palazzo Lanfranchi, Pisa
"European and American Edition",
Pace Gallery, New York
"Halle 6", Hamburg
"Neue Skulptur", Galerie Nächst
S.Stephan, Wien
"Zeitgeist", Martin Gropius Bau, Berlin
"New Figuration from Europe",
Milwaukee
Art Museum, Pabst Ross-Pain and
Winter Galleries
"Arte Italiana 1960 – 1982", Institute
of Contemporary Art, London

1983
"Tracce", Palazzo Sormani, Milano
"Les Rues d'aujourd'hui en Europe",
Marseilles
"Italia, la Transavanguardia", Obra
Cultural de la Caja de Pensiones,
Madrid
"Tema Celeste", Museo Civico d'Arte
Contemporanea, Gibellina
"Mario Merz, Mimmo Paladino,
A.R.Penck, Emilio Vedova", Galleria
Franco Toselli, Milano
"Artisti Italiani Contemporanei",
Venezia
"La Transavanguardia", Fundació Joan
Miró, Barcelona
"Concetto-Imago", Bonner Kunstverein,
Bonn
"Mimmo Paladino, A.R.Penck",
Galerie Buchmann, St. Gallen
"Nuovi Disegni", Kunstmuseum, Basel
"New Painting from the Collection of
Joshua Gessel", Tel Aviv Museum,
Tel Aviv
"L'Italie et Allemagne", Musée d'Art
et d'Histoire, Genève
"New Drawing, Evropska and
Amerisvka", Koper, Celje,
Liublijana, Zagreb
"Conseguenze Impreviste", Firenze
"Jarry e la Patafisica", Palazzo Reale,
Milano
"L'informale in Italia", Galleria d'Arte
Moderna, Bologna
"Aktuell'83", Städtische Galerie

im Lenbachhaus, München
"Expressive Malerei nach Picasso",
Galerie Beyeler, Basel
"Bilder der Angst und der Bedrohung",
Kunsthaus, Zürich
"New Art", Tate Gallery, London
"Costellazione", Galleria Giorgio
Persano, Torino
"Terraemotus", ICA, Boston
"Ars'83", The Art Museum of the
Ateneum, Helsinki
"Recent Painting", Sperone Westwater
Gallery, New York
"Recent European Painting", Solomon
R.Guggenheim Museum, New York
"Prints 1983", Waddington Graphics.
London
"Latitudine Napoli-New York", Galleria
Lucio Amelio, Napoli-Galleria Emilio
Mazzoli, Modena
"Nell'Arte.Artisti Italiani e Francesi a
Villa Medici", Roma
"Critica ad Arte", Palazzo
Lanfranchi, Pisa

1984
"Det Italienska Transaventgardet"
Stockholm Art Fair, Lunds Konsthall,
Stockholm
"Skulptur in 20 Jahrhundert, Merian
Park, Basel
"Reference", Palais des Beaux Arts,
Charleroi
"La Tradizione nel Presente", Varallo
"Contemporary Italian Masters",
Cultural Center of Chicago
Public Library, Chicago
"Terraemotus", Villa Capolieto,
Ercolano
"Content: A Contemporary Focus
1974 – 1984", Hirshhorn Museum and
Sculpture Garden, Washington Galleri
Ressle, Stockholm
"The Human Condition", Biennale
III, San
Francisco Museum of Modern Art, San
Francisco
"Images and Impressions", The Walker
Arts Center, Minneapolis
"An International Survey of Recent
Painting and Sculpture", Museum
of Modern Art, New York
"Rose'84", The Guiness Hop Store,
Dublin
"Via New York", Musée d'Art
Contemporain, Montreal
"Totem", Bonnier Gallery, New York
Annina Nosei Gallery, New York

"Modern Expressionists", Sidney Janis
Gallery, New York
Galerie Leger, Malmö
"Acquarelle", Kunstverein, Kassel
Galerie Rolf Ricke, Köln
"Il Modo Italiano, New York Newport
Harbour Art Museum, Newport Harbour
Centro d'Arte Contemporanea, Siracusa
"New Painting", Krannert Art Museum,
Champaign Illinois
"Opera su Carta", Antiope France,
Paris
"Un Section de la Collection Particulière
de Joshua Gessel, Halle Sud, Genève
Antichi Arsenali, Amalfi
"Europäische Malerei der Gegenwart",
Tuchfabrik Weber, Trier
"Samtida Konst", Stockholm
"Das Menschenbild in der Zeichnung",
Basel

1985
"The European Iceberg-Creativity
in Germany and Italy Today"Art Gallery
of Ontario, Toronto
"Il Flauto Magico", Palazzo della
Permanente, Milano
"XIII Biennale de Paris", Grande Halle
du Parc de la Villette, Paris
"Mixed Show", Thomas Segal Gallery,
Boston
Evelyn Aimis Fine Art, Toronto
Ponora Art Gallery, Toronto
Galleria Quintana, Bogota
Galleria Toselli, Milano
"Arbeiten zu Skulpturen", Schellmann
& Klüser, München
"Bilder für Frankfurt", Museum für
Moderne Kunst, Frankfurt
"São Paulo Biennale", São Paulo
"7000 Eichen", Kunsthalle, Tübingen
Sperone Westwater Gallery, New York
"Neue Bilder-W.A.Mozart", Galerie
Thaddaeus Ropac, Salzburg
"A New Romanticism", Hirshhorn
Museum and Sculpture Garden,
Washington-Akron Art Museum,
Akron, Ohio
"Images and Impressions", I.C.A.,
Philadelphia
"Selections from the William J.Hokin
Collection", Museum of Contemporary
Art, Chicago
"The Door", Annina Nosei Gallery,
New York
"Selections from the Frito-Lay
Collection", Chicago
Collection Musée St. Pierre, Lyon

"Aniottanta", Chiostro S. Domenico, Imola
"Horses in Twentieth Century Art", Nicola Jacobs Gallery, London
Ressle and Larsen Gallery, Stockholm
"Contemporary Italian Painting", Hirshhorn Museum and Sculpture Garden, Washington
"Museum?, Museum!, Museum", Hamburg
"Zeitgenössische Kunst bei Thomas", München
"New Art of Italy-Chia, Clemente, Cucchi, Paladino", Joslin Art Museum, Omaha, Nebraska-Dade County Center for the Fine Arts, Miami-
The Contemporary Arts Center, Cincinatti
"Ouverture", Deweer Art Gallery, Ewevegem-Otegem
"Europäische Malerei 1900 – 1985 bei Svetlana", Galerie Svetlana Achtaz, München

1986
"Naivety in Art", Setagaya Art Museum, Tokyo-Tochigi
& Prefectural Museum of Fine Art, Tokyo
Galleria Chisel, Genova
"Beuys zu Ehren", Städtisches Galerie im Lenbachhaus, München
"Sculpture", Waddington Galleries, London
Frankfurter Kunstverein, Frankfurt
"Sculpture For Public Spaces", Marisa Del Re, New York
Galleri Zero, Stockholm
"Sculture da Camera", Castello Svevo, Bari Galleri Mustad, Molnlycke, Sweden
"1960 – 1985: Aspekte der Italienischen Kunst", Haus am Waldsee, Berlin-Kunstverein, Hannover-Bregenzer Kunstverein, Palais Thurn und Taxis, Bregenz-Hochschule für Angewandte Kunst, Wien
Eugene Binder Gallery, Dallas
"Little and Large at the Waddington Galleries", London
"A Propos de Dessin", Galerie Adrien Maeght, Paris
"Mater Dulcissima", Chiesa dei Cavalieri di Malta, Siracusa
Waddington Graphics, London
"Focus on the Image", Phoenix Art Museum, Phoenix
Galleri Bel' Art, Stockholm

Galeria Juana de Aizpuru, Madrid

1987
"Works on Paper", Waddington Galleries, London
"After Pollock: Three Decades of Diversity",
Iannetti Canzone, San Francisco
"Painting in Europe", Karl Pfefferle, München
"Les Masques de Dieu", Nikki Diana Marquadt, Paris
Galleria Quintana, Bogota
"Monte Carlo Sculpture '87", Monte Carlo
"Hotel Brancusi", Galleria Lucio Amelio, Napoli
"101 Meisterwerke", Bayerische Staatsgemäldesammlungen, München
"A Century of Modern Sculpture-The Patsy and Raymond Nasher Collection", Dallas Museum of Art-National Gallery of Washington-Staatsgalerie Moderner Kunst, München
"Terraemotus", Grand Palais, Paris
"Focus on the Image", Museum of Art, University of Oklahoma
"Process and Product. The Making of Eight Contemporary Masterworks", Edith C. Blum Art Insitute New York
"Beelden Van Schilders, Werner on Papier",
Galerie Wanda Reiff, Maastricht
"Les Peintures d' Europe", Strasbourg

1988
"Costellazione Transavanguardia", Provinciaal Museum voor Moderne Kunst, Oostende
"Sculpture", Waddington Galleries, London
"Les Années '80: A la Surface de la Peinture", Centre d' Art Contemporain, Abbaye Saint-André, Meymac
"Mimmo Paladino, Nicola de Maria, Luigi Ontani", Alessandro Bagnai, Siena "Bridge", University of Lethbridge Collection, Calgary
"Altered Images", Penson Gallery, New York
"New Paintings", Sperone Westwater Gallery, New York
"Selected Masterworks", Ria Yares, Arizona
"Europa Oggi", Centro per l' Arte Contemporanea Luigi Pecci, Prato
"Materialmente", Galleria Comunale d' Arte Moderna, Bologna

"Tracce-Dannunziana", Università G. D' Annunzio, Pescara
"XLIII Biennale Internazionale d' Arte, Venezia
"Mythos Italien. Wintermärchen Deutschland", Haus der Kunst, München Galerie Michael Haas, Berlin
"Trade Decades-The Oliver Hoffman Collection", Museum of Contemporary Art, Chicago
"Tilbakenending Til Orden Oggsennopptagelsen av Malerkunsten. Den Figurative Kontinuitet Italiensk Malerkunstkl 1920 – 1987", Kunstners Hus Oslo-Atheneumin Taidemusco, Helsinki-Mathildenhöhe, Darmstadt-Bielefelder Kunsthalle, Bielefeld Munson Williams-Proctor Institute Museum of Art, Utica
"Mosaico e Mosaicisti", Castello Estense, Mesola
"Tridente Tre. Proposte e Riproposte", Roma
"L' Autoritratto non ritratto nell' Arte Contemporanea Italiana", Arte Fiera, Bologna-Pinacoteca Comunale, Ravenna
"A. B. O. Ritratti di un Nome", Fortezza da Basso, Firenze
"Voi che dite che io sia?", V Biennale d' Arte Sacra, Palazzo Pubblico, Siena
"Zeitgenössische Kunst", Galerie Thomas, München
"Bilder für den Himmel-Kunstdrachen", Goethe Institute Osaka
"Farbe Bekennen", Museum für Gegenwartskunst, Basel
"Le Retour de Marco Polo", Paris-Beijing

1989
"Wiener Diwan-Sigmund Freud-Heute", Museum des 20. Jahrhundert, Wien
"Boetti, Castellani, De Maria, Fontana, Gilardi, Manzoni, Paladino, Paolini, Pistoletto, Salvo", Edward Totah Gallery, London
"The Europeans", Evelyn Aimis Gallery, Toronto
"Italian Art in the 20th Century", Royal Academy of Arts, London
"Dhan, Carcia, Sevilla, Lamarzares, Paladino, Sarmento, Le Groumellacc, Plessi", Galeria Miguel Marcos, Zaragoza
"Xth Anniversary Show", Deweer Art Gallery, Otegem
"Group Exhibition of Canadian and International Artists", Evelyn Aimis

Gallery, Toronto
"L'inutilità della Bussola inventata in
Amalfi da Flavio Tioia nelle Derive
dell'Arte", Antichi Arsenali, Amalfi
"Selected Masterworks", Riva Yares,
Arizona
"Portraits", Biblioteca Civica, Verbania
"Disegno Italiano 1908 – 1982",
Staatliches Museum, Berlin
"Prima Crociera sull'Arte
Contemporanea", Italia-Grecia-Egitto

1990
"Presence Eternity-Traces of the
Transcendental in Today's Art", Martin
Gropius Bau, Berlin
"Tra Mito e Stereotipo", Galleria in
Arco, Torino
"Polyptyques et Paravents", Galerie
Bellier, Paris
"Dream of Artists", Galerie 121,
Antwerpen
"Exhibition of International Prints",
Gallery Moos, Toronto
"Summer Group Sculpture Exhibition",
Sperone Westwater Gallery, New York
"To Shuffle the Cards, Spectacular
Image", Galleria Gian Ferrari Arte
Contemporanea, Milano
"Art of the Eighties from the Thomas
Collection", Moderna Galerjia
Ljubljiana-Galerie Thomas, München

1991
"Mirror Image", Galleria Gian Ferrari
Arte Contemporanea, Milano
"Group Summer Show", New Art
Centre, London
"Peinture et Matière", Galerie Adrien
Thomas, Paris
"Third Monte Carlo Sculpture
Biennial", Marisa del Re, Monte Carlo
"La Metafisica della Luce", John Good
Gallery, New York
"Gli Anni'70", Studio d'Arte
Cannaviello, Milano
"Ceccobelli, Chia, Paladino", Galerie
Brinkham, Amsterdam
"Selection oeuvres de la collection",
FAE Musée d'Art Contemporain,
Pully, Lausanne
"Human Forms: Drawings and
Sculptures", Evelyn Aimis Gallery,
Toronto
"La Collezione Metamemphis 1991",
Metamemphis, Milano
"Bonecchi, Ceccobelli, Gallo,
Paladino, Pizzi Canella, Tirelli,

Arbeiten auf Papier", Galerie Hilger,
Frankfurt
"A Passion for Art", Tony Shafrazi
Gallery, New York
"Parallels: Lines of Contemporary
Sculpture", Gian Ferrari Arte
Contemporanea, Milano

1992
"Sculpture", Waddington Galleries,
London
"The Frozen Leopard Part III", Galerie
Bernd Kluser, München
"A Short History of Modern Italian
Sculpture", Baldacci-Daverio Gallery,
New York
"The Italian Transavantgarde", Ho-Am
Art Gallery, Seoul
"Terraemotus alla Reggia di Caserta",
Fondazione Amelio, Caserta
"Lo Spirito: New Art from Italy",
Newhouse Center for Contemporary
Art, Snug Harbor Cultural Center
"Drawn in the '90s", Katonah Museum
of Art, Katonah, New York
"Group Sculpture Show", Sperone
Westwater Gallery, New York

1993
Alberta College of Art, Calgary
Hunstville Museum of Art, Hunstville,
Alabama
"Transavanguardia", Gian Ferrari Arte
Contemporanea, Milano
"From Rodin to Serra", Galerie
Saqqaah, Gstaad
"Chia, Paladino, Salvo: Werken op
Papier", Galerie Delta, Rotterdam
"The Lyrical the Logical and the
Sublime: Chia, Merlino, Paladino",
Nohra Haime Gallery, New York
"The Spirit of Drawing", Sperone
Westwater Gallery, New York
"From Intimate to Monumental",
Associated American Artists, New York
"A la decouverte···des Collections
Romandes II", Musée d'Art
Contemporain, Pully, Lausanne
"Drawing the line against Aids",
Biennale di venezia, Amfar International
"Utopia-Arte Italiana 1950 – 1993",
Salzburger Festspiele, Salzburg (S.R.
Guggenheim Foundation and Galerie T.
Ropac)

1994
"From Beyond the Pale", The Irish
Museum of Modern Art, Dublin

1995
"Fuori Uso", Pescara
Biennale di Grafica, Ljubljiana
"Archeologie di Jean Le Gac e Mimmo
Paladino", Bologna-Museo Barracco,
Roma-Vance
"L'Arte in Croce-Bernik, Cucchi,
Frohner, Paladino, Rainer, Saura,
Vedova, Velickovic", Museo Diocesano
d'Arte Sacra, Venezia
"Artist's Choice", American Academy
in Rome, Roma

1997
"Arte italiana. Ultimi quarant'anni.
Materiali anomali", Galleria d'Arte
Moderna, Bologna

1997 – 1998
"Arte italiana. Ultimi quarant'anni.
Pittura Iconica," Galleria d'Arte
Moderna, Bologna
Born of Clay II, Garth Clark Gallery,
New York

1998
"Boetti, De Maria, Paladino", Galleria
Cardi, Milano

1999
Galleria Aminta, Siena
Galleria Cardi, Milano
XIII Quadriennale, Roma

Bibliography

1968
Bonito Oliva, Achille: Mimmo Paladino
(Catalogo), Galleria Carolina di Portici

1970
Menna, Filiberto: Mimmo Paladino,
《Il Mattino》, 30 ottobre

1972
Trimarco, Angelo: Struttura a l'oggetto,
《Il Mattino》, 11 aprile

1975
Venturi, Luca Maria:《Artitudes》,
nn.21/22
Venturi, Luca Maria: Le principe
immense de l'être est double,
《Artitudes》, nn.24/26
Mimmo Paladino, L'Arte Moderna,
Fabbri Ed, n.111
Mimmo Paladino,《Art Dimension
International Review of Arts》, n.1,

gennaio/febbraio/marzo
Mimmo Paladino,《Flash Art》,
nn.54/55, maggio

1977

Palazzoli, Daniela:Chi c'è nel mio
specchio?,《L'Europeo》,n.21
Radice, Barbara:Mimmo Paladino,
《Data》,n.26, aprile/giugno
Corbi, Vitaliano:Note d'arte:Mimmo
Paladino,《Il Mattino》, 1°giugno
Menna, Filiberto:Le immagine sono
riflessi bruciati,《Spazio Alternativo》,
ottobre Bandini, Mirella:Fotografia
come analisi(Catalogo),
Teatro Gobetti, Torino

1978

Mussa, Italo:Dislivello del reale,
《Interarte》,n.15
Altamira, Adriano:Ritorno al disegno,
《Fotografia Italiana》,n.242
Bonito Oliva, Achille:Tre o quattro
artisti secchi, Emilio
Mazzoli Editrice, Modena
Rinaldi, Rosamaria:Italian Art Etc.,
《Laica Journal》,Los Angeles, n. 18
aprile/maggio Vincitorio, Francesco:
《L'Espresso》,28 maggio
Radice, Barbara:L'arte non serve e io
sono un antieroe,《Modo》,
n.14, novembre
Barilli, Renato:Su quel muro c'è un
romanzo,《L'Espresso》,17 dicembre
Vescovo, Marisa:Segno labirinto,
Metafisica del quotidiano(Catalogo),
Galleria d'Arte Moderna, Bologna
Napens, Klaus:Ci ha pensato un
tedesco, 17
Italian Artists(Catalogo),Galerie
Maenz, Köln

1979

Celant, Germano:Die italienische
Erfahrung berührt, Jahresbericht
1978, Paul Maenz, Köln
Altamira, Adriano:Tra segno ed
installazione,G7,n.3
Petrilli, Antonio:《Proposta》,nn.41/42
Petrusca, Mariantonietta Picone:
Scomesse sui giovani,《La Voce della
Campania》,28 gennaio
Radice, Barbara, :Tra avanguardia
e sperimentazione,《Vogue》,n.337,
febbraio David, Armando:
Mimmo Paladino, vitalità
del colore,《Il Mattino》,3 febbraio
Vincitorio, Francesco:《L'Espresso》,

4 febbraio
Carluccio, Luigi:Mimmo Paladino,
《Panorama》,13 febbraio
Amman, Jean Christophe:Espansivo
Eccessivo,《Domus》,n.593, aprile
Bonito Oliva, Achille:La
Transavanguardia Italiana,
《Flash Art》,nn.92/93,
ottobre/novembre
Mussa, Italo:Vero e reale nelle opere
fatte ad arte,《Avanti》,11 novembre
Cherubini, Laura:Mimmo Paladino:
all'Interno dello spazio della pittura,
《Avanti》,18 novembre
Giglio, Rolando:Cinque
esempi di nostalgia,
《Il Messaggero》,19 novembre
Bramante, Vanni:Opere fatte ad arte,
《L'Unità》,20 novembre
Sinisi, Silvana:I segni d'oggi nel
castello del passato,《Avanti》,
9 dicembre
Bonito Oliva, Achille:L'artista dell'80
corre sul filo senza paura di cadere,
《Avanti》,30 dicembre
Report 1979, Galerie t'Venster,
Rotterdam Arts Council
Bonito Oliva, Achille:Le Stanze
(Catalogo),Castello del
Colonna, Genazzano
Bonito Oliva, Achille:Opere fatte ad
arte (Catalogo),Palazzo
di Città, Acireale
Faust, Wolfgang Max:Arte Cifra
(Catalogo),Paul Maenz, Köln

1980

Amman, Jean Christophe:Skira
Annuel, Genève
Bonito Oliva, Achille:EN DE RE,
Emilio Mazzoli Editrice, Modena
Faust, Wolfgang Max:Arte cifra? Neue
Subjektivität? Trans-Avantgarde?,
《Kunstforum International》,n.3
Amman, Jean Christophe:Was die
siebziger Jahre von den
sechzigern unterscheidet:Der
Weg in die achtziger Jahre,《Kunstforum
International》,n.3
Petrilli, Antonio:Alla vigilia della
Biennale di Venezia,《Proposta》,
nn.47/48
Oosterhaf, Grosse:Un'altra arte?,
《Museum Journal》(Rotterdam),n.80
Borgogelli, Sandra:Mimmo Paladino,
《Flash Art》,gennaio
Parigi o cara,《Flash Art》,nn.94/95,
gennaio/febbraio

Cabutti, Lucio:Opere fatte ad arte,
《Bolaffi Arte》,n.96, marzo
Cherubini, Laura:Le stanze,《Flash
Art》,nn.94/95,febbraio
Cherubini, Laura:Labirinto,《Flash
Art》,nn.94/95,febbraio
Bandini, Mirella:15 Artisti nel labirinto
tra ordine e caos
《Avanti》,24 febbraio Heybrook,
Christel:Einschiffung zu den Inseln der
Sehnsüchte,《Kunstforum International》,
marzo
Alinovi, Francesca:《Bolaffi Arte》,
n.96, marzo
Ferrari, Corinna:Le stanze del castello,
《Domus》, n.604, marzo
Vincitorio, Francesco:《L'Espresso》,
30 marzo
Marx, Heike:Eine Mischung aus
Naivität und Persiflage,
《Die Rheinpfalz》,2 aprile
Castagnoli, Pier Giovanni:
Caccia al giovane,
《La Repubblica》,9 aprile
Toselli, Franco:La febbre del quadro,
《Domus》,n.605, aprile
Bonito Oliva, Achille:Gli Anni'80 ci
portano l'arte casual
(l'arte intercambiabile),
《Bolaffi Arte》,n.97, aprile
Boujard, Willi:In Germania gli italiani
faranno cifre,《Bolaffi Arte》,
n.97, aprile
Piller, Micky:Mimmo Paladino,
《Artforum》(New York), aprile
Heybrook, Christel:Einschiffung zu den
Inseln der Sehnsüchte,《Mannheimer
Morgen》,31 aprile
Celant, Germano:Une histoire de l'art
contemporain en Italie,《Art Press》,
n.37, maggio
Toselli, Franco:Le impurità,
《Domus》,n.606, maggio
Izzo, Arcangelo:Intervista Ger Van Elk
a Napoli,《Domus》,n.606, maggio
Bonito Oliva, Achille:The Bewildered
Image,《Flash Art》,n.97, maggio
Mussa, Italo:Italiana Nuova Immagine;
《Flash Art》,n.97, maggio
Argan, G.Carlo:Computer il giovane
maestro del sec.XX,
《L'Espresso》,4 maggio Riva, Valerio:
Biennale contro Triennale,
《L'Europeo》,6 maggio Cabutti, Lucio:
Mannheim, Egonavigatio,《Bolaffi
Arte》,Estate
Cabutti, Lucio:Basilea, arte dall'
Italia,《Bolaffi Arte》,giugno

Radice, Barbara: L'avanguardia inseguita (intervista con Franco Toselli), 《Modo》, n.30, giugno
Mussa, Italo: 39 Biennale di Venezia, 《Avanti》, 1° giugno
Barilli, Renato: 《Avanti》, 1° giugno
Agnese, M.L. e Enriques, Rachele: La guerra dei pennelli, 《Panorama》, 2 giugno
K.V.: Gemalte Körperlichkeit, 《Die Weltwoche》, 11 giugno
Bonito Oliva, Achille: Transavanguardia, 《Flash Art》, nn.98/99, luglio
Vescovo, Marisa: Expo Arte, 《Flash Art》, nn.98/99, luglio
Celant, Germano: Bienale '80 sonni e risvegli, 《Domus》, n.608, agosto
Frey, Patrick: Südliche Geheimnisse, 《Tagesanzeiger》, 8 agosto
Mimmo Paladino, 《New Art》, Estate/Autunno
7 Artisti Italiani in Basel, Essen, Amsterdam, 《Domus》, n.609, settembre
Trini, Tommaso: Venezia, La Biennale '80, 《Gran Bazaar》, settembre/ottobre
Cernia, Maria Pia Quarzo: Die neuen Italiener, 《Die Kunstzeitschrift》 (Zürich), ottobre
Bonito Oliva, Achille: Anche Parigi ha la sua biennale, 《Avanti》, 5 ottobre
Larson, Kay: And four's a movement, 《Village Voice》, 15-21 ottobre
D.V.G.: 《Art World》, n.2, 17 ottobre/14 novembre
Castagnoli, Pier Giovanni: Attenzione pittura sporca, 《La Repubblica》, 22 ottobre
Bonito Oliva, Achille: New York ocara, 《Avanti》, 2 novembre
Faust, Wolfgang Max: Alla ricerca del··· (Intervista con Mimmo Paladino), 《Domus》, n.611, novembre (anche catalogo del Badischer Kunstverein)
Bonito Oliva, Achille: La Transavanguardia Italiana, Giancarlo Politti Editore Rickley, C.: New York, Mimmo Paladino Marian Goodman Gallery, 《Artforum》, vol XIX, dicembre
C.I.: 100 Guttuso di domani, 《Capital》, n.10, dicembre
Mimmo Paladino, 《Spazio Umano》, dicembre
Mimmo Paladino, 《Artforum》, dicembre
Van Ginneken, Lilly: Italiaanse schilders op snelle zegetocht, 《Volkskrant》, 13 dicembre

Vicncitorio, F.: Intervista con Lucio Amelio, 《L'Espresso》, 21 dicembre
Tosi, Barbara: La giovane pittura nel mirino della cultura internazionale, 《Avanti》, 21 dicembre
Zumbrink, Jan: Italiaanse avant-garde in Stedelijk, 《Kunst》 (Amsterdam), 24 dicembre
Bonito Oliva, Achille: Positivo bilancio del 1980 per l'arte, 《Avanti》, 28 dicembre
Cabutti, Lucio: Parigi X Biennale, 《Bolaffi Arte》, Inverno
Mimmo Paladino, 《Report 1980》, Rotterdam Arts Council
Egonavigatio (Catalogo), Mannheimer Kunstverein, Mannheim
Bonito Oliva, Achille, Franco Toselli e j. Christophe Amman: Chia, Clemente, Cucchi, De Maria, Ontani, Paladino, Tatafiore (Catalogo), Kunsthalle, Basel
Bonito Oliva, Achille: Nuova soggettività e Max W. Faust: Die Enthauptete Hand. 100
Disegni Italiani (Catalogo), Bonner Kunstverein, Bonn
Mimmo Paladino) Catalogo), Kunsthalle Basel
Schwartz, Michael, Andrea Franzke e Max W. Faust:
Mimmo Paladino (Catalogo), Badischer Kunstverein, Karlsruhe
The Chase Manhattan Bank Art Collection: Acquisitions (Catalogo), Chase Manhattan Bank, New York

1981

Mussa, Italo: Vediamo che cos'è la transavanguardia, 《Avanti》, gennaio
Bonito Oliva, Achille: Occorre portare l'arte nella scuola, 《Cultura》, gennaio
Schenke, Manns: Jonge Italianen in Niemandsland, 《Algemeen Dagblad》 (Amsterdam), 2 gennaio
Borten, Walter: Die Jonge Italianen en de Internazionale Avant-Garde Het, 《Financiede Vrig Dagblad》, 2 gennaio
Barilli, Renato: Prodotti Made in Italy che adesso tirano forte, 《Avanti》, 4 gennaio
Zdenek, Felix: Italiani ad Essen, 《Domus》, n.614, febbraio
Amante, Laura: 《Open Art》, febbraio
Bonito Oliva, Achille: Il nuovo spirito della pittura visto da Londra, 《Avanti》, 1° febbraio
Mimmo Paladino, 《Stedelijk Museum

Bulletin》, 1° febbraio
Cabutti, Lucio: Amsterdam giovani Italiani, 《Bolaffi Arte》, marzo
Martin, Henry: The Italian Art Scene, 《Artnews》, marzo
Trini, Tommaso: Mimmo Paladino-The Mozart Tongue, 《Domus》, n.615, marzo (anche 《Art Press》, n.55, gennaio 1982)
Bonuomo, Michele: Mostra fra parentesi, 《Il Mattino》, marzo
Bonito Oliva, Achille: Panorama dell'Arte nell'ultimo ventennio, 《Avanti》, 1° marzo
Maestri, Barbara: Young Italians, 《Flash Art》, n.102, marzo/aprile
Mimmo Paladino, 《Print Collectors Newsletter》 (New York), aprile
Bonito Oliva, Achille: Manierismo e Nomadismo, 《Flash Art》 n.103, maggio
Vincitorio, Francesco: 《L'Espresso》, 10 maggio
Vincitorio, Francesco: 《L'Espresso》 (intervista con Giulio Turcato), 17 maggio
Bonito Oliva, Achille: La Transavanguardia, 《Interarte》, 20 maggio
Bonito Oliva, Achille: Adesso Napoli non è più accettabile la prassi d'attesa, 《Avanti》, 24 maggio
Mussa, Italo: Mimmo Paladino alla Diacono, 《Flash Art》, n.104, Estate
Mimmo Paladino, 《Basel Museums Bulletin》, n.239, giugno
Bonito Oliva, Achille: Conquista New York l'ultima generazione della Transavanguardia, 《Cultura》, 7 giugno
Zecchini, Paolo: I poeti dell'arte, 《Il Settimanale》, n.23, 9 giugno
Von Besserich, Wolfgang: Der Zeichner und Maler Mimmo Paladino, 《Basler Zeitung》, 12 giugno
Mimmo Paladino im Kunstmuseum, 《Zürcher Zeitung》, 15 giugno
Netter, Maria: 《Basler Zeitung》, 17 giugno
Barilli, Renato: Ma dove sono i nuovi-nuovi?, 《L'Espresso》, 21 giugno
Bonito Oliva, Achille: Prospettive della Fiera di Basilea dedicata all'arte, 《Avanti》, 28 giugno
Bonito Oliva, Achille: L'immagine a frammenti, 《il Giorno》, 11 luglio
Vincitorio, Francesco: Intervista con Mimmo Paladino, 《L'Espresso》, 12 luglio

Bargiacchi, Enzo: Il grande test dell'
arte contemporanea, 《La Città》, 18
luglio
Struwe, Carlos: O caminho do scidente,
《Vaia》(São Paulo), 29 luglio
Felix, Zdenek: Westkunst a Colonia,
《Domus》, n.619, luglio/agosto
Mimmo Paladino, 《Neue Kunst in
München》, agosto
Puliafito, Isabella: 《Domus》,
n.619, agosto
Trini, Tommaso: 《Flash Art》,
n.103, ottobre
Bode, Peter M: I.R.Vitales
von Paladinos,
《Abendzeitung》(München), 21 ottobre
Kolsteren, Steven: Mimmo
Paladino en de
Jonge Italianen, 《Gröninger Muiseum
Bulletin》, novembre
Bonito Oliva, Achille: La
Transavanguardia internaziondle,
《Flash Art》, n.105, novembre
D.V.B.: Mimmo Paladino New York,
《Art World》, novembre
Somaini, Luisa: I diamanti della
Transavanguardia, 《La Repubblica》,
8-9 novembre
Cerina, Maria Pia Quarzo: Mobile
infinito, 《Journal》, dicembre
Quintavalle, A.Carlo: 《Panorama》,
21 dicembre
Payant, René: From Language to
Language, Parachute, Amsterdam
Busche, Ernst: Kunstkalender,
Hannover
Bonito Oliva, Achille: Tesoro, Emilio
Mazzoli Editore, Modena
Mimmo Paladino, Bilder und
Zeichnungen 1980/1981,
Verlag Schellmann & Klüser, München
Winkler, Federico e Marianne Kindler:
Mimmo Paladino (Catalogo),
Kunstmuseum, Basel
Joachimides, Christos M.: A New Spirit
in Painting (Catalogo), Rayal Academy
of Arts, London
Wildermuth, Armin, Dieter Koepplin
e Jean Christophe Amman: Mimmo
Paladino Zenchnungen 1976 – 1981
(Catalogo), Kunstmuseum Basel
Bonito Oliva, Achille: Paladino di
pittura.
Esercizi di lettura, Mimmo Paladino,
Galleria Comunale d'Arte
Moderna, Bologna

1982

Taddeo, Gabriella: Mimmo Paladino,
《Lapis/Arte》, n.8
Bonito Oliva, Achille: Ottimismo infine,
《Pagina》, n.2
Buch, Hugo Arne: Mimmo Paladino,
Tegninger 1976/1981, 《Lousiana
Revv》, n.2, gennaio
Koepplin, Dieter: Beskrivelse of nogle af
Paladinos Tergninger, 《Louisiana Revv》
n.2, gennaio
Ponti, Lisa: Franco Toselli, 《Domus》,
n.624, gennaio
Dieses Neueste Bild Von Mimmo
Paladino, 《Abendzeitung》, 12 gennaio
Heybrook, Christel: Rosa Bonbonmasse,
Bilder aus Draculas Schlob,
《Mannheimer Morgen》, 19 gennaio
Feeser, Sigried: Zwischen Traum und
Kitsch, 《Die Rheinpfalz》, 21 gennaio
Rein, Ingrid: Geheimnisvolle
Botschaften,
《Süddeutsche Zeitung》, 22-23 gennaio
Mele, Rino: 《Modo》, n.46,
gennaio/febbraio
Kvartic, Bild Dolf: Neue Ausstellungen
im Kunstmuseum und
Kornschutte Luzern,
《Luzerner Neueste Nachrichten》,
n.318, febbraio
De Felice, Attanasio: The Italian
Moderns, 《Attenzione》, n.3, marzo
Kruckmann, Pee O.: Frage und
Antwort, 《Badische Zeitung》
(Freiburg im Breisgau), 5 marzo
Edwards, Folke: Art is anything you can
get away with!, 《Paletten》, aprile
Kent, Sarah: Mimmo Paladino, 《Time
Out》, 16 aprile
Spruling, John: Doing versus being,
《The Listener》, 16 aprile
Einzig, Hetty: Anselm Kiefer, Mimmo
Paladino, 《Art Monthly》, maggio
Caramel, Luciano: Neo-espressionismo
all'attacco, 《Il Giornale》, 7 maggio
Weinstock, Nino: Mimmo Paladino,
《Basler Magazin》, n.188, maggio
Muller, Christine: Kunst im Kopf,
Paolini und Paladino in Wuppertal,
《Generalazeiger》, 12 maggio
Von Pohlen, Annelie: Ein Blick Zurück
und nach Vorne, 《Generalanzeiger für
Bonn》, 14 maggio
Morais, Federico: 《O Globo》(Rio
de Janeiro), 18 maggio
Wildermuth, Armin: Mimmo Paladino,
《Flash Art》, n.109, Estate
Titterington, Chris: Mimmo Paladino at
Waddington, 《Artscribe》, n.35, giugno

Coni, Enrico R. e Mimmo Paladino: Sul
nihilismo dell'uomo contemporaneo, 《Lo
Spazio Umano》, n.4, luglio/settembre
M.S.: L'ultima moda è la
transavanguardia,
《Lei》, n.22, settembre
Mimmo Paladino, 《Lei》, n.22,
settembre
Masini, Lara Vinca: Spazi Arte'82 a
Celle Santomato di Pistoia,
《Gran Bazaar》, settembre/ottobre
Von Gopfert, Peter Hans: 《Berliner
Morgenpost》, 16 ottobre
Amman, Jean Christophe: Paladino:
Diamonds and Secret Cards, 《Flash
Art》, n.109, novembre
Wildermuth, Armin: Mimmo Paladino,
《Flash Art》, n.109, novembre
Bode, Peter M.: Odysee im Weltraum,
《Abendzeitung》, 4 dicembre
Quintavalle, Arturo Carlo: 《Panorama》,
13 dicembre
Pohlen, Anelie: Das Abenteuer und der
Widerspruch, Schellmann & Klüser,
München
Mimmo Paladino, Neue Mappenwerke
der Edition Schellmann & Klüser,
München
Mimmo Paladino, Bilder Zeichnungen
Grafik (Catalogue), Städtische
Galerie Erlangen, Erlangen
New figuration from Europe (Catalogue),
Milwaukee Art Museum
Bonito Oliva, Achille e Armin
Wildermuth: Mimmo Paladino
(Catalogue), Galerie Buchmann, St.
Gallen

1983

Bonito Oliva, Achille: Trans Avant
Garde International,
Giancarlo Politi Editore, gennaio
《Bijutsutecho》, vol.35, n.505, gennaio
(Giappone)
Mimmo Paladino, 《El Pais》, 19 gennaio
Nickles, Joan: Trembles in Naples Art,
《Daily American》, 29 gennaio
Mimmo Paladino, 《ABC》(Madrid),
30 gennaio
Vincitorio, Francesco: La parte
dell'occhio,
《L'Espresso》, 30 gennaio
Morais, Federico: Com avaguardia ativa
á uma revisão do passado este ano
promete ser born para a arte no Rio,
《O Globo》(Rio de Janeiro), 31 gennaio
Cerina, Quarzo, M.P.: Der Garten ist
geheimnisvoller als der Wald, 《Die

Kunstzeitschrift》(Zürich), n.504, febbraio Cueto, Juan: El Nombre de la soa,《El Pais》(Madrid), 1° febbraio
Fuentes, Carmen: La Transavanguardia italiana o el ultimo movimiento pictorico,《ABC》(Madrid), 1° febbraio
Huici, Fernando: La Transavanguardia italiana presenta en Madrid un balance significativo de su aportacion estetica,《El Pais》(Madrid), 1° febbraio
Logrono, Miguel: Llego la Transavanguardia,《Diario》(Madrid), 2 febbraio
Del Romero, Pachi: La Transavanguardia ni mitos ni punto de referncia unico,《Cinco dias》(Madrid), 3 febbraio Vidali, Roberto: Mimmo Paladino: la pittura riposa nel nascondiglio di ghiaccio della magia,《Juliet Art Magazine》, 10 febbraio/marzo
Serraler, Francisco Calvo: Balance provisional de la Transavanguardia,《El Pais》(Madrid), 12 febbraio
Jimenez, Carlos: Transavanguardia, oltra vez,《Cambio》(Madrid), 14 febbraio
Combalia, Victoria: El voraz movimiento de la Transavanguardia,《El Pais》(Madrid), 24 febbraio
Trenas, Julio: La transavanguardia como arte de la transicion,《Jano Critica》, marzo
Vadel, Bernard Lamarche: La Transavanguardia,《El Socialista》, n.300, 9-15 marzo
Mimmo Paladino,《Diario de Barcelona》, 13 marzo
Garcia, Manuel: Transavanguardia Italiana,《Tiempo de Vivir》(Madrid), 14 marzo Wildermuth, Armin: Der Opfertisch M. Paladino,《St. Gallen Tageblatt》, 31 marzo
Kanslig finess, moget Malerei,《Stockholm Tidningen》, 2 aprile
Nittve, Lars: End ny medeltid,《Svenska Dagbladet》(Stockholm), 2 aprile
Vincitorio, Francesco: Mimmo Paladino,《L'Espresso》, 10 aprile
Picciche, Romano: La lezione di Morandi,《L'ordine》, 18 maggio
Vincitorio, Francesco: La parte dell'occhio,《L'Espresso》, 29 maggio
Berger, Danny: Mimmo Paladino (intervista),《Print Collector's Newsletter》, n.2, maggio/giugno
Henichelli, Luigi: Mimmo Paladino,

《Flash Art》, n.115, giugno
Fogliani, Piera:《Amica》, giugno
Guinle, Jorge: Expressionismo vs. neo-expressionismo,《Modulo》, n.74
Bernerdez, Carmen: La vanguardia y lo imaginario, Guia del ocio
Stam, Cecilia: Paletten, Stockholm
Bonito Oliva, Achille: Mimmo Paladino, Giardino Chiuso, Emilio Mazzoli Editore, Modena
Mimmo Paladino (Catalogo), Sperone Westwater, New York
Paladino bei Thomas (Catalogo), Galerie Thomas, München

1984

Somaini, Luisa:《La Repubblica》, 21 gennaio
Larsen, Susan: Mimmo Paladino, Newport Harbour Art Museum,《Artforum International》, Estate
Trini, Tommaso: Mimmo Paladino,《Vogue》, n.413, luglio/agosto
Pasini, Francesca: L'atelier aux yeux innombrables,《Décoration》, n.73, luglio/agosto
Mimmo Paladino,《Vogue》, agosto
Assunto, Rosario: L'imagines et il tiempo,《Tema Celeste》, n.4, ottobre
Januszczak, Waldemar: Waddington Gallery: Mimmo Paladino,《The Guardian》, 9 ottobre
Lyttelton, Celia: Painting Shadows in Imaginary Lines (intervista),《Ritz》, novembre
Rosenthal, Norman: Mimmo Paladino (intervista),《Artscribe》, n.49, novembre/dicembre
Kuspit, Donald: Mimmo Paladino at Sperone Westwater,《Art in America》Sundgren, N.P.:《Journalen》(Stockholm)
Paparoni, Demetrio: La disecca caverna,《Tema Celeste》
Dorfles, Gillo: Mimmo Paladino, Veglia, Mazzotta, Milano
Paladino, Mimmo: Sud, Schellmann & Klüser, München
Rosenthal, Norman: Mimmo Paladino (catalogo), Waddington Galleries, London
Zenek, Felix con Giovanni Jopollo e Thierry Raspail: Mimmo Paladino (catalogo), Musée de St. Pierre, Lyon
Faust, Wolfgang Max: Alla ricerca del···Fragen an Mimmo Paladino, Paladino bei Thomas (catalogo), Galerie Thomas, München

1985

Sozanski, Edward J: Works alluding to faith,《Philadelphia Enquirer》, 13 giugno Silverthorne, Jeanne: Mimmo Paladino,《Artforum》, settembre
Sjursen, Annette: Mimmo Paladino. I samtale md fjerne krefter,《Morgenbladet》, 5 novembre
Bugge, Erle Moestue: Endelig i Munchs hjemland,《Aftenposten》(Oslo), 5 novembre
Flor, Harald: Poeten Paladino,《Dagblat》, 6 novembre
Egeland, Erik: Med Paladino hinsides Kulturkrisen,《Aftenposten》, 12 novembre
Johnsrud, Even Hebbe: Vilje til a overleve Sensasjonen?,《Aftenposten》, 12 novembre
Mannila, Leena: Paladino orfiske sanger,《Arbeiderbladet》, 13 novembre
Grotvedt, Paul: Mimmo Paladino-meningstomhet og spontan intesitet,《Morgenbladet》, 15 novembre
Grotvedt, Paul: November Kunst,《City, Oslo》, n.5, dicembre
Rostad, Bernard: Paladino endelig i Norge,《Tique》, n.4
Rosenthal, Norman: Guardando New York, Mimmo Paladino,《Tema Celeste》, n.6
Mimmo Paladino I Kunsternes Hus,《Kunst》, n.3
Mimmo Paladino (Catalogo), Galerie Michael Haas, Berlin
Lehnerer, Thomas, Helmut Friedel e Donald Kuspit: Mimmo Paladino (Catalogo), Städtische Galerie im Lenbachhaus, München
Cora, Bruno: Mimmo Paladino (Catalogo), Sperone Westwater, New York
Kuspit, Donald e Dieter Koepplin: Mimmo Paladino. Skulptur og Tegning (Catalogo), Kunsternes Hus, Oslo

1986

Bond, Sue: Waddington Galleries Ltd,《Tableau》, Estate
Schutz, Sabine: Mimmo Paladino,《Kunstforum》, vol.86, novembre/dicembre
Wildermut, Armin: Das Erscheinen des Mythos bei Mimmo Paladino, Mario Merz, Enzo Cucchi e Francesco

Clemente,《Kunst und Kirche》, n.1
Paladino, Mimmo: Tane, Gian Enzo
Sperone, Roma
Crutchfield, Margo A. e Dr Howard
Risatti: Mimmo Paladino.
Recent Painting and Sculpture
1982 – 1986 (Catalogo) , Virginia
Museum of Fine Arts, Richmond
Minmmo Paladino (Catalogo) , Sperone
Westwater, New York
Caves, Richard E.: Mimmo Paladino.
Recent prints in context (Catalogo) ,
Waddington
Graphics, London

1987

Heartney, Eleanor: Mimmo Paladino,
《ARTnews》, n.2, febbraio
Vettese, Angela: Mimmo Paladino,
《Flash Art》, n.134, maggio
Minemura, Toshiaki: Occhi tattili,
Mimmo Paladino a Tokyo, 《Tema
Celeste》, n.14, dicembre/febbraio
Nibuya, Takashi: Nocturnal Song (Canto
Notturno) , Mimmo Paladino (Catalogo) ,
Fuji TV Gallery, Tokyo
Breicha, Otto, Dieter Koepplin,
Achille Bonito Oliva,
Siegfried J. Schmidt e Barbara
Wally: Mimmo Paladino-Arbeiten auf
Papier 1973 – 1987 (Catalogo) , Galerie
Thaddaeus Ropac, Salzburg

1988

Bourriard, Nicolas: Mimmo Paladino,
《Galleries Magazine》, febbraio/marzo
Vaizey, Marina: How to turn the
humdrum into art,
《The Sunday Times》, 1° maggio
Mammi, Alessandra: Mimmo Paladino-
Galleria Gian Enzo Sperone,
《Artforum》, Estate
Di Castello, Michelangelo: La tirrania
dell' informazione, 《Tema Celeste》,
n.16, giugno/settembre
Paparoni, Demetrio: L'origine della
ferita, 《Tema Celeste》,
n.16, giugno/settembre
Carboni, Massimo: Il luogo dell'arte,
《Tema Celeste》, n.17, ottobre/
dicembre
Tolzmann, Beatrix: Art Cologne '88,
《Contemporanea》, novembre/dicembre
Godfrey, Tony: Classicism in Painting
Today, 《Art and Design》, nn.5/6
Finch, Christopher: Twentieth Century
Watercolours, Abbeville Press, New
York

1989

Beaumont, Mary Rose: Italian Art in the
20th Century, 《Arts Review》, gennaio
Feaver, William: Chauvinism and Chic,
《Art News》, n.5, maggio
Turner, Jonathan: Trash and Treasure:
The Essence of Alchemy, 《ARTnews》,
settembre
Baradel, Virginia: As usum Dimorae,
《Tema Celeste》, ottobre/dicembre
Johnson, Ken: Mimmo Paladino-Sperone
Westwater, 《Art in America》, novembre
Felver, Christopher: Artists in Close-
up, 《Art International》, Inverno
Carnie, Andrew: A world of possibilities,
《Art and Design》, nn.3/4
Bann, Stephen: The True Vine: On
Visual Representation and Western
Tradition, Cambridge University Press
Mimmo Paladino e Giovanni Testori:
Veroniche, Zaira Mis Artiscope,
Bruxelles
Franchetti, Giorgio: Meditation about
Mimmo Paladino,
Mimmo Paladino (Gatalogo) , Sperone
Westwater Gallery, , New York Bandini,
Mirella: Mimmo Paladino-Disegno,
Galleria in Arco, Torino
Mimmo Paladino (Catalogo) , Galerie
Daniel Templon, Paris

1990

Severino, Emanuele: The Nihilism of
Making, 《Tema Celeste》, n.24,
gennaio/marzo
Brandt, Toby: Second outdoor exhibition
in Monte Carlo, 《Journal of Art》, aprile
Auregli, Dede: Mimmo Paladino,
《Tema Celeste》, luglio/ottobre
Mercuri, Bernardo: Trenta Cavalli per
una visione forte, 《Tema Celeste》,
novembre/dicembre
Paparoni, Demetrio: Trenta cavalli per
La Sposa di Messina, 《Tema Celeste》,
novembre/dicembre
Conte, Giuseppe: Ermes, ovvero
l'energia dello Spirito, 《Tema Celeste》,
novembre/dicembre
Mimmo Paladino, Giancarlo Politi
Editore, Milano
Mimmo Paladino: Peinture, Sculptures,
Aquarelles, Galerie Daniel Gervis,
Cannes Lucie-Smith, Edward: Art in the
Eighties, Phaidon Press, Oxford
Paparoni, Demetrio e Michelangelo
Castello: Specchi Ustroi, Tema Celeste
Edizioni, Siracusa
The 20th Anniversary Fuji TV Gallery

1970 – 1990, Fuji Television Gallery,
Tokyo
Mimmo Paladino, En Do Re, Tema
Celeste Edizioni, Siracusa
For the Collector: Important 20th
Century
Sculpture (Catalogo) , Meredith Long &
Co. Texas

1991

Vallese, Gloria: Ottanta: ritorno all'
opera, 《Arte》, n.218, maggio
Zecchi, Stefano: Paladino at Sperone
Westwater and Waddington Galleries,
《Flash Art》, n.159, Estate
Searle, Adrian: Mimmo Paladino:
Waddingtons, 《Time Out》, 3-10 luglio
Sagar, Ralph: Mimmo Paladino:
Waddington Galleries, 《What's On in
London》, 3-10 luglio
Hall Charles: Mimmo Paladino at
Waddington Galleries, 《Arts Review》,
n.12, 12 luglio
Hubert, Mike: Mimmo Paladino at
Sperone Westwater,
《Flash Art》, n.160, ottobre
Livingstone, Marco: Pop Art, Royal
Academy, London
Paparoni, Demetrio: La metafisica della
luce (Catalogo) , John Good Gallery,
New York IIIᶜᵐᵉ Biennale de Sculpture
Montecarlo 1991 (Catalogo) , Mimmo
Paladino, Drawings and Sculpture
(Catalogo) , Galleri Lars Bohman,
Stockholm
Sallis, John: Recondite Image, Mimmo
Paladino Amici (Catalogo) , Sperone
Westwater, New York
Gallo, Francesco: Parallele Linee della
Scultura Contemporanea (Catalogo) ,
Galleria Gian Ferrari Arte
Contemporanea, Milano
Bìlà Hora: La Montagna Bianca-Mimmo
Paladino (Catalogo) , Kancelàr Prezidenta
Regubliky Csfr, Praha
Raimanovà, lvona: Montagna Bianca
come visione fatale, Bìlà Hora
(Catalogo) , Praha
Kontovà, Helena: La Montagna Bianca,
Bìlà Hora (Catalogo) , Praha

1992

Turner, Jonathan: Mimmo Paladino: 30
Horses, a Watch and a White
Mountain, 《ARTnews》, n.3, marzo
Paparoni, Demetrio: Paladino at
Waddington Galleries, 《Flash Art》,
n.164, maggio/giugno

Tecce, Angela: Hortus conclusus, opera aperta, ⟪Il Giornale dell'Arte⟫, n.104, ottobre
Sculpture(Catalogo), Waddington Galleries, London
Mimmo Paladino (Catalogo), Emilio Mazzoli Editore, Modena
Mimmo Paladino, L'opera su carta 1970 – 1992(Catalogo), Galleria d'Arte Contemporanea, Trento

1993

Maler-Star und Stiller Magier, ⟪Art⟫, n.20, febbraio
Sallis, John: Very Ancient Memories, ⟪Tema Celeste⟫ n.40, Primavera
Monni, Riccardo: E Mimmo sfida Firenze, ⟪La Nazione⟫, giugno
Fanfani, Caterina: Cavallo gigante vola sul Forte, ⟪La Nazione⟫, 3 luglio
Mostardini, Milly: Il Belvedere di Paladino (Intervista), ⟪Il Tirreno⟫, 6 luglio
Paloscia, Tommaso: Mimmo il Forte o lo scudo, ⟪La Nazione⟫, 9 luglio
Pozzi, Gianni: Un nomade eccentrico, ⟪L'Unità⟫, 9 luglio
Vagheggi, Paolo: Paladino vince la sfida Forte, ⟪La Repubblica⟫, 10 luglio
Vettese, Angela: Il vero Forte di Mimmo è la bellezza, ⟪Il Sole 24 Ore⟫, 11 luglio
Mammi, Alessandra: Bella statua, pare un quadro, ⟪L'Espresso⟫, 11 luglio
Miliani, Stefano: Sculture in piazzai Oggi è meglio in un orto (Intervista), ⟪L'Unità⟫, 13 luglio
Bianco, David: In mostra il vago Paladino, ⟪Manifesto⟫, 14 luglio
Cicelyn, Eduardo: Mimmo Paladino

lancia la sfida da Forte Belvedere, ⟪Il Mattino⟫, 15 luglio
Guerri, Lorenza: Forme senza tempo, ⟪Il Giornale⟫, 18 luglio
Bartolini, Sigfrido: Ecco come ti fabbrico un bluff della pittura, ⟪L'Indidipente⟫, 19 luglio
Fiz, Alberto: Transavanguardia for sale, ⟪Milano Finanza⟫, 24 luglio
Petrignani, Sandra: Giardino di pietra, ⟪Panorama⟫, 25 luglio
Grasso, Sebastiano: Uno sguardo dal Forte, ⟪Il Corriere della Sera⟫, 25 luglio
Trimarco, Angelo: Finestra sul campanile, ⟪Il Mattino⟫, 26 luglio
Meneguzzo, Marco: Paladino arcaico, ⟪Avvenire⟫ 31 luglio
Cab, L: Viaggio tra le isole di Paladino a Forte Belvedere, ⟪Arte⟫, n.242, luglio/agosto
Boria, Arianna: A guardia del Forte totem e fantasmi, ⟪Il Piccolo⟫, 5 agosto
Siani, Annalisa: Paladino superstar dell'estate, ⟪La Nazione⟫, 10 agosto
Bartolini, Sigfrido: La dittatura culturale è in pericolo (intervista con Giovanni Carandente), ⟪L'Independente⟫, 15 agosto
Fiesoli, David: Nelle sculture il vento del Sud, ⟪Gazzetta di Parma⟫, 24 agosto
Bonito Oliva, Achille: Paeaggio con Paladino, Mimmo Paladino (Catalogo), Forte Belvedere, Firenze
Rosenthal, Norman: Mimmo e la Memoria, Mimmo Paladino (Catalogo), Forte Belvedere, Firenze
Mimmo Paladino (Catalogo), Forte Belvedere, Firenze-Fabbri Editore

1994

Eye Openers, ⟪The London Magazine⟫, n.20, febbraio
Norman, Geraldine: Sculpture spectacular fails to tempt buyers, ⟪The Independent⟫, 20 marzo
Lowe, Olivia: Mimmo Paladino, Waddingtons, ⟪What's On in London⟫, 23-30 marzo
Di Pietrantonio, Giacinto: Mimmo Paladino at Emilio Mazzoli, ⟪Flash Art⟫, n.178, ottobre
Throncroft, Anthony: Mimmo Paladino at Waddington, ⟪Art and Auction⟫, n.7
Rosenthal, Norman: Mimmo Paladino (Catalogo), Waddington Galleries, London
Braun, Emily: The spirit of the dead watching, Mimmo Paladino (Catakogo), Museo de Arte Contemporáneo de Monterrey, Messico
Rosenthal, Norman: Mimmo e memoria, Mimmo Paladino (Catalogo), Museo de Arte Contemporáneo de Monterrey, Messico Mimmo Paladino-Für Salzburg (Catalogo), Galerie Thaddaeus Ropac, Salzburg
Oberhuber, Konrad e Victoria Martino: Mimmo Paladino-Für Salzburg (Catalogo), Galerie Thaddaeus Ropac, Salzburg

1995

Shulman, Ken: The Uffizi goes Contemporary, ⟪ARTnews⟫, aprile
Klüser, Bernd: Mimmo Paladino-Ulysses 16 June 1994 (Catalogo), Bernd Klüser Editore, München

后 记

　　20世纪60年代后，西方现代艺术逐渐以观念、表现、装置、行为艺术为主流，这种"前卫"艺术的荒诞化和观念化，使艺术逐渐丧失自身的特征，艺术和非艺术、艺术与生活行为难以区分，传统的艺术观念、表现技巧、制作方式以及艺术个性、感情等都被否定，以使"前卫"艺术日趋面临前所未有的危机。70年代意大利一批年轻画家，摆脱只重观念的"贫乏艺术"，他们尊重艺术创作规律，尊重传统，重视技巧回到画布上，充分发挥艺术家各自的想象与直觉，创作出一批又一批新作。著名理论家阿·博·奥利瓦（A. B. Olivo）及时发现并肯定这一艺术新倾向，1979年在他与"艺术之掠影"一文中首先称这种艺术倾向为"超前卫"即超越前卫的艺术。在阿·博·奥利瓦的支持和推广下，"超前卫"艺术迅速在美国和欧洲各地兴起。20年来"超前卫"艺术受到越来越广泛的关注。

　　为了把意大利"超前卫"艺术比较完整地介绍给中国读者，我们和本书的策划者、中国美术学院全山石教授自1998年就开始酝酿画集在中国出版的可能性。为此，全山石教授利用在意大利访问的机会，经过了卓有成效的努力，在我们与意大利朋友之间架起了传播文化、增进友谊的桥梁，并最终使画集的出版成为现实，以期能够满足广大读者解读西方现代绘画的需求。为使本画集更具权威性，我们特邀了阿·博·奥利瓦先生担任主编，并由他亲自选定5位画家在不同年代创作的150幅具有代表性的作品，以使这本画集更准确地反映出这一艺术流派的艺术风貌。

　　本书的编选得到多方力量的惠助。在画集付梓之际，我们要特别感谢意大利的华伦蒂亚·布诺莫（Valentina Bonomo）女士和她的国际艺术交流会，在她的积极筹措和鼎力支持下，画集得以顺利出版。同样，我们也要感谢全山石教授为画集的出版付出的艰辛劳动和无私帮助。在编辑过程中，罗马中意艺术家工作室的马林先生、李向阳先生做了许多工作，在此一并表示由衷的谢意。

<div align="right">

编　者

2000 年 8 月

</div>

POSTFAZIONE

Dopo gli anni '60, l'arte concettuale, l'espressionismo, le installazioni, le azioni erano diventate gradualmente le correnti principali dell'arte. Distinguere l'arte dalla non arte, l'arte dalla vita era difficile: i concetti artistici, le tecniche tradizionali e le forme d'espressione, la figura dell'artista erano rivoluzionati; il concettualismo dell'avanguardia aveva indotto l'arte a perdere la sua natura, proprio nel momento in cui l'arte stessa era in crisi. Negli anni '70 cinque giovani pittori italiani hanno creato nuove opere, svincolandosi dall'Arte povera, rispettando le leggi della creazione artistica e ritornando alle tradizioni, rippropriandosi delle tecniche, ritornando sulla tela con le proprie fantasie e istinti. Il celebre teorico Achille Bonito Oliva ha scoperto ed approvato questa nuova corrente artistica:nel 1979 egli l'ha denominata'transavanguardia', con il significato dell'arte che va oltre l'avanguardia.Con l'appoggio ed il lavoro di diffusione di Bonito Oliva, l'arte della transavanguardia ha conosciuto un rapido sviluppo negli Stati Uniti e nei vari paesi europei. Nell'arco di venti anni essa ha attirato una sempre più grande attenzione del pubblico.

Per presentare una visione complessiva della transavanguardia italiana al pubblico cinese, fin dal 1998 abbiamo pensato di pubblicare in Cina questo libro, in collaborazione con il suo coordinatore, il prof. Quan Shanshi dell'Accademia delle Belle Arti della Cina. Il professore ha costruito un ponte d'amicizia e di scambio culturale con gli amici italiani, attraverso le sue numerose visite in Italia e con un impegno che ha reso possibile la pubblicazione del libro e ha promosso la conoscenza della pittura occidentale in Cina.

Abbiamo chiesto ad Achille Bonito Oliva di realizzare questo progetto, per il quale è stata determinante la collaborazione di Valentina Bonomo: insieme hanno selezionato centocinquanta opere rappresentative create dai cinque pittori negli anni, affinchè il libro potesse riflettere più Precisamente le caratteristiche di tale corrente ed essere un volume più comprensivo della transavanguardia.

Abbiamo ottenuto anche molti altri sostegni nel lavoro. Vorremmo dunque cogliere quest'occasione per ringraziare gli Incontri Internazionali d'Arte per la loro preziosa collaborazione, il prof. Quan Shanshi per il lavoro e l'aiuto offertoci con grande scrupolo, Ma Lin e Li Xiangyang dello Studio Arte Italo-Cinese per l'impegno sostenuto nello svolgimento delle relazioni culturali tra Italia e Cina.

Redattore

Agosto 2000

POSTSCRIPT

After the 1960, the mainstream of the modern art of the west was gradually occupied by the Avant-gard such as Conceptual Art, Expressionism, installations and happenings. As a result, cxdsew32art began to lose its own characteristics. Art and false art, art and daily life were undistinguished. Many are denied, including the traditional concepts of art, skills of expression, ways of creation and the individuality and emotion of art as well. All these made Avant-garde face an unprecedented crisis. In the 70s, five young Italian painters extricated themselves from "Arte Povera"which merely stressed concepts. What they respected were rules of art creation, tradition and skill. These artists took up brushes and produced groups of new paintings, making full use of their imagination and instinct. Professor Achille Bonito Oliva, the renowned theorist, discovered the tendency and affirmed it in 1979,When he declared the tendency "Trans-avantgarde", which meant it had surpassed the avant-garde. With his support, "Trans-avantgarde" sprang up all over the U.S. and Europe. In the recent 20 years, "Trans-avantgarde" is drawing more and more attention.

In order to completely introduce the Italian "Trans-avantgarde" to Chinese readers, we together with Professor Quan Shanshi from Fine Arts College of China, started to deliberated on the possibility of album being published in China. When he visited Italy, Professor Quan Shanshi made great efforts to bridge the cultures and friendship between Italian friends and us, and finally made it possible to publish the album. We expect that the album will meet the need of readers to explore the modern paintings of the west. We specially invited Mr. Achille Bonito Oliva to realize ambitious project: and together with the precious collaboration of so that the album is able to reflect more precisely the style of Trans-avantgarde.

In compiling the album, we have benefited from many people. First of all, special thanks to Incontri Internazionali d'Arte for the promotion of the project and the essential support. Valentina Bonomo, he selected 150 representative works of five painters in different times, We also wish to thank Professor Quan Shanshi for his hard work and generous help. And we appreciate the contribution made by Mr. Ma Lin and Mr. Li Xiangyang of Roman Zhongyi Artists Studio; they have done much work for the album.

<div style="text-align: right">

Compilers

August,2000

</div>

Special thanks for the realization of this volume:

Alessandro Bagnai (Galleria Alessandro Bagnai, Siena)
Giovan Battista Benazzo
Bruno Bischofberger (Galerie Bruno Bischofberger, Zurich)
Marilena Bonomo (Galleria Bonomo, Bari-Spoleto)
Guntis Brands
Barbara Burgerhout
Maurizio Caldirola (Galleria Cardi, Milano)
Renato Cardi (Galleria Cardi, Milano)
Galleria Continua, San Gimignano
Giorgio Franchetti
Mara Girace
Frederique Hutter (Galerie Bruno Bischofberger, Zurich)
Galerie Lelong, Paris-New York
Emilio Mazzoli (Galleria Mazzoli, Modena)
Tobias Mueller (Galerie Bruno Bischofberger, Zurich)
Annamaria Palermo
Gunter Salzman (Galerie Thaddaeus Ropac, Salzburg-Paris)
Eveline Schmid (Galerie Bruno Bischofberger, Zurich)
Katy Spurrell

English translation:
Jennifer Franchina